THE SECULAR SPIRIT:
Life and Art
at the End of the Middle Ages

Foreword by
Thomas Hoving

Introduction by
Timothy B. Husband
and
Jane Hayward

A Dutton Visual Book
E.P. Dutton & Co., Inc. New York
in association with
The Metropolitan Museum of Art
1975

Published simultaneously in Canada by Clarke, Irwin & Company Limited,
Toronto and Vancouver.

ISBN 0-525-49507-X (Cloth edition) ISBN 0-87099-096-9 (Paper edition)

Printed and bound in Japan.

Library of Congress Cataloging in Publication Data

New York (City). Metropolitan Museum of Art.
 The secular spirit: life and art at the end of
the Middle Ages.

 (A Dutton visual book)
 Catalog of an exhibition held at the Cloisters,
 Mar. 26, 1975—June 3, 1975.
 Bibliography: p.
 1. Art, Medieval—Exhibitions. 2. Art, Medieval—
Themes, motives. I. New York (City). Metropolitan
Museum of Art. The Cloisters. II. Title.
N5963.N4N46 1975 709'.02 74-7893

CONTENTS

THE CATALOGUE

VII. MUSIC AND MUSICAL INSTRUMENTS

VIII. CEREMONY AND CUSTOM

FOREWORD

In all eras, objects of everyday life are taken for granted: they are used and discarded, rarely discussed or preserved. It is, generally, a period's extraordinary works of art and architecture that have been preserved for our examination, rather than the pots, games, and other ordinary objects. But the focus of this exhibition, *The Secular Spirit: Life and Art at the End of the Middle Ages,* is on pots and games, clocks and saddles, almanacs and herbals, tools and gifts—a great variety of things made for use during the course of daily life in one of the great periods of transition in western Europe, the years between 1300 and 1550.

During these two and a half centuries of dramatic change, the restrictions and insularity of the feudal system crumbled under economic, social, military, and national upheavals. This period saw the development of capitalism and free enterprise, which gave rise to a wealthy and powerful middle class. It likewise saw the emancipation of the peasant and the expansion of opportunities for the average man to work for his own profit and better his living conditions. The new Atlantic trade routes and internationally accepted currencies, such as the ducat, florin, and taler (from which the dollar is derived), made international commerce a reality. With a developing sense of nationalism, governments became more centralized and more efficiently administered.

The foundations of modern Europe were laid during this period, and many of the legal, economic, and legislative changes survive to this day. Things were happening: it is easy to feel close to the busy, lively, inventive people who made and used the objects this show presents. Indeed, the emphasis of the exhibition is on individuals rather than institutions—men and women rather than the Church or military, the university or guild. And it avoids depictions of daily life in order to concentrate on the works themselves, showing what they were and how they were used.

The 320 objects range from the most ordinary everyday equipment to pieces that are without question glorious works of art. There are simple cooking vessels and spits, for instance, as well as five tarot cards

made as a wedding present for an Italian noblewoman, which are painted with designs as exquisite as those of the finest manuscripts. The varying levels of knowledge are also indicated: a charming though prosaic astrological treatise is shown with an astronomical compendium of astounding sophistication and accuracy. And the arcane manuscripts of the alchemists are presented as well; in one case, the text is still undeciphered.

The objects have been drawn entirely from collections in North America, and many are almost unknown—some have never been exhibited or even published before. Assembling an exhibition is always exciting, but putting together this one has been a surprise and a revelation, for we did not realize at the beginning how great was the quantity of secular material of this busy period. We hope *The Secular Spirit* will not only spark the scholars' interest in a rich field that needs much more study, but will also excite the casual visitor with its beauty and its human appeal.

Thomas Hoving
Director

ACKNOWLEDGMENTS

Gratitude is due to many for the organization of the exhibition, first, of course, to the many lenders both public and private whose cooperation and generosity have made the exhibition possible. We are indebted to the directors of all the lending institutions, and wish to thank the following individuals for their particularly kind assistance, advice, and cooperation: Marjorie and Roderick Webster, The Adler Planetarium; Ruth Fine Lehrer, The Alverthorpe Gallery; Robert B. McNee and Roman Drazniowsky, The American Geographical Society; Jeremiah D. Brady, The American Numismatic Society; Mrs. Leopold Blumka, New York; Harry Bober, New York; Mrs. Ernest Brummer, New York; James Tanis, Bryn Mawr College Library; Curt F. Bühler, New York; William D. Wixom, The Cleveland Museum of Art; Kenneth A. Lohf and Bernard Crystal, Columbia University, Special Collections, Butler Library; Robert H. Brill, The Corning Museum of Glass; Frederick Cummings, The Detroit Institute of Arts; O. B. Hardison, Jr., and Laetitia Yeandle, Folger Shakespeare Library; Kenneth E. Carpenter, Harvard University, Baker Library; Nelson O. Price and H. R. Bradley Smith, The Heritage Plantation of Sandwich; George Szabo, Robert Lehman Collection; Herbert J. Sanborn, Leonard Faber, William Matheson, and Carolyn H. Sung, Library of Congress; Stephen T. Riley and John D. Cushing, Massachusetts Historical Society; Robert C. Moeller III and Judith Applegate, Museum of Fine Arts, Boston; J. Fred Cain and H. Diane Russell, National Gallery of Art, Washington, D. C.; James W. Henderson, Joseph Rankin, Paul Rugen, and Walter J. Zervas, New York Public Library; David DuBon, Philadelphia Museum of Art; John Plummer and William Voelkle, The Pierpont Morgan Library; A. P. Clark, Princeton University, The Firestone Library; Dorothy and Robert Rosenbaum, Scarsdale; H. Hickl-Szabo and Peter Kaellgren, The Royal Ontario Museum, Toronto; Edwin A. Battison, Audrey B. Davis, Melvin C. Jackson, Otto Mayr, Uta C. Merzbach, Raidar Norby, Robert Post, Carl Scheele, and Deborah Warner, Smithsonian Institution, The National Museum of History and Technology; Seth G. Atwood, The Time Museum, Rockford, Illinois; Robert Beech and Richard H. Pachella, The Union Theological Seminary; Henrik Verdier, New York; Louis Martz and Marjorie Wynne, Yale University, Beinecke Library; Arthur Chartenier, Yale University, The Yale Law Library; Ferenc A. Gyorgyey and J. W. Streeter, Yale University, Yale Medical Library; Richard Rephann, Yale University, Collection of Musical Instruments.

In the preparation of this volume, an enormous debt is owed to the scholars who contributed the category essays: Carl F. Barnes, Jr., Robert L. Benson, Millia Davenport, Robert S. Lopez, Helmut Nickel, John Plummer, Derek de Solla Price, and Emanuel Winternitz. We also thankfully acknowledge the contributions made by the following individuals: Jeremiah D. Brady, essay on "Coinage," entries 141–155 and 253; Richard C. Famiglietti, entries 249, 255, 256, and 259; Carmen Gómez-Moreno, who supplied the information for entry 94; Jane Hayward, essays on "Commerce," "Guilds and Civic Affairs," "Travel and Communication," "Books and Learning," "Implements of Learning," "Technical Treatises," the "Arcane"; entries on all glass vessels and manuscripts, entries 79 a/c, 82, 85, 86, 121, 129, 131–134, 137, 139, 212a/b, and 225–227; Lawrence Libin, essays on "Instruments" and "Musical Texts," entries 242–245; Uta C. Merzbach, entries 193, 194, 196, 197, 200, and 209; Helmut Nickel, entries 81, 84, 91, 92, 117, 118, 163, 218, 219, 228 a/b, 230 a/b, 232–240,

275 a/g, and 276; Vera K. Ostoia contributed to entries 105, 158, 159, 264–266; Clare Vincent, essay on "Time," entries 205, 206; Deborah Warner, entries 170–172, and 203; Marjorie and Roderick Webster, essay on "Astronomical Instruments," entries 195, 198, 199, and 208. The remaining connective essays and entries were contributed by Timothy B. Husband, Nancy Sheiry Glaister, Anne Rounds Bellows, and Bonnie Young. The task of editing the catalogue manuscript was supervised by Jean Gallatin Crocker, and further editorial assistance was provided by Joan Sumner Ohrstrom, who checked the bibliographical references, Margaretta Salinger, who kindly provided editorial advice, Vera K. Ostoia, and J. L. Schrader. Elizabeth de Rosa sought out many of the illustrations for the category and connective essays.

In addition to the scholarly contributions to the catalogue, Timothy B. Husband, Jane Hayward, Bonnie Young, Anne Rounds Bellows, and Nancy Sheiry Glaister devoted many hours to the organization of the exhibition, ably assisted in administrative responsibilities by Ellen Grogan and Katya Furse. We are also grateful for the assistance and generosity of the many curatorial and service departments within The Metropolitan Museum of Art and their staff members, and wish that space permitted us to express our thanks to each. For the kind help and support given by Carmen Gómez-Moreno we are particularly appreciative. Stuart Silver and Melanie Roher of the Design Department are gratefully acknowledged for the effective exhibition installation, and Herbert Moskowitz and the Registrar's Office are to be thanked for the care taken in receiving and handling the loan objects. Thanks are also due to William Pons and Walter Yee of the Photo Studio for much of the color and black and white photography.

LENDERS TO THE EXHIBITION

THE ADLER PLANETARIUM, *Chicago, Illinois*

THE ALVERTHORPE GALLERY, *Jenkintown, Pennsylvania*

THE AMERICAN GEOGRAPHICAL SOCIETY, *New York*

THE AMERICAN NUMISMATIC SOCIETY, *New York*

MRS. LEOPOLD BLUMKA, *New York*

HARRY BOBER, *New York*

MRS. ERNEST BRUMMER, *New York*

BRYN MAWR COLLEGE LIBRARY, *Bryn Mawr, Pennsylvania*

CURT F. BÜHLER, *New York*

THE CLEVELAND MUSEUM OF ART, *Cleveland, Ohio*

COLUMBIA UNIVERSITY, SPECIAL COLLECTIONS, BUTLER LIBRARY, *New York*

THE CORNING MUSEUM OF GLASS, *Corning, New York*

THE DETROIT INSTITUTE OF ARTS, *Detroit, Michigan*

FOLGER SHAKESPEARE LIBRARY, *Washington, D.C.*

HARVARD UNIVERSITY, BAKER LIBRARY, *Cambridge, Massachusetts*

THE HERITAGE PLANTATION OF SANDWICH, *Sandwich, Massachusetts*

ROBERT LEHMAN COLLECTION, *New York*

LIBRARY OF CONGRESS, *Washington, D.C.*

MASSACHUSETTS HISTORICAL SOCIETY, *Boston, Massachusetts*

MUSEUM OF FINE ARTS, *Boston, Massachusetts*

NEW YORK PUBLIC LIBRARY, *New York*

PHILADELPHIA MUSEUM OF ART, *Philadelphia, Pennsylvania*

THE PIERPONT MORGAN LIBRARY, *New York*

PRINCETON UNIVERSITY, THE FIRESTONE LIBRARY, *Princeton, New Jersey*

DOROTHY AND ROBERT ROSENBAUM, *Scarsdale, New York*

THE ROYAL ONTARIO MUSEUM, *Toronto, Ontario, Canada*

SMITHSONIAN INSTITUTION, THE NATIONAL MUSEUM OF HISTORY AND TECHNOLOGY, *Washington, D.C.*

THE TIME MUSEUM, *Rockford, Illinois*

THE UNION THEOLOGICAL SEMINARY, *New York*

HENRIK VERDIER, *New York*

YALE UNIVERSITY, BEINECKE LIBRARY, *New Haven, Connecticut*

YALE UNIVERSITY, COLLECTION OF MUSICAL INSTRUMENTS, *New Haven, Connecticut*

YALE UNIVERSITY, THE YALE LAW LIBRARY, *New Haven, Connecticut*

YALE UNIVERSITY, THE YALE MEDICAL LIBRARY, *New Haven, Connecticut*

ONE ANONYMOUS LENDER

INTRODUCTION

Secular art is distinguished from religious art in that its design, iconography, and thematic presentation were neither dictated nor restricted by ecclesiastical dogma and tradition. It therefore expresses to a much greater degree the personal attitudes and needs of the individuals by whom and for whom it was made. In this exhibition we have assembled many diverse objects, chosen not only for their individual interest in terms of function and significance, but also for the degree to which they reflect the character and the broad developments of European life from 1300 to 1550.

These 250 years constitute a period of fundamental change during which the feudal system collapsed and from its ruins the foundations of modern Europe evolved. The succession of events that contributed to this transformation has generally been studied in historical segments, providing us with defined, though at times misleading, chronological divisions. Most recent scholarship, however, has tended to take a more comprehensive view, marshaling all aspects of artistic, philosophical, religious, social, economic, and political developments in an effort to interpret the years between 1300 and 1550 as a coherent period during which the patterns of European life and attitudes underwent basic and continuous change. The late Middle Ages, the Renaissance, the Age of Humanism, and the Reformation all represent vital constituents of this era, but only when viewed together can they explain the ferment on all levels of human thought and activity that must be considered in appraising the achievements of this period of transition.

The objects themselves and the text that follows explore the nature and impact of secular life and art during these two and one half centuries. Rather than considering the same issues, the purpose of this introduction is to present a brief historical survey with regard to one phenomenon—the rise of the commercially oriented middle class—which typifies the numerous, interrelated developments that gave unity to this period. That the struggle of this new social class found its ultimate resolution in religious reform should not be construed as a contradiction of the subject of this exhibition. The secularization of thought and attitudes at the end of the late Middle Ages resulted from the interreaction of all forces of society and, of these forces, the Church was one of the most potent.

The fourteenth century, wracked by wars, peasant uprisings, famines, plagues, and the resultant human misery, has generally been considered a period of social and moral decline. Political leadership, undermined by incessant strife and upheaval, could no longer uphold the society based on feudalism that had prevailed throughout the Middle Ages. Papal authority, weakened by the extended Avignon interregnum (1305–1378) and the Great Schism that followed, never again wielded the unified force that once dominated Western Christendom. Feudal lords, confronted by a new economy based on money rather than on land tenures, found their traditional strength and authority gradually eroded. Supplanting the nobility was a rising group of professional bureaucrats and skilled political officials; some were appointees of the crown, others, simply usurpers of power, but all were part of the structures of increasingly centralized governments. From this context of strife between the old and the new orders, however, a persistent undercurrent of revitalization slowly emerged. In spite of its failures, the fourteenth century witnessed constant protests against existing wrongs, and these protests fostered a revolutionary determination to reform and improve, not only material and spiritual conditions, but social and political institutions as well.

No single phenomenon better demonstrates this revitalization than the rise of the middle class, which was itself as much the cause as the result of the decline of the feudal system. Its firm establishment within the social structure was undoubtedly the single most important element in the evolving order of the fourteenth century. Comprised almost exclusively of town dwellers, this class not only controlled the rapidly developing commercial enterprises and the subsequent profit, but also, in many instances, achieved self-government of the urban centers which it dominated. The importance of these self-governing towns in the political organization of Western Europe is attested to by their representation in national legislative bodies and by their direct financial relationship to the crown. The growing power of centralized government was, to a considerable degree, based on the support that the towns accorded to the ruler. This relative autonomy, on the other hand, contributed to the revolutionary spirit, both social and moral, that was also basically urban-sponsored. The religious uprisings of Jan Huss in Bohemia and John Wycliffe in England, as examples, found their greatest number of followers among town dwellers. The fourteenth century can consequently be considered the era of a burgeoning society dominated by a new class with aims and ambitions radically different from those of the noble elite of the past.

During the fifteenth century, the discovery of new sea routes, as well as scientific and technological advancements, especially the development of reliable navigational aids, made the realization of the commercial potential of the middle class possible. The fulfillment of economic ambitions not only secured the position of this new class financially, but also freed it to pursue a rekindled interest in all areas of human endeavor. The merchant entrepreneurs of the fifteenth century, not the landed gentry, constituted the higher stratum of economic power, and were thus elevated to a position of political as well as cultural importance. While secular thought and institutions were progressively, though often reluctantly, altered to accommodate this evolving force, the attitudes of the Church were notably intransigent, creating a basic conflict within the reorganized social structure.

A constant frustration to the new, monied classes—the commercial entrepreneurs as well as the freed peasants—was the prohibition of lending or investing money for profit, a practice considered usury by ecclesiastical authority and an abominable sin. In a commercially oriented society that depended on commitment of capital, such a ban on reasonable interest-bearing loans was intolerable. By the late Middle Ages, elaborate systems had been devised to evade both Church and lay proscriptions against this practice. The resentment engendered by the restrictions was compounded by the manner in which the Church employed its system of indulgences, a means for purchasing remission of sin. The administering of indulgences was, under any circumstance, a questionable practice, but applied to usury, it became a perversion of the Church's moral authority, for the price of the remission of this sin was assessed in proportion to the amount of profit gained. In this way the Church took advantage of its spiritual prerogative to extract revenues from the faithful. It was this practice that first brought Martin Luther in conflict with the ecclesiastical authorities in 1517. Attacking the fundamental dicta of the Church, Luther declared that salvation was achieved, not as the Church would have it through "good works," such as the corporal works of mercy and Church-sanctioned practices including indulgences, but through faith alone. In this tenet, Luther not only separated man's earthly endeavors from his eternal life, but also provided a means of reconciliation between the human spirit and the divine, or, in his own terms, between knowledge and piety. Luther's theology gave the middle class religious sanction for the first time. It is therefore not surprising that

during the first half of the sixteenth century, Luther and the Reformation movement enjoyed the widest acceptance in those portions of northern Europe where commercial enterprise was of crucial importance. The spread of the Reformation and the acceptance of Protestantism thus acted as a resolution for the two and one half centuries of social, political, and economic struggle that accompanied the transformation of European society.

Martin Luther, however, can hardly be credited with the demise of the medieval world or the subsequent chain of events that altered the face of Europe. The revolutionary fervor read into his works was not calculated by him, nor would it have spread so widely had his writings not fortuitously coincided with the invention of the printing press. The Reformation and Luther's role in it stand as examples of the interrelated events and concepts that conjoined in the transformation of European life during these years. In the text that follows, other interwoven themes are discussed as evidence of the essential unity of this period. Although the roles of theology and religious practice cannot be discounted, it is the secularization of thought and activity that ultimately reveals itself as the motivating force during these 250 years. Whether scientific or arcane, domestic or commercial, literary or mundane, the objects exhibited here have in common a forthrightness of purpose, an exuberance of design, and a sense of experimentation that express the secular spirit so fundamental to the years between 1300 and 1550.

Timothy B. Husband

Jane Hayward

I

THE MEDIEVAL HOUSE

The house is the most indefinable aspect of medieval architecture. As is true today, it was the most common type of building and served universal human physical needs. From 1300 onward, dissimilar requirements from individuals of differing social and economic conditions, from both urban and rural areas, resulted in a variety of architecture. A century ago, Viollet-le-Duc warned that in studying medieval domestic architecture, "il faut distinguer les maisons des villes des maisons des champs, mais ces dernières ne sauraient être confondues avec les manoirs." Thus, it is difficult to define the medieval household; further, few medieval domestic buildings have survived. In the Middle Ages, domestic architecture was traditional, unexceptional, and expendable.

The objects in this exhibition come largely from the houses of the upper bourgeoisie and the lesser nobility of late medieval Europe. For this reason, the emphasis here will be on the type of house in which these objects were originally used. Peasant and king are ignored because each represents an extreme, although the house of the latter frequently served as an ideal model for those who sought and could afford to imitate royalty. The urban house assumes special importance because late medieval Europe was predominantly urban. In the 150 years before the great plague of 1348, urban populations increased rapidly and dramatically: Florence from 15,000 to 96,000, Ghent from 20,000 to 56,000, and Paris from 25,000 to 60,000 inhabitants. Late medieval Europe was also predominantly commercial as opposed to agrarian, and commerce centered in urban areas. It was in these urban areas that medieval domestic architecture, with the obvious exception of the rural manors of the upper nobility, found its greatest expression.

All architecture serves ritual: the cathedral serves one type of ritual, the castle another. The house serves yet another type which is universally constant and standardized: the basic human requirements of shelter, nourishment, and rest; anything else it does is incidental to these three. These basic physical requirements demand daily satisfaction—even in an age of faith, a man can forego prayer longer than he can forego food. The objects in this exhibition prove that while styles varied from place to place and from time to time in late medieval Europe, the physical needs served by these objects were invariable. Moreover, the pattern of satisfying these needs, the ritual of daily life, repeated itself endlessly throughout Europe.

In academic architecture, the total volume and the individual spaces of a building are generated from a preconceived two-dimensional groundplan. The medieval house was anything but academic, and rarely did its design involve drawn plans. Its function, and the spaces required to satisfy this function, determined what its plan would be. Considerations of the space available to the builder and the funds available to the patron frequently forced compromises with ideals. And in every instance tradition played a major part, domestic architecture always being the most traditional of all types of architecture.

The basic plan-type of the medieval house was the open-court plan. This plan-type developed in the protohistoric period of Mediterranean civilization and has been the standard of European domestic planning ever since. Although the open-court plan probably originated in the practice of keeping animals in pens inside the primitive house, the fortified château demon-

strates the principle: the curtain wall forms a court around the keep. In an urban setting, where space is always a prime concern and often a major factor in ultimate result, the open-court plan was not universal. But it could be modified for use in a domestic building that shared common walls with two adjoining buildings. The court in the urban house was neither for animals (although some may have been kept there) nor for protection, but to admit light to rooms that did not open on the front or the rear of the building.

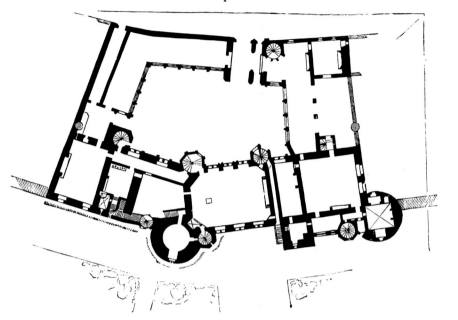

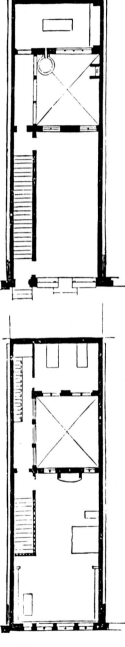

ABOVE: Plan of the house of Jacques Coeur, Bourges, France, 1443-1453. The standard plan of the medieval residence was an open-court house, an arrangement that dates from Mediterranean prehistory. In an urban setting, the central court provided air and light for rooms that did not open onto the street.

Plan of a combined commercial and domestic building, Cluny, France, after 1159. The ground floor (above right) was used primarily as a shop while the first floor (right) was used for living quarters.

The well that provided water for the household was normally found in this court.

The medieval house inherited from antiquity a role that was not principally domestic. In cities, perhaps as many as half the houses served as shops in which goods were sold and, frequently, manufactured. This commercial aspect of the building necessitated that the ground floor provide ready accessibility to the street. Several means of access were possible: large windows, the sills of which served as counters, in the front of the house (in

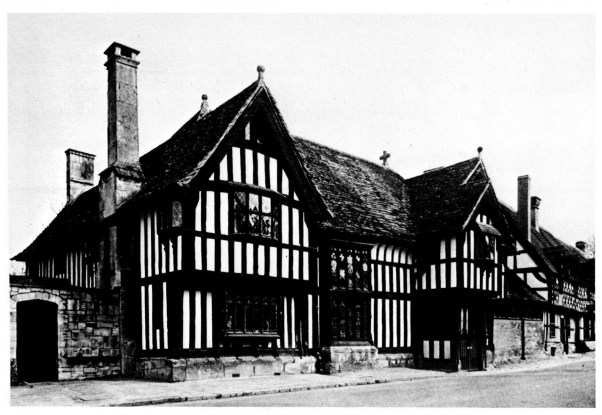

Façade of a half-timbered house, Potterne (Wiltshire), England, XIV century. While brick or stone was the common building material in Italy, Flanders, and Spain, timber was abundant in the North, and timber-framed houses such as this example were prevalent in Britain, France, and Germany.

which case, the public did not enter the house proper) ; a loggia formed by setting the ground floor of the house back from the street and supporting the front part of the upper stories on a series of arches set parallel to the street. The loggia was always more popular in the south of Europe, where it originated as a means of protection from sunlight, than in the north of Europe. Neither of these solutions to the problem of access would have been possible had the house itself not been protected by the walls of the city. This was not the case outside such walls in the suburbs, and the expression "a man's home is his castle" was not merely a cliché in the rural areas of medieval Europe.

The commercial activities carried out in the medieval house were of diverse types, ranging from those of the corner saloon to those of the neighborhood pharmacy. Even when manufacturing took place on the premises, it was craft production, which required neither specialized spaces nor large equipment. Storage, required either for commercial goods or for the ordinary supplies of the household, was located in a vaulted basement, in a room or rooms at the rear of the court, or in an attic loft. This explains in part why the upper stories of many shop-houses project beyond the ground floor; when the attic-loft was used for storage, materials were hoisted directly from the street by means of a block and tackle.

Whether used for commercial activities or not, the ground floor of the urban house normally was the living area. This is explained by the fact that whatever the water supply, that is, a private well in the court or a public well in the street, there was no possibility of piping water above the ground floor. In more modest houses, living room, dining room, and kitchen were combined in one large room centered around an open fireplace which served for cooking and which provided heat. In more lavish houses, the kitchen

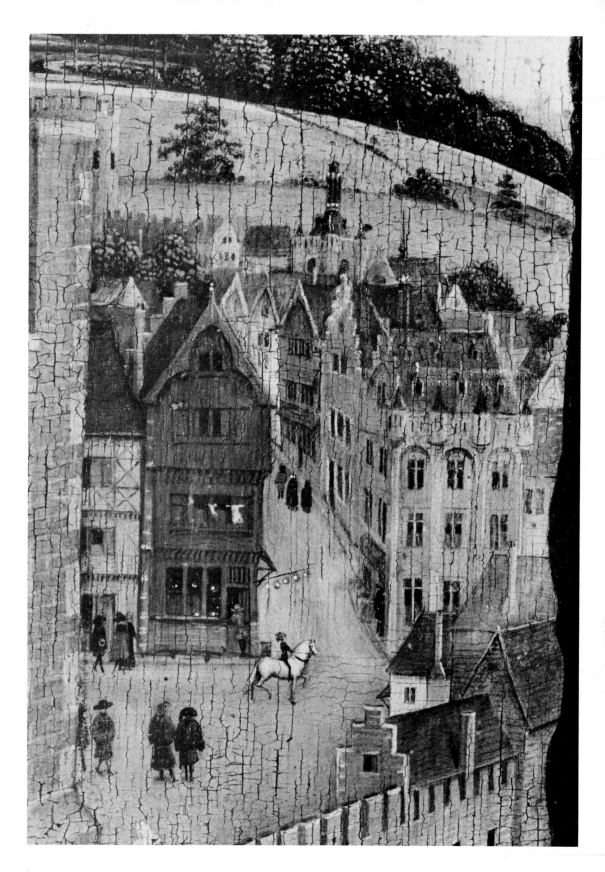

A town street, detail of *St. Luke Drawing the Virgin Mary,* oil painting by Rogier van der Weyden, the South Netherlands, 1430-1440 (Museum of Fine Arts, Boston).

In instances where residential buildings doubled as shops, the projecting upper stories were especially useful. In addition to providing shelter for the ground floor, they could be used for storage of commercial materials or household supplies, which were raised to the upper area with a block and tackle.

was isolated from the living area. In either case, cooking was inevitably done on the ground floor because of the ready accessibility to water, to wood, and to provisions stored in the basement or in the court.

The upper floors, generally limited to two (or to three including an attic loft), served as the sleeping area for the household. Depending on the space available, there were individual bedrooms or one large room divided by hanging curtains. Generally, a large front room overlooking the street served as a combination sitting room and bedroom. There was no bathroom as such in the medieval urban houses, washing was done in basins, and portable pots met the requirements of *latrina* functions. Stairs either constructed as flights or spiraled (depending on the space available to the builder and his capabilities) gave access from the ground floor to the upper stories.

Construction techniques varied throughout Europe and depended to a large extent on the materials available to the builder. In Italy, Flanders, Spain, and along the Baltic, brick was the most common material used for domestic architecture. In Britain, France, and Germany, timber-frame construction predominated, producing the famous half-timber buildings which most people think of as *the* medieval secular building. In most timber-frame buildings, the successive stories each projected beyond the story immediately below it, providing shelter to the ground floor and increasing the space in the upper stories. However, this construction required considerable amounts of timber and, by 1360, England, legendary for its hardwood forests, was forced to import oak from the Baltic. Throughout Europe, stone was used as a building and facing material by those who could afford it.

Interior walls were brick or half-timber construction and were normally whitewashed. Some houses had oak or poplar paneling, but this was a very late medieval development and limited largely to Britain. The pavement of the ground floor was generally composed of bricks or, in more expensive buildings, of finely decorated and glazed terra-cotta tiles. Holland and Flanders were famous for producing such tiles, and exported them throughout the Continent. The floors of the upper stories were composed of wide planks laid perpendicular to the massive beams that supported them. Tiles were avoided in the flooring of upper stories because of their weight, the flooring of one story being the ceiling of the story immediately below it. This accounts for the heavy beams which are found in medieval ceilings. In exceptional instances, stone and wood vaults were used. Roofs were constructed of terra-cotta tiles over a wooden framework. Slate shingles were used in northern Europe, but were never very popular because of their weight. In most cities, there were ordinances against the use of wood shingles or thatch because of their flammable nature.

Doors were of oak, heavily studded with iron nails. The Dutch or double door was used on interiors, but rarely in the main opening to the street. Apparently most windows were glazed, usually in fixed frames. Hinged casements were rare and, when used, only the bottom portion of the window was hinged to open. The upper portion of the window was fixed, although a portion of the lead cames holding the glass might be hinged so that it could open. Even more rarely, the casement was hinged at the top. Contrary to more recent practice, shutters opened to the interior of the house.

By the standards of today, the medieval house was quite undecorated and remarkably underfurnished. On facades, the timber or stone used in the construction of the building itself might be carved. However, medieval man does not appear to have been any more desirous than modern man of being or appearing to be substantially different from his neighbor. Medieval urban houses give the appearance of being rowhouses, which have never been noted for their individuality.

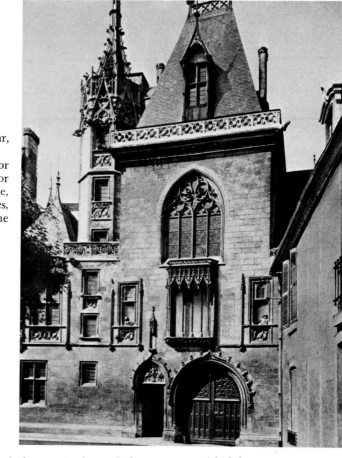

Façade of the house of Jacques Coeur, Bourges, France, 1443-1453.
Throughout Europe, stone substituted for brick or timber as a building material for those who could afford it. This house, owned by a wealthy merchant of Bourges, competed in scale and grandeur with the castles of the aristocracy.

Interiors were even less decorated than exteriors. Color was provided by tapestries rather than by wallpaper or by polychromed walls. Regardless of their decorative value, tapestries were used primarily to cut down on drafts and the dampness inherent in brick and stone construction. Some color was provided by panels of stained glass, usually containing familial coats of arms set into windows.

The medieval house had no built-in closets. Household storage was achieved in standing garderobes or in large low chests or *cassoni*. There do appear to have been some built-in cabinets and bookshelves, but freestanding cupboards were more common. Tables, chairs, benches, beds, and prayer desks (prie-dieux) constituted the normal complement of furniture in the late medieval house. Artificial illumination was obtained by means of candles in chandeliers or sconces.

Such was the late medieval urban house, an endeavor by no means representative of the greatest artistic or financial efforts of the age. Its importance—and the importance of this exhibition—is not that it illustrates the exceptional products of a period, but that it gives insight into the people of that period. As Sir Leonard Woolley wrote of the houses of Ur of the third millennium B.C., "The [domestic] building is important not merely as illustrating the history of architecture but as a setting for the lives of men and women, and as one of their chief forms of self-expression; if we do not know in what surroundings people moved and had their being we shall understand very little of their attitude towards life."

Carl F. Barnes, Jr.

Oakland University

THE GENERAL HOUSEHOLD

By today's standards, even the wealthiest of homes in the late Middle Ages would have appeared sparsely furnished. Apart from the demountable table and the cupboard or sideboard required at mealtimes, the basic pieces of furniture were a bedstead for the head of the family (frequently the canopied type, hung with curtains that could be drawn to provide privacy and to protect against the cold), a few chairs, and many chests and smaller coffrets used for storage. Chests also doubled as seats and the broadest ones, by the addition of a pallet, could be converted for sleeping.

In a wealthy household, the furniture was frequently richly carved or painted, and additional texture and color was achieved through a variety of means. Richly woven or embroidered fabrics covered the many pillows and cushions used not only to decorate the bed, but also to make the hard furniture more comfortable. Woven wall hangings, ranging from simple patterned textiles to elaborately executed tapestries, were especially favored in the colder climates of northern European countries, while frescoed wall decoration was preferred in the wealthy households of the southern regions. Cupboards sparkled with an impressive array of vessels: gleaming dinanderie (both plates and drinking vessels), silver and silver-gilt containers, and often the colorful Spanish lusterware which had become so popular by the late fifteenth century. Carpets, too, became fashionable, although because of their value, they were used more as table covers or wall hangings than as rugs.

What the more modest houses lacked in splendid furnishings was compensated for by a warmth and coziness due, in part, to their smaller scale. Interiors were decorated with less expensive materials: earthenware and pewter rather than silver and bronze vessels; wool and linen rather than rich brocades for covers and hangings. Decorated tiles and, in German-speaking regions, tile ovens, also brightened interiors. Because of the absence of closets or even a separate room where utilitarian equipment could be stored, objects that could not be easily placed in chests or coffrets remained visible, stacked on or hung (frequently inverted) from shelves on the wall. Cooking vessels were kept on the hearth, while brushes, bellows, and other utensils were hung nearby.

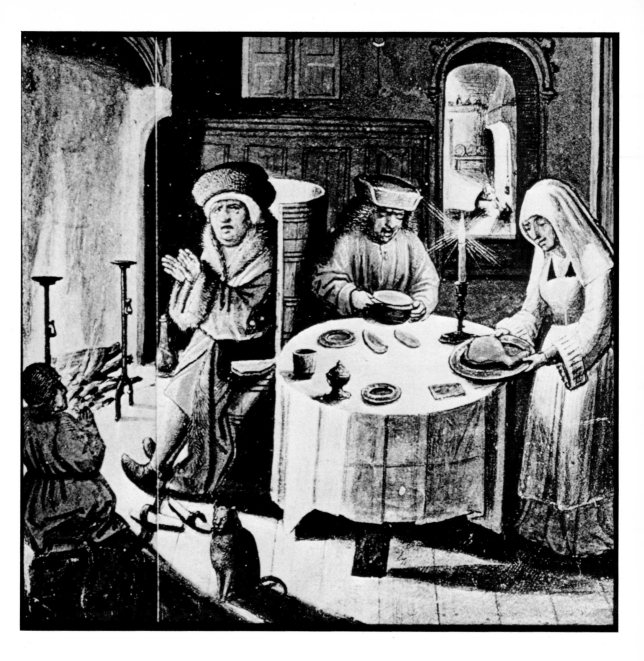

Supper by the fireside, detail of the illuminated
page depicting the month of January in the
Hours of the Virgin, Flanders, ca. 1515 (The
Pierpont Morgan Library, Ms. M399).

1. CANDLESTICK
Flanders
XV century
Bronze, H. 9¼ inches (23.5 cm), Dia. (of base) 4¼ inches (10.9 cm)
The Metropolitan Museum of Art, The Cloisters Collection, 57.135

Although common in Roman times, candlesticks of the socket variety were not seen again in Europe until the fourteenth century. The revival of this type might well have been due to the return of merchants of the wax trade from the East, where socket candlesticks are known to have existed as early as the thirteenth century. The sockets were usually left open at the sides to facilitate the removal of the candle ends in order to reuse the wax, an expensive commodity. The drip pan, which in pricket candlesticks (see no. 2) was placed directly below the candle, has here been lowered and incorporated into the high circular base. The fifteenth-century tendency to embellish the stem is manifested here with the skill that so distinguished the metalworkers of the Lowlands. A similar candlestick can be seen in the central panel of the Merode Altarpiece by Robert Campin (dated about 1425) in The Cloisters Collection.

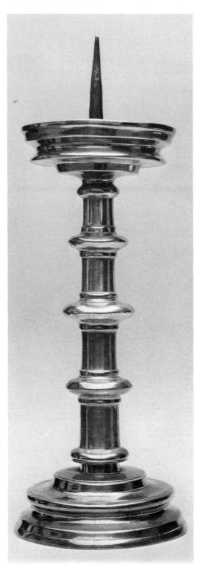

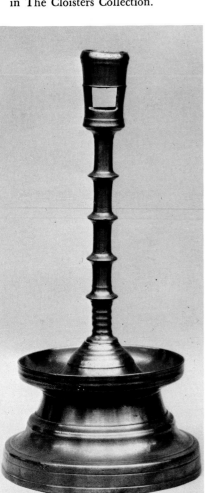

2. PAIR OF PRICKET CANDLESTICKS
Western Europe
XV or XVI century
Bronze, H. 16⅝ inches (42.2 cm), with pricket, 20⅝ inches (52.3 cm), Dia. (of base) 7⅜ inches (18.7 cm)
The Metropolitan Museum of Art, The Cloisters Collection, 55.40.1; 55.40.2

Medieval man took advantage of the light of day as much as possible, but, in the early dark of winter, he had to have recourse to other forms of light, most frequently that of the fireplace. In the fourteenth and fifteenth centuries, the smoky torches of resinous wood, which formerly had been used to provide additional light in the rooms of castles, were generally restricted to use at outdoor events. Candles mounted in wall brackets, chandeliers, or candlesticks, and in some cases, oil lamps, were used to light interiors. Common candles made of tallow had wicks that needed constant trimming and burned with an unpleasant smell. The better quality candles, made of beeswax and used with pricket candlesticks, were so expensive that only the wealthy could afford them. Although in the late Middle Ages large pricket candlesticks were more commonly found in the church, there are some representations of them in use on the dinner table or for other domestic purposes.

3. OIL LAMP
England (Surrey)
XV or XVI century
Lead-glazed earthenware, H. 7⅞ inches (20.2 cm)
The Royal Ontario Museum, Toronto, 930.29.1

By the high Middle Ages, candles had replaced oil as the principal means of household illumination. Only the humblest of households, which could not afford to purchase candles or did not have the necessary materials available to make them, were obliged to burn oil or animal fat lamps. This lamp was certainly a fixture in such a household. The upper basin was filled with oil or fat in which one end of the wick was immersed while the lit end was placed on the pinched spout. As nothing could be wasted in lowly households, the wide, saucer-shaped base, designed to catch any spilled oil, was fitted with two pinched spouts so that the spilled oil could be poured off and reused.

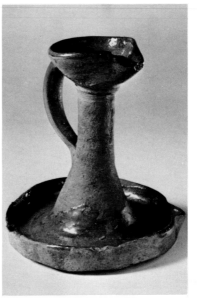

4a. COFFRET
France or Italy
XV century
Leather, with parchment lining and iron mountings, H. 4 inches (10.2 cm), L. 4⅛ inches (10.5 cm), W. 3¼ inches (8.2 cm)
The Metropolitan Museum of Art, Bequest of George Blumenthal, 41.190.252

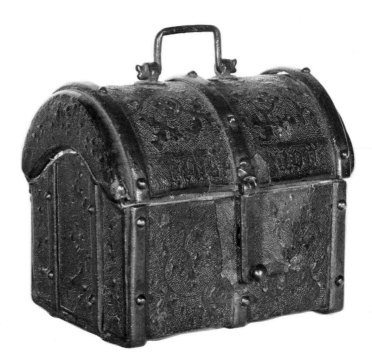

4b. BOX
Italy
Late XV century
Leather, H. 1½ inches (3.8 cm), L. 4⅝ inches (11.7 cm), W. 2⅝ inches (6.7 cm)
The Metropolitan Museum of Art, Gift of Harry B. Friedman, 56.150a, b

Throughout the Middle Ages, household goods of all types were stored in boxes and coffrets which both protected the goods in the home and provided traveling cases on journeys. The great number of these of all sizes, shapes, and materials that have survived from the medi-eval period testify to this method of storage.

Both of these small containers may have been intended to hold rings, ring brooches, and other jewels or trinkets. The leather coffret, with a domed lid, has the inscription EINSE MOY, which might be translated, "follow me" or "do as I do," probably a personal motto. A comparable inscription also appears on the small flat leather box, AMA DIO DE BON CORE A FIN ("Love God with a good heart to the end"). Unfortunately, neither of these inscriptions provides a clue to the specific uses for which the containers were intended.

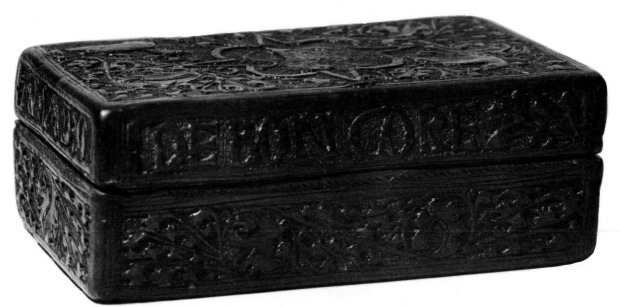

5. CASKET

France
XIV century
Painted and gilded leather over walnut, with brass mountings and lock, H. 4½ inches (11.4 cm), L. 8½ inches (21.6 cm), W. 6½ inches (16.5 cm)
The Metropolitan Museum of Art, Gift of George Blumenthal, 41.100.194

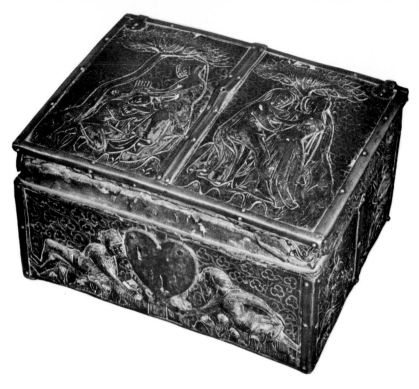

This casket, like many late medieval secular objects, is decorated with scenes of courtship or romances based on medieval concepts of courtly love. In this example, a lover offers his lady his heart while she combs his hair and gives him, in return, her girdle as a token of her affection.

The earliest cogent expression of courtly love is probably to be found in the twelfth-century troubadour songs of southern France. The code of courtly love, formalized in the late twelfth and early thirteenth centuries, was observed, in some places, well into the fifteenth century. A popular author, Christine de Pisan (circa 1360-1430), expressed the sentiments of her day: "For it is well known there is no joy on earth that is so great as that of the lover and the beloved."

Typical of the Middle Ages, the line between religious and secular subject matter is fine, for on the inside of the cover of this casket is a representation of the Virgin and Child.

6. INVENTORY OF EDWARD I

England
1301
Manuscript on vellum (roll), L. 42⅛ inches (107 cm), W. 8¾ inches (22 cm)
Bryn Mawr College Library, Goodhart Collections

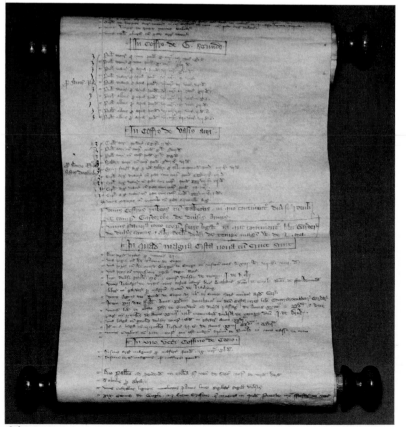

This lengthy and detailed inventory of King Edward I of England, for the years 1300–01, may have been compiled on the occasion of the conferment of the title of Prince of Wales upon the future King Edward II, possibly in connection with feudal ceremonies of homage and fealty. The roll gives a full account of jewels, plate, and other items stored in chests and coffers, many perhaps similar to the examples exhibited here. Objects that were gifts have the donors' names listed; among these were the Countess of Flanders, the Abbot of Fécamp in Normandy, and the Countess of Cornwall. Also listed is a ring given by Gwladys, sister of the Welsh prince Llewelyn ap Gruffyd. As both Gwladys and Llewelyn had died before 1300, it is possible that the ring was a gift made by Gwladys' husband to curry favor with the English king. The entry for this ring reads: "Annulus auri qui fuit sororae Lewelini quond' princ' Wall'." A sapphire ring presented by the Bishop of St. Asaph is also mentioned. Besides precious objects of gold, jewels, and even crystal, the coffers also contained such items as the signet seal of Henry III (father of Edward I), several wardrobe books, various farriers' tools, and a *mappa mundi* (map of the world). Most of the numerous items included in this and other inventories of Edward I have long been lost, but they leave a record of the great wealth accumulated by this monarch who was, ironically, noted for his dislike of pomp and ostentation.

7. COFFRET
France or Italy
Late XV century
Boxwood, with silver mountings, H.
8¾ inches (22.2 cm), L. 10¾ inches
(27.4 cm), W. 6⅝ inches (16.8 cm)
*The Metropolitan Museum of Art,
The Cloisters Collection, 55.36
(See color plate no. 5)*

This intricately carved coffret, probably used to hold jewelry and other small precious objects, is inscribed on the lid: IHS AUTEM TR NASRI RNS PERM. The inscription appears to be a garbled version of Luke 4, 30: *Ipse autem transiens per medium illorum ibat* ("But he, passing through the midst of them went his way"), referring to how Christ passed through the multitude to safety after it had taken Him to be thrown off the brow of the hill on which Nazareth was built. The passage was often invoked to insure a safe journey and might refer here to the safety of the contents of the coffret when it was moved. On the other hand, the reference might be to the transient quality of precious metalwork and jewels, so often melted down or sold when the owner needed money. Although the box appears fragile, boxwood is a durable wood and does not easily split. Objects of this quality, nonetheless, were often protected by specially made leather carrying cases.

8. COFFRET (*Minnekästchen*)
Germany (Upper Rhine)
Second quarter of the XIV century
Oak, intarsia, with iron mountings,
H. 4⅜ inches (11.1 cm), L. 10⅜ inches (26.3 cm), W. 6¼ inches (15.9 cm)
*The Metropolitan Museum of Art,
The Cloisters Collection, Purchase,
Rogers Fund and Exchange, 50.141*
On the inside of the cover of this coffret is a painting of Frau Minne, the German equivalent of the goddess of love, who is aiming her arrow at a young man. In the scene on the other side, he presents her with his heart pierced by three arrows. The inscriptions read: GENAD FROU ICH HED MICH ERGEBEN ("Gracious lady, I have surrendered") and: SENT MIR FROU DROST MIN HERZ IST WUND ("Lady, send me solace, my heart has been wounded").

The concept of courtly love spread quickly from France to Germany where its sentiments were echoed in the lyrics of the *Minnesänger* and often in the decoration of many secular objects including coffrets, such as this one, which are usually referred to as *Minnekästchen* or "boxes of love." The term, however, was not used during the Middle Ages, rather was coined in the nineteenth century. In the Middle Ages these coffrets were called simply *ledlin* (for leather coffrets) or *kistlin*. Like their French ivory counterparts, such containers were probably used to hold jewels or other treasured possessions.

In style and date, the painting of this *Minnekästchen* is similar to illuminations in the *Manesse Codex*, a manuscript which contains one of the largest collections of *Minnesänger* poems in existence. The arms that appear on this coffret may be those of the Birstell family of Baden and Alsace, but as they have also been associated with those of the counts zu Rhein of Basel, the original owners of the coffret have not been firmly identified.

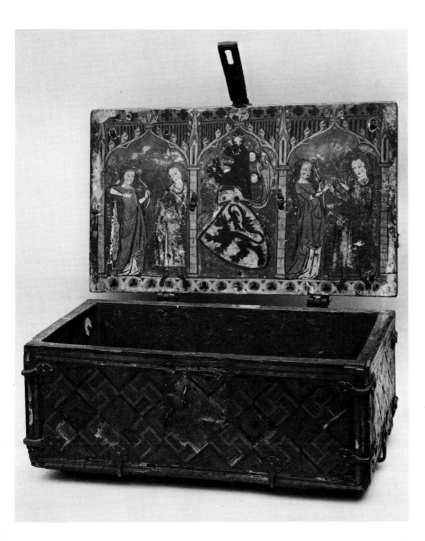

9. COFFRET (*Minnekästchen*)
Southern Germany or Switzerland
XV century
Wood, with iron mountings, H. 3¾
inches (9.5 cm), L. 7⅞ inches (20
cm), W. 5¼ inches (13.3 cm)
*The Metropolitan Museum of Art,
The Cloisters Collection, 55.28*
This south German or Swiss *Minne-
kästchen* varies in its iconography
from the more standard scenes of
courtship and literary romances
found on the majority of such cof-
frets . This deviation may indicate
that the themes of chivalric love, so
prevalent in France, had not pene-
trated as deeply into the region
where this box was manufactured.

The scene on the lid of the box
depicts an elephant bearing a castle
on his back, a motif possibly derived
from accounts in bestiaries of the
Indian and Persian custom of em-
ploying elephants, fitted with plat-
forms, in battle. The elephant, an
exotic Eastern animal, was, for West-
ern medieval man, a source of such
great fascination that in the later
Middle Ages, elephants, both live
and artificial, with castles on their
backs, were used for triumphs and
other spectacles. The grotesque fig-
ures playing musical instruments,
which appear on the side and back
panels of the casket, may be a fur-
ther allusion to the elephant, since
the flared form of the elephant's
trunk resembles a trumpet.

On the front panel appears the
more common theme of the unicorn
and the maiden. The unicorn here
dips his magic horn into the foun-
tain to purify its water as he ap-
proaches the virgin. The scene is
undoubtedly symbolic of purity, im-
plying perhaps the purity of the per-
son who gave or received this casket.

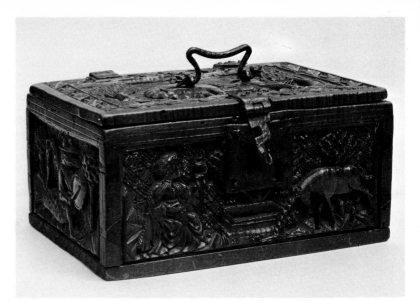

10. CASKET
France
XIV century
Ivory, with modern iron mountings,
H. 4⅜ inches (11.1 cm), L. 10 inches
(25.4 cm), W. 6⅛ inches (15.5 cm)
*The Metropolitan Museum of Art,
Gift of J. Pierpont Morgan,
17.190.173*
This casket is exceptionally rich
in carvings depicting chivalric scenes
from favorite romances. On the lid,
knights assault the castle of love,
defended by ladies; both sides use
flowers as weapons. Knights then
joust for their ladies' favors as the
women look down on them from a
balcony. Some of the other scenes
are from Arthurian romance; Sir
Gawain and Sir Gallahad rescue
maidens imprisoned in castles, both
having previously undergone or-
deals, including one in which Ga-

wain, fortunately in full armor, lies
asleep as a shower of swords de-
scends on him. Sir Lancelot, in
order to rescue his lady Guenevere,
crosses a raging torrent using the
sharp blade of his sword for a bridge.
Tristan and Isolde are spied upon
from a tree by King Mark, but the
king's reflection in a fountain re-
veals his presence to the lovers.
Other popular medieval themes, the
unicorn captured by the lady and
the hairy wild men of the forest, also
are depicted. The front panel, which
shows the fountain of youth and
Phyllis with Aristotle, is a late nine-
teenth-century replacement copied
from an almost identical casket.
Like many caskets decorated with
scenes related to the theme of
courtly love, this example was prob-
ably a lover's gift, designed to hold
jewels or other valued possessions.

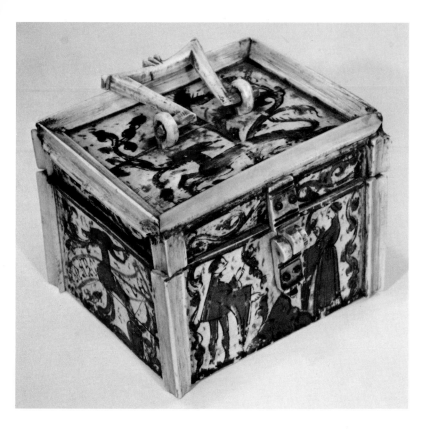

11. CASKET
France or Italy
XV century
Ivory, H. 2½ inches (6.4 cm), L. 3½ inches (8.9 cm), W. 2¾ inches (7 cm)
Collection of Mrs. Leopold Blumka

To judge from its size, this small ivory casket might have been intended as a container for rings. It is painted on its side and top panels with scenes of hunting animals. The front panel shows two lovers, dressed in stylish fashion, with hands extended toward each other. This courtly scene suggests that the casket was a lover's gift. The inscription, which might have verified this suggestion, is too worn to be deciphered.

The style and technique of the painting on the box are reminiscent of the painting on an ivory comb, also in the exhibition (see no. 107a). Although it is clear that the two objects do not belong together, it is possible to speculate that such items were executed as sets and were typical of the personal, treasured belongings of a young privileged woman of the period.

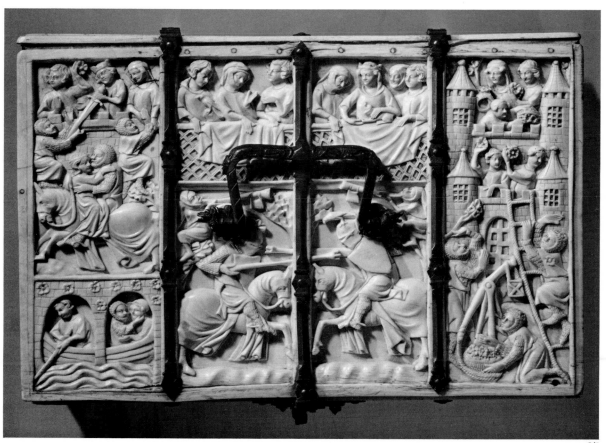

12. COFFRET
Western Europe
XV or XVI century
Iron, H. 8⅜ inches (21.2 cm), L. 11¾ inches (29.8 cm), W. 7⅝ inches (19.3 cm)
The Metropolitan Museum of Art, The Cloisters Collection, 55.61.14

In addition to the luxurious and decorative jewel caskets of ivory and leather, iron coffrets and chests of varying sizes, designed primarily for security, were common. Used in the household to safeguard valuables or important documents, they were likewise employed in business establishments to protect both the profits of the day's trade and valuable merchandise.

On the front of this coffret are three hinged reinforcing bands; the outer two are fitted with hasps, while the central band both covers the keyhole and provides an attachment for a padlock. The internal locking mechanism, activated by a turn of the key, sends a metal bar through the iron hasps of the side bands.

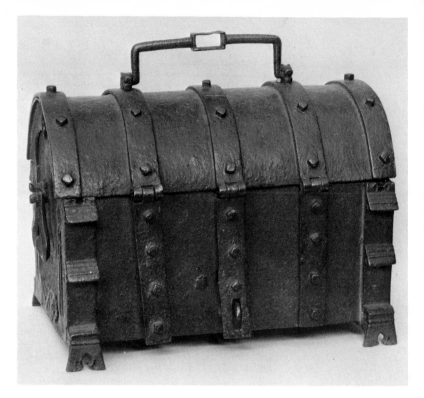

13. DOUBLE KEY
Western Europe
XV or XVI century
Wrought and chased iron, L. (open) 5¼ inches (13.4 cm)
The Metropolitan Museum of Art, The Cloisters Collection, 55.61.44

The decoration of Gothic iron locks and keys was often elaborate and of the highest standard of workmanship. The motifs were often drawn from Gothic architecture, reproducing on a miniature scale complicated tracery patterns and even tiny statuettes. A number of these locks were compound, with some of the mechanisms concealed from view, and required two or even three keys used in sequence to open them. The double key exhibited here was probably designed for such a lock.

, It has been suggested that the greatly expanded use of locks on doors, or coffrets and other types of storage chests was a result of the increasing urbanization of life and the new emphasis on material wealth and private ownership which developed in the late Middle Ages.

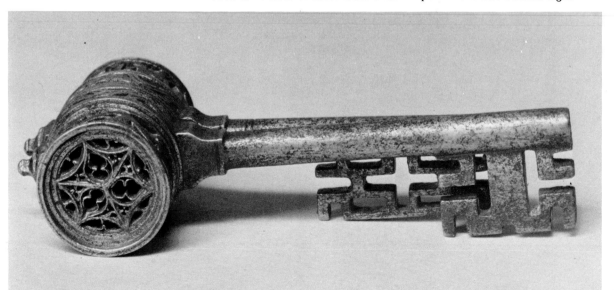

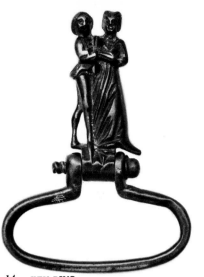

14. KEY RING
Germany
Second half of the XV century
Bronze, L. 4⅜ inches (11.1 cm)
*The Metropolitan Museum of Art,
The Irwin Untermyer Collection,
68.141.2*
During the fifteenth and sixteenth
centuries, particularly in the North,
it was common for mistresses of the
house to carry the keys for their
numerous chests, cupboards, and
doors on rings suspended from their
belts or girdles by a chain or cord.

Sometimes the key ring was at-
tached to one of several chains hang-
ing from a large broochlike device
fastened directly below the belt.
This device was used not only to
attach key rings and other items but
to pin up trailing skirts as well.

This key ring, though possibly
carried separately, may once have
been attached in the fashion de-
scribed above. The small sculpture
of the courting couple would have
served as the finial or handle.
Though key rings with non-figura-
tive terminals exist from the fif-
teenth and sixteenth centuries, at
least two other key rings with very
similar figures have survived. This
particular example is opened by de-
taching the screw that links the ring
to the figures. It is possible that
originally a small bolt or cap cov-
ered the exposed end of the screw.

15. BELLOWS
The Netherlands
First half of the XVI century
Oak and leather, H. 27 inches (68.6
cm), W. 8 inches (20.3 cm)
*The Metropolitan Museum of Art,
The Cloisters Collection, 53.207*
By the fifteenth century, bellows, an
implement known from antiquity,
were often richly decorated and
were displayed on the chimneys of
domestic interiors. This bellows,
carved in high relief and once
brightly painted, shows on one side
the Flight into Egypt. Beneath the

scene are two coats of arms, the left
one unidentified, the right identified
as that of Amsterdam, indicating
that the bellows was once used in
a household or a guild hall in that
city. The back of the bellows has a
circular inset within a deep gilded
molding pierced with three open-
ings for the intake of air. The air
was expelled through the metal pipe
projecting from the jaws of the
dragon's head at the end of the
bellows. The sides of the bellows are
of leather.

The decoration on this bellows of
a religious subject does not indicate
that it belonged to a religious estab-
lishment; such themes frequently ap-
pear on objects of daily household
usage. This same scene, in an almost
identical representation, though
without arms on the shields, appears
on a bellows thought to be from
Utrecht, circa 1510, now in the
Rijksmuseum, Amsterdam.

The existence of two such similar
bellows suggests that these items, in
common use in the household dur-
ing the Middle Ages, may have been
produced in large quantities with
the arms left blank for completion
after purchase.

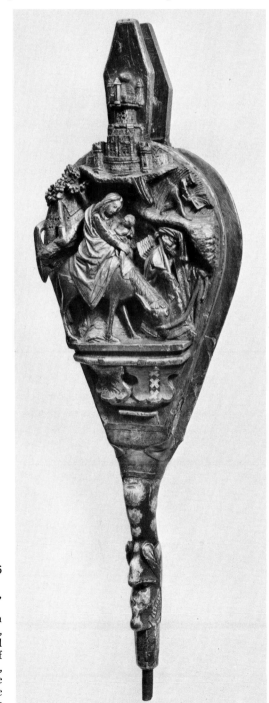

THE KITCHEN

In the households of the wealthy, provided with separate cooking quarters, the fireplace was either built into the thickness of the wall or set in the center of the room on a raised hearth equipped with a flue suspended overhead to channel the smoke and smells, which in earlier centuries had been left to find their own way out. In more modest dwellings, the wall-type fireplace in the main living area doubled as the place for cooking, containing the necessary spits for roasting and the mechanism by which pots and cauldrons could be suspended over the fire. Very large households were also equipped with their own ovens, while the average household had none. In the preceding centuries, there was a communal oven at the feudal manor, but in the later Middle Ages in urbanized areas, there were bake shops and cook shops where breads, prepared puddings, and meat-filled pasties could be bought and where one's own joint of meat could be taken for roasting.

The elaborate recipes and menus in the cookery books that begin to appear around the end of the fourteenth century (two of the most famous being that of Taillevent, the master chef for Charles V of France, and the *Forme of Cury* of the chef for Richard II of England) were clearly intended only for the rich. Even the Goodman of Paris, a Parisian burgher who wrote a book of instructions to educate his young wife in the art of running a household, mentions the extravagant cookery of the courts (which included such curiosities as peacocks cooked and then completely redressed in full plumage, and brightly gilded fish), but clearly states that even the preparation of a less elaborate dish such as a stuffed chicken was "not the work for a citizen's cook, nor even for a simple knight's." The actual process of cooking in noble circles, and wherever possible among the wealthier burghers, remained the exclusive domain of a male chef, but in the average household it was the responsibility of women. Everyday meals of the burgher class consisted in large part of "brewets" (thick broths), simple meat or fish dishes (either roasted, broiled, or ground in a mortar with other ingredients to form stews known as "mortrews"), enormous quantities of eggs, and a limited variety of vegetables. The vegetables differed from region to region, but leeks and beans of all sorts predominated. The widely varied combinations of spices and herbs with which almost everything was seasoned might seem odd and even unpalatable today. Although it is possible that such heavy seasoning was required to disguise otherwise poor-quality or badly-preserved meat, it was applied to even the freshest of fish or choicest of meat indicating that it was appreciated for its flavor as well.

Meat did not play as large a role in the average diet of the late Middle Ages as one might expect. The liturgical calendar required an incredible number of fish days, amounting to nearly half the year. There were also extremely harsh punishments for poaching on a lord's domain, and it was difficult to preserve livestock over the harsh winters. Consequently, meat rarely appeared on the average man's table, and both domestic livestock and wild game were consumed almost entirely by the upper classes.

Although culinary arts in all but the lowest classes improved considerably between the twelfth and the fifteenth centuries, the actual implements required in preparation remained basically the same. Although there are numerous later references to various utensils, none surpasses in vividness or completeness the account given by Alexander Neckam in the twelfth century. Along with the standard equipment, the pots and pans, bowls and pitchers, cooking knives and spoons, he lists a mortar and pestle, a meathook,

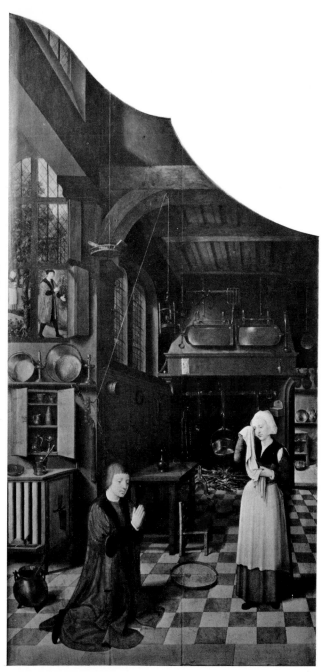

A kitchen, detail of *The Miracle of the Broken Sieve,* oil on panel by Jan van Coninxloo, the Netherlands, ca. 1525-1550 (Musées Royaux des Beaux-Arts de Belgique, Brussels).

a griddle, a pepper mill, a salt cellar, a hand mill, a vat for the pickling of fish, knives for cleaning fresh fish, which were kept in a *vivarium* (artificial pond), and an assortment of implements with which to retrieve the fish from the water. A spoon for skimming and removing foam from the surface of the cauldron is mentioned, as well as the indispensable slotted spoon for removing food boiled or fried in the cauldron. In addition, Neckam mentions the need for such items as a container for cheese, a cupboard for the storage of spices, a series of vessels required for washing and serving, such as ewers and basins, together with shaggy towels for the drying of dishes, and an "ordinary hand towel which shall hang from a pole to avoid mice." Beverages, including a variety of wines, nectars, mead, and beer, were to be stored in the cellar. Finally, for the disposal of wastes, there was what was known as the garderobe pit, generally located near the fireplace, which was most probably kept covered and emptied from time to time with a bucket or pail.

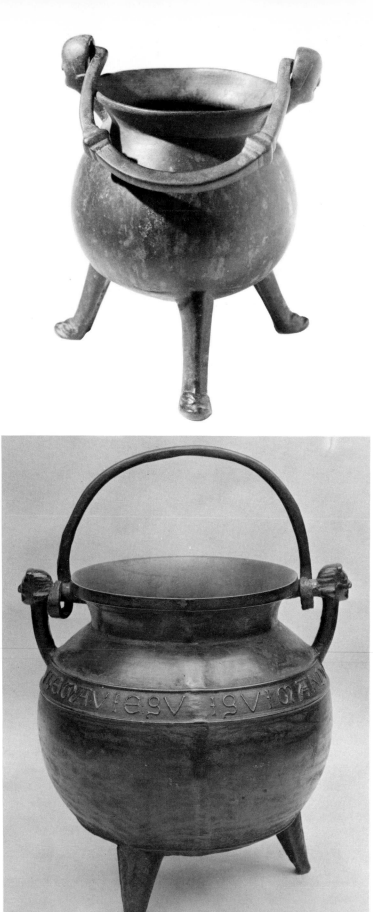

16a. COOKING POT
Flanders (?)
XV century
Bronze, H. 7 inches (17.8 cm), Dia.
6 inches (15.3 cm)
*Philadelphia Museum of Art,
George Gray Barnard Collection,
45.25.208*

16b. CAULDRON
France (possibly Lorraine)
XIV or XV century
Bronze, H. 14¾ inches (37.5 cm),
Dia. 13¾ inches (34.9 cm)
*The Metropolitan Museum of Art,
The Cloisters Collection, 49.69.6*

Cauldrons and cooking pots of all sizes were standard kitchen equipment of wealthy houses in which the lord was responsible for feeding the entire household and its staff. In more modest domestic circumstances, an entire meal could be cooked in one large pot by carefully wrapping the various foods and then suspending them in the pot, placing them at different levels, or adding them at different times. However, by the fourteenth and fifteenth centuries, medieval cookery had become sufficiently sophisticated as to require a variety of sizes of pots even in the average household.

Almost all metal cooking vessels were equipped either with legs so that they could be placed directly into the fire or with handles so that they could be suspended from the trammel. The trammel, a device from which pots and other equipment could be hung at varied heights, was standard equipment in almost every kitchen fireplace. Frequently cooking vessels, such as these two examples, were fitted with both legs and handles giving them greater versatility.

It was not unusual for cooking vessels to have parallel bands running around the body which were sometimes inscribed. The inscription on the cauldron reads: I AMERAI: TOUTE MA VIE: QUI: QUIMANPOENT BLAMEIR. These words have been variously translated as: "I will love all my life no matter who may sneer" or, "I will love all my life, whosoever could blame me for it." It has been suggested that the sentence may come from an old French lyric poem, a noble sentiment to be borne by a utilitarian object of constant use.

17. COVERED JUG

The South Netherlands (?)
End of the XIV century
Bronze, H. 17¾ inches (45.1 cm)
*The Metropolitan Museum of Art,
The Irwin Untermyer Collection,
64.101.1527*

It is not certain where this jug was made; because similar vessels have been found in England and northern Germany, some authorities believe that they are of local production while others feel that the superior quality of this vessel argues for an origin in the Lowlands, around Dinant, which had a long established tradition of outstanding craftsmanship in bronze work. The merchants of Dinant were not only members of the Hanseatic League but also had established themselves in London, and thereby enjoyed special export privileges. This could explain the widely divergent areas in which vessels of this type have been found.

The legs on this vessel suggest it was intended to be used for heating as well as serving. The hole through the flange at the base of the handle might have been used for attaching a device to aid in removing the jug from the glowing embers over which it had been set. It might also have been used in lifting or pouring from the vessel, which would have been of considerable weight when filled.

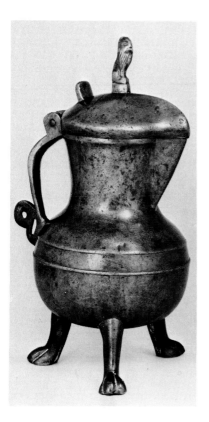

18. COOKING POT

England
XIV or XV century
Unglazed earthenware, H. 4½ inches (11.2 cm), Dia. 6 inches (15.3 cm)
The Royal Ontario Museum, Toronto, 939.9.50

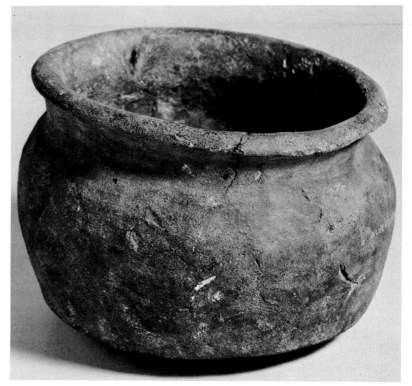

The most humble vessels were made of unglazed earthenware and were used for cooking or food storage by only the poorest families. Such vessels, little changed in shape and technique, have been excavated from sites dating from the Norman conquest. Pots of this sort were made of a white or buff clay which, when fired in a reducing atmosphere, turned dark gray or black, practical colors for vessels used in cooking over open flames. Throughout the Middle Ages, small amounts of sand or quartz granules were often added to the clay which accounts for its gritty texture. This admixture, when fired, tended to strengthen the clay, thereby reducing chances of collapse or distortion. The horizontal bandings indicate that such wares were thrown on wheels and that the convex bottom was the result of the vessel being lifted off the wheel while the clay was still soft. In the case of the present pot, however, the rounded base allowed the vessel to settle comfortably in a bed of hot ashes or coals while being used for cooking. This pot was excavated from Trinity Court, Aldersgate Street, London.

19. SUPPORT FOR A SPIT

Spain (?)
XVI century
Wrought iron, H. 15¾ inches (40 cm)
*The Metropolitan Museum of Art,
The Cloisters Collection, 58.174.1*

Although Spanish, particularly Catalan, ironworking had reached a level of great artistry by the late Middle Ages, many ordinary household objects continued to be wrought in the traditional and less refined fashion, as is the case with this support for a spit (once part of a pair). It is amusing, however, and its maker demonstrated great inventiveness in transforming the scaly fins of its arched back into rings through which the spit could be inserted at graduated intervals.

If contemporary illustrations accurately reflect the normal operation of the roasting spit, it was the fate of some poor knave to sit by the fire, endlessly turning the spit, which

was sometimes provided with a handle. By the fifteenth century, a number of more sophisticated mechanical devices had been devised. These included a series of disks set at an angle above the fire and driven in a circle by its heat, which, in turn, transmitted the rotary motion, through a series of cogged wheels, to the spit. This new "technology" did not, however, displace the traditional method of turning the spit by hand.

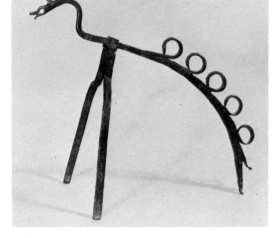

21. LARDING KNIFE
England, possibly London
Early XVI century
Iron, wood, and latten, L. 6 inches (15.2 cm)
The Royal Ontario Museum, Toronto, 927.28.164
Fresh meat was generally roasted on a spit, either whole or in large joints. The meat of wild game and that of domestic livestock (which usually had to forage for itself as grain was used for bread making and rarely for fattening cattle) was ordinarily tough and sinewy. These meats were both tenderized and enriched with flavor by a process of inserting lard into the meat before it was cooked. The introduction of this process, known as larding, has been credited to the cook of Pope Felix V (1440-1449), and represented a great advance in the preparation and enjoyment of meat.

The unusual shape of the blade of the larding knife, with a central ridge down one side, facilitated the insertion of the lard into the meat. This particular example was excavated in Worship Street, London.

20. NUTCRACKER (?)
France or the Netherlands
XIV century
Bronze, L. 6 inches (15.3 cm)
Museum of Fine Arts, Boston, William F. Warden Fund, 49.479
Although a nutcracker is mentioned in the inventories of Charles VI of France, medieval references to this type of implement are extremely rare. While the form and structure of this example and of another in the Irwin Untermyer Collection, The Metropolitan Museum of Art, certainly suggest that they were nutcrackers, their use cannot be unequivocally established.

Nuts, particularly almonds, played an important role in the medieval diet and "milk of almonds" appears frequently in cookery manuscripts of this period. The elaborate decoration of this implement indicates it was used at the table for cracking nuts, rather than in the kitchen. It has also been suggested that these implements were either part of a hunter's equipment, as some examples have small rings allowing them to be suspended from a belt, or were used simply as pincers for general household purposes.

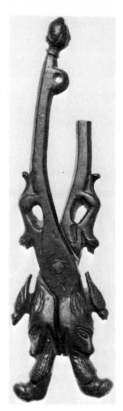

22. MORTAR
Austria, Salzburg
1451
Bell metal, H. 9¼ inches (23.5 cm)
The Metropolitan Museum of Art, The Irwin Untermyer Collection, 64.101.1541
Among the indispensable kitchen implements of the medieval period were mortars, which were used to reduce foods of all kinds to a pulpy state. Meats and poultry were frequently minced, boiled, then ground or pounded with a pestle in a mortar, and passed through a sieve. The resulting pulp was flavored with spices and various other ingredients. Other dishes were also made by "powdering" foods in a mortar. One medieval English recipe for a type of bread pudding specifies that to crusts of bread, ground small, be added "powder of galyngale [an East Indian aromatic root], of canel [cinnamon], gyngynes [ginger]," and vinegar, all to be passed through a strainer. Dishes made of ground ingredients, once prepared, could be either immediately "served forth" or encased in a pastry crust.

Though purely secular in function, bronze household mortars were frequently decorated with religious motifs. The saints represented on this mortar were favorites in the region of Salzburg where it was made. St. Virgil, for example, seen holding his attribute, a geometric instrument, was the founder of the cathedral of Salzburg and the monastery of St. Peter, and is a

patron saint of Salzburg. St. Rupert, also a patron saint of Salzburg, was credited with the introduction to the region of salt mining (he is shown holding a salt container), an industry which brought immense wealth not only to Salzburg but to the Froeschl von Martzoll family, which owned this mortar. The family can be identified by the arms which appear on it: a frog (Froeschl means "little frog" in German) surmounted by the letter "F." The mortar is dated 1451, and might be the one mentioned in a family inventory of 1553.

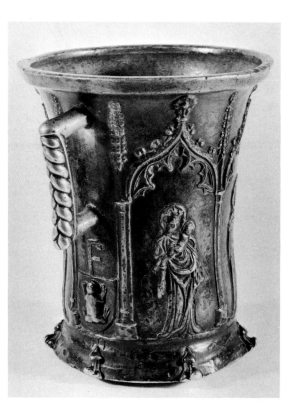

23. LIBRO DE ARTE COQUINARIA
Master Martino
Italy, Aquileia
Circa 1450
Manuscript on paper (codex), 65 folios, H. 8¾ inches (22 cm), W. 5½ inches (14 cm)
The Library of Congress, Ms. 153
This manuscript, written by the master chef Martino, is generally accepted as the first systematic presentation of the art of cooking. Included in the six chapters of the text are 259 different recipes arranged according to subject: meat dishes, soups, sauces, pastries, egg and fish dishes. The book is carefully organized, written in a neat Italian hand, with each recipe beginning with a heading, clearly distinguished by light brown ink. Under sausages (fol. 8v.-9r), Martino explains how to prepare *coppiette al modo Romano,* in which the meat is cut into large pieces and mixed with spices and herbs such as cardamom and fennel. He describes the making of *mortadella* from lean veal as well as *tomacelli* from pork livers. Head cheese is made from young, lean veal and pork to which saffron is added.

As stated on fol. 2, Martino was master chef to the patriarch of Aquileia when he wrote the manuscript. Later he was employed at the papal court in Rome where he collaborated with his friend, Platina, librarian of the Vatican, on a cookbook entitled *De honesta voluptate et valetudine* (Of honest pleasure and worthwhile life), first published in Latin in 1474. Before the middle of the sixteenth century, the book had gone through six editions, had been translated into three languages, and is today acknowledged as "the cornerstone of culi-

nary literature." Martino's part in this published cookbook, the last six chapters, are taken verbatum from the present manuscript.

At the beginning of this manuscript, Martino calls himself *egregio maestro* ("distinguished master"), a title of which he was justly proud. To those who would follow his craft he gives this advice:

The cook should immerse himself in his art and know it through long experience and patient work. If he wishes to be worthy of our praise he should be perfect in his art. The cook should not be a glutton nor prodigal, he should not keep for himself nor eat choice mouthfuls which are by right the master's.

25. MANUSCRIPT CONTAINING COOKERY RECIPES
England
Mid-XV century
Manuscript on vellum (roll), L. 20 feet (61 m), W. 11½ inches (29.2 cm)
Collection of Curt F. Bühler
Medieval cookery recipes are seldom precise in their directions. Exact amounts were left, in most cases, to the individual chef, who apparently knew from experience how much of a given ingredient was needed. Directions for preparation were equally vague and cooking time is rarely mentioned. These early manuals, however, reveal a surprising variety of dishes and methods of preparation. This English cooking manuscript, unusual in that it is a roll instead of a codex, contains 194 different recipes. They are written consecutively down the recto of the roll and continued on the

24. CUOCO NAPOLITANO
Italy, Naples
Late XV century
Manuscript on paper (codex), 89 folios, H. 8⅝ inches (22 cm), W. 6⅜ inches (16 cm)
Collection of Curt F. Bühler
The systematic compilation of recipes for the preparation of food is a phenomenon of the late Middle Ages. In earlier times, it has been assumed that the art of cooking was passed on orally, since few members of the artisan class could read. By the fifteenth century, as numerous examples show, a cookbook must have been standard equipment for at least master chefs, who presumably were literate. The master chefs who produced these books probably created the recipes as well, since many of those listed appear to betray local tastes. This cookbook is a compilation of Neapolitan recipes.

verso in brown ink with titles in red. The fineness of the script suggests, in this instance, that the manuscript was written by a professional scribe and, consequently, that it was prepared at the order of the owner of a great household for use in his kitchen, and was not the property of his chef. Among the recipes described are special dishes for the Lenten season with directions "for to make noumbles in Lent" and "for to make chaudon for Lent." "Noumbles" were made from animal innards for food, and "chaudon" was a sauce made of chopped entrails. These inclusions in the cookery roll emphasize the restrictions of the Church regarding abstinence during the Lenten season from flesh or fowl. These restrictions applied to clergy and laity alike and appear to have been observed quite rigidly.

One finds directions for the preparation of tripe, calf's head, thrush, turtle, and a special sauce known as *Salsa Papale;* many of these are still considered delicacies in regions of Italy today. One recipe is for pasties filled with fine capons, pullets, and pigeons mixed with veal, while another is made of the combs of roosters, a special delicacy in medieval cuisine. Also included in the book are several menus of dinners prepared by the cook for important guests: one for the archbishop of Benevento and another for the prince of Capua. The chef who wrote this book was obviously attached to the household of one of the noble families of Naples.

26. JUG
England, London (or Surrey)
Late XIV century
Lead-glazed earthenware, H. 11¼ inches (28.5 cm)
The Royal Ontario Museum, Toronto, 929.16.1
From early in the fourteenth century, a number of English pitchers and jugs appear with more elaborate and masterful decoration than that on the simple, turned vessels. The technique generally employed was that of applied ornament. Rosettes, grape clusters, rampant lions, trellis patterns, and even heraldic devices were stamped out and applied to the bodies of vessels. Often clays of different compositions were used and then fired to different colors producing a polychrome scheme of decoration. The present example has a series of parallel ribbings framing rows of yellow-glazed pallets over a brown band. The pattern is continued in an abbreviated

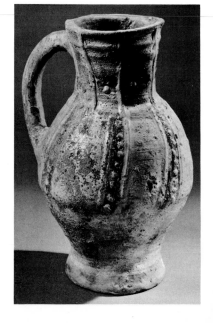

fashion around the neck, and there are applied vertical bands, as well. This type of jug is a copy of those frequently associated with the potters of Rouen, and is one example of the impact of commercial intercourse between France and England. In spite of its more decorated nature, this piece, like most English earthenware, was not destined for the tables of the wealthy but rather for use in the kitchen, the cellar, or in the table service of a humble household. Although the jug was excavated in King Street, Cheapside, London, it is unclear whether this type of ware was made in London or Surrey.

27. BALUSTER JUG
England (Surrey)
XV century
Lead-glazed earthenware, H. 11⅝ inches (29.5 cm)
The Royal Ontario Museum, Toronto, 929.16.7

Jugs or flagons of this unusual shape existed in England from the time of the Norman Conquest, but were unknown on the Continent. The thirteenth- and fourteenth-century varieties were less exaggerated in contour and were fashioned in red clay with a yellow green smeared glaze. In the fifteenth and sixteenth centuries, these jugs were manufactured in Surrey, which explains the more familiar buff clay with green glaze associated with this region. Also typical of English pottery, this jug is sturdily constructed with a heavy

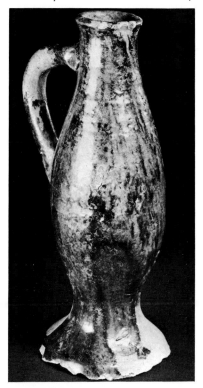

handle, which was attached, not simply with paste clay, but by pressing the end with the finger and thumb until it splayed out securely against the vessel wall. The resultant depressions added a decorative detail which was imitated or elaborated upon in later wares. Clearly used for pouring beverages such as wine, cider, or beer, these flagons closely followed the form of metalwork flagons. Found in great numbers in London, this example was excavated in Moorgate Street.

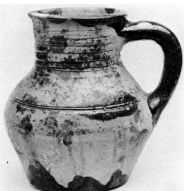

28b. JUG
England (Surrey)
Early to mid-XVI century
Lead-glazed earthenware, Dia. 6⁹⁄₁₆ inches (17.5 cm)
The Metropolitan Museum of Art, Rogers Fund, 52.46.3

Unlike Spanish and Italian tin-glazed earthernwares, English pottery was not produced in a few particular sites, but over the entire country wherever the necessary clay beds existed. Produced in vast numbers for ordinary usage, these wares had little decorative value. For this reason, few examples have survived, and these have been recovered almost exclusively through excavation. The representation of English earthenware on the tables of affluent households, such as that in the Luttrell Psalter, is exceedingly rare. In spite of their commonplace nature, these objects can be appreciated,

28a. JUG
England (Surrey)
Early to mid-XVI century
Lead-glazed earthenware, Dia. 5⅚₁₆ inches (14.9 cm)
The Metropolitan Museum of Art, Rogers Fund, 52.46.8

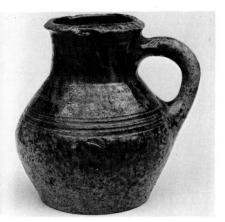

however, for the pleasing profiles and simple, if occasionally careless, decoration.

Vessels such as the two exhibited here, produced during the first half of the sixteenth century and generally referred to as Tudor jugs, were decorated with bands incised by a stylus on the wet clay while the jug was still spinning on the potter's wheel. The vessel was then fired and given a bright green glaze. The darker green brown color of the second jug was the result of inconsistencies in the composition of the glaze and firing conditions. These jugs were made not only for pouring but were apparently used for drinking as well. As they resemble certain types of Rhenish stoneware vessels, it is possible that their style was influenced by German or Netherlandish immigrant potters working in Surrey, the probable site of their manufacture.

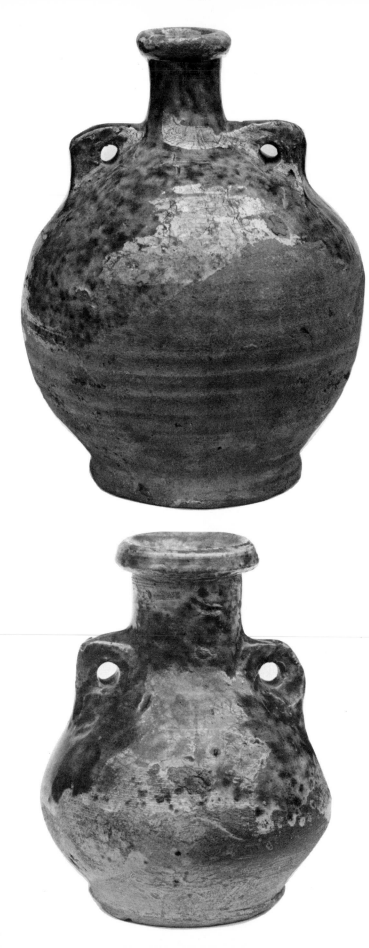

29a. FLASK
England (Surrey)
Early XVI century
Lead-glazed earthenware, H. 7⅛ inches (18.1 cm)
The Metropolitan Museum of Art, Rogers Fund, 52.46.5

29b. FLASK
England (Surrey)
Early XVI century
Lead-glazed earthenware, H. 3¼ inches (8.2 cm)
The Metropolitan Museum of Art, Rogers Fund, 52.46.6

The shape of these two vessels is unusual in English pottery. The greatest number of surviving examples are jugs, but, by the sixteenth century, pipkins, drinking cups, and costrels (vessels similar to canteens) appear with greater frequency. These flasks are related to costrels in their squat, round shape and the small wing handles pierced with a hole through which a cord or thong could be passed to strap the vessel to a belt or to sling it over the shoulder. Unlike costrels, which are flat on one side to lie against the body, these flasks are spherical, making them impractical to carry in this manner. It is more probable, therefore, that a cord was passed through the piercings as a makeshift handle to facilitate pouring or to suspend the vessels in storage. The miniature size of the flask on the right indicates it might have been used as a container for a spicy or savory liquid doled out sparingly in cooking or for a condiment on the table. The narrow necks of both allow for sealing with a cork or wooden plug.

30. JUG
Spain, Manises (Valencia)
Mid-XV century
Tin-glazed and lustered earthenware, H. 8½ inches (21.6 cm)
The Metropolitan Museum of Art, The Cloisters Collection, 56.171.83

Generally identified as pharmacy jugs, this type of vessel along with various other jars, pots, urns, and gallipots lined the shelves of fifteenth-century pharmacies and herb shops. As they were designed to hold liquids such as balsams, syrups, and oils, these jugs, known as *botijos*, commonly appeared in the household, particularly in the kitchen, to hold olive oil or similar staples. The shape is a simplified and less refined form of the taller and more elegantly proportioned gallipot. By the second half of the fifteenth century, demand required that these jugs be turned out rapidly and in great

quantities, and, as a result, the decoration, in comparison to other examples of Valencian lusterware, is crudely drawn.

31. VASE

Moravia, Lŏstice
XIV century
Sand-glazed earthenware, H. 7½
inches (19 cm)
Collection of Mrs. Leopold Blumka

The earthenware produced in Bohemia during the late medieval period falls into two distinct categories: that produced under the Luxemburgs from the mid-thirteenth century to 1420, and that produced during the century following the Hussite revolution. The present example probably dates from the late fourteenth century, and was no doubt made in the important manufacturing center of Lŏstice, a town north of Brno in the fiefdom of Moravia. The gritty, bubbly surface, typical of these wares, was the result of sand added to the clay which bubbled through the surface during the firing and annealing processes. Vessels of this type exist both with small loop handles, which vary in number from three to 18, and without. Those of the thirteenth and early fourteenth centuries tend to be squatter and thicker, while those of the later period, due to the introduction of the foot-driven, fast-spinning potter's wheel, were taller, thinner-walled, and generally more elegant in appearance. The Bohemian potter benefited greatly from the development of commerce toward the end of the Middle Ages. Previously he worked for a manor overlord, producing limited numbers of wares for a local market, but, with the gradual migration to the urban centers, his position rose considerably as he then became a supplier of goods to a wide commercial market. These wares have been found with some frequency in areas of Hungary and northeastern Austria. Unlike his Italian or Spanish counterparts, the Bohemian potter was producing goods of a purely utilitarian nature, chiefly domestic wares, tiles, and the like. This vessel could have been used for a drinking vessel, but, because of the rough lip, it probably served as a storage jar or container. Several examples have lips mounted with silver-gilt rims of the late fifteenth and early sixteenth centuries, indicating not only their adaptation for drinking purposes but their value as decorative objects as well.

Prior to the fifteenth century, when the "dormant" or stationary table as we know it came into general use, meals in the houses of all ranks were taken at a board set upon trestles, which could be easily dismantled at the end of the meal to allow space for the day's other activities. There were two main meals of the day—dinner, taken somewhere between 10 A.M. and noon, and a light supper, usually consumed around 5 P.M. In the more opulent houses, the main table for the lord and his important guests was raised upon a dais at one end of the hall, looking out and over the tables for the less distinguished diners. In more modest circumstances, meals were taken in the same areas that served for cooking and sometimes even sleeping quarters. Benches, and, in rare instances, stools, sufficed for all but the lord, who alone was privileged to sit in a chair. The only other standard piece of furniture connected with eating was a serving table of some sort, which in modest households was usually a high chest. In wealthier homes, this serving piece took the form of a cupboard or credenza with a series of stepped shelves to allow the display of "show pieces," usually ornate plates and drinking vessels. The number of shelves which a cupboard or credenza had was closely associated with the rank of the individual—five or six, for example, being a number usually appearing only in royal households.

The laying of the table was tantamount to ritual in affluent households, each step being carefully described in such contemporary treatises as John Russell's *Boke of Nurture* and Wynkyn de Worde's *Book of Carving*. First came the laying of the tablecloth, and, in England at least, this could involve as many as three cloths, the first being centered and the other two placed so as to extend from the edge of one side of the board to the floor of the opposite side.

The first object to be placed on the table once it was covered was the salt cellar; the seating of guests in relation to the position of this main salt cellar was of the highest importance. Those seated on the same side of the salt as the host were members of the family and honored guests, and those seated "below the salt" were considered lower on the social scale, frequently being the lord's retainers. On the most splendid of tables this ceremonial salt took the shape of a ship, or nef, which might also contain the personal eating utensils and condiments for the lord.

The preparation of the trenchers, originally the slices of stale bread which served as "plates" for each individual, was the responsibility of the pantler. More important were the duties of the "sewer," or steward, who oversaw and "assayed" or tested all dishes taken to the table, which, as can be seen in paintings of the period, were covered, stacked three or four high, and girdled by a long cloth to facilitate their transport from the kitchen to the serving table. The carver was required not only to know the "fayre handlynge of the knyfe," but also to have mastered the most bewildering set of terms. A separate phrase applied to almost every type of meat, fish, or fowl, ranging from an obsolete but still comprehensible expression "unbrace a malarde" to the more cryptic "alaye that fesande," which meant, simply, to remove the wings of the pheasant and then begin to carve. Although other minor "offices" abound—saucers, spicers, and larders, to name but three— the only other office of importance was that of the cupbearer, whose duty it was to keep each cup properly filled and, more importantly, to assure that that of the lord remained untainted (death by poison being by no means infrequent). Although this highly ritualized division of labor obviously applied only to the wealthiest of households, the members of the burgher class sought to emulate it to whatever extent they could afford.

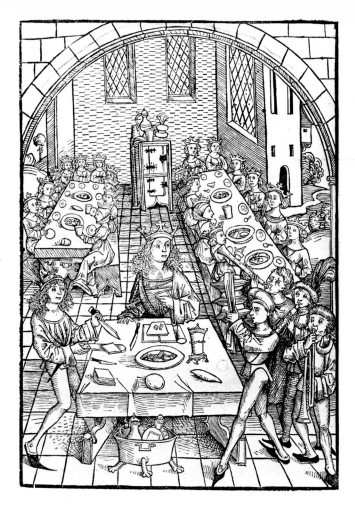

The princely banquet, woodcut by Michael Wolgemut in the *Schatzbehalter*, Nuremberg, 1491 (The Metropolitan Museum of Art, Rogers Fund).

At table, the diners sat in pairs with a bowl placed between them from which they could convey food to their trenchers. Although knives were brought to table by each individual and spoons were supplied in some cases, eating was done primarily with the fingers. No description can surpass the famous lines in Chaucer's *Canterbury Tales* which describe the "impeccable" manners of Madame Eglantine:

> At mete wel i-taught was sche withalle
> Sche leet no morsel from hire lippes falle
> Ne wette hire fyngres in hire sauce depe
> Wel cowde sche carie a morsel and wel kepe
> That no drope ne fille uppon hire breste
> In courteisi weas set ful moche hire leste
> Hire overlippe wyped sche so clene.
> That in hire cuppe was no ferthing sene
> Of greece, whan she dronken hadde hire draughte
> Ful semely after hire mete sche raughte.

Napkins appear in the inventories of even such modest homes as fishmonger's, and many authorities believe that they were used quite regularly. When used, they were apparently to be laid not in the lap but over the shoulder; but since they are rarely represented in paintings of the period—and since there are frequent admonishments in the *Books of Courtesy* not to wipe one's knife on the tablecloth—it might be that they were not used so frequently as one would expect.

Every meal ended as it began, with the washing of the hands.

32. BEAKER

Germany, Cologne
XV century
Pattern-molded glass, H. 3⁹⁄₁₆ inches
(9.1 cm)
Corning Museum of Glass, 69.3.6

Glass, because of its cheapness and availability, gradually replaced metal in the fifteenth century as the most common material for drinking vessels. Medieval examples before this time were extremely rare, implying that glass was not in common use for tableware. Beakers such as this one, because they were blown in metal molds rather than hand-formed, could be mass-produced. Accounts from Aschaffenberg of 1406 indicate that a glassblower with one helper could produce between 175 and 300 of these glasses a day. Small wonder that they were the most common type of glass drinking vessel of their period. These beakers appear frequently in contemporary paintings and prints, for example in the work of Dirk Bouts and the Master of the Housebook. Most of them are, like this one, blown of a bubbly, greenish tinted glass. The impressed diamond pattern on the side served a dual function: its textured surface not only provided the means for a firm grasp but also enhanced the appearance of the vessel.

33. CUP (*Maigelein*)

Germany
XV century
Pattern-molded glass, H. 2⅛ inches
(5.5 cm)
Collection of Mrs. Leopold Blumka

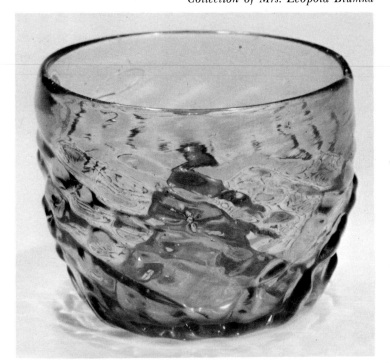

The name *Maigelein,* used today to designate these small pattern-molded cups, was probably a general term for all types of beakers in the late Middle Ages. These glasses were easily produced and appear to have been made in large quantities. Of a light greenish color, this example is typical of the *Wald* or forest glass produced in the wooded sections of Germany where fuel and ash necessary for the making of glass were plentiful. The local river sand, the basic material for this glass, contained impurities such as iron, which accounts for the greenish color of most of these cups. Characteristic of this *Maigelein* is the high "kick-up" or indentation of the base. After removal from the mold, and while the glass was still soft, its conical lower surface was pushed back into the bowl so that the cup would rest firmly on its flat base. Because the diamond pattern on the side of the vessel is so softly impressed, this cup was probably blown in a wooden rather than a metal mold. Though most fifteenth-century drinking vessels are comparatively small in size, the shallow shape of the *Maigelein* was hardly suitable for a beverage such as beer. In all probability, this cup was reserved for the drinking of wine and mead.

34. BEAKER (*Krautstrunk*)
Germany
XV or XVI century
Glass, H. 5¾ inches (14.5 cm)
*The Metropolitan Museum of Art,
Munsey Fund, 27.185.211*
(See color plate no. 3)

Judging by the number of extant examples, and by the frequency with which they appear in paintings of the fifteenth century, the *Krautstrunk* beaker was the most popular type of drinking glass in Germany at the end of the Middle Ages. Made of a fine quality blue or green glass, these sturdy, thick-walled beakers were perfectly designed to serve their function. As in this example, the stocky bowl of the beaker bulges slightly and is firmly seated on a crimped base ring. The sides of the bowl are decorated with applied drops of glass, called "prunts," drawn into the points that give the beaker its name *Krautstrunk* ("cabbage stalk"). A flaring rim has been added to assure ease in drinking. *Krautstrunken* have survived in all sizes, from tiny cups, probably used for wine or spirits, to large ones, such as this, for ale or beer. Many have been found in tombs as containers for personal or religious relics favored by the deceased.

35. BEAKER (*Stangenglas*)
Germany
Mid–XVI century
Glass, H. 8⁹⁄₁₆ inches (21.8 cm)
*The Metropolitan Museum of Art,
Munsey Fund, 27.185.203*

This exceptionally tall, straight-sided beaker, sometimes called a "stick" glass, is a later development of the *Krautstrunk*. Because of its shape and size, it was undoubtedly a beer glass. Technically, this beaker is more accomplished than the other German examples previously described. It is free blown, of an exceptionally clear greenish blue glass, with an applied spiral-threaded foot to give it stability. Its decoration is also unusual. In this example behind each print there is a hollow spike of glass that projects into the interior of the vessel. These spikes, formed by pressing a sharp-pointed tool through the wall of the beaker when the glass was still soft, were undoubtedly intended to serve some useful purpose. Since the beaker was probably used for beer, the spikes perhaps provided a stirring action to aerate the liquid when it was swirled in the glass. Stick glasses of this type were often represented in German painting of the sixteenth century; an example appears in the *Last Supper* by Martin Schaffner in the *Sippenaltar* at Ulm.

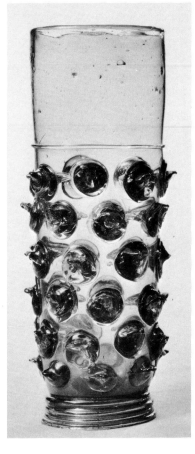

36. BEAKER
Germany, Ingolstadt
Circa 1500
Horn and silver gilt, H. 9⅜ inches (23.8 cm)
*The Metropolitan Museum of Art,
Gift of J. Pierpont Morgan, 17.190.-496*

The size of the section of mountain goat (ibex) horn from which this beaker was fashioned dictated its scale. Though small, the beaker is handsomely mounted, a reminder that drinking vessels, particularly the more elaborate ones, of the late Gothic period, were intended not only for use but for display.

The use of horn as a material for drinking vessels was not uncommon, although the exploitation of the natural protrusions of this ridged horn as a grip is an unusual feature. The basic form, however, is essentially that of the traditional beaker, a cylinder with a slightly flared mouth and a flat base. This vessel rests on three feet in the form of mountain goats of the type from which the horn came. The embossed, lobed cover, executed in a technique popular in Germany, has a repoussé lion on the inside and is surmounted by a finial of a man carrying a shield with no armorial bearings. The cup does, however, bear the town mark of Ingolstadt, which securely establishes its provenance.

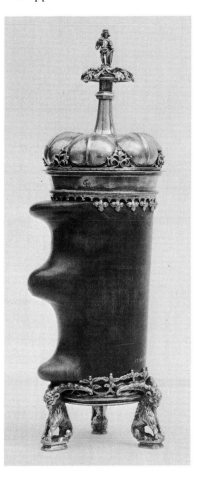

37. MAZER BOWL
England
Second half of the XV century
Maple wood and silver gilt, H. 2¾ inches (7 cm), Dia. 6¾ inches (17.1 cm)
*The Metropolitan Museum of Art,
The Cloisters Collection, 55.25*

Mazer bowls, similar to this one, were among the vessels commonly used in England for drinking wine. Popularly believed to ward off the effect of poison and commonly used for bowls and various drinking vessels, mazer is a general term for lathe-turned root wood or other hard wood. Mazer in German means "burled" or "grained" and such wood could be found in excrescences on trees, particularly maple.

The shape of this mazer cup is typically English, of the type common from circa 1450 to 1540, being a broad, shallow wooden vessel with a wide silver rim or cup-band. Earlier mazers were generally deeper with narrower cup-bands; the broader mount of the later mazers compensated, in terms of capacity, for the shallower bowl.

The band of this bowl, like those

of many similar mazers, is engraved with an inscription, here written in Gothic script in the English of the fifteenth century, *Resun bad I Schulde write th(i)nk micul t' spek lite,* which has been rendered as, "Loose talk is bad, I should write, think much, and speak little." Though some English rim-bands are plain, the edge design of this mazer is not unusual. The interior of the cup has a raised circular disk, or boss, on which is found the sacred monogram IHC; bosses with coats of arms, merchants' marks, or scenes of combat are also common.

It is possible that this vessel originally had a narrow-rimmed mount at its base decorated perhaps with a motif similar to that on the cup-band.

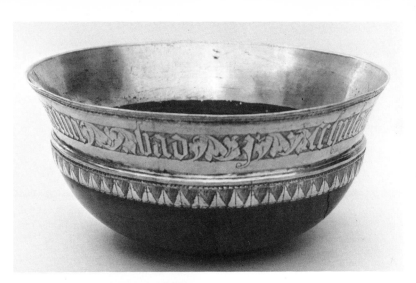

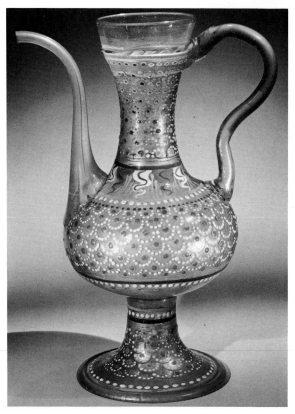

38. EWER
Italy, Venice
Late XV or early XVI century
Glass, with enamel decoration, H. 11 inches (27.9 cm)
Collection of Mrs. Leopold Blumka
The ewer, commonly used as a liturgical vessel, had, by the time of its translation from metal into glass in the fifteenth century, become a popular table vessel. Though not as commonly represented in contemporary painting as the tazza, the ewer appears in a fourteenth-century fresco in Pomposa where it is depicted being used as a wine pitcher. The present example demonstrates the finesse achieved by Venetian craftsmen by the end of the fifteenth century. The ewer is assembled from four different parts: the body, the base, the handle, and the pouring spout. By the beginning of the sixteenth century, the shell motif in enamel decoration was a common feature in the decorative vocabulary of Venetian glassmakers. Less common is the flame motif seen at the base of the neck. Ewers such as this one were a popular export item, as is demonstrated by the frequency of examples in German collections bearing German arms.

39. PITCHER
Italy, Florence
Circa 1460
Tin-glazed earthenware, H. 6⁵⁄₁₆ inches (17.5 cm)
The Metropolitan Museum of Art, Gift of J. Pierpont Morgan, 65.6.14

Small pitchers of this type were among the most common serving vessels produced in the fifteenth-century Italian potteries. Of a simple but well-balanced shape, the pouring spout was impressed in the still-wet clay between the thumb and forefinger, a technique which can be traced back to Roman wine jugs and ultimately Greek oenochoe. By the mid-fifteenth century, Italian pottery was greatly influenced by the designs and patterns of Spanish, particularly Valencian, lusterware. One of the most popular ground decorations was the so-called bryony pattern which depicted bryony leaves, acacia blossoms, and an interlace of tendrils rendered in deep cobalt and luster glazes. The decoration of this jug is clearly taken from a Spanish model. Although much Valencian lusterware was imported into Italy, eventually the Italian potters learned the techniques and copied some of the patterns in an effort to curb the imported competition. Documents relate that a certain Galgano di Belforte went to Valencia to learn new techniques and to bring them back to the factories of Faenza. The circular area on the belly of the pitcher was normally decorated with a coat of arms. In this case, a dog is represented, which may be the badge of a certain family, but it is too generalized to be identified. Wares influenced by Spanish design have been uncov-

ered not only in the outlying towns, but in Florence itself. Numbers of sherds with patterns similar to those on the present pitcher have been excavated in the Piazza Torquato Tasso, which indicates that potteries, or at least a market for these Spanish-influenced wares, were located there.

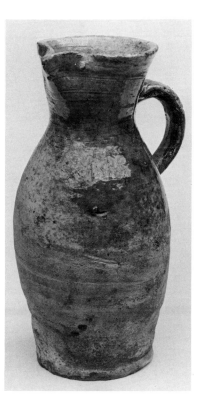

40. EWER
Flanders
XIV century
Bronze, H. 9 inches (22.9 cm)
Collection of Mrs. Leopold Blumka
This three-legged bronze ewer, now missing its lid, belongs to a category of vessels commonly found in fourteenth- and fifteenth-century kitchens of moderately wealthy households. Even vessels of less precious metals such as bronze were generally too costly to be owned by poor families; consequently, ones of similar form were made of pottery. Ewers, like other cooking vessels raised on three legs, could be stood directly over hot coals on the hearth to heat whatever liquid they contained and then be carried to the table for service. This particular bronze example is skillfully fashioned and ornamented indicating that it was a valuable though utilitarian possession. The animal-paw motif and the animal-head terminals on the spout and handle are features of many Gothic water containers such as ewers, aquamanilia, and lavers, but the elegantly simple faceting of the body of the vessel is less frequently seen. Both forms of decoration, however, continued through the fifteenth century, despite the generally more complex design of the later examples.

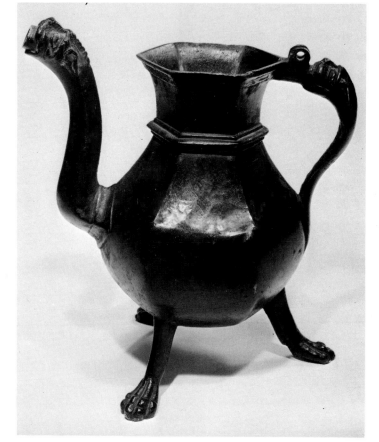

41. PITCHER
England (Surrey)
Late XV or early XVI century
Lead-glazed earthenware, H. 7 inches (17.8 cm)
The Metropolitan Museum of Art, Rogers Fund, 52.46.7
Simple, small pitchers of this type were very common during the late Middle Ages in England and served as dispensers of beverages at the tables or in the kitchens of ordinary households. The simplicity of this pitcher is reflective of the enduring and functional nature of medieval English pottery. The buff color biscuit is the result of a low iron-content clay fired in an oxidizing atmosphere, while the typical bright green color was achieved by adding copper filings to the lead glaze. Many of these wares have been excavated in or around London, but it seems probable that they were made in Surrey where abundant supplies of clay existed. Jugs of various shapes were the major product of the English pottery industry, and, in England, virtually no plates or trenchers of earthenware have survived as they have in Spain or Italy, indicating that such objects were generally made of wood, or, in more affluent households, of pewter or other metals.

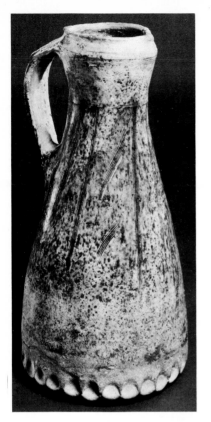

42. JUG
England (West Kent)
Circa 1400
Lead-glazed earthenware, H. 14⅞ inches (37.5 cm)
The Royal Ontario Museum, Toronto, 930.14.9

This sturdy and unusually large conical jug is a typically simple but functional English serving vessel. The wide, heavy handle is firmly attached in order to support the weight of the jug's contents while being carried. When the still-soft clay vessel was lifted from the potter's wheel, the bottom normally sagged; to give it stability, the artisan extended the bottom edge by pressing in a thumbprint pattern. In the late fifteenth and early sixteenth centuries, the convex bottom was avoided by cutting the vessel from the wheel with a cord or wire, but the thumbprint pattern was continued as a decorative element. A further decorative element is found in the scored sets of parallel lines distributed in an arbitrary fashion on the body of the vessel. This jug was excavated in Wood Street, Cheapside, London, but it was probably made in Kent.

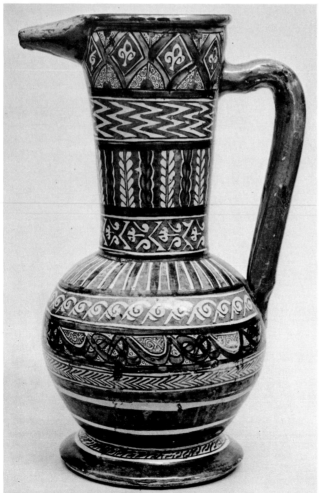

43. PITCHER
Spain, Manises (Valencia)
1430–1440
Tin-glazed and lustered earthenware, H. 18⅜ inches (46.6 cm)
The Metropolitan Museum of Art, The Cloisters Collection, 56.171.146

Pitchers with exaggeratedly tall necks, beaklike spouts, and large heavy handles were common in fifteenth-century Spain. This unusually large pitcher, probably made in Manises, the principal center of Spanish lusterware throughout the fifteenth century, holds almost eight quarts, and is a rare example of earthenware technique. Although pitchers were common items of tableware, this particular example, when full, would have been much too heavy to wield conveniently. It therefore might have been used for dispensing wine or water into smaller table pitchers, or for serving wine at large banquets. Its large size and its ornamentation have made it also a valuable decorative piece which perhaps explains its fine state of preservation. The decoration, which includes patterns of pseudo-Kufic script, points to the Muslim origin of all Spanish lusterware. The technique, which originated in the Near East, found its way into Andalusia by the tenth century. By the fifteenth century, piracy and the wars with the Christians had prompted many craftsmen to move northward into the region of Valencia, where all artisans, whether Muslims, Mudejares (Muslims living under a Christian king), or Christians, were allowed to work, and where ships sailed freely to their Mediterranean markets, unhindered by pirates.

44. BOTTLE (refredador)
Spain, Manises (Valencia)
First half of the XVI century
Tin-glazed and lustered earthenware, H. 11½ inches (29.2 cm), W. 8¾ inches (22.2 cm)
The Metropolitan Museum of Art, Gift of Henry Marquand, 94.4.358
Vessels of this type, generally referred to as *refredadores,* or beverage coolers, appear with increasing frequency in inventories of Valencian potters during the first half of the sixteenth century, although they were mentioned in documents as early as 1446. Typical of many types of Spanish lusterware vessels, the form was derived from Near Eastern models and was probably used to hold either wine or water. The thick walls and narrow spout served not only to retain the temperature but to retard evaporation as well. Generally *refredadores* were constructed with a neck for filling at one end and a spout, often of a zoomorphic design, for pouring, at the other end. The present example has a single neck in the center which served both functions. The coat of arms on the side is that of the first duke of Aragón-Segorbe, Enrique, or his son Alfonso, to whom the father resigned his title in 1516. These dukes were the lords of Paterna, a major pottery manufacturing town, close to the more important center of Manises.

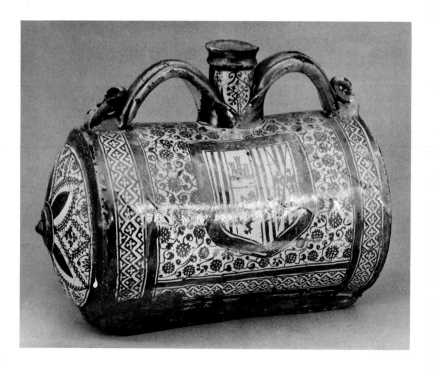

45. PILGRIM FLASK
Italy, Venice
XVI century
Glass, with enamel decoration, H. 15 inches (38.1 cm)
Collection of Mrs. Leopold Blumka
(See color plate no. 1)
This flask is an example of the translation into glass of an earlier ceramic type. Though the type originated as a portable water bottle and was known as a pilgrim's flask, it is hardly likely that this exquisitely blown and decorated example was intended to be carried on a journey. A similar flask in Bologna bearing the arms of Bentivoglio and Sforza was, in all probability, a wedding gift. Blown of a pure colorless glass, the present example is decorated with medallions of gilt and points of enamel. Though the loops that in a more utilitarian example would have held the cord that passed over the wearer's shoulder have been retained, their function in this example is purely decorative.

46. COVERED FLAGON
Germany, Reinkenhagen (Pomerania)
XIV or early XV century, with mid-XV-century mountings
Quartz veined with jasper, silver gilt, H. 13⅜ inches (34 cm)
The Metropolitan Museum of Art, Gift of J. Pierpont Morgan, 17.190.610
(See color plate no. 3)
This flagon has been somewhat improbably associated with a group of variously shaped vessels called *vases de Cana,* referring to the vases filled with the water Christ converted to wine at the marriage at Cana. Over thirty of these vases were known to have been exhibited throughout the Middle Ages for the veneration of the faithful. In its medieval context, however, the term "Cana" also indicated a container for or a measure of liquid as indicated in a 1337 reference: *pro una Cana vini presentata uxori Petri Pellon.* Whatever its traditional associations, the present flagon, because of its weight and costly materials, was undoubtedly intended as an object of decorative rather than functional value. The pear-shaped body and the angular handle associate it with a group of predominantly rock crystal vessels attributed by some scholars to late fourteenth- or early fifteenth-century Burgundian workmanship. Nonetheless, this vessel is known to have come from the Pomeranian town of Reinken hagen. The metal mountings, however, are of mid-fifteen-century Rhenish workmanship. Although more durable than glass, vessels of semiprecious stone were susceptible to breakage. Because of their intrinsic value, these objects, like the present example, were repaired when broken by resetting them in metal mounts.

Aqua dorzo · e freda e secha in secondo
grado la migliore e quela che e bene
bulita in uno vaso de vedro · beuta giova
alo stomecho caldo · noce al interiori fredi
removere el nocimeto beuta co zucharo
roxado

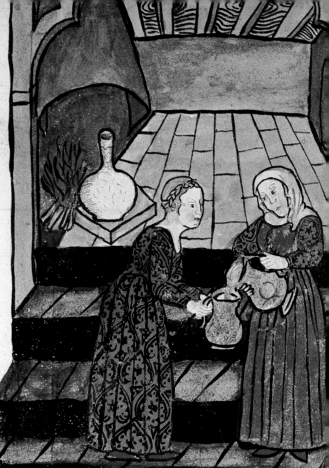

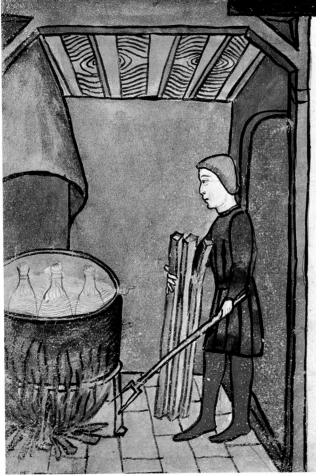

A fare uno stilado el modo sie questo
como vedete · ele comerete avere una
caldera emeterla a focho piena de aqua
poy bisogna avere tre o quatro amole
e conviene aver aparegiato le polpe de
caponi sel ge la febra · bisogna moyare
quele polpe ne laqua roxa con fermiti
cordiali e se ano mal di corpo conviene
moyarle nel sucho de pome codogne co
li fermori cordiali poy nifilzarle co un
pocho de filo e caxarle ne lamola dentro
dal colo che no tochano el fondo ma stiano
cosi amezo poy meterle abolire in laque
dentro la caldera per hore un e poy levarle
fora e laqua che se trovera dentro se gianno
salate e quelo se de usare

Polte de orzo sono frede e seche
in secondo grado. le migliore:
cocte mesedandole longo tempo
per spatio de doy hore. mangiate
giouano ali polsi coleriaj. Noce
Ele genera inflatione. Nremouere
el nocimeto. mangiate con zucharo

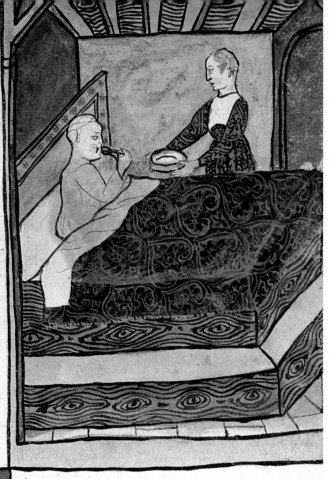

Taro. e caldo e caldo e humido in
secondo grado. el migliore sie el
groso e. compido in cectura mangiata
giona alli corpi inti. Noce che fa vento
litade superflua et. Nremouere el
nocimeto con multo sale.

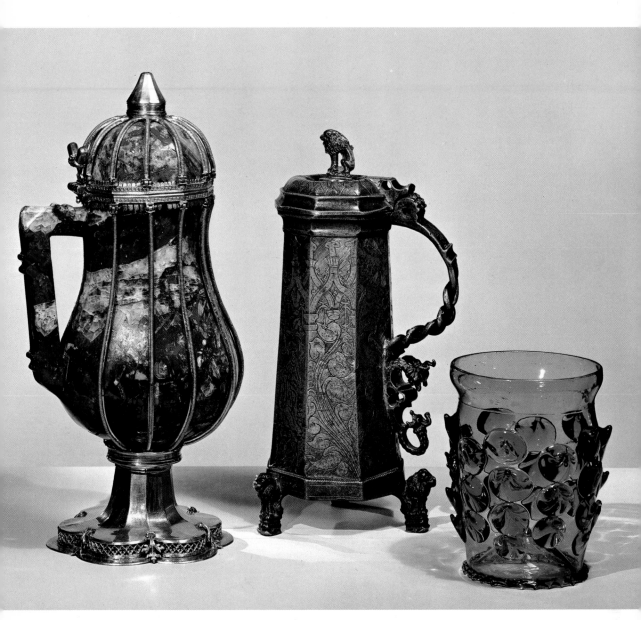

PLATE 3
Cat. Nos. 34, 46, 267

49. BOWL

Spain, Manises (Valencia)
1430–1460
Tin-glazed and lustered earthenware, Dia. 9 inches (22.9 cm)
The Metropolitan Museum of Art, The Cloisters Collection, 56.171.156
This small bowl, presumably a remnant of a large table service, bears the coat of arms of the Florentine family of Dazzi. The town of Manises supplied large amounts of ware for the export market. Italy, particularly the cities of Florence and Siena, was a primary consumer, as well as Sicily, which was at this time part of the kingdom of Aragon. Small bowls of this sort with broad horizontal rims are known in the documents as *scudulles* and were used more as eating than as serving dishes. The decorative motif employed on this bowl is known as the blue bryony pattern, and is referred to in an inventory of René of Anjou as *feuillages pers*. It was particularly popular in Italy, and was often imitated in the decoration of its indigenous earthenware. Bowls of this general size are depicted on a table in a Catalan painting of the Last Supper, now in the Museo Arqueólogico Diocesano, Solsona.

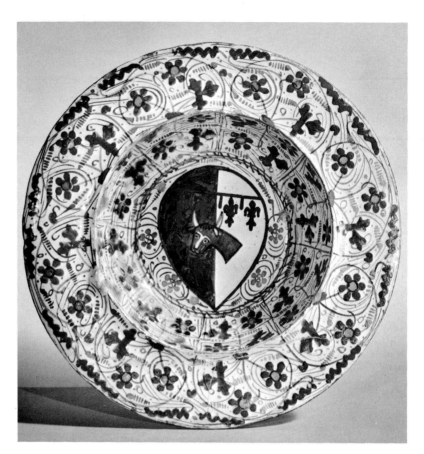

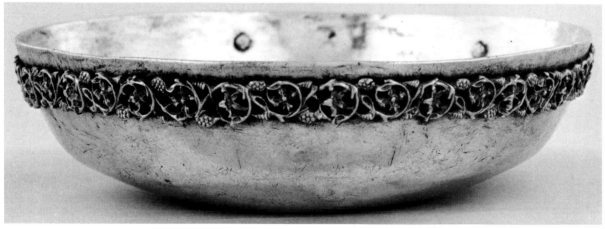

50. BOWL OF JOHN THE FEARLESS, DUKE OF BURGUNDY

France, Paris
Circa 1400
Silver and silver gilt, Dia. 6½ inches (16.5 cm)
Museum of Fine Arts, Boston, 48.264
This elegant bowl, which has silver hallmarks indicating Parisian workmanship, has been associated with John the Fearless, duke of Burgundy (1371–1419). Engraved on the underside of the bowl is a shield bearing his arms.

Though drinking bowls for wine were used during the Middle Ages, it is unlikely that this bowl was intended for this purpose. The absence of a handle, which was a usual feature of fifteenth-century Burgundian drinking cups; the placement of the riveted silver-gilt foliated mount on the rim, which would have made drinking awkward; and the extreme shallowness of the bowl itself suggest that it was probably intended for sweetmeats, such as sugared almonds, or spices, which were often in semiliquid form. Burgundian bowls of similar size and shape, thought to have been used for this purpose, date from the second half of the fifteenth century in the time of Duke Charles the Bold, whose fondness for spices, sweetmeats, and wine was noted in contemporary sources.

51. BOWL

England
Circa 1500
Pewter, Dia. 6¾ inches (19.7 cm)
Philadelphia Museum of Art, Gift of George H. Frazier, 29.192.25

The use of pewter for tableware in England is documented as early as the late thirteenth century when the inventories of Edward I indicate that in 1290 he had in his possession over 300 pewter dishes, salts, and platters. Cornwall became a principal source of tin, the primary constituent of pewter, and the Pewterers' Company of London was accorded official recognition in 1343, during the reign of Edward III. The quality of pewter could vary greatly. Fine pewter was that which contained tin and copper or brass in a proportion that "as of its own nature it will take up." Common pewter consisted of tin and lead "in reasonable proportions." Early ordinances required that common pewter be used only for making such ordinary objects as candlesticks, pots, and cruets. To assure compliance with these regulations, makers of pewter were obligated to identify their work with a stamp, which explains the otherwise unidentified mark under the rim of this bowl where a partially obliterated "F" (?) appears within an oval.

By the fifteenth century, pewter tableware had found its way into much more common usage, although it by no means replaced wooden or earthenware versions in the homes of less wealthy people. This small, shallow, and extremely simple bowl would most probably have been used at the table of a member of the upper or merchant class.

52a. PLATE

Spain, Manises (Valencia)
1430–1470
Tin-glazed and lustered earthenware, Dia. 11 inches (28 cm)
The Metropolitan Museum of Art, The Cloisters Collection, 56.171.119

52b. PLATE

Spain, Manises (Valencia)
1430–1470
Tin-glazed and lustered earthenware, Dia. 17⅝ inches (47.7 cm)
The Metropolitan Museum of Art, The Cloisters Collection, 56.171.136

Both of these plates are emblazoned with the coat of arms of the Morelli family of Florence, and must have belonged to a large table service. Examples of matching services have only rarely survived, although documents indicate great numbers were made for both the domestic and the export markets. In a receipt dated 1454, the widow of Don Pedro Buyl, overlord of the Manises lusterware factories, received payment of 6000 gueldos (roughly equivalent to $80,000) as a tithe on the potters' goods destined for the export market. These wares leaving Grao, the port of Valencia, destined for Mediterranean markets, generally were transported by ships of Mallorcan registry. For this reason, lusterware, and later all glazed earthenware, became known as majolica. The small plate, because of its size, was probably used primarily for eating, while the larger plate, called in the documents a *tayador* or *tallador*, could have been used as a trencher for carving or a salver for serving meats or other foods. Large plates were often used as decoration, either placed on a credenza or hung on the wall by the two holes on the outer rim. These holes, which appear on the majority of large serving dishes, may also be explained by the firing process in which the plates were hung in a reducing kiln to avoid marring the glaze by contact with other objects being fired at the same time. The ivy pattern rendered completely in copper luster became an increasing popular decorative motif toward the end of the century as potters more literally imitated the surface sheen of precious metalwork.

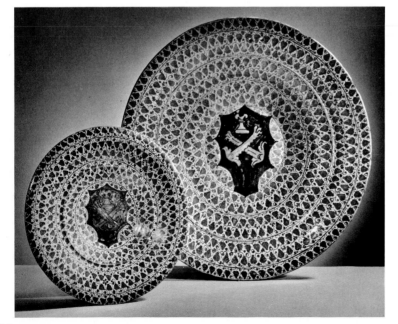

53. TRENCHER

England, London
End of the XVI century
Sycamore wood, H. 7⅝ inches (19.3 cm), W. 6⅛ inches (15.5 cm)
The Royal Ontario Museum, Toronto, 930.15.5

In early medieval times, trenchers were made of large sections of bread, usually several days old, and took the place of individual plates. The bread, according to *Le Ménagier de Paris,* circa 1393, should be "half a foot wide and four-inches high, baked four days before." Diners filled their trenchers with food from large platters placed in the center of the table.

By the end of the fifteenth century, however, trenchers, particularly in northern Europe, were more commonly made of wood and pewter. The first mention of "trenchers of tree" appears in *For to Serve a Lord* of circa 1500. The present example of a rectangular trencher has a small depression in one corner for salt. It was excavated in London, and, although probably dating from the end of the sixteenth century, it resembles earlier wooden trenchers, despite the addition of a salt cavity. In the North, pottery plates, referred to as "trencher plates" or "plate trenchers," were not generally used to eat from until the late sixteenth and early seventeenth centuries. Even at this late date, however, wooden trenchers continued to be used as well.

54a. KNIFE

England
First half of the XVI century
Iron, with wood and latten handle, L. 7⅛ inches (18.2 cm)
The Royal Ontario Museum, Toronto, 927.28.34

54b. KNIFE

England
First half of the XVI century
Iron, with modern wood and latten handle, L. 5⅝ inches (14.4 cm)
The Royal Ontario Museum, Toronto, 927.28.35

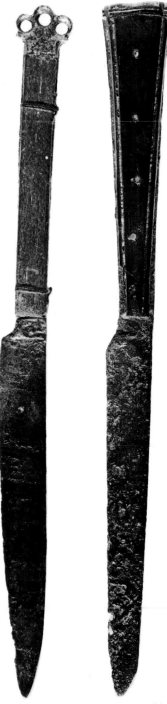

A variety of knives for serving and eating at the table existed, including large knives for carving meat, knives for slicing and shaping the stale bread that served as trenchers, and the indispensable eating knife (which frequently doubled as a hunting knife), brought to the table by each individual. Men carried them in a sheath attached to their belts, while women carried them in cases suspended from their girdles. Although the length and width of the blades of these personal knives changed considerably over the course of the centuries, those of the late Middle Ages were invariably pointed to allow the user to spear pieces of food. By the fifteenth century, very strict rules of etiquette for the use of knives had been laid out in such treatises as John Russell's *Boke of Nurture* and William Caxton's *Noble Boke of Curtasye.*

The two knives here exhibited are examples of these personal knives. Although the mounts on the handle of the smaller one are modern replacements, both knives are representative of the extremely simple and unpretentious types produced by the cutlers' company in England in the late fifteenth and early sixteenth centuries. In all these examples, only the maker's mark of the cutler appears impressed on the blades and is inlaid with latten, a variety of brass (missing in one knife). The manufacture of knives normally required four craftsmen: the blacksmith to make the blade, the hafter who then made the "haft" or handle, the sheathmaker who created the case (with which almost all medieval knives, no matter how simple, were equipped), and, finally, the cutler, who assembled the knife and acted as agent for its sale.

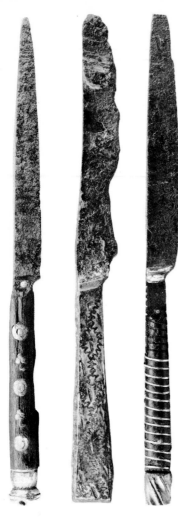

56. SPOON
England, London
1487
Silver, L. 5¹³⁄₁₆ inches (14.8 cm)
The Metropolitan Museum of Art,
The Cloisters Collection, 55.42.4
Numerous inventories refer to spoons "slipped on the stalk," that is, spoons the stems or handles of which were simply terminated at right-angles. A great number of spoons of this type have survived and their popularity may well be explained by the simple and consequently less expensive decoration of the handles.

This example is considered by some scholars to be the earliest extant example of an English slip-top spoon. On the back of the handle at the top appear the crowned leopard's head, the London hallmark for the years 1485 to 1488, the date letter for the year 1487, and an illegible maker's mark.

57a. SPOON
England
Second half of the XV century
Silver, L. 6 inches (15.2 cm)
The Metropolitan Museum of Art,
The Cloisters Collection, 55.42.2

55a. KNIFE
England or the Netherlands (?)
First half of the XVI century
Iron, with wood and latten handle, L. 7¹⁄₁₆ inches (18 cm)
The Royal Ontario Museum, Toronto, 927.28.200

55b. KNIFE
England, possibly London
XVI century
Iron, with latten trim, L. 4¾ inches (12.1 cm)
The Royal Ontario Museum, Toronto, 927.28.196

55c. KNIFE
England, possibly London
XVI century
Iron, with bone and latten handle, L. 6⅝ inches (16.9 cm)
The Royal Ontario Museum, Toronto, 928.17.79
The variety of size and handle design of late medieval table knives is much greater than that of spoons. Knives were the personal property of each person coming to table, whereas spoons, when used at all, were generally provided by the host. The choice of materials which could be used to decorate knives often varied according to class. In fourteenth-century England, for example, such middle-class citizens as tradesmen and mechanics were strictly forbidden by law to carry knives decorated with gold, silver, or precious stones. A clear division also existed in the fabrication of knives. The Goldsmiths' Company of London was granted exclusive rights in the production of tableware employing precious metals. This might well explain the skillful if unpretentious use of bone on latten in the handle decoration of knives produced by the Cutlers' Company of London during the fourteenth, fifteenth, and early sixteenth centuries. The ornamentation on the handle of the smallest of these three knives consists of iron incised with a zigzag pattern which is inlaid with latten. This decoration may be compared to the damascened handles which became popular in the sixteenth century. The constant sharpening of the knife with a whetstone, often placed near the main hall, eventually wore away the blade. If the handle did not have any intrinsic value, the knife was simply discarded. Were it not for excavations such as those in Worship Street, London, which produced one of these examples, hardly any record of the more ordinary types of knives would exist.

57b. SPOON
England
Late XV century
Silver (partly gilt), 6⅛ inches (15.6 cm)
The Metropolitan Museum of Art,
The Cloisters Collection, 55.42.9
The first known mention of the acorn knop appears in a will of 1348, in which one John de Holegh bequeathed to Thomas Taillour "12 silver spoons with akernes." Later references to such acorn-knop spoons indicate that the finials were gilded as were those of other types of silver spoons of this period.

Maidenhead spoons seem to have made their appearance in the late

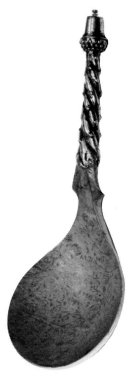

58. SPOON
France
Circa 1500
Copper, L. 6 inches (15.2 cm)
Philadelphia Museum of Art,
George Gray Barnard Collection,
45.25.250

Although late medieval silver spoons have survived in great numbers, they were never in widespread use, but remained the possessions only of the wealthy. Because of the precious nature of their material and its resistance to corrosion, they have survived in misleadingly large numbers. The vast majority of spoons for the lower and middle classes were made of bone or wood, and, because of the perishable nature of the materials and the lack of intrinsic value, relatively few have survived. Spoons, such as this example, belong to a third category comprising those made of various metals such as pewter, copper, and latten.

Although considered to have been made around 1500, this spoon is an excellent example of a type known to have been in use by the latter part of the fourteenth century. The fig-shaped bowl is characteristic of spoons of this period, but the diamond section of the extremely long and slender stem and the pine-cone-shaped terminal are characteristic only of the later types made of common metals.

59. SPOON
Germany
XV century
Mazer wood and silver, L. 5¾ inches (14.7 cm)
Collection of Mrs. Leopold Blumka

This spoon is representative in form and material of a large proportion of those used in the homes of the nobility and wealthy merchants of the late Middle Ages. Although spoons with bowls of ivory, mother-of-pearl, or rock crystal and with mounted silver handles are known, as well as spoons entirely of silver, the predominant material for spoons was wood. (The English word "spoon" is derived from the German *Span,* meaning chip or shavings.) The burled mazer wood bowl of this spoon is of the typical broad, round Gothic shape, curving gently upward from the handle. The silver-mounted handle takes the unusual form of a twisted and gnarled branch (perhaps suggested by the mazer wood bowl) surmounted by a stylized acorn finial. Though acorn finials are not uncommon, plainer silver handles, often surmounted by arms, are more frequently seen on mazer wood spoons than the ornate branch form of this example.

fourteenth century. That some were intended to represent the Virgin Mary is revealed in an inventory of Durham Priory, in 1446, in which *"ij coclearia argentea at deaurata unius sectae, cum ymaginibus Beatae Mariae in fine eorundem"* ("two partially gilded silver spoons with the image of the Holy Mary at their ends"), and again in a much later inventory of 1525 in which spoons "knopped with the image of our Lady" are mentioned. In the present example, the Virgin, dressed in the fashion of the first half of the fifteenth century, wears an elaborate rolled headdress and a dress with a V-shaped neckline and a raised collar.

These two spoons, although both probably of provincial workmanship since they bear no clearly identifiable London silver mark, are good examples of two of the most popular types of spoons in the late fourteenth and fifteenth centuries. The other most common types were the diamond point, the seal top, and the slip-top (see entry no. 56).

60. PLATE

Italy, Venice
XVI century
Glass, with enamel decoration, Dia.
12½ inches (3.18 cm)
*The Metropolitan Museum of Art,
Bequest of Edward C. Moore,
91.1.1451*

Though decorated Venetian glass was probably never as commonly used as pottery or pewter for tableware, plates such as this one are clearly not presentation or ceremonial pieces. As a type, the plate appears somewhat later in Venetian production than does the tazza, though it is clearly in evidence in Butteri's painting of a glass furnace of the sixteenth century, and other examples appear earlier. The pontil mark, the place at which the piece was attached to the iron while being spun and shaped, shows in the center of the plate, and would have been disguised by enamel decoration, such as that around the rim, had the object been intended as a luxury item. It is also possible that the center was left undecorated to provide a place for the arms of the purchaser.

61. TAZZA

Italy, Venice
Late XV or early XVI century
Glass, with enamel decoration, Dia.
9 inches (22.9 cm)
Robert Lehman Collection, New York

The tazza is a footed bowl that was used for serving fruit or sweetmeats. Examples of the type are numerous and appear frequently in works of art showing scenes of the table such as those in the mosaics in the baptistry at Venice and the frescoes at St. Zeno in Verona. In some cases, a single tazza served the entire table. In other instances, as shown in the St. Zeno fresco, one tazza was placed between two diners for their exclusive use. The large size of this particular example suggests that it was used as a common serving bowl. It is made of a fine clear glass decorated with points of colored enamel and gilt. The ribbed portion of the bowl was mold-blown, and then the rim and foot were added. Animal motifs, such as those painted in the bottom of this bowl, were often used to decorate this type of tazza. These motifs are, apparently, purely ornamental without any symbolic connotations.

62. PLATE

Portugal
Late XV century
Silver gilt, Dia. 8¾ inches (22.2 cm)
*The Metropolitan Museum of Art,
Rogers Fund, 12.124.1*

Deeply embossed scrollwork relief fills the center of this small plate, and tiny repoussé figures of late Gothic wild men and animals amid foliage appear in a hunting scene

on the rim. The lavish decoration of this plate is characteristic of a group of Portuguese plates and vessels of the fifteenth century, and reflect the general tendency of this period toward abandoning simple motifs in favor of more elaborate and complicated designs. Later Portuguese examples generally depict scenes of a more classical nature such as the history of Troy. Larger dishes of this type were intended to be used as basins made as sets with equally sumptuous ewers, but the small size of this example precludes such a possibility. So small a plate, called a *salva* in Portuguese, would hardly have been intended for regular service use at the table, although it might, on special occasions, have served as a dish for a few choice pieces of fruit.

63. PLATTER
Spain, Manises (Valencia)
1427–1441
Tin-glazed and lustered earthenware, Dia. 15¾ inches (40 cm)
The Metropolitan Museum of Art, The Cloisters Collection, 56.171.148 (See color plate no. 1)
This unusually shaped platter is emblazoned with the coat of arms of Blanche of Navarre and her husband, John II of Aragon. The arms are reversed, however, incorrectly showing those of Blanche on the left. Often the craftsmen responsible for the decoration were illiterate and ignorant of the laws of heraldry. These shortcomings, coupled with limited numbers of pigments, led to imprecise or incorrect renderings of arms and inscriptions. Blanche, daughter of Charles III of Evreux, king of Navarre, married John II of Aragon in 1419 and became queen of Navarre in 1427. As she died in 1441, this platter was probably commissioned between 1427 and 1441. The coloring and fine detail suggest the earlier years of this period. There are numerous documents relating to royal commissions of lusterware from the Manises factories, the most notable of which pertain to Maria of Castile, consort of Alfonso V of Aragon. In a letter to Don Pedro Buyl dated 26 November 1454, and signed by the queen, an entire service, itemizing the numbers of meat dishes, washing basins, porringers, broth bowls, pitchers, vases, and other objects, all to be "lustered inside and out," is ordered. A further letter from the queen to Don Pedro, dated 21 March 1455, thanks the overlord for his fulfillment of the order and requests several additional pieces. This platter, like others of its size and quality, could have been used either for table service or decoration.

64. DEEP DISH
Italy, Florence
Circa 1420
Tin-glazed earthenware, Dia. 27 inches (68.6 cm)
The Metropolitan Museum of Art, Fletcher Fund, 46.85.1

Early in the fifteenth century, tinglazed earthenware in Italy began to achieve a high level of artistic quality. The elevation of ordinary wares to showpieces of skilled design and execution is first manifested by examples related to this deep dish. The present example and others in the Louvre and the Kunstgewerbemuseum, Berlin, are among the only survivors of an early group that derived from the archaic Orvieto style and is often referred to as the "severe" or "green Florentine" type. The figural representations were an innovation independent of the engraved sources which became a dominant influence in the later years of the century; the background ornament is purely Gothic in spirit.

Dishes of this shape, referred to variously as *piattelli grandissimi, bacili, or conche,* were directly influenced by the Valencian *brasero* or type of deep dish often used as a serving platter. The scale of this example, however, along with its accomplished decoration, suggest that it was intended for display, perhaps on a credenza in the manner depicted in several panel paintings by Appollonio di Giovanni.

65. PAIR OF SERVING KNIVES
Austria, Hall (Tirol)
Attributed to Hans Sumersperger
Late XV or early XVI century
Steel, brass, wood, bone, and mother-of-pearl, L. (each) 17½ inches
(44.5 cm)
*The Metropolitan Museum of Art,
Rogers Fund, 51.118.2; 51.118.3*

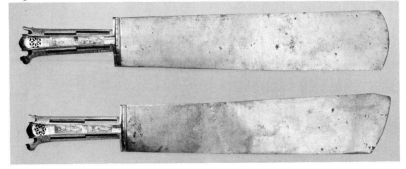

These serving knives have been attributed to Hans Sumersperger of Hall, the knifesmith of Maximilian I, at whose splendid court the influence of northern late Gothic and Italian Renaissance met. This master's name appears in the royal accounts of 1492–1498. The brass handles are inlaid with bone, walnut, and carved mother-of-pearl. The steel blades are flat and thinly ground. Although there are no maker's marks on either the handles or the blades, the style, design, and iconography connect these knives with other works by Sumersperger. Both these knives, and a hunting knife also in the exhibition (see entry no. 232), are related to hunting knife sets of a Burgundian type that became popular in Maximilian's court after his marriage to Mary of Burgundy. It is possible that these two serving knives (the broad tongue-shaped blade of one has been repaired) were themselves part of a complete hunting set which would have included two single-edged knives of varied size for skinning and cutting, a more delicate table knife and fork, and knives for serving pieces of meat while on the hunt. The knives exhibited here could have been used either for the hunt or the banquet. One knife would have been used to slice the meat, the other as a salver to carry the meat to the trencher or plate.

66. FORK
Italy
XV century
Iron, bronze (partly gilt), and niello,
L. 11½ inches (29.2 cm)
Collection of Mrs. Leopold Blumka
An eleventh-century manuscript now in the Biblioteca dell'Abbazia, Montecassino, depicts two men at a table, using two-pronged forks to assist in carving and eating. This practice was extremely rare, although a letter written by Peter Damiano (circa 1070–1072) mentions that the Byzantine wife of the doge of Venice refused to follow the Western custom of eating with her fingers and insisted that she be allowed to use a two-pronged fork. It seems, then, that the custom of using forks came from Byzantium, and that it was introduced into Western Europe by the Venetians. The cookery of the day, consisting in large part of stews, called *mortrews, pottages,* and broths, really did not require the use of a fork for eating. The widespread acceptance of the fork as an eating utensil is definitely post-medieval. Introduced into France soon after 1553, when Catherine de' Medici married the future Henry II, the fork was only really accepted in England in the seventeenth century.

Although extremely rare throughout the thirteenth century, early references to forks do exist. A *furchetto de cristallo,* for example, is mentioned in an inventory of circa 1300 of Edward I. Fourteenth-century references become more frequent, but evidently refer almost exclusively to small forks for the purpose of eating fruit, especially blackberries, which if eaten with the fingers left them badly stained, or for serving sweetmeats or ginger.

Exactly when larger forks became more common cannot be determined precisely, but they were ini-

tially intended only to facilitate the carving or serving of meat as is indicated by the sixteenth-century inventory list which mentions 12 knives and a single fork. Although the present fork must have been matched with a knife, it was probably not a part of a larger set of 12 knives as this combination only became popular later.

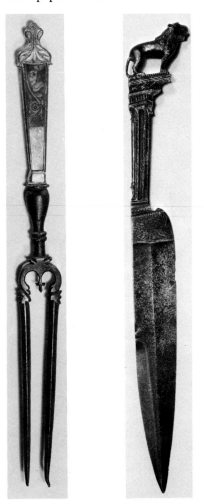

67. KNIFE
Italy, Venice
XV century
Iron (partly gilt), L. 12½ inches
(31.8 cm)
Collection of Mrs. Leopold Blumka
The greater than average length of this knife and the particular shape of the blade suggest that it could have served either as a hunting or a table knife. The handle of this elaborate and finely executed knife has a terminus in the form of a lion, an animal which throughout the Middle Ages was considered the mightiest and most admirable of beasts, and whose image became one of the most frequently used heraldic devices. For Venice, where this knife may have been made, the lion had a special association as it is the symbol of St. Mark, the patron saint of the city.

By the late fifteenth and early sixteenth centuries, the size of knives brought to table had diminished, but the tips of the blades remained pointed, so that pieces of food could be stabbed and carried from the dish to the trencher, from which they were eaten with the fingers. This rule of etiquette was frequently not observed as the food was often carried directly to the mouth on the point of the knife. It was not, however, this particular breach of etiquette that lay behind the change of the shape of the table-knife blade to the more rounded form common today, but rather the equally rude practice of using the tip of the knife to remove bits of food from between the teeth. If tradition can be trusted, it was only

when Cardinal Richelieu was revolted by the fact that even so distinguished a guest as Chancellor Séguier used his knife as a toothpick, that he ordered all the knives in his household blunted and the pointed tip went out of style.

68. AQUAMANILE

The South Netherlands or eastern France (Lorraine)
Circa 1400
Bronze, H. 13³⁄₁₆ inches (33.5 cm)
Robert Lehman Collection, New York

The washing of hands before and after dinner was a necessary ritual, particularly as fingers were frequently used for eating. In a noble household, the water used for such occasions was specially prepared, and in one fifteenth-century manuscript in the British Museum, a recipe is given for an aromatic mixture of marjoram or rosemary boiled with orange rind. Strictly speaking, aquamanilia are any sort of pouring vessels, either liturgical or secular, used for the washing of hands, but as a twelfth-century inventory of the Mainz Cathedral treasury indicates, they frequently took the shape of lions, dragons, griffins, or other marvelous animals of the bestiary. The thirteenth and fourteenth centuries saw the emergence of other forms such as a warrior or falconer astride his horse. However, it was apparently only in the very late fourteenth or early fifteenth centuries that aquamanilia with narrative decoration appeared. These vessels not only served a utilitarian function, but also provided entertainment for seated guests and might therefore be considered the forerunners of the mechanized figurative table decorations of the early seventeenth century. The example exhibited here represents the seduction and humiliation of Aristotle by Phyllis, the wife (or mistress) of Alexander the Great.

69. PLATE

The Netherlands or Germany (Lower Rhine)
Third quarter of the XV century
Brass, Dia. 17 inches (43.1 cm)
The Metropolitan Museum of Art, The Irwin Untermyer Collection 64.101.1501

According to some scholars, Dinant was the only French-speaking town of the Lowlands to join the German Hansa as a selling agent and a guarantor of the delivery of copper (the major component of both bronze and brass) imported from northern Germany via Cologne and Aachen. Already the center of a flourishing metalworking trade, Dinant became the principal center for the production of plates such as this one. Its distinct position is evi-

dent in the generic name "dinanderie," which came to be associated with metalwork of this sort. Dinant's primacy in the trade continued until the city was sacked by the duke of Burgundy in 1466.

Although dinanderie plates were in enormous demand in the second half of the fifteenth century, the traditional, painstaking method of brass beating was not to be replaced by the easier process of casting until the sixteenth century. The need for mass production led to a decline in quality. Certain motifs, like the seated woman holding a coronet of

flowers on this plate, were repeated almost without variation. The encircling motifs did, however, become more complex. In this example, the petallike shapes alternate with addorsed flowers flanking tiny bears seated on poles, each grasping one of its hind paws.

Although dinanderie plates were undoubtedly proudly displayed on sideboards (and sometimes used in the liturgy), the worn and battered condition of many of them indicates that they might also have served as chargers on which the food was brought to the table.

HEALTH AND CLEANLINESS

As in the discussion of any aspect of the medieval household, it is difficult to make generalizations concerning the habits of personal hygiene; research indicates, however, that they were of a surprisingly high standard. Great differences, of course, existed between the noble and peasant classes, and practices varied from region to region, depending upon climate, cultural background, and the degree of development of local civic codes of sanitation. Spain and Portugal, for example, not only had highly advanced systems of water delivery and civic sanitation but also had a high standard of personal cleanliness, largely as a result of Moslem influence.

Bathing was a universally practised form of personal hygiene. The lord or lady of a large household generally bathed in the privacy of their own chambers, seated on a stool in a large tub filled with aromatic waters, sometimes surrounded by a curtain. The remaining members of the household were often provided with a communal bathing area in the vicinity of the kitchen, from which hot water could easily be transported. The majority of people, however, were obliged to use public baths, a perpetuation of an ancient tradition which enjoyed greater popularity in the Mediterranean countries than in the north. But to judge from contemporary illuminations, public baths had become a widespread and established custom by the Middle Ages. Although men and women are occasionally depicted bathing nude together and engaging in licentious frolic, generally in communal bathing, to maintain decorum and modesty, the women wore chemises and the men underdrawers.

Bed chambers were frequently supplied with wash basins and water tanks. The soap used in personal cleansing was of two basic varieties. For the less privileged, the same type of soft soap used for washing clothes had to suffice. This was an unpleasant mixture of animal fat, wood ash or potash, and natural soda. Wealthier people enjoyed hard soaps which were made of olive oil, soda, and lime with aromatic herbs added to impart a pleasant scent.

Men in the late Middle Ages were customarily clean-shaven. For those who could not afford the services of a professional barber, shaving must have been a painful process because of the lack of high quality soap and tempered steel razors. Daily care of the teeth also existed. Although some possessed toothbrushes, picking between the teeth with a pointed instrument, rubbing them with a green hazel twig, and then wiping them with a woolen cloth was the normal method of cleaning.

Even people of high rank had to contend with vermin of all types. The Goodman of Paris suggests to his young wife that the only way to rid cloth of them was to regularly hang it outside to air in the sun. For those fabrics that could be washed, soap and water usually sufficed, although fuller's earth, lye, and other substances were used when more drastic measures were required.

It is a well-known fact that the medieval diet was generally poorly balanced and both the peasant and the nobleman consumed mostly foods of high starch content. Concepts of nutrition were simply not well understood. Fresh fruits and vegetables were, as an example, widely thought

capitulo. C.xvij.

The fole is the chidle of an hors or a mare and it sucketh long his dames teris. Aristotell saithe that in the forhede of the fool is founde a thinge ý is named veneficiu / and the dame licketh it of / and some folke do there it of for som sorcers do their cure therwith ꝫ the pace that it hathe in his youthe / thesame it kepeth gladly in his age.

ca. C.xviij.

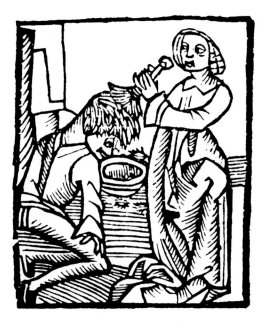

A Lous is a worme wꝮ many fete ꝫ it cōmeth out of the filthi and onclene skȳne ꝫ oftentymes for faute of atendaūce they come out of the flesshe through the skȳne or swet holes. ℂ To withdrepue them / The best is for to wasshe the oftētimes and to chaūge oftentymes clene lynen.

The removal of lice and fleas, woodcut in the *Hortus Sanitatis* (*The Noble Lyfe & Natures of Man of Bestes Serpentys Fowles & Fishes*), Antwerp, ca. 1521. (Courtesy of Bernard Quaritch, Ltd., London)

dangerous to eat. The resulting deficiencies of vitamins A and C account, respectively, for the frequent occurrence of blindness and scurvy. Household medical texts, generally of Arabic origin, such as the *Tacuinum Sanitatis*, recorded dietary remedies for many common diseases. While known at an earlier date, it was only toward the end of the Middle Ages, with the increased awareness of their value, that these texts were widely copied and circulated.

70. TURRET LAVER

Western Europe (probably Germany)
Circa 1400
Bronze, H. 21 inches (53.3 cm), Dia. (at base) 5⅞ inches (14.9 cm)
The Metropolitan Museum of Art, The Cloisters Collection, 47.101.56 a,b

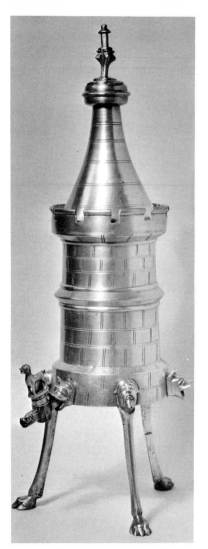

A stationary laver such as this one would usually have been set in a niche in the main living area of the house. Together with a basin and a towel, it was used for washing hands before and after dinner. There was a distinct etiquette required in hand washing, as is clear from Bartholomew Anglicus' words from *De Proprietatibus Rerum* in the section on "Dyner and Festynge." Anglicus observes that "Guestes ben sette with the lorde in the chefe place of the borde, and they sitte not down at the borde before the guestes washe theyr handes." The lord's hands, however, were washed at table after the water had been "assayed," or tested for purity. This required a very different type of vessel equipped with a handle for pouring. The fact that water could be drawn from a turret laver without the assistance of an attendant meant that it was frequently used in the bedchambers of more modest homes. An example of this can be found in a painting by an upper Rhenish master of about 1420, *Joseph Reassured by the Angel,* now in the Musée de l'Oeuvre Notre-Dame, Strasbourg.

71. LAVER

The Netherlands
Circa 1440
Bronze, H. 5¼ inches (13.4 cm), L. 11¼ inches (28.6 cm)
Collection of Harry Bober

As with almost all medieval vessels intended for the washing of hands, lavers of this type were used for liturgical as well as domestic purposes. In the ritual washing of the priests' hands, one of the spouts was used before the mass and the other afterward. No such ceremonial use of the two spouts would have been observed in domestic usage. Lavers of this type were suspended by a swivel handle from either a hook or a chain so that water could be poured out of either spout into the basin below. A number of lavers of this type are still in existence, most of which not only have female heads at the point where the swivel handle is joined to the main vessel, but also have spouts in the form of animal heads. The installation of these lavers in the domestic interior can be seen in many paintings of the period, including the Annunciation panel of the *Ghent Altarpiece* by Jan van Eyck (in which the laver is provided with a lid) and the central panel of the *Merode Altarpiece* of about 1425 by Robert Campin (in which the vessel without a lid is hung in a niche by a chain). The present example closely resembles the one in the Campin altarpiece.

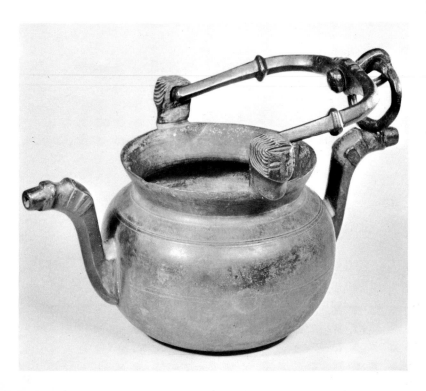

72. WATER TANK

Southern Germany
Circa 1530
Pewter, with cast-iron hanging bar and spigots, H. 15 inches (38 cm)
The Detroit Institute of Arts, Sarah Bacon Hill Fund, 48.378

In the 1353 inventory of the silver of the kings of France, mention is made of several large fountains *en guise d'un chastel* made of silver,

enamel, and crystal, with little *sergens d'armes* standing guard in the towers. Though these fountains were obviously of a much more elaborate nature than the present example, there is no doubt that this pewter version is of a similar type. The size and lack of legs of the lavabo indicate that it must have been mounted on a wall or in a niche by means of the iron crossbar attached to its back. It could be filled by lifting off the roof and turrets. As many as three persons could have washed their hands at the same time from the three faucets which issue from lions' heads at the bottom of the vessel. This suggests that the original installation of this water tank would not have been in a bedchamber but in the main hall of a large establishment.

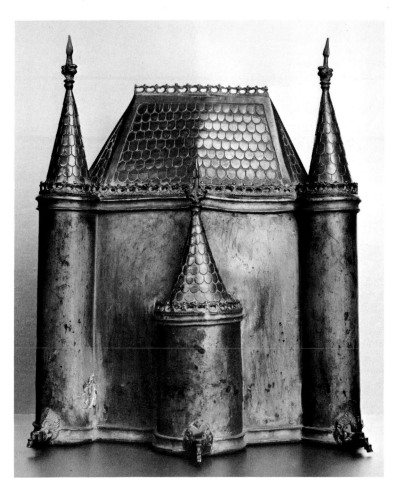

73. PLATE
The South Netherlands, Dinant or Malines
Circa 1480
Copper, Dia. 20 inches (50.8 cm)
The Metropolitan Museum of Art,
The Irwin Untermyer Collection,
64.101.1499

The scene on this copper plate is usually thought to represent Aristotle being ridden by Phyllis, but it may be more accurately identified as a depiction of the tyrannical rule of a woman.

Spinning has throughout the ages been considered the work of women. Although by the time this plate was made, a relatively sophisticated type of spinning wheel had been developed, as seen in an illustration in *Das Mittelalterliche Hausbuch* of about 1480. The object to the left in this plate represents the method of spinning wool by hand from a fixed distaff (which had the advantage of leaving both hands free, one to rotate the spindle and the other to draw out the fibers). The yarn spun onto the spindle, however, could not be slipped off but had to be wound off with a cross-reel such as that held by the man on this plate. The fact that a man could be reduced to hank winding would alone have been considered quite amusing, but that he has been reduced to a most embarrassing position, and is in the process of being beaten—possibly for not performing correctly even this simplest of tasks—can only be viewed as a domestic satire, quite different from the story of Phyllis and Aristotle. The motif of the wife astride her husband, however, was probably derived from it. A plate of this size and depth could have served either as a charger on which to carry large portions of food to the table, or as a basin into which water could be poured.

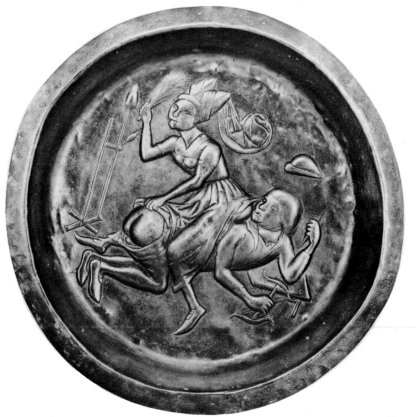

74. BASIN
Spain, Manises (Valencia)
Circa 1440
Tin-glazed and lustered earthenware, Dia. 18¾₄ inches (47.6 cm)
The Metropolitan Museum of Art, The Cloisters Collection, 56.171.154

Deep basins of this type were common in affluent houses of the late fifteenth century and probably can be identified with the term *bacin* which appears in a number of documents. One household is recorded owning 130 bowls and basins of various sorts, while another, in Barcelona, is described as having six lusterware bowls hanging on the wall. The depth of this basin and the wide brim designed for easy carrying would indicate that it was filled with water and was used for washing the hands and face. This may well be the type described in the inventories of King René, duke of Anjou, for the years 1471–1472, as "a large plate of Valencia, tin-enameled with golden foliage," which was kept in his private quarters. The crowns around the brim of the basin may reflect the owner's rank, while the I and M in the center are probably the holy initials of Jesus and Mary. The subtlety of the design is revealed in the undersides of the crowns which are painted on the inner wall of the basin giving them an illusion of three-dimensionality.

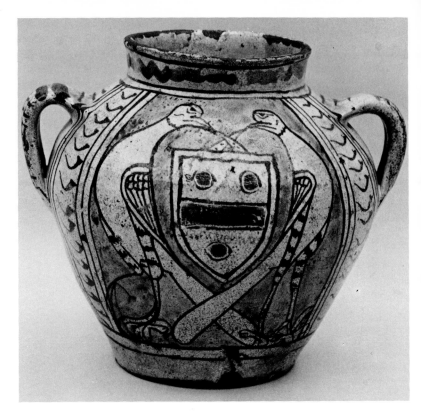

75. DRUG OR HERB JAR
Italy, Florence
Circa 1420
Tin-glazed earthenware, H. 8¼ inches (20.9 cm)
The Metropolitan Museum of Art, Fletcher Fund, 46.85.7

From 1400 on, finely turned and decorated glazed earthenwares have been associated with Florence. It is unlikely, however, that the earlier of these wares were actually made within the city walls, but rather in outlying Tuscan towns such as Montelupo, situated in the Arno Valley between Florence and Pisa. Unlike the earlier Italian earthenwares, the so-called Florentine vessels initiated the use of an all-over white to gray tin-enamel glaze slip, against which the painted decoration was highlighted. For the first several decades of the fifteenth century, the palette was generally limited to tones of pale green, manganese purple (used primarily as an outline color) and, less frequently, cobalt blue. This particular example bears a coat of arms that has tentatively been identified as that of the Guida family of Siena or the Della Marchina family of Faenza. As with Spanish lusterware, the limitations of the palette rendered precise tinctures impossible, consequently, the heraldic devices are not easily identified. The vessel, made for a private individual, was probably used as a household storage jar for dried herbs, medicinal compounds, or other such substances.

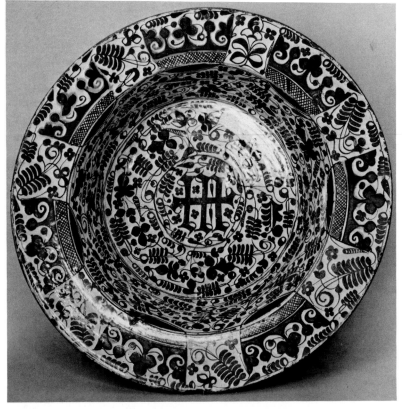

76. TACUINUM SANITATIS
Italy (Lombardy)
Circa 1475
Manuscript on paper (codex), 109 folios, H. 15⅝ inches (40 cm), W. 11 inches (28 cm)
The New York Public Library, Spencer Collection, Ms. 65
(See color plate no. 2)

> Beer is cold in the first and dry in the second degree. The best is that which is well boiled in a vessel of glass. When drunk hot it helps the gall. When cold it harms the insides. To remove the harm, drink it with rock sugar.

This is the type of household remedy found in the *Tacuinum Sanitatis,* a manual of health, written originally in Baghdad by a Christian physican known as Ibn Bitlan in the eleventh century. With the importation of Arab medicine to the West in the twelfth century, the *Tacuinum* was translated into Latin and then into the vernacular. This example is in Lombard dialect. It contains tables of dietetics, hygiene, and domestic medicine. Included are lists of herbs and their medicinal properties, foods that are helpful in various types of physical distress, and therapeutic cures such as mineral baths. In addition to the beer remedy given on folio 88 v., Ibn Bitlan explains the making of a distilled drink from chicken broth, cordials, and quince juice that is good for fever, and continues by describing the preparation and general usage of gruel made of barley and spelt. The author also discusses the healthful properties of foods and their preparation: hard cheese is good for the flux, soft cheese is best made with warm milk, and purple grapes are good for whooping cough. Each section of the text is accompanied by a scene illustrating the gathering and preparation of the food or remedies—a summary of daily needs and life in a fifteenth-century rural community.

77. HERBARIUS ZU TEUTSCH
Published by Johann Schönsperger
Germany, Augsburg
10 May 1496
Incunabulum on paper, H. 10½ inches (26.7 cm), W. 7¼ inches (18.4 cm)
The Metropolitan Museum of Art, Whittelsey Fund, 47.7.25

The *Herbarius zu Teutsch,* commonly known as the *Gart der Gesundheit* ("The Garden of Health"), was a notable medieval medical book that appeared in numerous editions. In the prologue, the unknown author refers to it as "Thou noble and beautiful garden, Thou delight of the healthy, Thou comfort and life of the sick." The prologue also indicates that the author and his illustrator traveled extensively to find examples of rare herbs. The book includes the following categories of agencies: "vegetal," "animal," "mineral," and "natural." In addition to the whole of pharmaceutical knowledge of the day, it contains about 400 illustrations of herbs, animals, and other items useful for the practice of medicine. The frontispiece, which varies in other editions, shows three doctors in an apothecary shop. Scales and other necessary equipment are shown, as well as shelves full of apothecary jars with symbols resembling heraldic devices which perhaps identified their contents.

By around 1500, medieval herbals appear in various languages, but almost all of the information they contain derives from the herbal of the Greek author, Dioscorides, written in the first century A.D. The *Gart der Gesundheit,* however, discusses subjects other than herbs, such as the use of unicorn horns (usually the misidentified horn of a narwhal) and cures produced from other animal and mineral sources.

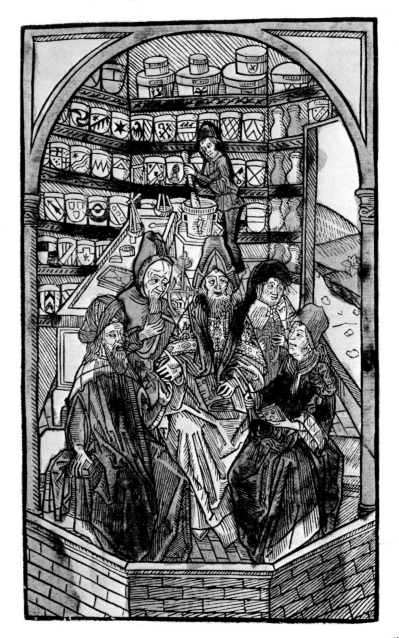

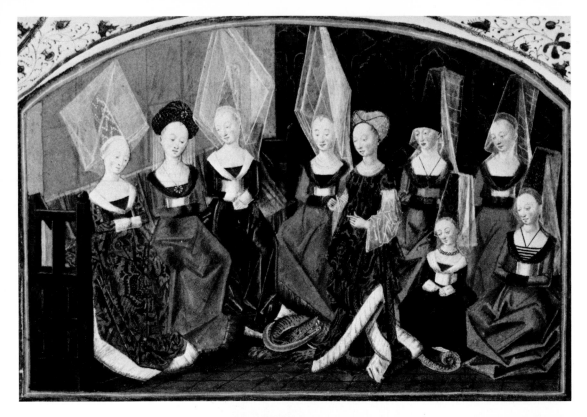

Company of court ladies, illuminated page in *Le livre des trois vertus* by Christine de Pisan, France, XV century (Beinicke Rare Book and Manuscript Library, Yale University, Ms. 427).

By the end of the fourteenth century, the Eastern houppelande had evolved, in women's wear, to a full-skirted dress with a low, wide neckline. The hair was hidden beneath a hennin.

Portrait of a Young Woman, tempera on panel by Antonio Pollaiuolo, Italy, ca. 1455-1490 (Museo Poldi-Pezzoli, Milan).

Italian women during the fifteenth century did not adopt the hennin favored at that time in the North. Instead, the hair itself was woven in an elaborate arrangement resembling a headdress.

II

EUROPEAN DRESS

Medieval life had one enormous and seldom recognized advantage. Europe's climate was warm despite the cold of wattle and daub huts, or of stone castles with smoky fires. In the lifetime of Elizabeth I's grandfather, Henry VII (1457–1509), there were seven consecutive winters without a freeze; it was assumed that winter had gone for good. This temperate weather lasted until late in the sixteenth century.

Position, and the recognition of it, were all important in European society. The knight's crest which he carried on his surcoat was worn "parted" (halved) on the garments of his wife and their retainers, i.e., his wife's father's arms appearing on the right, his own on the left. By the late fourteenth century, the bourgeoisie had begun to compete with the nobility both in luxury, which sumptuary laws failed to control, and in the upper-class custom of wearing coats of arms. They, too, wore parti-color until the armigerous nobles gave up this fashion, and mi-parti was reduced to servants' wear. Whether out of regard for social position or out of affection, powerful people were referred to by the badges, emblems, and mottos that were embroidered on their garments and furnishings, and hung as pendants from the chains worn about their necks. The son of King Edward III of England was known as the Black Prince because of the colors of his coat of arms.

Garments were relatively simple and unfitted in the first half of the fourteenth century. Bateau necklines might be covered by short, hooded capes; long, hooded overgarments and the poncholike tabard cloaks were slit to allow mobility of the arms.

Unsophisticated fabrics, woven by women and often locally produced, were enriched by braids which were used as edgings or belts. The sleeve of a kirtle, the long, closely fitting undergarment worn by ladies, and the linings of outer garments as well, provided additional color to be seen at the slits and hems. Long popular with royalty, sleeveless surcoats, with deeply cut-out armholes and edges trimmed with fur or braid, also allowed the contrasting color of undergarments to show. Narrow-sleeved outer garments had lined pendant "liripipes," starting at the elbows, and tippets. The edges of these tippets and also of wide sleeves might be slashed or "dagged" at regular intervals for additional interest.

The liripipe ends of dagged hoods worn wrapped around the head became the "chaperon" turban. Travelers, hunters, and especially pilgrims wore duck-billed hats, turned up in back. High, conical hats were often worn over close-fitting caps or "coifs." By the end of the fourteenth century, coifs and fur lappets were outmoded in fashionable dress and became the traditional headgear of lawyers.

Garments were adorned with lines of buttons, pins, or ornaments, and precious girdles, to which were attached *aumônières*, the purses worn by ladies which, as the name suggests, derived originally from alms bags, and *gibecières* or men's pouches, misericorde daggers, or the knife one needed for eating. Shoes were often ankle-high and embroidered; soles might be sewed to tights and wood pattens worn over them for protection out of doors.

With the advent of a wider variety of elastic materials which were used to make better fitting tights, men's outer garments became short. Belts became wider, lost their pendants of precious stones and metals, and were

worn lower, especially on a new garment introduced in the second half of the fourteenth century. This garment, the "houppelande" robe, was worn by both sexes. It was originally an Eastern garment, brought back by the crusaders, and often made of brocade, which was produced in Italy by the late fourteenth century. The houppelande had long, fur-lined, funnel-shaped, or "bag" sleeves, and its great trailing length was laid in careful cartridge pleats secured under a belt. This garment, when eventually shortened to the crotch for men's wear, was worn with tights, often accompanied by high boots. *Poulaines,* shoes with exaggeratedly long toes which were sometimes chained to the belt, came into fashion at this time. Cloaks largely disappeared with the advent of the houppelande, which is the ancestor both of the coat and of today's shirtwaist dress. Toward the end of the fourteenth century, the belt of the houppelande became narrower, less lavishly decorated and, in female attire, was worn higher on the rib cage. In women's wear, the houppelande in its final stages developed into a full-skirted dress, so long that it had to be held clutched up, with a fitted bodice which had a lowered and widened neck opening. Because of the bared neck, necklaces became more important as fashion accessories, and were designed with lacy and elaborate decoration.

Men's hair was first rolled at the neck, then bowlcut, and finally lengthened to the shoulders. Women's hair first was spiraled in braids at the ears, was then banded with wimples and caught in "crispine" nets and, finally, was covered by horned headdresses and towering hennins with pendant veils, which allowed no hair to show at all. The tall, sugar-loaf, felt hats worn by men echoed this female style.

In Italy, where hair had always been superbly cared for, these headdresses were not worn. The hair itself was manipulated into equally elaborate headdresses, especially in north Italy where it eventually loosened into locks. Chaplets and roundels of rich fabrics or metals were sometimes used, both on the hair and as necklaces; these might also be cords with a pendant of corals or pearls. Belts in Italy were neither stressed nor made of precious materials. The male Italian body was not overwhelmed nor was it deformed, as was the Franco-Flemish male with padded "mahoitre" shoulders. Italian men's caps were small, even tiny in comparison with those of the North. As Germany was, in the Middle Ages, less hygienic than most countries, Italy was the most fastidious—consequently, gloves and handkerchiefs first appeared there.

The costume of the peasant in all of Europe was the same. The women covered their heads, often with linen headcloths; they wore kirtles, full skirts, often hiked up, aprons, and sensible shoes, if not bare feet. Working men wore shirts and drawers, doublet and hose, and sock-boots, sometimes without hose, and hose sometimes without heels or toes.

French fashion led that of England, while Germany, Italy, and Spain developed regional styles which, in turn, would affect the dress of all Europe. Late in the fourteenth century, to the German modes of slitting and dagging were added the slope-shouldered extravagances of the Franco-Flemish courts—brocade on brocade, and cuffs extended to reach over the hands in a last appearance of the ancient Roman notion of the elegance of uselessness.

Men's collars mounted to the ears while women's necklines widened and were lowered to the edge of the highest and widest possible belt. Outer seams of sleeves were left open, pendant sleeves were split or the bottom of the armhole's connection with the bodice was left open to show the under linen. Sleeves were made separately and were interchangeable. The shirt increased in importance with both pleating and embroidery as Italianate wide V-openings, laced across, permitted it to show beneath men's doublets and women's bodices.

In the late fifteenth century, the sedate look of the Flemish *Hausfrau* affected women's dress, while that of men remained dandified and extravagant. This change is clearly evident in one of the greatest fashion illustrations of all time, the Harlean *Roman de la rose* in the British Museum. As this manuscript illumination shows, women's heads were now enclosed in turbans or in dark hoods with long velvet lappets, which tended to be turned up. In Flemish regions, these hoods were typically gauzy and white.

Self-portrait, oil on panel by Albrecht Dürer, Germany, 1498 (Museo del Prado, Madrid).
During the fifteenth century, delicately pleated and embroidered shirts became increasingly popular.

In Cranach's Germany, on the other hand, women wore immensely wide, plumed hats, set over jeweled cauls, with many massive necklaces and chains above elaborately embroidered fronts. The skirt's fullness was placed at the back, its train caught up at the hipline with emphasized belts of goldsmith's work, carrying chained pomander pendants. Fur pieces were given gold claws and jeweled snouts.

The Black Death, which had devastated Europe in the middle of the fourteenth century, provided increased leverage for the reduced number of workmen. Middle-class people could now afford the new inventions of the fifteenth century in their houses. Flues were invented so that coal could be used for heating, and domestic architectural improvements included casement windows replacing wood or parchment shutters. Italy, with increasingly hot summers and colder winters, lost the advantage of its three comfortable seasons. With the new methods of domestic heating, Italy suffered a further deprivation, for England and the countries of the Continent were nearer the coal mines. All these changes affected styles of dress.

Such engravings as Israhel van Meckenem's *Feast of Herodias* and Master M.Z.'s *Dancing Party* show the influential transitional dress of south Germany and the Netherlands at the turn of the fifteenth to sixteenth century. Men's garments widened at the shoulders and gained lapel collars. Short, full capes appeared, and the dress of both sexes showed diagonal closings. Elaborate puffings and slashings on both men's and women's sleeves foretold the advent of padding which would eventually transform the male torso into the "peascod belly" shape.

ITEMS OF COSTUME AND COSTUME ACCESSORIES

Olivier de la Marche, historian for the luxury loving court of Burgundy in the late fifteenth century, wrote a poem in which he described what the noble lady's costume should be. He mentions a number of costume accessories, including a purse, a small knife, a second belt for her pater noster, a collar, and gloves. The inventory for the trousseau of Mary of Burgundy, daughter of John the Fearless, mentions a variety of costumes and accessories. Documents such as these, in addition to works of art of the late medieval period, provide a wealth of information on costume accessories, and help to supplement the few remains of actual pieces that have come down to us. One has only to examine these documents to learn how extraordinarily varied and lavish the costume accessories of this period were for both men and women. Jeweled belts, pearled hair nets, filigreed buttons, feathered headdresses, silk veils, and furs all adorned the ladies of the fifteenth century. Each of these accessories was modified in design from the fourteenth to the fifteenth century—some becoming more accentuated and others less so as fashion changed. The belt shows a marked development during this period. The long and elaborately ornamented type of the fourteenth century, the end of which hung almost to the feet of the wearer, is modified in the fifteenth century for both men and women to a shorter type, fastened with a buckle, and the loose end looped over the belt or girdle. This was further modified in women's fashions later in the century, becoming a narrow, unornamented band worn high under the bust to display the newly adopted wide-skirted gown favored in Italy. The *demi-ceint* belt, described by La Marche, was fastened low in front with a chain. He also mentions a hook on the belt from which could be suspended the lady's purse and a small dagger or *aumonière* and other accessories. Because pockets were unknown in the Middle Ages, both men and women used belt hooks for carrying all manner of personal articles including money purses, keys, weapons, or even Bibles enclosed in leather cases. The sword belt, a second belt worn by men, was worn lower on the hips than the costume belt.

The accessories of the poorer classes were no more elaborate than their costumes. Although knives, tinder-boxes, or other implements were suspended from peasants' belts, they were all of a purely utilitarian nature. Fashion clearly distinguished the upper from the lower classes and the rich from the poor.

78a. CAP
England
XVI century
Wool, Dia. 8 inches (20.3 cm)
The Metropolitan Museum of Art,
The Costume Institute, Bashford
Dean Memorial Purchase, 56.63.15

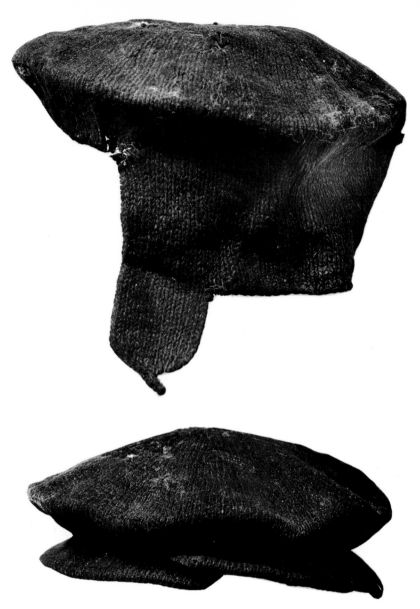

78b. CAP
England
XVI century
Wool, Dia. 9 inches (22.9 cm)
The Metropolitan Museum of Art,
The Costume Institute, Bashford
Dean Memorial Purchase, 56.63.14
Although both these caps were excavated in London and are presumably English, similar ones were worn in other parts of Europe. The basic form of the two ordinary caps shown here was not limited to any single class. Both the wealthy and the poor adopted a general fashion in headgear; it was the cost of material that indicated the class distinctions so integral a part of the late medieval period.

The cap with earflaps is close in style to those seen on peasant figures in tapestries woven in France and Flanders around 1500, but the type is also seen in a contemporary miniature portrait of King Charles VIII of France. The second type, the circular cap, was first seen in England in the early sixteenth century during the reign of Henry VIII. Associated with the London working classes, these caps were known as "city flap caps" and "statute caps," undoubtedly because of a later Tudor statute, issued to promote home manufacture, ordering men and boys over the age of six to wear such hats of "wool, knit thick and dressed in England." Similar hats, though of richer materials and often trimmed with fur, feathers, and jewels, are also seen in early sixteenth-century portraits of aristocrats and wealthy members of the bourgeoisie.

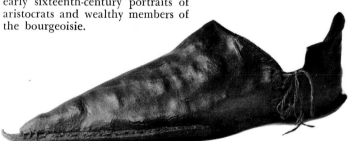

79a. POINTED SHOE *(poulaine)*
England
XV century
Leather, L. 12½ inches (30.8 cm)
The Metropolitan Museum of Art,
The Costume Institute, Bashford
Dean Memorial Purchase, 56.63.33

79b. SANDAL
England
XV Century
Leather, with bronze buckles, L.
10½ inches (26.7 cm)
The Metropolitan Museum of Art,
The Costume Institute, Bashford
Dean Memorial Purchase, 56.63.30

79c. SHOE

England
Early XVI century
Leather, L. 9½ inches (24.1 cm)
*The Metropolitan Museum of Art,
The Costume Institute, Bashford
Dean Memorial Purchase, 56.63.3*

Footgear in the late medieval period
varied greatly according to the
classes of society and the changes of
fashion.

The three types of shoes shown
here were common types and
frequently appear in medieval
painting. The long, pointed-toe
poulaine, of French origin and es-
pecially favored by young men, has
a laced opening at the side. This
particular style was especially
frowned upon by the clergy who
complained that such shoes impeded
the wearer from kneeling to pray.
The sandal was a house shoe, meant
to be slipped on for use indoors.
The clog is a variant of the sandal,
made of wood with leather straps
that could be slipped over the *pou-
laine* for walking in the street, with
a high sole that protected the
foot against mud and weather. The
eminently more practical and com-
fortable broad spade-shaped shoe
abruptly succeeded the *poulaine* to-
ward the end of the fifteenth cen-
tury. It was thought that this style
was introduced by Charles VII of
France who supposedly had six toes
on one foot. While the origins of
this type of shoe are conjectural,
changes in fashion were frequently
the result of royal taste.

Materials used in making footgear
in the Middle Ages ranged from
wood or stout leather used for the
clogs and shoes of the middle class
and the peasants to the costly tex-
tiles embroidered with gold thread
and pearls used for the slippers of
the rich. Canvas bound about the
feet and legs with rawhide thongs,
a type of footgear known as "bag
shoes," was not uncommon among
the rural peasantry. The shoe-
makers' guild in Paris in the thir-
teenth century was divided into two
groups, one making leather shoes
for common people and the other
fashioning the elaborate footgear
for the wealthy. With the introduc-
tion of the highly valued Cordovan
leather from Spain in the fourteenth
century, a special group of the guild
was granted exclusive rights to pro-
duce shoes made only from these
imported hides. Cordovan leather
shoes were often enriched with
painting, gilding, and fur lining.
The spade-shaped shoe exhibited
here was excavated in the area of
Guild Hall, London, which was, dur-
ing the Middle Ages, the district of
the shoemakers' and tanners' guilds.

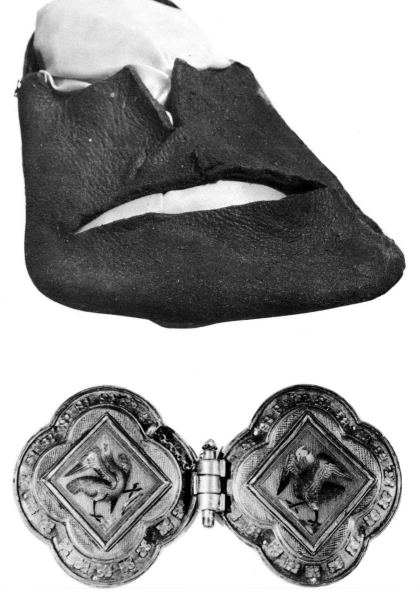

80. AGRAFFE

France, Burgundy
First half of the XV century
Silver, silver gilt, and translucent
enamel, H. 2½ inches (6.4 cm), W.
5 inches (12.7 cm)
Collection of Mrs. Ernest Brummer

The word *agraffe* appears in medi-
eval French inventories and expense
accounts to describe a type of clasp
comprised of two interlocking pieces
and used to close garments at the
neck or to fasten belts. Each half
was sewn or, in the case of the
heavier types, riveted to the mate-
rial of the garment or belt. Gener-
ally made of metal openwork, the
agraffe was hooked or clasped to-
gether. The more sophisticated slip-
bolt mechanism and the use of

translucent enamel distinguish this
example from the more ordinary
types. The translucent enamel was
applied in thin layers over an in-
cised metal base, usually silver, as
gold tended to distort the colors of
the clear enamel. In the fourteenth
century, Paris was the center of this
enamel technique but Italy, and
later Burgundy and Germany, also
produced comparable work. While
it is difficult to ascertain the precise
origin of this clasp, the enameled
birds that decorate it recall the four-
teenth-century sketchbooks of Gio-
vannino dei Grassi and Pisanello,
which frequently influenced works
of the International Gothic Style
in the North, particularly in Bur-
gundy.

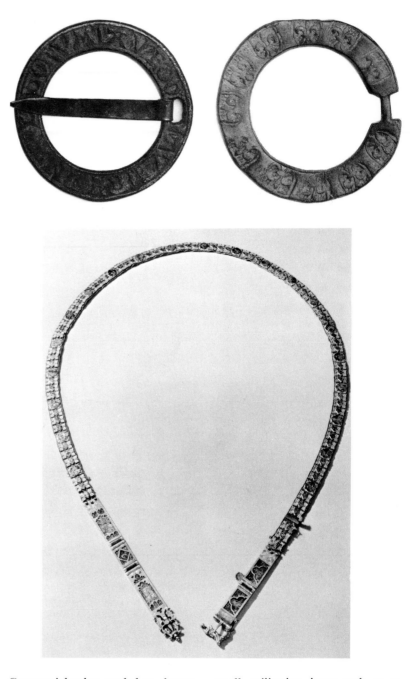

81a. BROOCH
France (?)
XIII or XIV century
Brass, Dia. 1⁹⁄₁₆ inches (4 cm)
*The Metropolitan Museum of Art,
Bashford Dean Memorial Collection,
29.158.872*

81b. BROOCH
France (?)
XIII or XIV century
Brass, Dia. 1¹¹⁄₁₆ inches (4.3 cm)
*The Metropolitan Museum of Art,
Bashford Dean Memorial Collection,
29.158.831*

Together with the belt, the clasp was a most essential accessory to the loose gown worn before the middle of the fourteenth century. Brooches like these two were used to close the slit at the neck of a gown, at the time before buttons were widely in use. One of them (its tongue is missing) is stamped with a decorative pattern of fleurs-de-lys, which suggests a French origin: the fleur-de-lys was the heraldic emblem of the kings of France. However, the fleur-de-lys was also understood as a stylization of the lily, a flower specially connected with the Virgin Mary. Therefore, any devotee of the Virgin in any country might have worn a clasp decorated in this way. The other clasp bears a stamped inscription that too refers to the Virgin, addressing her in Latin by two of her more usual titles: AVE.REGINA.-CELORVM.AVE.DO (MINA) ("Hail, Queen of Heavens; Hail, O Lady").

In the thirteenth century, these clasps were worn by men and women alike, because clothes, such as loose smocks and wide capes used as cloaks, were practically identical, even interchangeable, for both sexes. A knight-errant on arriving at a castle in bad weather could by normal practice be given dry clothes by the lady of the house, her own, if they fitted him better than those of her husband. In the middle of the fourteenth century, the development of the crossbow made it necessary for knights to change from their loosely fitting mail shirts to tightly fitting plate armor, and from then on men's clothes became different: much shorter, and so tight that they could no longer be pulled over the head but had to be buttoned in front, as is the case to the present day.

82. GIRDLE
Italy, Siena
Late XIV century
Silver gilt and translucent enamel, L. 90¾ inches (239 cm)
The Cleveland Museum of Art, Gift of the John Huntington Art and Polytechnic Trust, 51.30

Ceremonial robes tended to change in style less rapidly than did ordinary clothing. A fresco of King Edward II of England from the first quarter of the fourteenth century depicts him in robes and a long-tongued belt of a type that had gone out of style a century earlier. The present belt, dating from the latter part of the fourteenth century, because of its extraordinary richness, may well have formed part of a court costume, which would also explain its conservative form. It is long-tongued and lavishly adorned with translucent enamels showing scenes of courtly love, musicians, and fantastic animals. The clasp is in the form of a female figure and has a hook to hold small utilitarian items such as a purse or knife. Attached to the belt, which is made of silver wire woven to give it flexibility, are plaques of silver gilt and enamels. The scenes on the ends, which may be read in sequence, describe the formalities of courtly love. The knight first woos his lady with music which he plays on a cithara, then the couple converse, and their love is finally consummated by a kiss. The scenes are accompanied by musicians who appear on the other plaques on the girth of the belt. Lavish articles of dress such as this could be afforded only by the very rich and it is not unlikely that this belt was originally worn by a member of one of the ruling houses of Italy.

83. BUCKLE AND TONGUE
France, Paris
Late XIV century
Silver gilt and translucent enamel,
L. (of buckle) 4¾ inches (12.2 cm),
L. (of tongue) 5½ inches (14 cm)
Collection of Mrs. Ernest Brummer
Throughout the latter part of the Middle Ages, sumptuary laws forbade excesses in luxury of dress, though usually without results. The wealthy bourgeois continued unceasingly to imitate the nobility in matters of costume and domestic luxuries. Dress became more and more elaborate and the use of precious materials for accessories more frequent. This buckle and tongue, made of silver gilt with translucent

enamel, is an example of the richness of the apparel in the latter part of the fourteenth century. The girdle itself (now missing) was probably made of fine leather or silk and was worn loosely clasped about the waist with the end hanging in front or looped over the girth. The long-tongued belt, favored in the thirteenth century, had given way to this newer, shorter type.

Genre scenes and fantastic animals are used as decoration with ladies in affected poses and a gentleman holding a falcon. Richly ornamented belts, such as this, set off loose folds of the simply cut dresses of the period.

84. BUCKLE
France (Haute Savoie)
XIV century
Bronze, L. 2¾ inches (7 cm)
*The Metropolitan Museum of Art,
Gift of Bashford Dean, 20.152.53*
As the belt was an essential accessory it was often treated as a piece of jewelry, to be adorned with a pretty buckle and many decorative mountings, such as rosette-shaped eyelets, small plaques, and an ornate strap end which hung down, often well below the knees.

Because of its function of holding the loose folds of the gown together, the belt or girdle was regarded as a symbol of modesty and chastity, though, on the other hand, it helped, as wearer and observer alike were well aware, to emphasize the slimness of a waist and the curve of a hip. The fabled chastity belts, in which hapless ladies of the manor were locked while their lords and masters went off on crusade were first documented in a technical handbook written in 1402. The author, Konrad Kyeser, court engineer of the king of Bohemia, carefully notes that these contraptions were said to be used in faraway Florence and seems to consider them a practical joke.

85. FRAGMENT OF A GIRDLE
Germany (?)
Circa 1500
Silver gilt, L. 28½ inches (72.5 cm),
W. 1¼ inches (3.2 cm)
*The Metropolitan Museum of Art,
The Cloisters Collection, 72.134*
Beginning in the sixteenth century, female costume displayed an increasing tendency to differentiate between shirt and bodice. Not infrequently, these two parts of the dress were made of different materials to emphasize the waist which was pulled in with stays. Women of the

middle class in Germany frequently wore metal girdles, sometimes fastened with a buckle or a hidden link clasp. The present example is undoubtedly a fragment of the latter type. The large links with foliate ornament are joined by scroll-shaped plaques, many of which have been lost or replaced and which bear letters apparently part of an inscription no longer decipherable. Some of these letters form words or names, such as EVA, while others such as T.G.O.M. are simply initials.

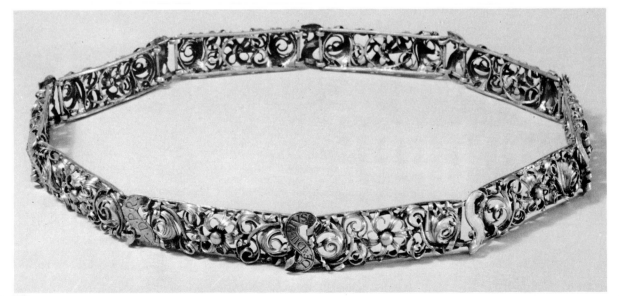

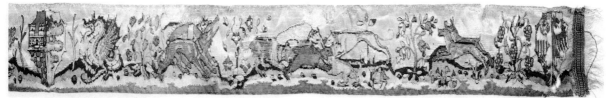

86. FRAGMENT OF A BELT
Italy (Lombardy), Milan (?)
First half of the XV century
Silk in tapestry weave, with silver and gold thread, L. 36¾ inches (93.5 cm), W. 3 inches (7.5 cm)
The Cleveland Museum of Art, J. H. Wade Fund, 50.3

High fashion in Western Europe toward the end of the fourteenth century was distinguished by well-cut and fitted clothes and by luxurious accessories. This fragment of a lady's belt bears the devices of the Visconti family of Milan: the eagle shield and the winged serpent were employed by Fillipo Maria Visconti who ruled Milan until 1448. It is quite possible that the belt was made originally for his wife, Maria of Savoy, or his daugher Bianca. Interspersed between the armorial devices are animals hunting in the forest, many of them so lifelike that they recall the exquisite northern Italian drawings of the International Gothic Style. Since the dukes of Milan regularly employed their court painters for all manner of designs, including clothes, it is not unlikely that the designer of this belt was the resident artist of the court. Some of Pisanello's designs for court fashions for the Visconti ladies still exist.

The belt of a lady's costume in northern Italy in the first half of the fifteenth century was worn high under the bust and was comparatively wide and without a buckle fastener. In all probability, this example is nearly complete and was worn so that the parti shield displaying the lady's device and the winged serpent of the Visconti were centered in front while the ends were caught at the back.

87b. BELT HOOK
France
XIV century
Silver gilt and enamel, L. 5⅛ inches (13 cm)
The Metropolitan Museum of Art, Rogers Fund, 48.13

Since the pocket was rarely, if ever, used in medieval dress, personal belongings often were suspended from the belt. Documents from the fourteenth century describe key holders of metal and silk that could be suspended from the belt. The French word *clavendier* came into use in the sixteenth century to describe similar objects. The word was also used in England; an early seventeenth-century record identifies a *clavendier* as "the chaine whereon women use to wear their keys." Belt hooks, such as the two shown here, must have been used for a similar purpose. One of the present examples has a rectangular loop at the back through which the belt could be inserted, and bears the coat of arms of Burgundy before it was combined with those of Flanders and Brabant under Philip the Bold. The other silver-gilt belt hook with filigree was attached to a girdle by the upper hook.

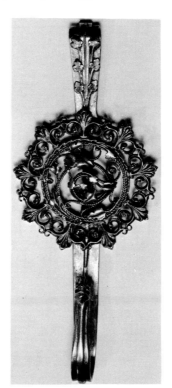

87a. BELT HOOK
France
XV century
Silver gilt, L. 8 inches (20.3 cm)
Collection of Mrs. Ernest Brummer

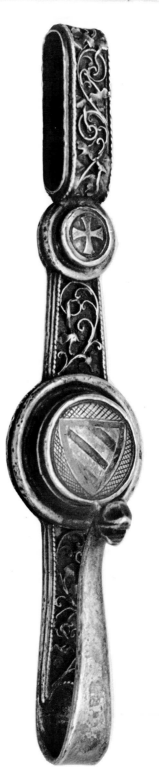

88a. POUCH *(forel)*
France
XIV century
Silk and metal thread embroidered on linen, H. 6 inches (15.2 cm), W. 5⅝ inches (14.3 cm)
The Metropolitan Museum of Art, Gift of Mrs. Edward Harkness, 27.-48.2

88b. POUCH *(forel)*
Switzerland (?)
XIV century
Silk and silver-gilt thread embroidered on canvas, with couching, H. 8⅜ inches (21.2 cm), W. 8 inches (20.3 cm)
The Metropolitan Museum of Art, The Cloisters Collection, Fletcher Fund, 46.156.34

Purses and pouches were commonly used to carry coins, cosmetic aids, and other personal possessions. Although textile pouches were often tied at the top or closed with drawstrings, the embroidered examples shown here are square in shape, with no closure at the top. Probably carried over the arm or wrist, they follow the type illustrated in several late fourteenth-century tomb brasses in Bruges.

The embroidered decoration of these pouches frequently derived from contemporary literary themes. The scenes on both sides of the French purse may represent part of the tale of "Patient Griselda," a popular figure who appears both in Chaucer's *Canterbury Tales* and Boccaccio's *Decameron*. Displaying the virtue which became part of her name, Griselda endured a series of trials administered by her husband in order to test her complete and abject obedience.

Whether these pouches were the work of professional artisans or particularly skilled amateurs is difficult to determine. The renowned English embroidery, called opus anglicanum, was produced in guild workshops, mostly in the city of London, by both men and women who had established their competence by seven years of apprenticeship. On the other hand, it was part

of a young woman's education to attain a command of both embroidery and tapestry weaving. In a detail from an altarpiece of the Virgin and St. George in Barcelona, a number of young girls display their embroidery work to a watchful mother. Convents also gave thorough instruction in this art and the stylized animals on the reverse side of the Swiss pouch are very close to those pictured in pattern books used in the convents of Lower Saxony.

Generally, embroidery of the type shown here was worked in silk thread over a linen base. The basic stitches were the split stitch and the tent stitch. In the former, used in refined detail work, the needle was sent through the previous stitch, thus splitting it, while in the latter, the thread was worked diagonally across the weave of the linen base. While the repertoire of stitches was limited, professionals and amateurs alike frequently attained a remarkable degree of technical and artistic refinement.

89. CASE (*étui*)
Italy, probably Venice
Late XV century
Leather, L. 8½ inches (21.6 cm)
The Metropolitan Museum of Art, Rogers Fund 50.53.1

Etui in medieval inventories and expense accounts was a general term for storage or travel containers of various materials and sizes. One such inventory of the early fourteenth century itemizes a small *étui* of enameled silver, designed to hold face powder. A large leather case, ordered from a coffret maker and referred to as an *étui de cuir bouilli*, was purchased to hold a painting by Jehan d'Orléans, painter to King Charles VI of France. The term *cuir bouilli*, literally, "boiled leather," is used to describe a particular type of leather decoration. Soaked in a lukewarm solution of resin or wax to

make it soft and flexible, the leather was molded into the desired shape. Decorative patterns were then tooled or impressed on the surface and often highlighted by color, gilding, or punching.

References are also made to small *étui* of *cuir bouilli* which were designed specifically to be attached to one's costume. Used to carry quill pens, ink wells, books, cutlery, and other personal possessions, these objects are frequently depicted in fifteenth-century paintings and manuscript illuminations. This Italian example has two interior compartments designed to contain a knife and spoon, and is inscribed A BONA FEDE DE TEL BON ("in good faith of so good" [a heart]); the tooled heart that appears at the end of the inscription replaces the actual word.

90a PURSE
Western Europe
XV or XVI century
Leather, with iron mountings, H.
5½ inches (14 cm), L. 6 inches (15.2 cm)
The Metropolitan Museum of Art, The Cloisters Collection, 52.121.2

90b. PURSE
Western Europe
XV or XVI century
Iron handle and mounts with velvet and silk bag (probably modern), L. (of frame) 6⅜ inches (16.2 cm)
The Metropolitan Museum of Art, The Cloisters Collection, 55.61.17
Purses of various shapes and sizes, carried by both men and women, were given descriptive terms in medieval inventories, such as *bourse* or *poche à compartement.* In the fifteenth century, purses with clasps of metal and loops on the rear which could be attached directly to the belt superseded the pouches which closed with drawstrings and hung from the belt. The clasp no doubt came into use to provide greater security for money or other valuables when the owner walked on crowded city streets. The leather purse has two inside pockets and a concealed smaller section with two small openings hidden beneath the front flap. The velvet bag has a double pouch with an opening in the front section that still uses the older drawstring closure. The iron frame at the top is decorated with acorns, human heads, and lizards, some of which move to release catches for opening the frame.

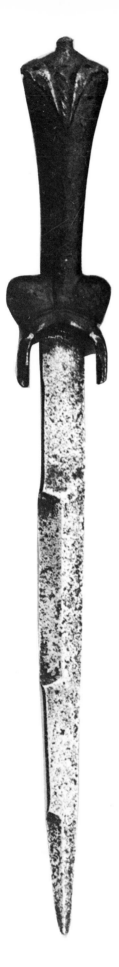

91. DAGGER
Flanders or England
Mid–XV century
Steel and wood, L. 14¾ inches (37.5 cm)
The Metropolitan Museum of Art, Rogers Fund, 04.3.123
Daggers were worn with the civilian costume of the Middle Ages as a badge of status of the free man. Their practical uses were, besides self-defense, those of all-purpose knives, which included their use at the table.

The peculiar shape of the grip with the two carved knobs prevented the hand from slipping onto the edge of the blade. At the same time, because of this shape, and because these daggers were worn at the belt in front of the body in an upright position, they were called "ballock knives," a term that was changed by Victorian antiquarians into "kidney daggers."

92. DAGGER
France (Burgundy)
Mid–XV century
Steel, brass, and wood, L. 14⅜ inches (37.5 cm)
The Metropolitan Museum of Art, Gift of George D. Pratt, 25.188.17
These daggers with cross-quillons were considered a special status symbol by the proud burghers of the rich and self-governing cities of Flanders. Because of their shape they were called *kruismes* or "cross-knives."

The knobbed grip, which afforded a firmer handhold, was a decorative form reminiscent of "ragged staves," i.e., naturally-shaped sticks with short branch-stubs, very popular in the Late Gothic period.

These daggers were worn at the belt together with a large pouch, in which the money purse, tinderbox, and other small items were carried.

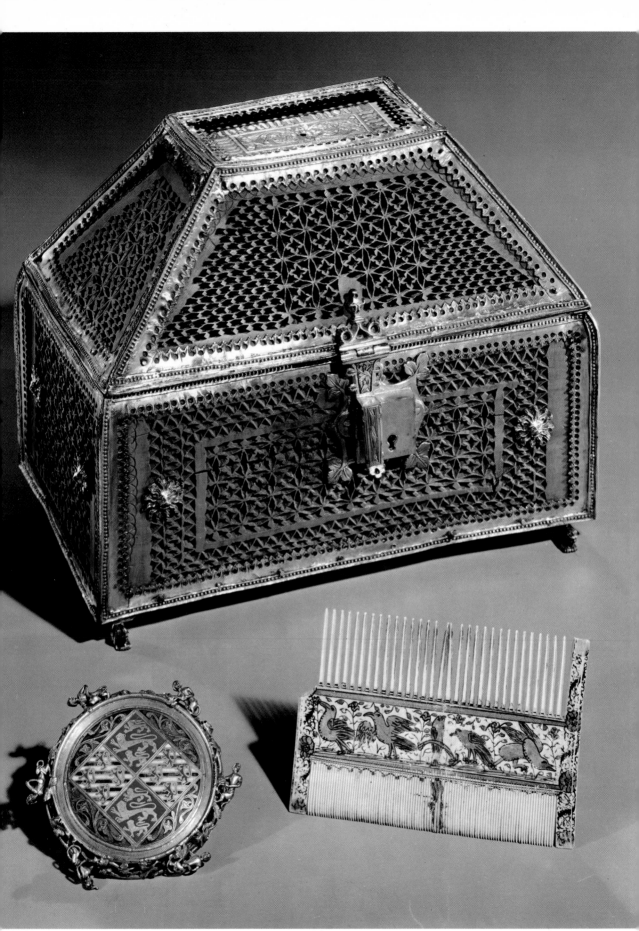

 PLATE 5 Cat. Nos. 7, 105, 107a

Bracelets appear in records of the fifteenth century for the first time with any frequency, possibly because sleeves were no longer tightly buttoned but open to expose the wrist. Because of the elaborate coiffures and jeweled headdresses that covered the ears in the fourteenth and early fifteenth centuries, earrings were not worn. When the style of piling the hair high on the head was introduced in Italy, earrings returned to fashion. Jewelry was also considered a wise investment, for precious stones and metals could always be sold, pawned, or melted down when ready cash was needed, whether to restock a royal treasury or to finance a merchant venture.

Throughout the Middle Ages, gems and semiprecious stones were often prized not only for their intrinsic worth but also for the curative or protective powers attributed to them. The diamond, the hardest and most valuable of all jewels, was presumed to give strength in battle. A Swiss chronicler of Bern reported that Charles the Bold wore a large diamond, the symbol of love and reconciliation, as a talisman in the Battle of Grandson against the Swiss in 1476. The sapphire, considered the perfect kingly jewel, was believed to increase devotion and cure ulcers. Lorenzo de' Medici was administered a potion of diamond dust and ground pearls by his physician, Lazarus of Pavia. Shortly thereafter, the famed Florentine died.

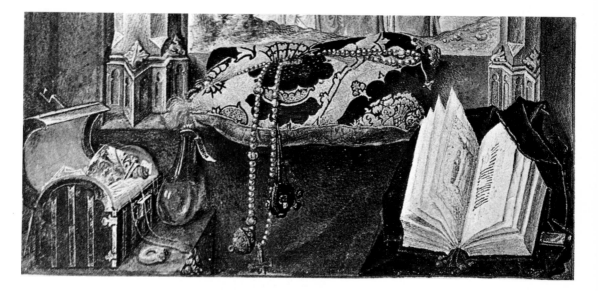

Jewelry, other personal objects, and a jewel casket, detail of an illuminated page by the Master of Mary of Burgundy in the *Breviary of Mary of Burgundy,* Flanders, 1477-1482 (Österreichische Nationalbibliothek, Vienna, cod. 1857).

93a. RING BROOCH
Western Europe
XIV century
Silver, cabochons, and glass paste,
Dia. 1⅛ inches (2.8 cm)
The Metropolitan Museum of Art,
The Cloisters Collection, 57.26.3

93b. RING BROOCH
France
XIV century
Silver, turquoise, and glass paste,
Dia. 1⅛ inches (2.8 cm)
The Metropolitan Museum of Art,
The Cloisters Collection, 57.26.2
Worn at the center of the neckline,
the ring brooch, with a hinged
tongue fastener, was used to close
the long thin undergarments worn
by both sexes. The weight of the
material pulling against the tongue
of the brooch, through which it was
looped, held the garment closed.
Lovers of the fourteenth century
often exchanged small brooches, ap-
propriately inscribed with senti-
ments. Thus, a lady fastening her
shift with a treasured ring brooch
found its intimate purpose enhanced
the amorous significance of the gift.
In his *Canterbury Tales,* Chaucer
mentions a brooch inscribed *Amor
Vincit Omnia* worn by the formi-
dable prioress, Madame Eglantine.
 In the fourteenth century,
brooches set with polished, uncut
semiprecious stones and fashioned

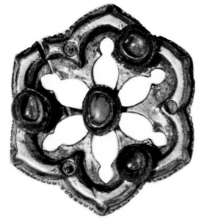

from ordinary metals were made in
increasing numbers for people who
could not afford gold and gems. In
a short rhyme, *Dit du Mercier,* a
merchant of this period declared
that he now sold brooches of gilded
or silvered brass and of latten.

 Ring brooches were also fitted
with pin closures. The brooch set
with turquoise, a popular stone im-
ported from the Near East, is an
example of this type.

94. HAT ORNAMENT
France
Circa 1520
Gold, gold filigree, and enamel,
Dia. 2¼ inches (5.7 cm)
Robert Lehman Collection, New
York
Avarice, greed, and worldly pleasure
were themes frequently represented
in art in the early sixteenth century.
An example is this hat ornament
which represents a woman between
an old and a young man. While the
old man holds her breast, the
woman is reaching into his purse
with one hand and holding the
young man's hand with the other.

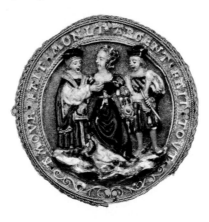

The inscription reads: AMOR FAIT
MOVLT ARGENT FAIT TOVT ("Love
does much but money does every-
thing"). The subject, woman's fickle
and deceitful nature, suggests that
the piece may have been a man's hat
ornament.

 The enameling technique of this
object, known as *en ronde bosse,*
developed in Paris and was popular
by the end of the fourteenth cen-
tury. Both opaque and translucent
enamel in white and color were
applied to the gold relief that had
previously been roughened to hold
it securely.

95. TWELVE MEDALLIONS
France (Burgundy)
Circa 1400
Gold, enamel, semiprecious and
precious stones, and pearls with
(modern) gold chain, Dia. (of largest
medallion) 1¾ inches (4.5 cm)
The Cleveland Museum of Art,
J. H. Wade Fund, 47.507
Tradition holds that these medal-
lions were offered to the Virgin of
Louvain by Margaret of Brabant,
whose daughter married Philip the
Bold of Burgundy. Though there is
no specific documentation, the asso-
ciation of the medallions with the
house of Burgundy is almost surely
valid since descriptions of similar
jewels are mentioned in early Bur-
gundian account books. Further-
more, the principal medallion of
this group recalls the description of
a "golden clasp with a white lady"
given in 1393 by Mary, daughter of
Philip the Bold, to her husband on
the occasion of their marriage. The
white enameled petals on some of
the other medallions resemble those
of a daisy known in French as *mar-
guerite,* and may therefore be a
motif associated with Margaret of
Brabant, her daughter, or her grand-
daughter. The use of white enamel,
as well as the style of dress of the
lady on the large medallion, help to
confirm a date of circa 1400.

 It is possible that these medal-
lions, which are today mounted with
modern chains as a necklace, were
originally single clasps or pendants.
There is no evidence, however, to
preclude their having been part of
a necklace. Indeed, comparison with
a mid-fifteenth-century Burgundian
necklace based on a German design,
now in the Neuenstein Castle,
Hohenlohe Museum, suggests such
a possibility. Necklaces, according to
many records, including the account
books of Philip the Bold, were com-
missioned as presentation gifts for
the new year, for marriages, and for
diplomatic events, and were given
to both men and women.

 Although generally thought to be
of French-Burgundian origin, it has
been suggested that these medal-
lions were executed in Paris, as they
are fine examples of the *en ronde
bosse* enameling technique fre-
quently used by the goldsmiths of
that city during the reign of Charles
VI (1380–1422).

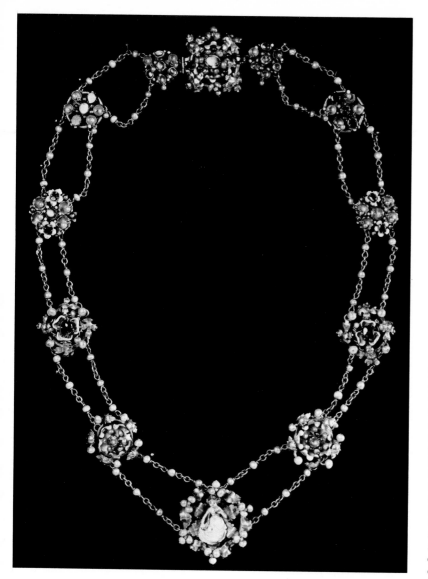

97. BROOCH
Hungary (?)
XV century
Silver gilt, with enamel and jewels,
Dia. 4⅜₁₆ inches (11 cm)
Collection of Mrs. Ernest Brummer

The medieval brooch, used singly or in pairs and connected by a chain to fasten a mantle or cloak at the breast, appeared in two distinct forms. In one, jeweled projections extended from the outer edge of the brooch in a starlike fashion, while in the other, the so-called wheel brooch, flat bars radiated, as the spokes of a wheel, from the center to the outer rim. Although a flat silver disk covers the back, thus closing the space between the spokes, this example is of the latter type. The backing disk bears the mark of a Hungarian goldsmith active from about 1596 to 1625. As the brooch itself can, on the basis of style, be dated earlier, it is reasonable to assume the back was added later as a reinforcement. The original portion of this brooch is quite similar, not only in shape and in diameter, but also in the arrangement of jewels, to several other but much larger examples. In 1818, a similar one, now in the National Museum, Stockholm, was dredged from the water in an eel net in East Gotland. This massive brooch, measuring about eight and a half inches in diameter and weighing an incredible one and a half pounds, also had a backing added about one hundred years after it was made.

Numerous Italian and Flemish paintings of the fifteenth and sixteenth centuries illustrate the two principal ways in which circular brooches were worn. In an Italian painting of the Virgin and Child, a single large, round, jeweled brooch fastens Mary's cloak, while in a work by Gerard David, two such brooches, connected by a gold chain, serve to close the Virgin's mantle at the neckline. The present example was undoubtedly used in one of these ways, but the later alterations have obscured the precise manner of closure.

96. PENDANT
France
Circa 1450–1475
Gold, pearls, and glass paste, L. 1⅛ inches (2.8 cm), W. ¹⁵⁄₁₆ inch (2.4 cm)
The Metropolitan Museum of Art, The Cloisters Collection, 57.26.1
(See color plate no. 4)

Contemporary panel paintings and manuscript illuminations indicate that by the beginning of the fourteenth century, both men and women wore a great variety of pendants. This French example, delicate in composition, is small in comparison with the extravagantly large pendants which became popular by the early sixteenth century. Four gold letters forming the word AMOR are suspended from this pendant, lending it an amorous significance.

Since the days of ancient Egypt, craftsmen had used a technique similar to enameling to make imitation or paste gems such as the "emerald," and the "crystal" set in this pendant. Backed with foil, pastes effected a satisfying brilliance and were known to have been owned in great numbers by Jeanne d'Évreux, queen of Charles IV of France between 1325 and 1328.

Gems, nonetheless, remained for the ruling class among the most prized of objects. Around 1400, John, duke of Berry, is said to have left a state meeting in order to examine a new diamond brought for his inspection.

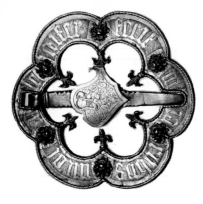

98. RING BROOCH
Germany or Flanders (?)
XV or XVI century
Silver gilt, Dia. 5 inches (12.7 cm)
Collection of Mrs. Ernst Brummer
Although the tongued ring brooch
was more common in the earlier
centuries, it was still in use in the
late Middle Ages, particularly in
northern Europe. Brooches of this
type were often used purely for
ornamentation, but the size of the
present example indicates that it
may have been used to fasten the
neck of a heavy cape or cloak. The
coat of arms, which shows the leg
of an animal pierced by an arrow
surmounted by a winged helmet, is
unidentified, but the style and ar-
rangement of both the shield and
arms are typical of those found in
Flanders and the Rhineland.

The brooch is inscribed IA-COBVS-
NICOL-AE-LE-GIFER FECIT-M ("Jacobus
Nicholas' son *le gifer* made me").
The meaning of the word *gifer* or
givre is obscure but, depending on
the arrangement of the letters and
interpretation, could be translated
as "frosty" or "old one" (*le gifer*),
"the lawyer" (*legiter*), or "the tavern
keeper" (*aelegifer*).

99. PENDANT
Germany
Circa 1500
Coral and pearl, with gold and
silver-gilt mountings, L. 2¹¹⁄₁₆ inches
(6.8 cm)
*The Metropolitan Museum of Art,
Gift of Alastair B. Martin, 56.125.6*
The popularity of pendants in the
Middle Ages (which could be worn
on chains and collars or incorpo-
rated in necklaces), as well as the
intrinsic value of their materials
and workmanship, account for the
great variety which have survived.
Although pendants were often dec-
orated with gems and enamels,
other prized materials were fre-
quently used. This pendant of red
coral exemplifies the use in jewelry
of a material highly regarded not
only for its decorative value, but
also for its amuletic properties.
Coral, which was found in abun-

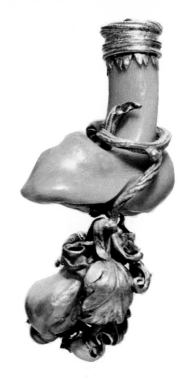

dance in the Mediterranean, was
traditionally believed to ward off
the evil eye, to counteract poison,
and to protect the traveler from
danger. Branches of it were hung
around the necks of Roman children
to ward off pestilence; this singular
practice continued in Italy as seen
in a painting after Jacopo Bellini,
circa 1474, in which the Christ
Child is depicted with a red branch
of coral around his neck.

100a. PENDANT
Northeastern France
First half of the XV century
Painted ivory under rock crystal,
with silver and niello mounting,
H. 3³⁄₁₆ inches (8 cm)
*Museum of Fine Arts, Boston, Helen
and Alice Coburn Fund, 54.932*

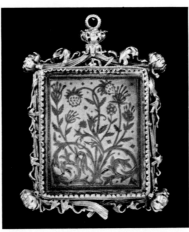

100b. PENDANT
Germany
Early XVI century
Silver (partly gilt), Dia. 2⁵⁄₁₆ inches
(5.8 cm)
*The Metropolitan Museum of Art,
The Cloisters Collection, 65.68.1*
Among the most popular jewelry of
the late Middle Ages were pendants
with religious subjects which were
suspended from chains around the
neck, from belts, and from chaplets
or rosaries. Particularly popular
were those depicting the Virgin, St.
Anne, and the Three Kings who
were thought to protect the wearer
from specific infirmities and diseases.

On the front side of the Boston
pendant is an ivory plaque depicting
the Coronation of the Virgin, while
on the back there is a silver and
niello plaque with a design of straw-
berry plants. A technique popular
at the end of the Middle Ages, niello
was achieved by brushing a sulphur
compound into a design incised on
metal which was then fired and pol-
ished. The border of the pendant, a
floriate pattern worked in silver, re-
calls the naturalistic borders of
Franco-Flemish manuscript illumi-
nation of the period. Rich pendants
of this sort were worn by both men
and women; in a portrait of Albert
V of Bavaria, the duke is wearing a
similar pendant on a heavy gold
chain. As the silver and niello back
is displayed in that instance, it may
have been the custom to wear such
pendants with the devotional scene
facing inward, thus, figuratively, di-
rected toward the soul and away
from the evils of the surrounding
world.

While the Boston pendant was an
item of great luxury, the Cloisters'
pendant was an ornament more
available to the middle classes. De-
picting the Virgin and Child on a
crescent moon, a theme inspired by
the apocalyptic vision of St. John,
the composition is derived from a
Dürer engraving. As at least two
other similar pendants are known, it

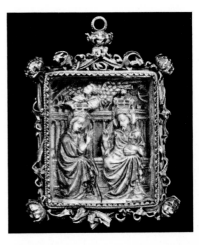

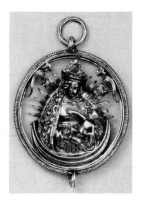

is probable that they were made in large numbers for a wide market. Pendants of this sort were often fitted with a small compartment in the back to hold a relic or a talisman.

101. PENDANT
Germany, Cologne
1504
Silver gilt and translucent enamel, H. 2¾ inches (7 cm)
Museum of Fine Arts, Boston, Grace M. Edwards Fund, 47.1450
(See color plate no. 4)
This pendant, inscribed with the date 1504, follows the form of large altarpieces with painted wings and sculptured centerpieces. On the enameled wings are St. George and St. Mary Magdalene, while the martyrdom of St. Barbara is depicted in the centerpiece. One of the Fourteen Helpers-in-Need, to whom one could turn in moments of peril or sickness, St. Barbara was a very popular saint during the late Middle Ages, and

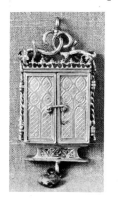

scenes from her life are commonly depicted on a variety of secular objects.

Triptych pendants enjoyed considerable popularity among the wealthy classes of the fifteenth century. Several pendants of this type, decorated with religious subjects, were included in the 1458 inventory of Philip the Good, duke of Burgundy, and others appear in the 1488 and 1497 inventories of the duke of Brittany and the countess of Angoulême respectively. While Bur-

gundian examples capitalize on the brilliance of precious stones, pearls, and cameos, the ornamentation of pendant triptychs produced in the Rhineland relies more on the use of enamel and skillful goldsmith's work. Suspended from the predella of the present example is a small heart inscribed with the sacred monogram, but jewels and talismans were also used for such additional decorative appendages. By the sixteenth century, pendants in the shape of altarpieces were superseded by those of ornate circular form.

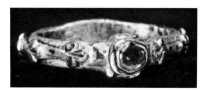

102. RING
England
XIV century
Gold, silver gilt, and cabochon sapphire, Dia. 1⅛ inches (2.8 cm)
The Cleveland Museum of Art, J. H. Wade Fund, 50.38.3
In the fourteenth and fifteenth centuries, rings were worn in great numbers; it was not unusual to wear four or five rings on one hand, some of which were worn on the middle joints of the fingers as well as above the joints and on the thumbs. Apart from serving a purely decorative function, rings incorporated seals, bore mottos and devices of a superstitious, religious, or aphoristic nature, and often served ceremonial functions. Of the ceremonial type, wedding rings were the most common. The symbolic motifs with which these rings were decorated is well demonstrated by the present example. The clasped hands which appear on the back are representative of unity, while the sun and moon, representative of day and night, may be interpreted as a lifetime through which the bond of marriage will last. By the end of the Middle Ages, rings, known in England as "posy" or "poesy" rings, inscribed with sentimental verses such as "I like, I love as Turtledove," were extremely popular. In the sixteenth century, jewelers kept large stocks of rings with lengthy lists of similar verses from which the purchaser could choose an inscription. While the later rings tended to be broader and of more complicated forms, the delicate style of the earlier medieval rings is represented in the present example, dating from the fourteenth century, and said to have been found in a garden in Winchester.

103. HAT ORNAMENT
Scotland (?)
XV century
Gold, Dia. ¾ inch (1.9 cm)
Museum of Fine Arts, Boston, Arthur Mason Knapp Fund, 63.1526
(See color plate no. 4)
Throughout the Middle Ages badges worn on the broad brim of pilgrims' hats were a popular and widely used means of identifying the holy site from which the travelers were returning. The famed crossed keys indicated St. Peter's in Rome, and the shell designated the shrine of Santiago de Compostela. It was only late in the fourteenth century, however, when turbans and other elaborate headgear became the vogue for men, that a variety of hat ornaments of a purely decorative nature became popular; these could be attached either on the front or on the side of the hat. In French and Burgundian manuscripts of the early fifteenth century, men are depicted wearing hats decorated in this fashion. The hats themselves were frequently of enormous size, but the hat ornaments were, in contrast, quite small.

Many of the hat ornaments, such as this one in the form of a ring brooch, were probably only pinned rather than permanently affixed to the hat—a practical approach that allowed the owner to use the ornament on a number of different hats or to rearrange the same floppy hat yet have the ornament still prominently placed.

This small gold brooch is inscribed: JOIE AURAY ("I shall have joy"). The inscription on the reverse side, CE NRS N (?) ENT, has not been deciphered.

COSMETICS

The use of oils, lotions, and creams to alter the appearance, to cleanse the skin, and to enhance the general attractiveness of the person is a practice known from the earliest civilizations. Cosmetics were widely used in Egypt, Greece, and Rome and were undoubtedly introduced by the Romans to the outposts of their far-flung territories. At the collapse of the Roman Empire in the fourth century, however, the use of cosmetics in Western Europe seems either to have disappeared or to have declined greatly. The barbarian hordes were apparently unused to such refinements, employing vegetable dyes instead to color the skin to achieve a more ferocious appearance in battle. By the twelfth century, however, cosmetics seem to have been reintroduced into Western Europe, probably by the returning crusaders who had evidently learned of them in Byzantium, where old Roman customs persisted. Because they had to be made according to a formula, cosmetics were dispensed by doctors and apothecaries. It is significant that one of the first manuals on the care of feminine beauty was written at Salerno, the great medical center of the Middle Ages. Written around 1100, by a lady physician and teacher named Trotula, the treatise contains recipes for beauty preparations for use in the care of the skin, the face, and the hands. Trotula's manual was copied, translated, and widely used throughout the Middle Ages. The English version, known under the authorship of Dame Trot, even discusses a steam chamber heated with elderwood for weight reducing. A late thirteenth-century French treatise, *L'Ornament des dames,* probably combining Trotula's work with information derived from the writings of Galen and Hippocrates, expands cosmetics to include such personal enhancements as hair coloring. A mixture of iron, gall nuts, and alum, boiled in vinegar and left on the head for two days, would dye the hair black.

Herbals also list extensive beauty aids: rosemary mixed with white wine made the face beautiful, the red lily was used to make rouge, and the root of the madonna lily could whiten the face. That these recipes appear so frequently and in such commonly read household manuals as herbals indicate that cosmetics were widely used and not restricted to members of the upper class. Lists recording the wares of peddlers in England in the late Middle Ages include items for a lady's toilet such as combs, mirrors, hair frizzers or curlers, rouge, powder, and toothbrushes, a selection that was undoubtedly intended to serve the needs of women in the towns and outlying districts.

Perfumes and sachets were also much in demand. Sweet-smelling flowers such as lavender and roses were especially cultivated for distillation, and their oils were used in the preparation of perfumes. Animal secretions such as musk, which formed the fixative for the scent, were known and employed then, just as they are today, to produce the sweet odors desired by both sexes. In her treatise, Trotula prescribed a deodorant comprising an infusion of bay leaves and hyssop.

The new fashion of the high forehead, introduced from Italy to the North in the fifteenth century, required the plucking of the hairline as well as the plucking of eyebrows. Special tweezers are mentioned in inventories for this purpose. As the coiffure became more elaborate, the making of wigs and false tresses became a special industry with a guild of its own. The use of these cosmetics and beauty aids was so extensive by the end of the Middle Ages that the practice was repeatedly condemned, though without much effect, by both clergy and secular moralists alike.

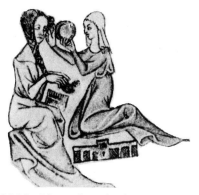

Maid with comb and mirror grooming a lady, detail of an illuminated page in the *Luttrell Psalter,* East Anglia, ca. 1340 (British Museum, Add. Ms. 42130). (Reproduced by permission of the British Library Board)

104. MIRROR BACK
France
XIV century
Ivory, Dia. 4½ inches (11.4 cm)
The Metropolitan Museum of Art, Gift of George Blumenthal, 41.100.160

Although large mirrors with decorated bases and handles were common throughout the late Middle Ages, few examples have survived. More familiar are the small mirror cases, usually made of ivory and intended to be carried on the person. Most were products of the fourteenth-century Parisian ivory workshops. Production dropped noticeably in the following century when the popularity of ivory as a material for luxury items, such as caskets, mirror cases, and toilet articles, had waned. An Italian example, half of which is now in the Walters Art Gallery, Baltimore, and the other half in the Cluny Museum, Paris, has two holes in its ivory frame indicating it was to be hung from a belt.

The scene on this example depicts a lady and a gentleman in resplendent costume, engaged in falconry, one of the more popular pastimes of the period. The less strenuous nature of this sport made it a suitable outdoor activity for ladies.

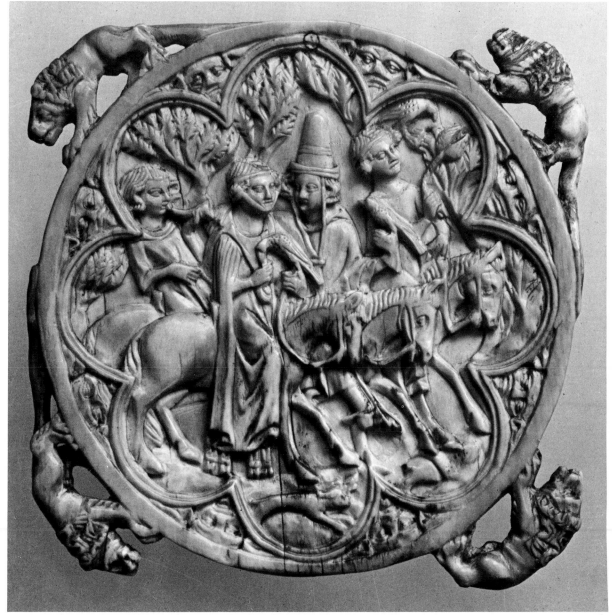

105. MIRROR BACK
France (Paris)
Circa 1300
Silver gilt with champlevé enamel,
Dia. 3¾ inches (9.5 cm)
*The Metropolitan Museum of Art,
The Cloisters Collection,* 50.7.4
(See color plate no. 5)

The frame of this mirror back is
composed of an ivy wreath from
which emerge six figures, half-men,
half-lions, similar to those seen in
marginal drolleries or on contempo-
rary manuscripts. The case of this
box-type mirror originally consisted
of two halves provided with a bay-
onet joint (with lugs on one half
and corresponding grooves on the
other) which would, with a slight
turn, fasten the two parts of the
mirror securely together. The mir-
ror itself, made of highly polished
metal, would be attached to the in-
ner side of the case, in this particu-
lar example, to the inside of the
mirror back.

On the enameled back, within
the silver vine frame, a square area,
set against a background of translu-
cent green enamel with silver-gilt
leaf scrolls, bears heraldic devices of
the original owner. The square is
divided into four smaller squares to
display the quartered arms: *gules*
three lions *passant regardant or,* for
the royal arms of England, and
barry argent and *azure* for the arms
of the Poitou family of the Lusig-
nans, differenced with four lions
rampant gules, probably for Hugh
XI, Le Brun, sire of Lusignan,
whose shield bore on his seal of
1246 a border of six lions *rampant
gules.* The number of lions is re-
duced to four in the case of the mir-
ror back to fit the available space.
Hugh XI could have quartered his
arms with those of his mother,
Isabel of Angoulême, as the widow
queen of John the Lackland of Eng-
land, in her second marriage, the
wife of Hugh XI's father. Or he
could have adopted them for his
sponsor and half-brother, Henry III
of England. The differenced arms
of Hugh XI of Lusignan appear
among other coats of arms on the
tomb of his wife, Yolande of Brit-
tany (d. 1276), and on that of his
brother William of Valance, in
Westminster Abbey, London, dated
1296.

106. HAIR PARTER (*gravoire*)
Italy
XIV century
Ivory, H. 11½ inches (29.2 cm)
Collection of Mrs. Ernest Brummer
The handle of the rattail comb may

be the only modern counterpart of
this object, called in medieval
French either a *gravoire* or *broche,*
and used in parting the hair or ar-
ranging the coiffure. Most *gravoires*
were made of ivory and date from
the fourteenth century, but records
indicate that occasionally they were
made of precious metals, inset with
enamels and jewels. One of the
dukes of Burgundy had a set which
included a *gravoire,* a comb, a mir-
ror, as well as two razors made of
silver gilt with the duke's arms on
them.

Shaped like a curved knife, most
gravoires have a decorative carving
on the handle. The hilt of this one
shows a man playing an organ on
the top with a grotesque figure be-
low.

107a. COMB
France
XV century
Painted ivory, L. 5½ inches (14 cm),
W. 3½ inches (8.9 cm)
*The Metropolitan Museum of Art,
Gift of J. Pierpont Morgan,
17.190.245*
(See color plate no. 5)

107b. COMB
France
Late XV century
Boxwood, L. 5⅝ inches (14.3 cm),
W. 6⅛ inches (15.5 cm)
Collection of Mrs. Ernest Brummer

107c. COMB
France
XV century
Boxwood, L. 6¾ inches (17.1 cm),
W. 4⅝ inches (11.7 cm)
Collection of Mrs. Leopold Blumka

By the late fifteenth century, box-
wood had supplanted ivory as the
preferred material for combs. This
dense and finely grained wood, the
closest of all in texture to ivory, lent
itself to the elaborate decorations
and the finely carved teeth of these
later combs. To assure the strength
of the teeth, the wood was carved
with the grain. Both boxwood combs
have inscriptions. The side of one
comb is inscribed E DONC while on
the reverse is the word BON, fol-
lowed by a carved heart, probably
an amorous allusion ("take there-
fore, good" [heart]). The other
comb is inscribed PRE-NES PLAISIR
("take pleasure"). Since this comb
has on the reverse side two small
round compartments with sliding
covers which could be filled with
cosmetics, it may be that the inscrip-
tion, instead of alluding to a senti-
ment of love, referred to the plea-
sure this combination comb and
makeup case would provide by im-
proving one's appearance.

The center section of the ivory
comb is decorated with painted
hounds and rabbits, while a large
insect is depicted across the surface
of the fine teeth. Because the paint-
ing would have worn off with con-
stant use, the fine-toothed side was
apparently less frequently used, per-
haps only for the finishing touches
of the coiffure. According to English
and German sources of the sixteenth
century, combs made of certain ma-
terials such as lead, were believed to
darken the hair.

III

LABOR, COMMERCE, AND TRAVEL

The period between 1300–1550 encompassed some of the sharpest fluctuations in economic history. As a result, the changing conditions of labor, commerce, and travel cannot be fully reflected in an exhibition of material objects from that time, no matter how skillfully chosen. The following brief description of trends is necessary to fill the gap.

Shortly before 1300, Europe had reached the highest point of medieval progress in almost every field; what has been called the "commercial revolution" was at its peak. Not everybody was happy, of course, despite the fact that the medieval pursuit of this goal had narrower horizons than ours; but, it is only fair to compare an age with its past, not with its future. Never before had such a large proportion of Europe's population been so well fed, so free to move, so blessed with expanding opportunities. Growth manifested itself at the root of existence—more people were alive than at any earlier time, with an average life expectancy raised from about 25 years (as in ancient Rome) to about 35 (not much less than England's expectancy around 1850). Slavery had almost disappeared, serfdom was abolished over wide stretches of the land and in virtually every city, some degree of political participation was available to an ever-increasing number of men, and some civil rights were extended to women. Labor was still arduous for the no-longer silent majority, but a variety of new tools and techniques had made it somewhat less burdensome, more productive, and better rewarded. Commerce kept enlarging its clientele, building up the roster of goods, broadening its geographic scope. Italian merchants and bankers were prominent over much of Europe, ranging from England to Morocco and from southern Russia to western Iran; a few traveled with merchandise as far as India and China. German merchants had the upper hand in parts of northern and eastern Europe, an area where few Italians were seen. Indeed, all the nations of Europe had their native traders, and travel was no longer a dangerous adventure for clergymen, soldiers, scholars, or for peasants looking for unoccupied land in the still underexploited frontiers of Europe.

Economic growth generates its own wear and tear. Its pace, already slowing down around 1300, continued to slacken in the following years: there was no general crisis before the mid-fourteenth century, but lower birth rates (probably because of birth control), soil exhaustion, labor problems, and banking failures occurred here and there. Then, a number of shocks changed the trend to economic decline: the Black Death of 1346–1348 started a cycle of plague epidemics at intervals of about fifteen years; the disintegration of the Mongolian Empire (completed by 1369) and the ad-

vance of the Ottoman Turks (culminating in 1453) rolled back the frontier of European trade and travel from China to Greece. The Hundred Years' War (1337–1453) and other prolonged conflicts transformed most of Europe into a battlefield. Despite this, however, the European people preserved sufficient strength and zest to use every interval between disasters to recover as best they could. There was a decrease in the number of men, the quantity of goods, the extent of liberty, and the mobility of the population, but the quality of products did not substantially change.

In the late fifteenth century, a longer lull made a measure of recovery possible, but, after 1492 the invasions of Italy and the struggles of the Reformation braked the economic renaissance and delayed the effects of the great geographic discoveries. By 1550, however, the crisis had been overcome and a new age of economic growth had begun. Growth was slow at first, but it was to lead without major interruptions to the Industrial Revolution and the tremendous expansion of our time.

The objects in this section of the exhibition aim at reconstructing the general atmosphere of the 1300–1550 period, and must be seen as complements to those examples from other categories; there is hardly an object that has not been produced or transformed by labor, handled by commerce, and delivered to the customer after travel. Unfortunately, the largest instruments, even if extant and transportable, would not have fitted in the cases of a museum. The wheeled plough with mold-boards, which opened the heavier soils to cultivation; the water mill, which was adapted to various industrial uses such as fulling cloth, throwing silk, lifting triphammers, and blowing air into blast furnaces; the ships of every shape and dimension, which were built for different cargoes and destinations—none of these could be shown except through miniatures, prints, or written descriptions. They would remind us that the 1300–1550 period was not as barren of large and ingenious contraptions as one might think, nor was it incapable of precision and exact duplication.

The fact remains, however, that labor, commerce, and travel were far less mechanized and mass-produced than now. Nearly everything depended on the physical strength, manual dexterity, and good taste of the worker or the artisan rather than on the clever, light tools he used. That is why we speak of artisans in almost the same terms as artists. To bring some speed and uniformity to what would seem today an ill-equipped, inefficient society, team work and faithfulness to tradition were desperately needed; every man had to expend his effort and to use his imagination. There were standardized weights and measures, many of them shown here, but standards varied almost incredibly from place to place. There were manuals of agricultural, commercial, industrial, or navigational techniques—such as the farmers' encyclopaedia of Pietro de'Crescenzi (written in Bologna shortly before 1300, and transmitted by numerous manuscripts in the original Latin or in translation) or the miscellaneous compilation of Zibaldone da Canal (a unique Venetian collection of older texts of various origins)—but manuscripts were expensive and copyists often inaccurate. The printing press could do better, but as late as 1550 it produced more Bibles and poems than books on business. Nor were books always felicitously chosen: Marco Polo's genuine travelogue had an unusually wide diffusion, but so had the spurious travelogue attributed to Mandeville.

Farming and animal husbandry, at any rate, were usually performed by people who read no books but had learned traditional practices and the use of fairly simple tools from their elders or their neighbors. Even the most determined and enlightened landowner could not easily introduce innovations into the routine of a village community; it is a wonder that innovations nevertheless came through. Industrial training, normally ob-

tained through apprenticeship, also tended to be bound by tradition and frozen by guild regulations; but it was more responsive to change, especially in the crafts that required artistic talent or ability to capture large markets at home and abroad. Most craftsmen lived in towns, where life was more exciting and mobility greater than in the country; their tools were more sophisticated and their work more specialized; they learned their profession by doing, but very often they also acquired some knowledge of reading, writing, and arithmetic. Their individual production was too small to raise them to wealth and power, but they made their collective weight more effective through their guilds.

Commerce was the most flexible, dynamic, and rewarding branch of the economy. Its total output and the number of people involved were incomparably smaller than those of agriculture; but merchants were the core of the ruling elite in the leading independent or autonomous cities as well as the great promoters of economic development in the great feudal monarchies. Money was their weapon: golden florins of Florence, ducats of Venice, genoins of Genoa—soon imitated in a growing number of royal, princely, and ecclesiastic mints—financed wars, built cathedrals, brought food to the hungry, and extorted privileges from the improvident or overambitious ruler. Among themselves, they did not use hard cash as much as credit; their capital was represented by entries in account books and invested in the inventory of their warehouses. They had to be proficient in reading, writing, arithmetic, commercial law, the knowledge of merchandise, and the experience of foreign markets. Some of them had literary and artistic talent; almost all were politically well informed and, in their cities, politically active. By associating with others, they endeavored to spread risks and maximize profits. In a world where position of birth and strength yielded more than labor and cunning, the merchant was almost the only one who could rise from rags to riches through his peaceful endeavors; but he also had to use force when needed, and—like everybody else—he was exposed to failure.

There were merchants who thrived by local trade, but long-distance trade normally was more rewarding. In 1300, the most prosperous traders spent a good proportion of their time on horseback or aboard ship, but the contracting economy of the period of crisis forced them to reduce their disbursements as best they could; it did not pay to travel for modest returns. Still, mobility remained the essence of commerce, and if a merchant could not himself follow his wares he had to engage in a voluminous correspondence with business associates. The archives of the Datini business company, centered in Florence, and still preserved in the pious foundation Francesco Datini established in nearby Prato to save his avaricious soul (1410), contain more than 300,000 letters exchanged between the main branch and its correspondents and employees, besides 500 books of account.

One of the most fascinating by-products of travel is the so-called portolan map. The earliest specimens originated in Genoa, shortly before 1300; Catalan Jews produced many in the fourteenth century; northern Europe lagged behind, but became the home of great cartographers by the late fifteenth century. Made by seamen for their own use, with the help of the astrolabe and other nautical instruments, these remarkably accurate charts recorded the continuous progress of discovery; significantly, Columbus earned his living for a long time by drawing maps, and America was so named (after Vespucci) by a German cartographer.

Travel, unlike commerce and labor, gained more than it lost by the long depression following 1350. The disruption of the old routes to "the Indies" stimulated the search for new ones. Without forgetting what they had learned from Marco Polo and less famous visitors to the Mongolian Empire, sailors kept probing and lengthening their voyages over unknown seas. By

1550, while commerce and labor had little more than recovered the ground lost during the depression, travel had doubled the span of the known world and, with Magellan, the circumnavigation of the earth had been accomplished. The appeal of travel also had considerably expanded. Few people around 1300 undertook a trip for its own sake: merchants, diplomats, pilgrims, soldiers, scholars, and peasants moved because they had to. The educational value of visiting foreign lands was hardly recognized before the Renaissance: in this as in many other fields, Petrarch was the pioneer in the fourteenth century, and Leonardo da Vinci, in the late fifteenth, asked the most pertinent questions. The answers are still partly to be found.

Robert S. Lopez

Yale University

only in the late tenth or eleventh centuries was water power applied for other purposes, such as in mills for the fulling of textiles, where mechanical devices replaced the earlier method of trampling the cloth by foot. Water mills exploiting the force of the tide also developed in the eleventh century in sea areas, while during the twelfth century the invention of the European windmill provided an additional source of power, which, though dependent on the vagaries of the wind, could be operated in northern Europe during the winter when water sources occasionally froze. Though rudimentary by modern standards, these developments led increasingly, during the later Middle Ages, to the utilization of mills for multiple industrial purposes, including sawing, tanning, crushing ore, draining and ventilating mines, producing cast iron, even for the production of pulp for paper.

Thus, though medieval tools were limited in general terms to forms which had been in use since long before the beginning of the period, advances were made. Some involved only minor improvements, such as the more efficient press developed for obtaining the oil from olives and the juice from grapes; others, such as the development of the plow early in the period or the invention of the printing press near its end, were of major significance, both altering the pattern of labor during the Middle Ages and providing the capability for new industry in the periods following the close of the Middle Ages. The realization of the potential of mechanical power and the desire to exploit it, were integrally part of the energetic and exploratory spirit of the later Middle Ages.

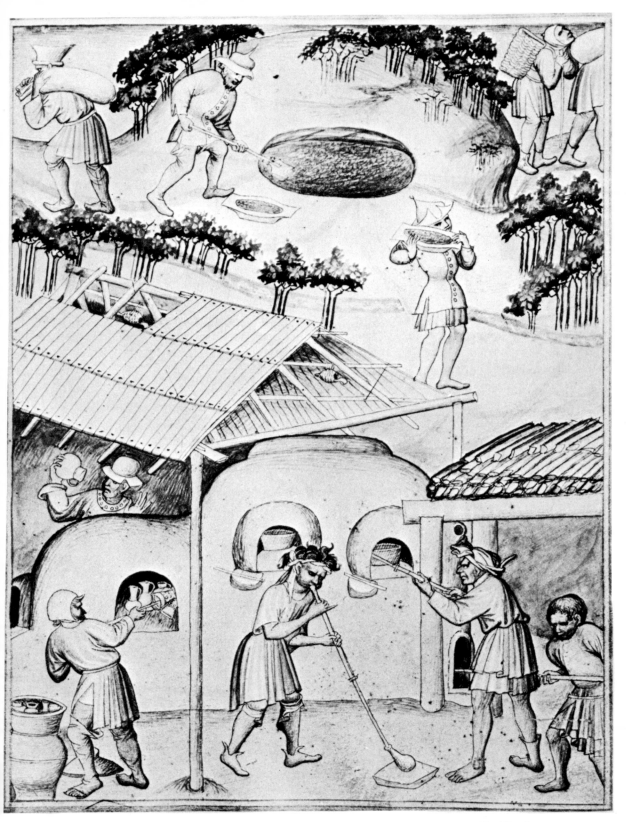

Glassmaking, ink and watercolor drawing in the *Travels of Sir John Mandeville,* Flanders or Germany, early XV century (British Museum, Add. Ms. 24189). (Reproduced by permission of the British Library Board)

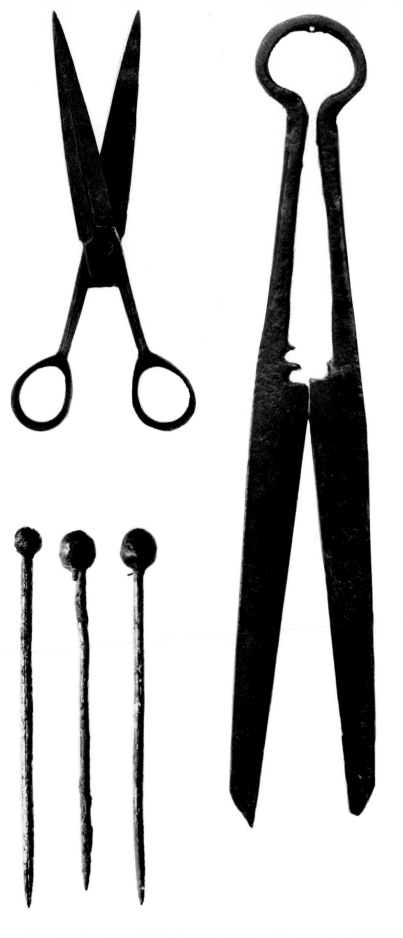

108a. SCISSORS
England
XVI century
Iron, L. 5⅚₆ inches (13.3 cm)
The Royal Ontario Museum, Toronto, 927.28.14

108b. SHEARS
Western Europe
XV or XVI century
Iron, L. 4⅞ inches (12.4 cm)
The Metropolitan Museum of Art, The Cloisters Collection, 55.61.43

108c. PIN
England
XVI century
Gilt brass, L. 2⅛ inches (5.4 cm)
The Royal Ontario Museum, Toronto, 927.28.12

108d. PIN
England
XVI century
Iron, Dia. 1⅚₆ inches (3.2 cm)
The Royal Ontario Museum, Toronto, 927.28.28

108e. PIN
England
XVI century
Iron, Dia. 2 inches (5.1 cm)
The Royal Ontario Museum, Toronto, 927.28.29

Shears and scissors, common implements in the Middle Ages, were made in a variety of sizes and shapes, in materials ranging from iron to gold and silver. The most ornate examples were generally for cosmetic purposes, and expense accounts enumerate not only gold examples for the use of ladies of the court, but also sets of scissors, razors, and combs used by court barbers. Heavier shears, usually of wrought iron, were used by professional tailors and clothes merchants, and frequently these implements became the emblem of their guilds. A pair of scissors identified the tailors' guild of Paris, while in England, shears were carved into the tombstones of deceased guild members. Scissors and shears of various shapes are also frequently depicted on scholars' shelves or writing desks in panel paintings and manuscript illumination of the fifteenth century. The present examples were, because of their small size, undoubtedly intended for everyday household use, possibly for needlework.

Ordinary pins of latten, bronze, iron, and bone were made in great numbers and were used for very much the same purposes as today. Contemporary expense accounts indicate that royal households ordered as many as 4,000 pins at a time for dressmaking. Pins of gold and silver, often mounted with a single pearl, were also used to fasten headdresses.

109. WATERING POT (*chantepleure*)
England
Late XV or early XVI century
Lead-glazed earthenware, H. 12 1/16
inches (30.6 cm)
*The Metropolitan Museum of Art,
Rogers Fund, 52.46.1*

Two types of watering pots were
familiar to the medieval household,
of which the present example,
known as a *chantepleure,* was the
more usual. This pot, derived from
a form known in antiquity, is
shaped like a jug. The handle arch-
ing from the body of the vessel to
the very top of the neck is so placed
that the thumb can easily cover the
small opening. The bottom of the
vessel is perforated with numerous
holes and serves as a sprinkler. The
pot was immersed in water until
filled, and once the thumb was
placed over the hole the water
would not flow. As soon as the
thumb was lifted, however, the
water would sprinkle out of the
bottom. The other type of watering
pot, the English versions of which
were primarily produced in Sussex,
more closely resembles the modern
type, having a sprinkler head on a
pouring spout attached to a can-
nister-shaped vessel. Watering pots
were used to tend not only small
kitchen gardens but indoor potted
plants as well. This example was ex-
cavated in Cannon Street, London,
but its origin of manufacture is un-
certain.

110a. AX HEAD
France or Flanders (?)
XV century or later
Iron, H. 12 3/8 (31.4 cm), W. 13 3/8
inches (34 cm)
*The Heritage Plantation, Sandwich,
Massachusetts, 70.18.89*

110b. AX HEAD
France or Flanders (?)
XV century or later
Iron, H. 13 1/2 inches (34.2 cm), W.
16 7/8 inches (40.5 cm)
*The Heritage Plantation, Sandwich,
Massachusetts, 70.18.90*

Axes, one of the most ancient of
tools, have changed little in shape
or function throughout history.
With the development of advanced
iron-forging techniques in the early
Middle Ages, however, it became
possible to vary the basic forms to
suit specialized needs. Such refine-
ments began to distinguish the
shapes of axes and hatchets used for
land clearing, shipwrighting, coop-
ering, carpentry, and other specific
trades. The ax head on the left is
similar to those depicted in a num-
ber of north French and Flemish
manuscript illuminations, being
used for felling trees and clearing
land. The unusually shaped ax head
on the right, probably intended as
a single-handed tool, was designed
for the more refined hewing and
shaping required by a carpenter. An
almost identical ax head, with a
slightly different maker's mark on
the blade, appears in the depiction
of Joseph at his workbench in the
Merode Altarpiece. The descending
sleeve of both these examples, into
which the shaft was tightly inserted
and riveted, appears to have been
a common means of attachment by
the late Middle Ages.

14.48

111. INDENTURE: ENFEOFFMENT OF LAND
England
1448

Manuscript on parchment, H. 10½ inches (26.1 cm), W. 6 inches (15.2 cm)
The Library of Congress, Manuscript Division, Wakefield Papers

During the later Middle Ages, although the complex feudal system, which varied widely throughout Europe, was no longer the economic basis of progressive states such as England, the enfeoffment of land was still practiced. By this process, parcels of land which formed part of a large estate could be granted by the owner (who was not necessarily of high rank) to free peasants who farmed it for their own livelihood. In return, the peasants owed certain obligations, usually in the form of services and sometimes in goods or rents, to the lord of the manor. The land, though occupied by the peasants, did not leave the ownership of the lord. The enfeoffment was considered a contract equally binding upon both parties. This particular legal document covers the enfeoffment of a tenement, or holding, of certain crofts and land, called Davys and Berkele, to

William Carston Bekensfeld who, with his wife, Johane, is "to have and to hold the said lands" during the "t(y)me of [their] bothe lyfes." The document further states that the land then reverts to the grantors of the feoff. The names of several witnesses are given, and the date of the contract, the 20th day of August in the 26th year of the reign of Henry VI (1448). A seal, now lost, was affixed, in lieu of signatures.

The document was an indenture, as stated in the beginning of the contract. An indenture, which could be any contract regardless of the content, was so called because of the indented or serrated edge made by the cutting of the original document, issued in duplicate, into two like parts. As each party to the contract was given one half of the duplicate document, the indented edges of which matched, the indenture served to guarantee the validity of the contract should it ever be subject to question. The existence of such contracts and guarantees in documentary form (though examples exist from earlier dates) demonstrates the increasing awareness of the legal rights of the individual, whatever his social position, during the late Middle Ages.

112. DEED: GRANT OF WATER AND FISHING RIGHTS
Northeastern France (Valley of the Meuse)
1481

Parchment, H. 21¾ inches (55.2 cm), W. 12 inches (30.5 cm)
The Library of Congress, Manuscript Division, Mercy-Argenteau Collection

The game and fish found on manorial property (land held by the lord and not enfeoffed) constituted a monopoly pertaining only to the lord of the manor. Only with his permission could game and fish be taken and poaching was severely punished. This monopoly provided the lord with a source of income since he could grant for a fee deeds allowing individuals the right to hunt or fish on his property.

This deed, in French, dated 24 February 1481, grants water and fishing rights on the Meuse River to two individuals. Loren is granted water rights (*grande eawe* [*eau*]), while his son, Gerair Loren, is granted water and fishing rights (*eawe et pessirye*) for a period of twelve years by Jacques, seigneur d'Argenteal. The document, or chirograph, is in a form equivalent to that of an English indenture: originally written in duplicate on a sin-

gle leaf, it was cut in a straight line through an inscription which separated the two texts, and each like half given to the two parties to the deed. As in the case of an indented edge, the upper and lower parts of the severed inscription would match, guaranteeing the validity of each half of the deed.

113. TABLE FOR CALCULATING ENGLISH MEASURES OF LAND
England
Circa 1400
Manuscript on parchment (roll), L. 38¾₁₆ inches (97 cm), W. 3⁹₁₆ inches (9 cm)
Columbia University Libraries, Special Collections, Ms. X.510 p. 21

This mathematical roll, written in English and made of two pieces of parchment sewn together, was intended for calculating the measurements of farm land.

That such a table was a necessity for simple computation of land measurements is readily apparent from the use of Roman numerals on the roll. Calculations involving Roman numerals, rather than Hindu-Arabic forms (which by 1400 had not reached the general populace north of Italy), presented great difficulties. A table such as this simplified computations.

This table shows widths corresponding to various lengths of a rectangular piece of land containing an acre. The first column gives the lengths in rods and reads: "This is the lenght [sic] of the acre of lande." The second column gives the largest number of rods in the width or breadth ("brede") of the rectangular piece. The third and fourth columns give the fractions of a rod in halves and fourths. The fifth column gives the number of feet rather than proceeding to eighths of a rod.

The sixth column gives inches, using the symbols ~ to indicate a half inch and • to indicate a quarter inch. A farmer could, thus, calculate accurately to within a fraction of an inch, the width of an acre of land for which he knew the length in rods. All that was necessary was to read from left to right the figures in the second through the third columns, which followed the number of the known length in the first column.

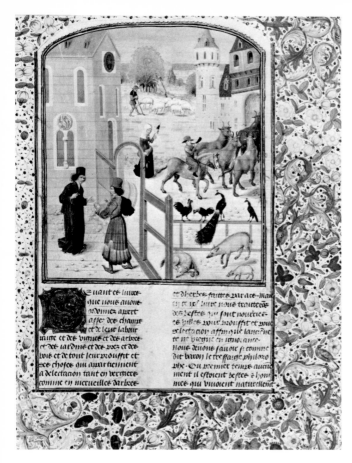

114. LIVRE DES PROFITS RURAUX
Pietro di Crescenzi
Flanders, Bruges
Circa 1470
Manuscript on vellum (codex), 293 folios, H. 16⅝ inches (42 cm), W. 12¾ inches (33 cm)
The Pierpont Morgan Library, Ms. M. 232 (See cover illustration)

The emphasis placed upon the growth and importance of towns at the end of the Middle Ages has led to an underestimation of the significance of the rural community. Each town depended equally for its survival on the supplies from its outlying agricultural areas and on its own ability to transform raw materials into manufactured goods. The true importance of the agricultural community at the end of the medieval period lies in its changing composition and function. Throughout most of the Middle Ages, the division of land had been predicated upon the vast holdings of the feudal overlords. With the rising power of the monarchies, the seizing of lands in the name of the crown, and the corresponding decay of the feudal system, land holdings had been increasingly fragmented. With the emancipation of the peasant class and the decline of the manorial system there appeared an increasing number of independently owned farms or rented tracts clustered about villages which were often controlled by no more august personages than parish priests or country squires. It is to the seigneurs of this level that Pietro di Crescenzi, though his original patron was King Charles II of Sicily, addressed his treatise on agriculture in the first decade of the fourteenth century. The numerous later copies of the treatise attest to its popularity and to its worth as a manual on farming. It is based partly on the author's own experience in rural living and partly on writings surviving from classical antiquity. Pietro di Crescenzi divided the treatise into twelve parts discussing buildings and the purchase of land, fertilization and planting, field plants and weeds, viniculture, fruit and shade trees, herbs, the care of meadows and forests, ornamental gardens and shrubs, the care and breeding of farm animals, falconry and hunting, and, in conclusion, a calendar of agricultural routine for the twelve months of the year. This handsomely illuminated copy, made in the third quarter of the fifteenth century, perhaps for one of the Burgundian dukes, is a remarkable document on rural life of its period. Its carefully detailed miniatures describe with scrupulous accuracy the implements and activities of the late medieval farm.

115. ALMANAC
England
1433
Manuscript on vellum (fragments of a roll), 3 folios, L. varies, W. 5¼ inches (13.2 cm)
The Pierpont Morgan Library, Ms. M.941

Originally a roll, now cut into three pieces, this fifteenth-century almanac served much the same purpose as *The Farmer's Almanac* of today. Like today's version it contains a calendar, phases of the moon, weather prognostications, and household remedies. The almanac, as evidenced by this example, was not for the scholar but for the landholder who might not be literate and thus would rely more on symbols than text. Only two months of the calendar, November and December, have survived. Saints' days are indicated by bust portraits or attributes. There are tables for the harvesting and planting of crops, charts defining the hours of the day and night, as well as the labors of the months, all indicated by an appropriate symbol. There are prognostications for the twelve months in the event of thunder. The prophecy for January reads, "If it thunders in the month of January, it betokens that great winds, an abundance of fruit, and battle will come in that year." The illustrations for this prophecy include men in battle, sacks of grain, and fruit trees. Astrological diagrams show the signs of the zodiac, a zodiacal man with the signs indicating weaknesses of the body, and the principal veins for bloodletting. A final section of the almanac lists principal events in history and the number of years that have elapsed since each, beginning with the Creation and ending with the coronation of Henry VI of England (ten years before). In its curious blend of fact and fantasy, of religion and superstition, the almanac characterizes the dichotomy of medieval thought.

116a. HAMMER
England
XVI century
Iron, L. 8½ inches (21.6 cm)
The Royal Ontario Museum, Toronto, 928.17.5

116b. CHISEL
England
XVI century
Iron, L. 5¹³⁄₁₆ inches (14.8 cm)
The Royal Ontario Museum, Toronto, 928.17.3

116c. GOUGE BIT
England
XVI century
Iron, L. 6³⁄₁₆ inches (15.7 cm)
The Royal Ontario Museum, Toronto, 927.28.43

From ancient times, mallets, chisels, and gouges were standard equipment of the carpenter's bench. Chisels, distinguished by a flat blade with a beveled edge, used for paring, shaping, fitting, and finishing, were either designed to be struck with a wooden mallet, or pushed by pressure of the hand. Gouges, with their curved blade surface, were used for excavating holes and grooving and, like the chisel, could be either struck or pushed. The flat-surfaced terminus of the present example, along with its width, indicate it was designed to be used in the former manner. The gouge bit, which superficially resembles the gouge, is sharpened at all edges and was fitted into an auger, thus used for drilling. Unlike the spoon bit, which it closely resembles, the gouge bit was flat along the bottom cutting edge. The spear-head terminus was designed to be set firmly in the auger handle. While wooden mallets were the more common percussive instruments, iron-headed hammers such as the present example did exist and were used in heavier construction, particularly for driving spikes and nails, both of which were in common usage by the fifteenth century, although wooden pegs were preferred in more refined joinery. All three of the present tools were excavated in London, the hammer and chisel in Finsbury Square and the gouge bit in Worship Street.

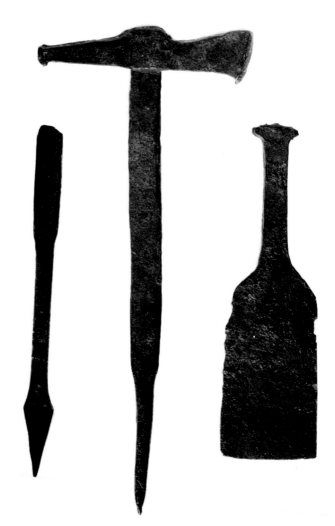

112

121. PRINTING BLOCK FOR PLAYING CARDS
France, Lyons
XV century
Pear wood, H. 15½ inches (39.4 cm), W. 11¼ inches (28.6 cm)
Beinecke Library, Yale University, Cary Collection

It is thought that the craft of printing began in the early fifteenth century with the production of playing cards. Examples of printed cards are said to predate the earliest religious pictures and appeared long before books. Card makers and painters are noted in German guild registers as early as the end of the fourteenth century. This wood block demonstrates one method employed in printing cards. All twenty court or face cards of the four suits have been carved into the one block. The block was then inked, impressed on a sheet of paper, and the individual cards were then colored and cut apart. The pips or suit symbols were stenciled on after printing. On this block, the name of the maker, Maître Jacques, is lettered on the scrolls carried by the four valets. He is the earliest recorded card maker of Lyons, and the output of his shop must have been prolific since numerous examples of his work survive. The obvious advantages of printed cards for a growing market can be realized by comparing the 1500 pieces of gold paid by Filippo Maria Visconti to his card painter Marziano in 1415 for a hand-illuminated set with the 15 francs received from the dauphin of France in 1454 for a printed one.

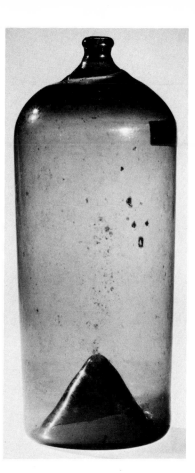

122a. BOTTLE
Germany
XV or XVI century
Glass, with leather cover, H. 7½ inches (19 cm)
Corning Museum of Glass, 67.3.10

122b. BOTTLE
Germany
XV or XVI century
Glass, H. 6¾ inches (17 cm)
Corning Museum of Glass, 67.3.24

Though extremely rare at the present time, these two bottles were probably among the most common types of glass vessels produced in the fifteenth and sixteenth centuries. One should bear in mind, however, that the function of the bottle at that time was not the same as it is today. The idea of the bottle as a storage vessel for wine or beer was unknown. Yet, bottles were employed by physicians and apothecaries for the preserving of medical potions and, as the leather case on one of these examples suggests, for transporting liquids. Most of the bottles preserved from this period are smaller than these two examples, so it is doubtful that they could have been used as cosmetic containers, another use for flasks in the late Middle Ages. That they served as utility items is suggested by the greenish tint of the glass and the bubbles and impurities present. Both bottles were blown in a mold and finished by the half-post method, in which the body of the flask was dipped a second time in the molten glass for added strength.

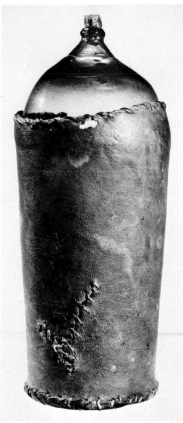

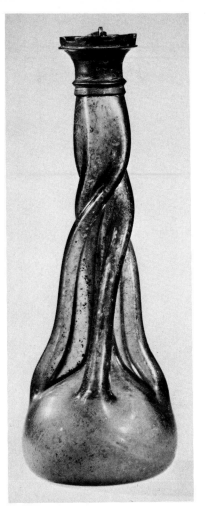

123. BOTTLE (*Kuttrolf*)
Germany or the Netherlands
XV century
Blown and tooled glass, H. 8 1/16
inches (20.5 cm)
Corning Museum of Glass, 56.3.22
The name *Kuttrolf* is probably derived from the Latin *gutta* meaning "drop." The shape of this bottle with its separately drawn, entwined tubes that form the neck suggests that its purpose was to impede or slow down the flow of its liquid contents. Inventories of the late Middle Ages are unclear as to its use. The *Kuttrolf* has been noted as a drinking bottle for spirits, a storage bottle for tinctures of herbs and flowers, and a distillation bottle. The last two notations suggest that it formed part of the equipment of the apothecary. The metal top and cork of this example further indicate that its use was for storing liquids, which were apparently widely used but were required only in small amounts. Regulations for the Spessart glasshouse at Aschaffenberg of 1500 specify production of 200 of these bottles per day. The bubbly, green glass from which this example is made is another indication that it was a utility vessel. The type also appears in woodcuts of the period.

124. MORTAR
Italy, Venice
XV century
Bronze, H. 5 3/4 inches (14.6 cm)
Yale University Medical Historical Library, Streeter Collection, 314
Mortars were employed from antiquity onward, those of stone and marble being among the oldest known. Metal mortars were in use during the medieval period by at least the twelfth century, since a mortar of copper and tin is described in the treatise *On Divers Arts* by Theophilus, and cast-iron mortars from the thirteenth century exist. Medieval bronze mortars made in Italy, as was this one, are often distinguishable from those made north of the Alps, in that the former were usually of a darker bronze and shorter and stockier in shape than the latter.
 Although many domestic mortars were necessarily large in order to contain the quantities of food which were crushed in them, less massive ones were used as well. Small and undecorated mortars such as this example were also standard equipment, along with crucibles and retorts, of both apothecaries and alchemists, and were used to pulverize herbs, drugs, or other substances. The use of metal mortars presented little problem to medieval workers as the substances with which they experimented and from which they prepared medicines were not corrosive.

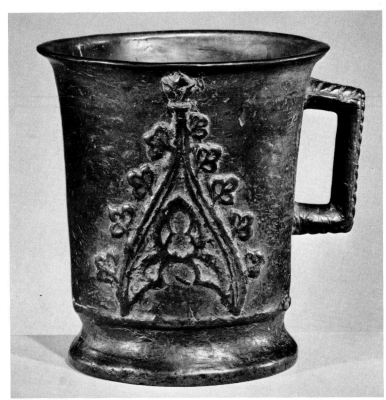

125. DRUG JAR *(albarello)*
Italy (Umbria)
Late XIV century
Tin-glazed earthenware, H. 3½ inches (8.9 cm)
Smithsonian Institution, The National Museum of History and Technology, Gift of Merck and Co., Inc.

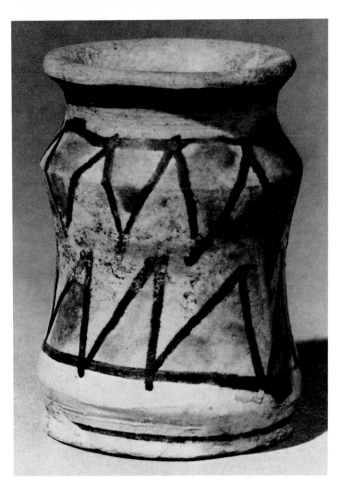

The earliest appearance of albarellos of this general shape in Italy seems to have been toward the end of the fourteenth century, a date which coincides with the decoration of this small and exceedingly rare vessel. On the basis of sherd excavations, wares of this type have been ascribed to the region of Umbria-Latium, and particularly to the town of Orvieto. At this early date, however, it is difficult to attribute examples to a particular center, and other important manufacturing towns such as Viterbo should not be overlooked. The pale green and brownish, broad linear designs are typical of these early glazed wares. Unlike the later examples, the so-called Orvieto wares employed a tin-enamel glaze of an off-white to a nearly transparent color that generally covered only the decorated areas. The interior surfaces were invariably sealed with a lead-based glaze. Although albarellos of this shape are known to have been exported to the West, particularly Spain, and were quickly reproduced, it is also thought that the general shape might have been influenced by the hollowed sections of bamboo which were also employed for shipping herbs and spices. The term albarello seems to owe a debt to the Arabic word for bamboo, *elbarani.* After the outbreak of the plague, this type of vessel, filled with every type of compound, herb, and elixir to protect against future epidemics, lined the shelves of pharmacies, apothecary shops, and hospitals. Decoration being secondary to utilitarian aspects, albarellos at this time were made for commercial use and rarely ever found their way into the household. This example was excavated from the Tiber River in Rome.

126. DRUG JAR *(albarello)*
Spain, Manises (Valencia)
Circa 1450
Tin-glazed earthenware, H. 12¾ inches (32.3 cm)
The Metropolitan Museum of Art, Bequest of George Blumenthal, 41.190.225a

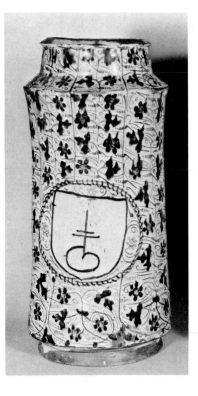

The albarello, a vessel introduced to Spain from the Near East through the spice trade, was rapidly adopted by Valencian potters and produced in great numbers. Although the profiles of the fifteenth-century examples vary, they are all typically cylindrical, slightly concave in the center, with a sloped shoulder, a collar with a narrow-lipped mouth, and a similarly sloped bottom leading to a beveled edged base. Although earthenware covers may have been used, contemporary panel paintings illustrate the more common technique of sealing the mouth with a piece of parchment tied with a string. Generally, albarellos were labeled, not in the design, but by affixing identifying marks or inscriptions on parchment to the container. In rarer cases, such as this albarello, markings were painted on and glazed. In this example, the symbol within the shield identifies the contents as a type of powder.

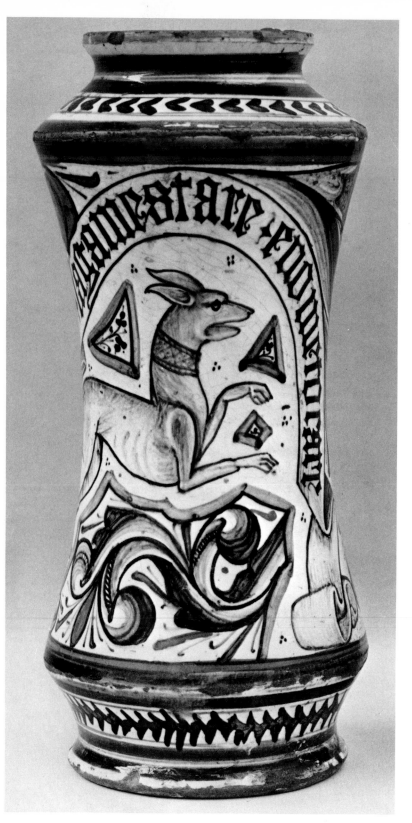

127. DRUG JAR *(albarello)*
Italy, Faenza
Circa 1480
Tin-glazed earthenware, H. 12 inches (30.5 cm)
The Metropolitan Museum of Art, Fletcher Fund, 46.85.21

This albarello is distinguished by its cryptic inscription which reads, *lagamestare enometocare (lascia me stare e no me tocare)* and may be rendered as "leave me alone and do not touch me." Presumably this was intended as a warning to prevent careless or uninformed usage of the vessel's contents, a potentially toxic or incapacitating herb or drug. A less likely explanation is that it was the personal or family motto of the commissioner. Although this vessel may have been intended for household use, albarellos produced for apothecary or other forms of commercial usage are occasionally distinguished by marks or inscriptions identifying the contents. Painted in a rich cobalt blue, the decorative elements of this albarello are still Gothic in spirit indicating that such vessels were still being produced primarily for their functional rather than decorative aspects.

128. APOTHECARY BOTTLE
Italy, Faenza
Circa 1500
Tin-glazed earthenware, H. 12 inches (30.5 cm)
The Metropolitan Museum of Art, Gift of J. Pierpont Morgan, 65.6.5

The intended use of this apothecary bottle is indicated by an inscription which reads, *agua de bogolosa* or bugloss water. A distillation of bugloss leaves (*Anchusa officinalis*) mixed with water was considered, according to fifteenth- and sixteenth-century herbals, a good remedy for a variety of ailments including "putrid and pestilential fevers," weakened hearts, swollen feet, the lack of mother's milk, and "pensiveness and melancholy." The roots of the bugloss plant produced a red dye that was employed primarily for coloring food, a practice in fashion during much of the fifteenth century. Apothecary shops served not only purely medicinal needs, but culinary ones as well, for both were intertwined during the Middle Ages.

By the end of the fifteenth century, the town of Faenza, in Romagna, was firmly established as a competitor to the Florentine potteries and produced wares that are distinguished by a rich and varied color scheme as well as a brilliant transparent lead glaze *(coperta)*. A decorative motif known as the peacock feather pattern, demonstrated in this example, provided the Faenza potters with an excellent means of displaying their technical and artistic abilities. The origin of this pattern is reported to lie in a complimentary allusion to Cassandra Pavona *(pavone* or "peacock"), the mistress of Galeotto Manfredi (d. 1488), lord of Faenza.

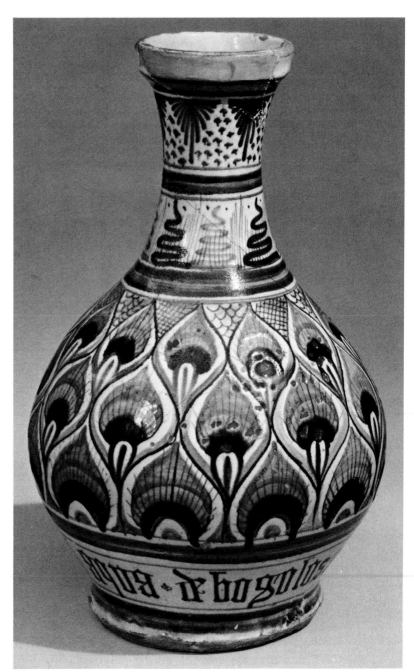

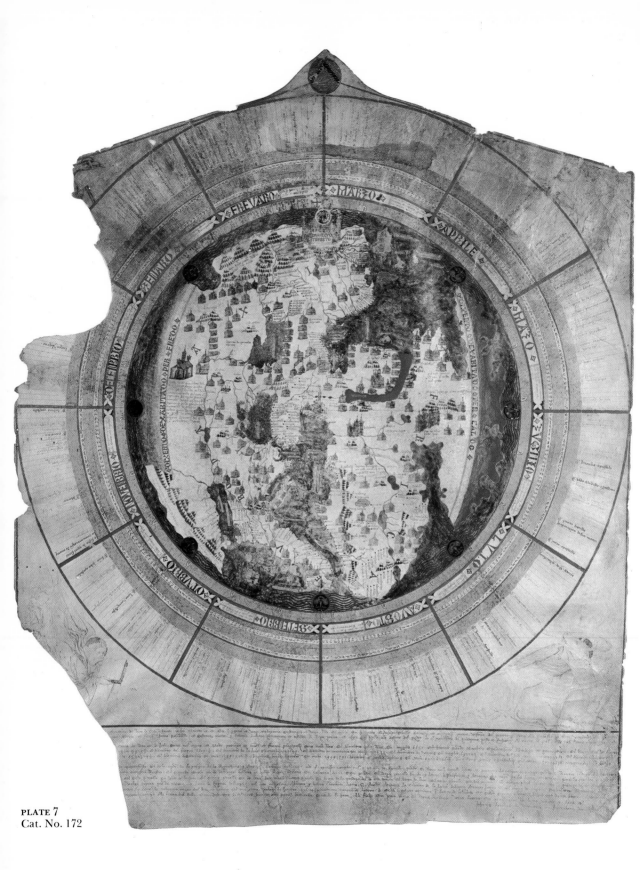

PLATE 7
Cat. No. 172

120

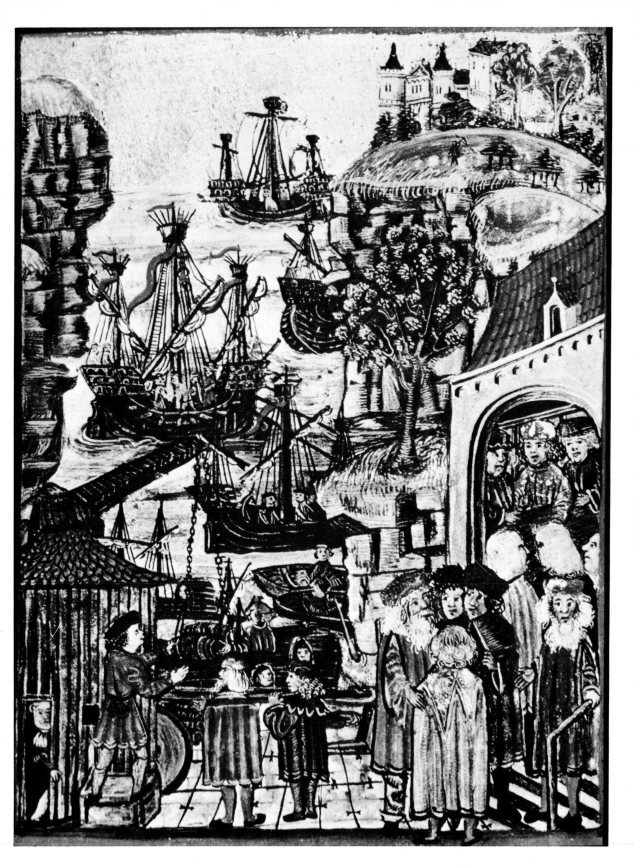

Harbor scene, detail of an illuminated page in a manuscript of the town laws of Hamburg, Germany, 1497 (Staatsarchiv, Hamburg).

Banking scene with account books, detail of an illuminated page in *De septem vitiis,* Italy, late XIV century (British Museum, Add. Ms. 27694). (Reproduced by permission of the British Library Board)

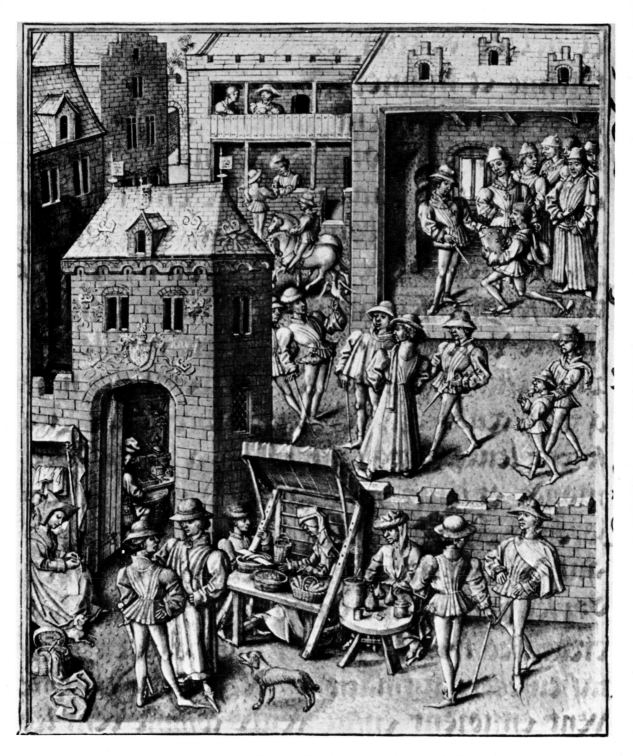

Town gate and street scene, detail of an illuminated page by Jean le Tavernier in the *Chroniques et conquêtes de Charlemagne,* Flanders ‚1460 (Bibliothèque Royale de Belgique, Brussels, Ms. 9066).

129. MEASURE FOR LIQUIDS

Switzerland

XV century

Bronze, H. 6¼ inches (15.9 cm)

Yale University Medical Historical Library, Streeter Collection, 315

Trade, whether local or international, required standards of weight and measure as well as of coinage. These standards varied widely in the Middle Ages from country to country and even from town to town. Merchants having international business connections were forced to keep handbooks in which local differences in standards were carefully computed. Infractions among tradesmen were not infrequent, in spite of guild regulations, and punishments and fines were severe. A document of 1351 for the City of London mentions the confiscation of 23 *potels* of improper measure made by a member of the pewterers' guild. Most measures bore the mark of the maker as an indication of just capacity. This example has, unfortunately, been damaged and repaired at the base of the vessel so that the maker's mark is lost. Its capacity is somewhat less than a half liter, and it was in all probability a liquid measure perhaps used for measuring wine.

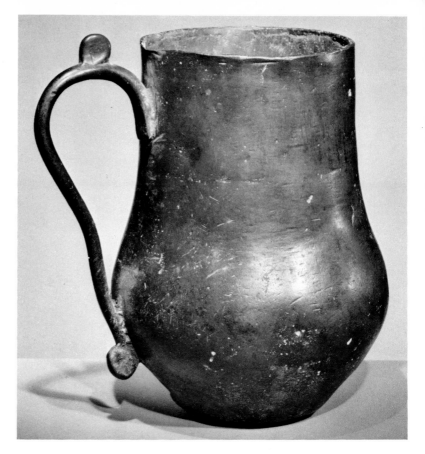

130. COMPENDIUM INCLUDING THE ASSIZE OF BREAD AND ALE AND A NAVIGATIONAL DIRECTORY

England

Mid–XV century

Manuscript on vellum (codex), 320 folios, H. 9¾ inches (24.8 cm), W. 6¾ inches (17.1 cm)

The Pierpont Morgan Library, Ms. M. 775

This compendium is known to have been made for Sir John Astley (d. 1486), a Knight of the Garter and victualer for Alnwick, the castle of Edward IV. Sir John's arms are found throughout the manuscript, which belonged at one time to Edward VI when he was Prince of Wales. It was returned to the Astley family possibly by Queen Elizabeth I, who was a cousin of the Astleys, or by James I to a later Sir John Astley, a master of ceremonies at his court.

A section of the manuscript is devoted to the ordinances of chivalry and is illustrated by the feats of arms of Sir John Astley, who was famous for his deeds in tournaments and jousts. Other brief sections cover a miscellany of secular information including a poem about the coronation of Henry VI (1429) which describes the procession and gives the bill of fare of the feast, a table for calculating expenses by day and by year, the assize (a regulatory ordinance for standard measures) of bread and ale, and the names of various weights and measures. All of these must have been of special interest to Sir John Astley who also served as victualer of a royal castle. The selections included in the compendium undoubtedly reflect the personal tastes and needs of its owner, both in the literary passages and the miscellany of practical information, such as the calendar, astrological table, and prognostications of the weather, as well as navigational directions for sailing from Berwick-on-Tweed to Holyhead and to the Bay of Biscay. The navigational directions are beautifully illustrated by a miniature of a ship taking soundings. That the compendium, though certainly a valuable possession, was intended to be used and enjoyed, is indicated by the fact that it is written almost entirely in English; those excerpts from literary works originally in a foreign tongue were translated. The later additions to the compendium (circa 1520) include recipes for making a powder called *aqua imposta,* and other medical recipes.

131. BALANCE

Germany or Flanders

XVI century

Steel and brass, L. (of beam) 20 inches (50.8 cm), Dia. (of pan) 9½ inches (24.1 cm)

Yale University Medical Historical Library, Streeter Collection, A-109

One of the oldest weighing devices, the balance was the common method for obtaining just weight throughout the Middle Ages. Market produce was usually weighed on a small scale such as this. The flat pans were easily adaptable for the weighing of both dry and green foodstuffs. This type of scale would have been the property of the individual shopkeeper, as would the set of weights, such as those shown in this exhibition (see entry no. 132 a,b,c). Bulk goods in the Middle Ages were required to be weighed on a large balance that was the property of the town. A sculptured relief on the portal of the public weighing office of Nuremberg, dated 1497, shows the use of the public scale. Operation of the balance was the responsibility of the town weighmaster who was paid a fee by each user. He was assisted by his apprentice, who performed the menial and often backbreaking task of placing the load and balancing weights on the pans. Chains were used to support the pans of these large balances. Cords attached the pans to the beam of the shopkeeper's balance, while silk, usually green in color, was employed for the small, finely calibrated scales of the goldsmiths and apothecaries. The principle of the balance, regardless of size, was the same: a weight placed in one pan equal to the amount of the object being weighed in the other pan would result in a level beam, shown by the vertical position of the indicator. In this scale, the correct position of the indicator is viewed in the center of the hexafoil ornament of the shears, the two-pronged fork through which the beam passes and by which the balance is suspended.

132a. COMMERCIAL WEIGHT
France, Toulouse
1495
Bronze, 1 pound, Dia. 2⅝ inches (6.9 cm)
Yale University Medical Historical Library, Streeter Collection, C111 F111

132b. COMMERCIAL WEIGHT
France, Narbonne
1504
Bronze, ½ pound, Dia. 2⅛ inches (5.5 cm)
Yale University Medical Historical Library, Streeter Collection, C111 F71

132c. COMMERCIAL WEIGHT
France, Albi
1503
Bronze, ¼ pound, Dia. 1¾ inches (4.5 cm)
Yale University Medical Historical Library, Streeter Collection, C111 F8

French towns, during the latter part of the Middle Ages, issued weights measured according to local standards. They ranged in denomination usually from one-quarter to four pounds, but varied considerably in weight. Weights of small denominations such as these were for local commercial use in the town marketplace. Each merchant had his own set of weights with which to serve his customers. There were, however, strict laws governing the amount that could be weighed privately. In Cologne, anything over 25 pounds had to be weighed on the public scale. In France, there were similar restrictions on goods weighing over 100 pounds. Manufacture of commercial weights was a local industry because of the variation in standards from town to town. The scale and weight makers were usually members of other guilds, in some cases the blacksmiths', and in others, the goldsmiths'. Maintenance of just standards was the responsibility of the wardens of the guilds, but the accuracy of weights was measured against a set of standard weights guarded by the town officials. Each town marked its weights with its own insigne and the date of issue.

a) 1 pound, Toulouse:
O. Château Narbonnais, Ins.: + LIVRA O TOLOSA
R. Church of St. Sernin, Ins.: + LAN M CCCCLXXXXV

b) ½ pound, Narbonne:
O. Shield: key and double cross under 3 fleurs-de-lys, Ins.: MIEGIA LIVRA DE NARBONA
R. Pierced ball, Ins.: LAN MIL Vᶜ ET QUATRE

c) ¼ pound, Albi:
O. Castle with lion *passant* between G and B
Ins.: + POES-DE VN-C-DE LA C-D ALBI
R. B between two dots, Ins.: + LAN MIL CING CENZ O 3

133. BUTCHER'S SCALE
Spain
XV–XVI century
Iron and brass, L. 26¹¹⁄₁₆ inches (68.3 cm)
The Metropolitan Museum of Art, Harris Brisbane Dick Fund, 57.137.43

Another ancient weighing device that originated in classical antiquity, and that continued in use throughout the medieval period, was the steelyard. Unlike the balance, the principle of the steelyard is based on an arm of unequal length and a sliding weight for counterbalance. This butcher's scale is an example of the steelyard type. The meat to be weighed was suspended from the hooks. There are numerous references regarding the weighing of meat in the Middle Ages. Though the weighing of meat in England was not compulsory, the city government of Cologne in 1438 had already prohibited the sale of unweighed flesh. This restriction caused such a revolt by the butchers that the city council temporarily suspended the butchers' guild. In France, in 1368, the butchers went so far as to offer the king an amount of silver and an annual revenue if he would dispense with the custom of selling meat by weight. The fishmongers of Cologne resented the fact that fresh fish was sold by weight while salt fish was not. These discrepancies and objections were, however, not typical of medieval trade, which by and large adhered to the governmental insistence on fair practice regarding weight and measure and periodic inspection of weighing equipment.

134. TALLY
England, London
XVI century
Bone, H. 4¹⁵⁄₁₆ inches (12.6 cm)
The Royal Ontario Museum, Toronto, 927.28.27
While Italian and Flemish merchants had from the fourteenth century onward employed standard systems for bookkeeping, the small merchant or shopkeeper, if he allowed credit, employed much simpler systems. One of these, known as the tally system, involved the mere notation of the name and amount on a wood or bone slat. The slat was hung from a peg with other tallies in the shop until payment was made and the account erased. This tally, found on the site of the Bank of England, is the simplified type. The method employed by the English exchequer was somewhat more complex involving the splitting of the wood tally, which had been notched on both sides according to the sum owed (notches one-inch apart equaled 100 pounds), so that one part was kept at the bank and the other given to the customer. Partial payment of the debt was recorded by intermediate notches until the account was closed.

135. DEED CONCERNING THE INDEBTEDNESS OF GOBELINUS DE ZEERSDORP AND HIS WIFE KATHERINA DE GHELEENIS TO FREDERICUS DE EVERSALE
Belgium
28 March 1336
Manuscript on vellum (folio), H. 6⅛ inches (15.6 cm), W. 10⅜ inches (26.5 cm)
The Library of Congress, Mercy-Argenteau Collection
In this document, Waltus de Berbelgheem and Johannes de Echove, municipal magistrates of Malines, state that in their presence Gobelinus de Zeersdorp and his wife have recognized their debt of 5 lbs. 10 sous to Fredericus de Eversale, and have promised to repay the sum on the following June 24. They have put up as collateral an estate which they hold from the seigneur of Bouterscheem. Of note are the seals of the two magistrates attached to strips cut horizontally from the document itself, as was customary with deeds of this size and nature. Larger documents had seals on cords or vellum strips which were looped through holes made at the bottom of the document.

136. MERCHANT'S COMMONPLACE BOOK

Zibaldone da Canal
Italy, Venice
Circa 1312
Manuscript on paper (codex), 69 folios, H. 11 inches (28 cm), W. 8½ inches (21.5 cm)
Beinecke Library, Yale University, Ms. 327

Among the most fascinating and illuminating accounts that remain from the medieval period are those found in the day books and records of the merchants. In these little books, which were handed down from father to son, are records of the daily life and activities of the men who controlled commerce. Zibaldone da Canal apparently was a Venetian merchant who left his own account book to his descendants. That Zibaldone was the original owner can only be inferred from a study of the genealogy of the Canal family and by the date 1311 (during his lifetime) which appears on folio 26 verso. The manuscript, written in the Venetian dialect, was owned in 1422 by a Nicolaus de Canali, presumably a descendant. Zibaldone, if he was the author, probably wrote the book from existing information, and drew the diagrams and architectural designs. For the more important illustrations of ships and human figures, he apparently hired a professional artist. This professional obviously painted the scene on folio 27 which illustrates Zibaldone's calculation of the time it would take two messengers to meet if they started respectively from Rome and Venice simultaneously. The two messengers are shown taking their dinner at an inn after their journeys.

The book begins with a section on mercantile arithmetic, and continues with computations on the distribution of profits to shareowners in shipping, distances to seaports in the Mediterranean, lists of standard sizes of cloth, weights and measures used in various cities, desirable qualities in various products, and a listing of all spices on the market. In addition, Zibaldone includes other information of more general interest, such as: weather forecasts and notes on the calendar, household remedies, and bloodletting. He lists the Ten Commandments and certain magic formulas, as well as dates of historical significance to Venice. The volume concludes with two allegorical poems and some moral proverbs.

From Zibaldone's account, one can gain a glimpse not only of the mercantile acumen of Venice's merchants, but also of the types of men they were, of their interests and knowledge and of their society.

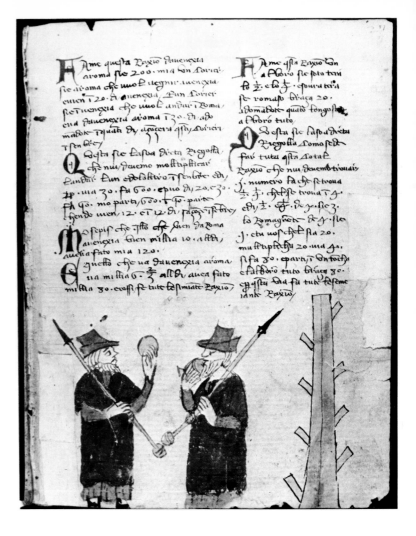

137. SUMMA DE ARITHMETICA, WITH A TREATISE ON BOOKKEEPING

Lucas de Burgo Paccioli
Italy, Venice
1494
Incunabulum on paper, 308 folios, H. 11¾ inches (29.9 cm), W. 8⅞ inches (22.5 cm)
The Baker Library, Harvard University

There are three things necessary to one who wishes to operate a business successfully. The most important is cash, . . . the second is to be a good accountant and a ready mathematician . . . and the third is that all affairs be arranged in a systematic way. . . .

This passage is the beginning of Lucas Paccioli's remarkable treatise on the art of double-entry bookkeeping, published in 1494. Paccioli goes on to say that the method he will employ in discussing his subject is that used in Venice. Thus he pays homage to the business acumen of the Venetian republic. Though Paccioli did not invent double-entry bookkeeping, which had been in use since the fourteenth century, his was the first attempt at a systematic presentation in print of the subject for the use of the businessman. Written in the vernacular, Paccioli's text remained the only work on the subject for over 30 years. The treatise is divided into two principal parts: the first is called the "Inventory" and the second the "Disposition." In these two parts, Paccioli discusses the bookkeeping process as it is known today, including instructions on how to take an inventory, recording entries based on the inventory, recording business transactions, posting in the ledger, preparing a trial balance, and closing accounts through profit and loss in the capital account.

Paccioli, who appears in the decorated initial on leaf 198 verso, was no less remarkable than his treatise. Born about 1445 into a lower class family, he was educated in the Franciscan school at Borgo Sansepolcro. He apprenticed himself to the painter Piero della Francesca with whom he studied mathematics and proportion. Through Piero he met the duke of Urbino, to whose son

the treatise is dedicated. Later he studied rules for measuring with Leon Battista Alberti, the greatest architect of his day, who took Paccioli with him to Rome to meet Pope Paul II. The pope was a Franciscan, and Paccioli realized that if he was to be a true scholar and teacher his only opportunity was through taking Holy Orders. He joined the Franciscan Order in 1472, but to the displeasure of the brothers since Paccioli was interested only in teaching. Upon becoming abbot of the monastery of Borgo Sansepolcro in 1510, he also accepted a professorship at the University of Perugia and left the running of the monastery to his second in command.

That Paccioli's treatise was republished in 1523 and was translated into six languages is not surprising. Systematic business organization was among the greatest achievements of the fifteenth century. Through their commercial enterprises, these merchants developed a new culture in Western Europe, a culture that was not only of the educated middle class but also purely secular in nature.

138a. LEDGER FROM THE FIRM OF MEDICI AND COMPANY, MERCHANT-EMPLOYERS
Italy, Florence
1431–1434
Manuscript on paper (codex), 66 folios, H. 16½ inches (41 cm), W. 11¾ inches (29.8 cm)
The Baker Library, Harvard University, Ms. 496

138b. LEDGER FROM THE FIRM OF MEDICI AND COMPANY, MERCHANT-EMPLOYERS
Italy, Florence
1444–1450
Manuscript on paper (codex), circa 180 folios, H. 16½ inches (41 cm), W. 11¾ inches (29.8 cm)
The Baker Library, Harvard University, Ms. 499

In 1431, Giovenco di Giuliano and Giovenco d'Antonio de' Medici, cousins, formed the firm of Medici and Company, Merchant-Employers, that was to exist for more than 160 years. This branch of the Medici family were cousins of the more illustrious Cosimo, but not unimportant in the industrial and mercantile affairs of the Florentine republic. Of special interest to the history of commerce is the remarkably complete series of ledgers and account books of the firm that have come down to us. The earlier

of the two examples shown marks the establishment of the firm. Its pages, written in the hand of a merchant's clerk rather than that of a trained scribe, are very difficult to read, but one can discern names in which the entries were made and amounts given in florins, scudi, and dinari. At the top of the two exhibited pages is the sign of the cross, which was placed on pages containing records of financial transactions in an attempt to prevent dishonest entries. The flyleaf of each ledger also contains an invocation to God, the Virgin, and selected saints beseeching "Good profit" with the additional request for salvation of soul and body. The signs in the margins of the pages are the "trademarks" of the various firms with which the Medici did business. The Medici's own symbol, a foil containing two dots, a bar, and the letter *alpha*, surmounted by a cross, appears stamped on the vellum cover of each of the account books together with the title "Debitori & Creditori" followed by the years involved.

At the time of the founding of the firm, Giuliano and Antonio were engaged in the wool trade, and the account books contain entries and transactions with woolworkers, weavers, dyers, and other Florentine firms. Among the names that appear are those of Cosimo the Elder and his brother Lorenzo de' Medici, of the Bardi and of the Albizzi family, greatest of the Florentine woolen manufacturers. In the ledgers of the Medici one can read of the success of the Italian mercantile enterprise, the risks that were taken and, above all, of the shrewdness and the capabilities of these merchants.

139. NESTED WEIGHTS
Germany, Nuremberg
1567
Bronze, H. 1 inch (2.5 cm)
Yale University Medical Historical Library, Streeter Collection, CIN 11
Numerous paintings from the fifteenth and sixteenth centuries illustrate nested weights as part of the equipment of the merchant or money changer. They were used primarily to ascertain the exact weight of coins at a time when there was considerable variation in coinage. The nested weight consists of a box or master cup with a hinged cover and clasp that contains a series of smaller cups that fit into each other. Each cup is calibrated and marked according to the weight of the coin it measures. The master cup or box weighs exactly the sum of the smaller cups; the second largest cup weighs exactly half the sum of the master cup and the sum of all the

remaining cups. Nested weights vary considerably in size. This particular set is one of the smallest, with a total weight of only 16 ducats. The interior cups are marked from eight down to one-eighth of a ducat. The master boxes of nested weights of the sixteenth century such as this one were very simple in design, flat on the top, and decorated only by the hinge and clasp plates. The maker's mark and the place where the weights were to be used were usually stamped on the lid. The standing emperor and wolf stamps of this box are unidentified. All nested weights from the fifteenth to the seventeenth century were made in Nuremberg, a city renowned for the craftsmanship and precision of its goldsmiths and coppersmiths. From Nuremberg, these weights, made according to the coinage of the country in which they were to be used, were exported throughout Europe.

140. BOXED COIN SCALE AND WEIGHTS
Berndt Odental and Jacob Heuscher
Germany, Cologne
1699
Wood, iron, paper, and brass, H. 1⅝ inches (4.2 cm), L. 5⅞ inches (14.3 cm), W. 3½ inches (8.8 cm)
American Numismatic Society, 1930 (See color plate no. 6)
The advertisement inside the lid, dated 1699, describes this composite set as made by Odental and improved by Heuscher. The weights are ascribed to Odental, who worked between 1636 and 1652, and one of the pans of the scale is stamped by Heuscher, whose dated work is between 1661 and 1669. The box bears the stamp (double A and X in a cartouche) of an unidentified and undated member of the Cologne guild of woodworkers who had a monopoly in this field. The coinage of Great Britain, France, Spain, Portugal, Italy, Germany, and the Netherlands is represented here—a remarkable index of the economic cosmopolitanism of Cologne. The weights, stamped with identifying marks, are cut square to avoid confusion with real coins. Although of a late date, this boxed coin scale and weights vary little from earlier examples, and many of the weights are based on late medieval coinage.

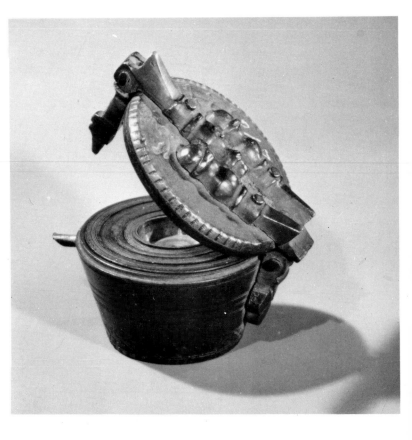

COINAGE

Medieval accounting was based on the Carolingian silver pound, divided into 20 shillings, and each of them in turn divided into 12 pennies. Early in the period, the only denomination coined for daily transactions—generally on a restricted regional basis—was the penny. The commercial revolution of the late twelfth and early thirteenth centuries fostered the creation of more valuable pieces that could be used internationally. The first innovation was the silver *grosso* or groat, a multiple of the penny; the most dramatic was the coining of gold in bulk for the first time since late antiquity. The final innovation in this period was the issue of very large silver pieces or talers. The differing needs of commerce and government were reflected by alterations in the weight and metallic content of coinage, or, if the coinage was unaltered (as in Florence), by fluctuations in value against the money of account.

Coin types were essentially a statement or an image of the issuing authority; in and beyond this there was latitude for ornamentation. The designs of English silver and Florentine gold coins are relatively austere. As in antiquity, however, coinage was used for propaganda and display. On the English noble, for example, the figure of Edward III, aboard a ship and bearing a shield of arms joining those of France with England, was a statement of policy in the first generation of the Hundred Years' War. Eighty years later, however, the majestic image of Charles VII of France, earlier disinherited by Henry V but triumphantly restored by Joan of Arc, appeared on the French royal. At the end of the period there was room for more domestic types within the vocabulary of heraldry and state: the young dukes, informally dressed, on the taler of Saxony; or the bridal couple on Maximilian's taler, emblematic of the motto: *Bella gerunt alii, tu felix Austria nube* ("Others wage war; you, happy Austria, wed").

The Money Lender and His Wife, oil painting by Quentin Massys, Flanders, 1514 (Musée du Louvre, Paris).

141. PENNY
England
Henry VI
London, 1422–1427
Silver, 0.93 grams
American Numismatic Society,
43.102

From the late eighth until the mid-fourteenth century, the silver penny was the largest coin circulating in

England, and, until the decimalization of the coinage in 1971, it was the base of the monetary system of pounds, shillings, and pence. Although the number of pennies to the pound sterling was nominally 240, the weight and fineness of the coin varied during the Middle Ages. As a result of commercial competition between England and the Netherlands, the weight was fixed in 1412 at 15 grains (0.97 grams) of 92.5% fine silver. Until it was replaced by a realistic portrait at the end of Henry VII's reign, the conventional facing bust was substantially unmodified from 1279. The reverse type of a large cross was a holdover from an earlier period when small change was made by cutting pennies into halves and quarters.

142. GROAT
England
Henry VI
Calais, 1422–1427
Silver, 3.45 grams
American Numismatic Society, 1932
(See color plate no. 6)

The English groat of four pence was introduced in 1279, on the model of the *grossi* issued by Venice from 1202 and widely imitated elsewhere. As with the penny, the types remained formalized until the end of the Middle Ages. The city of Calais on the French coast was held by the English continuously from 1347 to 1558, and coins were struck there to finance foreign trade and warfare.

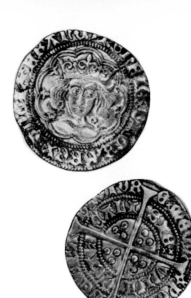

143. FLORIN
Italy, Florence
1418
Gold, 3.51 grams
American Numismatic Society,
66.163
(See color plate no. 6)

Authorized in pure gold in 1252 at face value of £1, or eight pieces to the ounce, the florin was the first

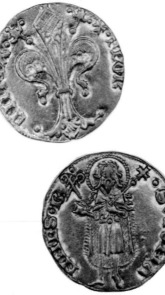

gold coin produced in bulk during the Middle Ages, and one of the great international currencies. Except for the mint master's symbol at the end of the reverse inscription the types were invariable: on the obverse, a lily or "fiore" indicating the city of origin, and, on the reverse, the figure of John the Baptist, patron saint of Florence. The coin was widely imitated.

144. LEOPARD
France (Aquitaine)
Edward III
1351–1360
Gold, 3.28 grams
American Numismatic Society,
54.237
(See color plate no. 6)

The marriage of Eleanor of Aquitaine to Henry II of England brought her extensive lands into the patrimony of succeeding kings of England. As lord of Aquitaine, Ed-

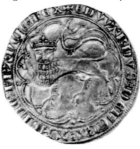

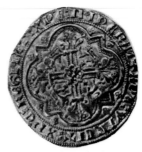

ward III struck the first distinctive gold coinage for the region in 1345. The obverse type of a crowned heraldic lion is derived from an ephemeral English gold issue of the previous year, while the reverse type is taken from French royal coinage, but with the substitution of lions for lilies in the quarters of the cross. The leopard was first coined on the standard on the French *chaise,* but in the second issue was aligned to the English noble.

145. FRANC À CHEVAL
France
John II
1360–1364
Gold, 3.91 grams
*The Metropolitan Museum of Art,
Bequest of Joseph H. Durkee,
99.35.110*
(See color plate no. 6)

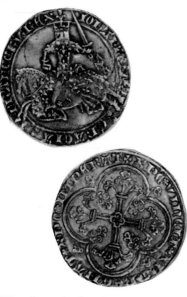

The *franc à cheval* represents the restoration of sound coinage after the treaty of Brétigny between France and England. The mounted rider is derived from the seal types used by the French kings and nobility from the early twelfth century. The word *franc* (free) is possibly a punning allusion to the liberation of John II from English captivity.

146. HARDI
France, Aquitaine
Edward, the Black Prince
Poitiers, 1362–1371
Silver, 1.15 grams
*American Numismatic Society,
66.163*
(See color plate no. 6)

The *hardi* originated with Edward III as duke of Aquitaine and was continued by his son, the Black Prince. The obverse type is a half-length figure of the ruler, sword in hand, clothed in robes of state and standing under a decorated canopy. The type was used by later dukes of the French royal house, and is possibly the prototype for the full figure in the *royal d'or.* The reverse includes the heraldic leopards of England and the lilies of France claimed by Edward III.

147. NOBLE OF FLANDERS
Flanders
Philip the Bold
Ghent, from 1388
Gold, 7.67 grams
*American Numismatic Society,
66.163*
(See color plate no. 6)

War, the Black Death, and shifting patterns of foreign commerce led to the general revision of English coinage in 1351. With the adjustment of the ratio of gold to silver at 1:12, the noble was coined at a

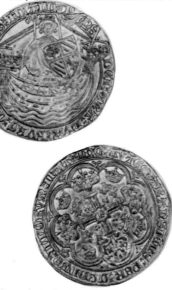

value of six shillings and six pence, one-third of the pound sterling. The new denomination was the first viable English gold coin, and was widely imitated in the Netherlands. In 1388, Philip the Bold authorized *nobles de Flandre,* which differed from the originals only in the substitution of his own name and arms for those of the English king. The ensuing competition for bullion and the profits of coinage—the "war of the nobles"—led to a devaluation of English currency in 1412.

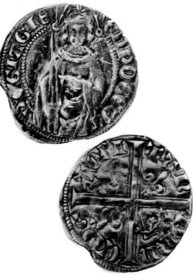

148. ROYAL
France
Charles VII
Tours, 1431
Gold, 3.80 grams
*American Numismatic Society,
67.182*

In 1429, the year of his coronation at Rheims after the victorious campaigns of Joan of Arc, Charles VII

of France authorized a new coin in pure gold. The obverse type of king in full regalia is possibly derived from the Anglo-Gallic coinage of Aquitaine. The reverse inscription is the beginning of the regal acclamations or *laudes regiae* long associated with the French monarchy and imitated in other lands and on other coins.

149. UNICORN
Scotland
James III
Circa 1484–1485
Gold, 3.75 grams
American Numismatic Society,
54.237
The heraldic unicorn of Scotland provides the name and obverse type of this piece authorized near the end of the reign of James III. It is possible that the dies for this, the first issue, were executed in the Netherlands.

150. HARDI
Brittany
Charles VIII
Nantes (?), from 1491
Billon, 1.09 grams
American Numismatic Society, 42.23
Anne, duchess of Brittany in her own right, married two French kings in succession, and the double inher-

151. GULDEN
Germany, Nuremberg
Circa 1496–1506
Gold, 3.49 grams
American Numismatic Society,
64.100
In Germany, the generic name for

152. SOVEREIGN
England
Henry VII
London, 1504–1507
Gold, 15.41 grams
American Numismatic Society,
54.237
(See color plate no. 6)
The sovereign of 20 shillings, equivalent to £1 sterling, was authorized in 1489. The obverse type, derived

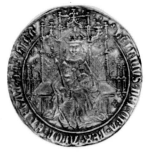

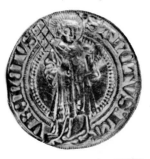

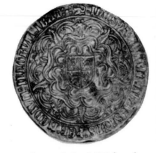

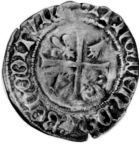

itance was finally combined in Henry II (1547–1559). Her first husband, Charles VIII, ruling Brittany in her name, coined this debased silver piece using a conventional obverse type of standing figure, but incorporating on the reverse the heraldic ermine of Brittany.

the gold coins equivalent to the Italian florin was gulden. While approximately the size and weight of the Italian prototype, this coin of Nuremberg carries the local type of an eagle on the obverse and St. Lawrence on the reverse.

from the *royal* struck in 1487 for the Netherlands by Maximilian of Austria, shows the king crowned and seated on an elaborate throne. The reverse has the royal arms displayed on a double or "Tudor" rose, symbolizing the union of the warring parties of Lancaster and York through the marriage of Henry VII to Elizabeth of York. Alexander of Bruchsal, a goldsmith of Amsterdam, was chief engraver at the mint from 1594 to the end of the reign.

154. TALER
Saxony
Frederick III with John and George
Leipzig, circa 1507–1525
Silver, 28.87 grams
American Numismatic Society,
60.111
(See color plate no. 6)
Between 1500 and 1525, Frederick III issued a large series of talers depicting himself and several of his relatives as joint dukes of Saxony.

153. 1½ TALER
Hungary
Ladislas II Jagiello
1504
Silver, 41.55 grams
American Numismatic Society, 1937
(See color plate no. 6)
At the end of the fifteenth century, the growing exploitation of large silver deposits in Bohemia and the Tirol led to the creation of new types of large silver coins. Originally equivalent to the gold florin

The common name of this type, *Klappmützentaler,* is taken from the flat caps shown in the stylized bust of the two dukes on the reverse. The obverse, in contrast, carries the image of Frederick in electoral costume. Coats of arms are given on obverse and reverse of various components of the family holdings: electoral Saxony, Meissen, ducal Saxony, Thuringia, and palatine Saxony.

155. TALER
Germany, Cologne
1516
Silver, 28.94 grams
American Numismatic Society,
54.100
To honor the patron saints whose relics were revered in Cologne, a coin was issued which portrayed the three Magi on the obverse, and the principal characters of the story of St. Ursula and the Eleven Thousand

or gulden, these coins came to be called talers (dollars) after the Joachimstal in Bohemia. The obverse of this piece shows at the left the arms of Ladislas II Jagiello, king of Bohemia and Hungary, combined at the right with those of his wife, who was countess of Foix. The whole is surmounted by an elaborate crown of lilies. The reverse is a representation of St. Ladislas (Laszlo) I of Hungary (d. 1095).

Virgins on the reverse. From left to right, the Magi with their coats of arms are Balthasar, Caspar, and Melchior. The reverse type of a ship in sail is derived from the English noble, possibly alluding to the legendary origins of Ursula's spouse, shown here under the leopards of England. Ursula herself is shown under the ermine banner of Brittany.

GUILDS AND CIVIC AFFAIRS

The guild system, which had played such an important role in the development of standards for work in the earlier Middle Ages, weakened in the fourteenth century as a result of a number of factors. Commerce, for one, placed those guilds involved with mass production for export, such as the textile workers, in a dependent position with respect to the market for their goods—a market which was controlled externally by the merchant-entrepreneur. The general decrease in the population of Western Europe affected those guilds providing local services, such as the building trades, which could no longer depend upon the establishing of new families as sources for income. Lack of human mobility, the result of the founding of few new towns, made it impossible for guild members to seek work in neighboring communities or for aspiring apprentices from rural areas to receive training from masters in the towns. Repeated visitations of the plague decimated towns and all but paralyzed production. All these factors contributed to a reduction of political and economic power for the guilds in the fourteenth century—a situation from which the guild system would never recover.

Throughout the fifteenth century, guild membership became more and more restricted. The rank of master in many guilds became hereditary; in the city of York the rolls of the glassmakers' guild were closed to all except the sons of masters. A journeyman who had served as much as a six-year apprenticeship could no longer automatically succeed to the rank of master in the guild of his town, even if he qualified by examination; he was also powerless to seek advancement in other locations because of the tightening of guild restrictions. Certain guilds, like the fullers and dyers, had remained independent up to the fifteenth century only to become the pawns of the more powerful weavers' companies who, in turn, owed their livelihood to the merchants.

As the guilds tended to become exclusive, they also tended to become more ceremonial in nature. Elaborate rituals accompanied the acceptance of apprentices for membership. The presentation of the masterpiece was a ritual presided over by the guild wardens. Feast days were the occasion for elaborate pageants produced by the town guilds, which proudly displayed their regalia in competition with each other for the best float. The accumulated wealth of the guilds resulted in the building of stately guild halls that still exist in the more important towns of Western Europe. Elaborate ceremonial cups and chalices which rivaled in splendor the liturgical vessels of the church were presented as display pieces by the most important guild members. The gatherings of members in their guild hall became more social than administrative.

It is significant that most of the statutes for guilds date from the end of the medieval period and are written more to guard exclusive rights than to assure honest work. Representation on town councils during and after the fifteenth century was no longer automatic for the guilds. Even in the Italian city states the family names with which the consular roles were inscribed were included not because of membership in the "arte," but because of personal wealth and political prestige. Civic affairs were controlled by the powerful merchants who had, in effect, usurped the authority of the hereditary suzerain.

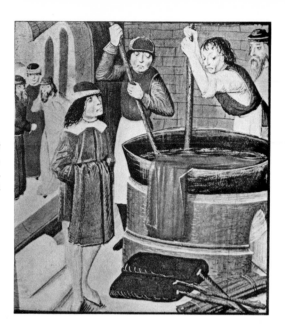

Cloth dyers, detail of an illuminated page in *Le livre des proprietez des choses* by Jean de Ries, Bruges, Flanders, 1482 (British Museum, Royal Ms. 15.111). (Reproduced by permission of the British Library Board)

Trial of the duke of Alençon at Vendôme by Charles VII in 1458, detail of an illuminated page by Jean Fouquet in *De casibus illustrium virorum et mulierum* by Giovanni Boccaccio, France, second half of XV century (Bayerische Staatsbibliothek, Munich, cod. gall. 6).

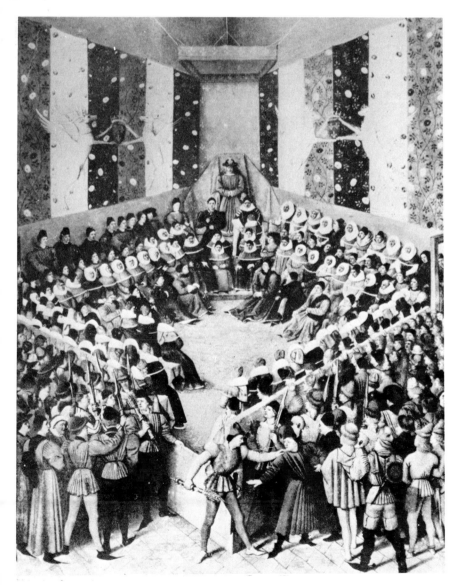

156. BADGE OF THE FLORENTINE WOOL MERCHANTS
Italy, Florence
Early XV century
Copper and champlevé enamel, H.
4 11/16 inches (12 cm)
Museum of Fine Arts, Boston, William F. Warden Fund, 49.489

As early as the twelfth century, the flourishing wool and textile industry of Florence was organized into two principal guilds: the *Arte della Lana*, the guild of the wool trade, and the *Arte de Calimala*, the guild of the dealers and finishers of foreign-made cloth. By the fourteenth century, the *Arte della Lana* was one of the largest and most powerful of the city.

It was customary for the guilds to assume civic responsibilities in addition to the regulation of their own industry. The preeminence of the *Arte de Calimala* and the *Arte della Lana* is attested to by the fact that they were the two guilds awarded the responsibility for the construction and maintenance of the Cathedral of Santa Maria del Fiore and its baptistery.

This badge, with the motif of the Agnus Dei bearing a banner with a cross surmounted by four fleurs-de-lys, would have immediately identified its wearer as a representative of the *Arte della Lana*. The badge was probably suspended from a chain and worn around the neck. Although it may have been worn by the master of the guild on ceremonial occasions, it is more likely that it was used by professional messengers, frequently employed by city or guild corporations before the establishment of regular mail service. The flourishing business in which the *Arte della Lana* was engaged, involving numerous transactions with northern European centers, must surely have required such messenger service.

157. LEAF FROM A BOOK OF STATUTES OF THE GOLDSMITHS' GUILD OF BOLOGNA
Nicolo di Giacomo di Nascimbene
Italy, Bologna
Circa 1383
Manuscript on parchment (folio),
H. 14 inches (35.5 cm), W. 8 inches (20.5 cm)
Alverthorpe Gallery, Jenkintown, Pennsylvania, Rosenwald Collection, B-13 659

This leaf was illuminated by Nicolo di Giacomo di Nascimbene with a miniature of the Virgin and Child flanked by St. Petronius, the patron saint of Bologna, and St. Alle (St. Eligius), the patron saint of the goldsmiths' guild. Below, the coats of arms are identified as, left, those of the House of Savoy and, right, those of the guild; the central arms are as yet unidentified. The leaf is the first page of the statutes and ordinances (possibly those promulgated in 1383) of the goldsmiths' guild of Bologna. The text begins with an invocation to God, the

Blessed Virgin, the apostles Peter and Paul, and other saints, including Petronius and Alle. It then states that the statutes and ordinances of the goldsmiths' guild (*sotietatis aurifici*) are set forth in the manuscript and begin the list of the officers of the guild.

The missing pages of this manuscript would have included very detailed rules for the internal operation of the guild and the standards imposed for control of quality in the work produced by members, as well as possible regulations for the sale of the items and rules protecting the rights of the membership. These purposes could only be achieved through the imposition and strict observance of its regulations.

Traditionally guilds were not only business organizations but also fraternal institutions that took pride in their membership. In this leaf the officers are listed with brief descriptions of their qualities, such as *prudentis viri Bartolomei* ("the prudent man Bartholomew").

158. BEAKER WITH COVER
Germany, Ingolstadt
Circa 1470
Silver (partly gilt), and enamel, H.
15½ inches (39.4 cm)
*The Metropolitan Museum of Art,
The Cloisters Collection, 50.7.2a,b*

Metalwork drinking vessels intended for presentation gifts or ceremonial purposes are among the most spectacular objects created during the late Middle Ages—not only in the superb quality of execution of many of them, but also in their sheer size and sumptuousness. Ingolstadt, a flourishing Bavarian town on the Danube, about 50 miles north of Munich, is renowned for its medieval goldsmiths' work, especially for a closely related series of elaborate drinking vessels, known as beakers, all coming from the Treasury of Ingolstadt's Rathaus (Town Hall). The panther rampant on the bottom of the beaker is the hallmark of Ingolstadt's goldsmiths' guild. And its leading member, Hans Greiff, is the probable maker of this covered beaker. The arms that appear on the shield held by the three knights in armor that form the feet of the beaker have been identified as those of Hans Glätzle, burgomaster of Ingolstadt, who became a member of the inner council of the city in 1452 and lived until 1494. The bearded head (presumably a portrait of Hans Glätzle) reappears, carved in wood, as the crest of a helmet (a nineteenth-century restoration) over the finial on the beaker's cover.

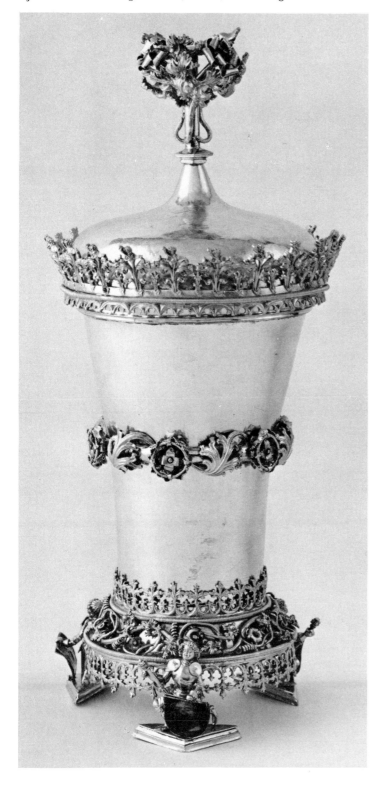

Inside the cover is attached an enameled plaque bearing a shield, quartered, which has been read as: 1. *gules barrel* (?) *argent*, 2. *gules*, two crossed implements (possibly flails?) *or* and *argent*, 3. *gules* three sheaves of wheat (?) *or* rising from three *mounds sable or* or *vert*, and 4. a shield *per bend azure* and *or* with a *bend argent* over all. Because of the combination of heraldic charges, some of which were believed to be connected with the ingredients of bread making, it has been suggested that the beaker might have been presented to the Town Hall in honor of Hans Glätzle by the bakers' guild. However, with a different reading of the charges, one could identify the coat of arms as that of the barbers' or the bathhouse attendants' guild. Whether the beaker was given by Hans Glätzle himself, or by a guild or guilds in his honor, it would have been displayed with great pride in the Town Hall, to be used on festive occasions. At such events, when the cover would have been lifted, it would have revealed a smooth, elegantly shaped and gilded lip. Filled with wine the beaker would either be used by an important person, or be passed from person to person as a common cup during the course of the feast.

159. BEAKER WITH COVER
Germany, Ingolstadt
Circa 1470
Silver (partly gilt), H. 11⅝ inches (29.5 cm)
*The Metropolitan Museum of Art,
Gift of J. Pierpont Morgan,
17.190.615a,b*

Although this beaker bears no hallmark, it is similar in workmanship to another beaker which bears the hallmark of Ingolstadt in the Bayerisches Nationalmuseum in Munich, and it is included as item No. 4 on the list of objects the Ingolstadt Town Hall treasury had to give up

in 1813. There can be little doubt that the beaker exhibited here comes from Ingolstadt. Judging from the coat of arms, seen on the enameled medallion attached to the inside of the cover, but not definitely identified, it might have belonged to or been given to the Town Hall by the fishermen's or boatsmen's guild of the town, as both these guilds could have used oars and grapling irons as charges. The beaker must have been used at the guilds' festive meetings or dinners. An old tradition relates that the meetings of the fishermen's guild, and possibly other guilds as well, were concluded with music and frolic. This might explain the figures which serve as the feet of the vessel: in most examples of this type of beaker, such figures take the form of lions, or knights in armor holding shields, or of hairy wild men which were favored in northern Europe in the late Middle Ages. Here, however, the beaker is supported by three kneeling figures of jesters, in caps and bells, playing flutes.

During the late Middle Ages, it was impossible to preserve fresh fish over long distances due to the rapid spoilage of seafood and the slow methods of transportation. The only sorts of fish that could be shipped over great distances were those which had been preserved in one form or another, either by salting and drying, or by pickling. However, fish treated in this manner were obviously not as tasty as fresh fish. Many late medieval households, in an effort to conform with ecclesiastical demands for the many "fysshe dayes" (Lent, or fast days) yet avoid a constant diet of these most unpalatable preserved varieties, particularly the much despised "stockfish" (usually dried cod), constructed "stews" or artificial fish ponds in which to keep fish caught locally until needed.

The citizens of the town of Ingolstadt, located on the Danube, were not faced with this particular problem. A flourishing *Fischerzunft* (fishermen's guild) kept them well supplied with an abundance of fresh water fish. Even so, theirs was not the best of all possible situations, according to contemporary comments. An English schoolboy complained "Wolde to gode I wer on of the dwellers by the see syde, for ther see fysh be plenteuse and I love them better than I do this fresh water fysh." Furthermore, according to Andrew Boorde, in his *Dyetary of Helth* (1512), "(f)ysshes of the see . . . be more holsomer than they the which be in pooles, pondes or mootes, for they doth laboure, and dothe skower themselfe . . ." rather than "feede on the moude."

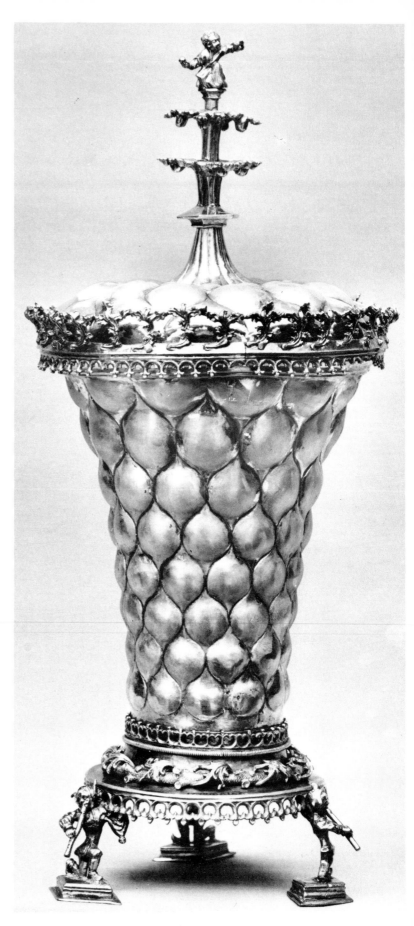

160. **REGISTER OF THE CAPITOULS OF TOULOUSE, 1371–1372**
France, Toulouse
Last quarter of the XIV century
Manuscript on vellum (folio), H. 16½ inches (41.9 cm), W. 11 inches (28 cm)
The Pierpont Morgan Library, Ms. M. 717

This single leaf was torn from the annals of Toulouse in 1793, when the twelve ancient registers of the city were ordered to be burned by the delegate to the French National Convention. Fortunately, many of the pages of the registers were preserved by individual citizens and later purchased by the city of Toulouse. The document is concrete evidence of the medieval system of government in the south of France, a large region loosely under the jurisdiction of the counts of Toulouse. However, royal French patronage and protection was extended to the southern towns (among them Toulouse, Carcassonne, Nîmes, and Béziers) giving their wealthy citizens a measure of independence from feudal overlords through the institution known as the Consulate.

On the recto of this leaf are depicted the twelve "capitouls" or municipal officers of Toulouse. These men were elected to the king's council at the assembly convened 17 February 1371 by Gaston de Parata. (The term *capitoul* may be derived from Latin meaning "heads of Toulouse.") The officers, who are not portrayed in exact likenesses, are shown in their ceremonial crimson and black robes beneath their identifying coats of arms. The lower margin contains the arms of the city of Toulouse: *per pale gules,* the château of Narbonne, the church of St. Sernin. On the verso, the capitouls elected at the assembly convened by Bernard de Grisignac, 17 February 1372, are shown in robes of crimson and light tan also beneath their coats of arms. Beneath the miniature on each side of the leaf, the Latin text gives the date of the election and the names of the elected officials with the districts they represent.

161. BOOK COVER
Italy, Siena
1343

Tempera on wood, H. 16⅛ inches
(41 cm), W. 9¾ inches (24.8 cm)
*The Metropolitan Museum of Art,
Rogers Fund, 10.203.3*

This cover, from an account book
of the Biccherna (a committee of
five citizens composing the administrators and treasurers of the commune) shows an accounting scene
on the upper half, below the now
obscured arms of the committee.
The scene includes one of the *provveditori* (the purveyors) on the
right, the committee's clerk in the
center, and, on the left, the secretary, known as the *camarlingo*. The
latter is represented as a monk (his
name is given as Don Simone di Ser
Vanni, monk of San Galgano), a
point of interest in that the *camarlingo* ceased to be chosen from the
monastic community a short time
after the painting of this panel.
Parts of the text, which begins below
the scene, have been repainted incorrectly, but the beginning of the
text reads clearly in the medieval
dialect of Siena: "Book of the income and expenses of the Biccherna
of the commune of Siena from the

first of July to the first of January,
1343," and is followed by the names
of the committee members and its
clerk. The accounts which were originally enclosed are no longer united
with the book cover.

Although leather was used from a
very early date in bookbinding, and
eventually became its principal material, wood, because of its weight,
was often used for the covers of
vellum manuscripts to keep the
parchment from buckling. These
wooden boards were usually fastened with clasps, and in this example there are on the unpainted side
(below the right edge of the painted
side) three indentations where such
clasps may have been attached. Particularly in the earlier Middle Ages,
the wood boards were often embellished with ivory or metalwork.

The wooden covers of the account
books of two Sienese magistracies,
the Biccherna and the Gabella, were,
however, painted. The earliest of
those of the Biccherna, from the
mid-thirteenth century, generally
bore only the coats of arms or the
portraits of the *provveditori*. Allegorical and religious scenes or
scenes of contemporary history soon
became popular, as well.

162. STATUTA ANGLIAE NOVA
England, London
1444, with later additions to 1477
Manuscript on vellum (codex), 392
folios, H. 9⅞ inches (25 cm), W.
7½ inches (19 cm)
*The Law Library, Yale University,
Mss. 6, S.T. 11, No. 1*

One of the most important contributions of late medieval thought was
the development of civil law, and in
no country of Western Europe were
the laws more carefully codified than
in England. It is significant that the
Statuta Angliae Nova, a compendium of the new laws of England,
was commissioned by Henry VI, king
of England, as a wedding gift for
his youthful bride, Margaret of
Anjou, daughter of King René. In
less than ten years after their marriage in 1445, Henry became insane;
as a result, Margaret assumed an
influential role in the ruling of
England. It was she, not her husband, who carried on the War of
the Roses, which finally resulted in
her exile.

The first part of the manuscript
contains statutes enacted from 1327
to 1444, the year in which the book
was commissioned. The second part,
beginning in 1446 continues to
1477, the year when Margaret was
exiled to France, indicating that the
queen had had the statutes continually up-dated during her unfortunate reign.

Queen Margaret's book of statutes, emblazoned with the arms of
England and Anjou, is probably the
most lavishly decorated law book
ever made. In addition to the royal
arms and those of its subsequent
owner, Sir Richard Elyot, attorney-general to Henry VII's queen, Elizabeth, the book contains six miniature portraits of the kings of England from Edward III to Edward
IV enclosed in richly decorated
borders. The "portraits" are of special interest as they show the kings
as sovereign givers of law. In the
miniature of Edward IV, the king
is shown seated on his throne surrounded by his legal counselors. On
the left are the canonists, tonsured
and wearing ecclesiastical garb, and
on the right are the civil lawyers in
robes of state. Each of them carries
a rolled document in his hand.

Preceding the statutes are introductory sections including parliamentary laws and the duties devolving upon the office of high steward.
The book is remarkable as a record
of English law, as a unique manuscript, and as a comment on the
interests of its original owner.

TRAVEL AND COMMUNICATION

Though migrations, excepting those to the eastern frontiers of Europe, lessened at the end of the Middle Ages, travel increased to a level never reached before. This was largely due to improved means of transportation and to an expansion of trade routes through exploration. But overland transportation was still hazardous and slow; road repair was sporadic and travelers were frequently attacked by brigands. By far the most efficient means of transportation was by sea. Improved fast ships, such as Venetian galleys, could cover as many as 100 miles in 24 hours on the open sea. Technological inventions such as the magnetic compass were used, at least in the Mediterranean, from the fourteenth century onward. Though shallow waters and hidden reefs still made coastal shipping hazardous and necessitated the dropping of anchor at night or resorting to the tedious and ancient practice of sounding, rivers were well charted and difficult passages were marked by buoys.

Postal services developed in late medieval times probably out of the messenger services established by monasteries, feudal lords, magistrates, universities, and the like. Growing trade and commercial activity, in particular, provided an impetus for ensuring faster and more efficient means of communication. By the fourteenth and fifteenth centuries, governmental postal services were being established. Service in Milan was founded in 1387 and available for private correspondence by 1466; that of France was founded in 1464, and was made available to the public in 1576; the service of Poland was established in 1485, and that of England in 1512. State communications were carried by special courier with the royal badge and seal identifying both sender and messenger.

The opening of the sea lanes in the search for new trade routes in the fifteenth century rekindled interest in the science of geography. The direct translation of Ptolemy's geographical works led the way toward improved cartography. Among the leaders in overseas exploration were the Portuguese who, under the inspiration of their prince, Henry the Navigator, sailed further and further along the west coast of Africa. Diego Cam discovered the mouth of the Congo River in 1482, Bartholomeo Diaz rounded the Cape in 1498, and Vasco da Gama sailed around Africa to the Indies and back in that same year. These voyages were of immense importance for commerce in providing a direct sea route to India. The bypassing of the Mediterranean route with its land portages spelled the death of Venice as a mercantile power and led to the ascendancy of the Atlantic countries and their ports as the major centers of trade in Western Europe.

Letter sent to Venice with marks for haste (*cito*), changes of horse (stirrups), and penalty for interference with mail (gallows), Brescia, 1502 (Postal Division, The National Museum of Science and Technology, Smithsonian Institution, Washington, D.C.).

163b. IDENTIFICATION BADGE
Italy or Spain
Circa 1300
Bronze and silver, L. 5⅛ inches (13 cm)
The Metropolitan Museum of Art, Rogers Fund, 04.3.301

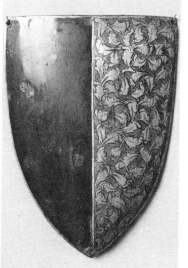

163c. IDENTIFICATION BADGE
Italy
XV century
Bronze and silver, L. 4⅛ inches (10.5 cm)
The Metropolitan Museum of Art, Rogers Fund, 04.3.302

Before the introduction of regular mail service by the government, letters and messages had to be transported by heralds and trusty messengers employed by feudal lords or city magistrates. These men were identified on their official missions by shield-shaped badges worn on their clothing which displayed the arms of their employers.

In some early examples, these badges were constructed as boxes with lids, probably to store credentials or even small messages on parchments; many were made of silver, and therefore their bearers were called in German, *Silberboten* ("silver messengers"); in France such badges were called *émaux*, because they were enameled.

One of the three badges shown here—half-silvered and half-enameled red—bears the arms of one of the corporations of the mighty Italian city republic of Florence; the other two show arms—a golden lion on a field enameled blue, and a crowned red lion grasping three green branches on a silvered field—that seem to be those of noble families. The lion, however, was a common heraldic device, making the exact identification of these arms difficult.

163a. IDENTIFICATION BADGE
Southern Germany
XV century
Bronze and silver, L. 4½ inches (11.4 cm)
The Metropolitan Museum of Art, Rogers Fund, 04.3.299

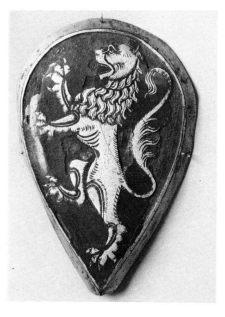

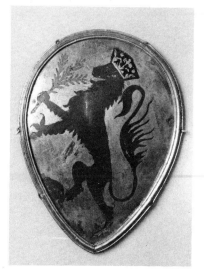

† Jn nome de dio et de la bona mar 1390 a dì Jndamasscho

...

Andrea ve me ... di moro
ve ... mercha[n]ta

164. LETTER
Italy, Venice
Circa 1390
Manuscript on paper (folio), H. 11¾ inches (29.8 cm), W. 8¾ inches (22.2 cm)
Smithsonian Institution, The National Museum of History and Technology

Venice, in the forefront of foreign trade, operated postal services at an early date. In 1305, the company of Venetian couriers was founded to carry foreign and some domestic mail of the republic. A great volume of commercial mail was carried by Venetian ships. An example of Venetian mercantile correspondence survives in this letter dated 24 November 1390. Written in the Venetian of the period, the letter is from Andrea Venier in Damascus to his father-in-law, Nicoló da Pesaro in Venice. Venier, who had been entrusted with the sale of bolts of cloth (he specifies 75 bolts of *saie*, probably twill, and 25 bolts of silk velvets) on the foreign market, with the profits of which he was to buy spices, writes of his difficulties. The cloth, he states, was not of the colors (gray and green) that sold well, so his profit would be unexpectedly low. Few spices, and not the requested ones (among them cinnamon), were available on the market because of the delayed arrival of the caravan from Baghdad. Profiteering was rife since the Venetian galleys bearing goods for trade had already arrived at the port of Beirut; the price of available spices and other goods (cloves, ginger, nutmeg, sugar, incense, pearls) had increased suddenly. Venier had, however, purchased 215 "rolls" of pepper (the Damascus "roll" was the equivalent of 2.55 kilos) for 1975 ducats. The outside of the letter bears, in addition to the merchant's mark and the address, a note of receipt, probably in the hand of da Pesaro, stating, "This came with the galleys of Beirut the 15th of December 1390. This letter belongs with the accounts of credits I have with Andrea Venier in Damascus."

The speed with which the letter arrived demonstrates the efficiency of the Venetian system of communication. Another Venetian letter of 1502, sent from Brescia to Venice, also in the Smithsonian Institution, indicates the importance of this efficiency and speed; on its exterior it bears the word *cito* or "haste" several times, as well as five marks representing stirrups, the symbol for the number of changes of horse to be made by the couriers, and the symbol for the gallows, representing the penalty incurred by anyone interfering with the post.

165. SEAL
France or Italy
XIV century
Copper gilt and champlevé enamel, H. 2 inches (5.1 cm)
The Metropolitan Museum of Art, Gift of J. Pierpont Morgan, 17.190.797

There were in the Middle Ages a large variety of seals ranging in importance from the great seal of the king, which might be as large as five inches in diameter, down to the vast numbers of smaller seals which belonged to more ordinary individuals. There were also corporate seals belonging to guilds, cities, cathedrals, monasteries, or universities. The materials from which seals were made vary in relation to the wealth of the owner. Silver and brass were most frequently used, but gold, and, among the less costly materials, lead, stone, and even wood were employed. Seals varied in quality of workmanship from the most elaborate to the rough-cut merchant marks or the simple initials of yeomen.

Since almost all legal and business transactions were executed by a seal, it was a closely guarded object. There are records of a king's councilor who lost his silver seal and the chain which attached it to his belt, and a French nobleman whose seal was stolen by the English, both of whom requested that their seals be revoked so they could not be used illegally.

In the center of the seal was usually a device, and around the border a lettered legend which might specify the authority of the seal, or give an instruction to the recipient of the letter or document to which the impression of the seal was affixed. Sometimes the inscription was a personal device and even love mottos appear. This seal was most probably a private one, but neither the device in the center nor the inscription ✝Z . ꙅ . Ꙇ . L . Ꙇꙋ OE . I . L . I . I . Vc has been deciphered.

166. COSTREL
England (Surrey)
XVI century
Lead-glazed earthenware, Dia. 5¼ inches (13.3 cm)
The Royal Ontario Museum, Toronto, 926.29.1

Costrels, used to contain beverages, were common appurtenances of travelers and field laborers from the earliest medieval times. The term derives from the Latin word *costra* meaning "side," as the vessels were carried or hung at the side, much as canteens are today. Although commonly made of wood and leather, earthenware examples have survived. Numbers of contemporary paintings and manuscript illuminations show that the ends of a leather strap were passed through the perforated ears or handles and knotted to form a loop handle for carrying, or through which a belt could be passed to strap the vessel to one's side. This example varies from the more usual type in that one side is footed so that it could stand on a flat surface. As this

would be an unnecessary feature on the road or in the field, it is probable that this costrel was made primarily for use in the house, adapting the familiar shape of the older types.

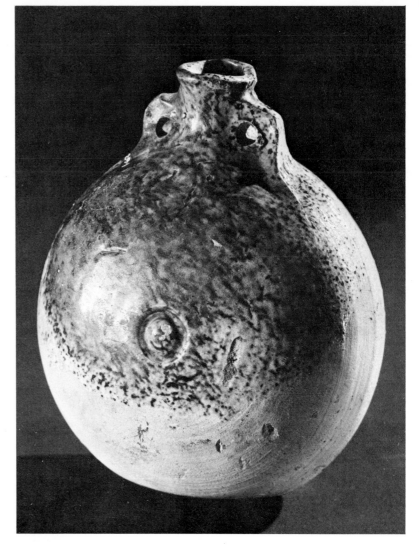

167. CASE FOR A CUP
Italy or France
XV century
Leather *(cuir bouilli),* H. 6⅝ inches (16.8 cm), Dia. 4¾ inches (12.1 cm)
The Metropolitan Museum of Art, Fletcher Fund, 24.135.4
Since travelers in the Middle Ages usually carried their own eating utensils, there were a number of leather cases molded to fit the shapes of cups, knives, forks, or spoons, which would protect the objects while they were being carried on a journey. As such objects were often made of costly materials, their value alone warranted the making of cases for them, often with rich decoration. Lavishly tooled and painted cases made for the imperial crown and ceremonial sword of the Holy Roman Empire have survived, while others less ornately adorned and identifiable by their shapes as cases for a variety of eating utensils and drinking vessels are not uncommon. While the shape of this case is not explicit, it was probably intended for a wine cup or similar drinking vessel. The loops on the sides, through which a strap could be passed, indicate that the case was designed to be transported.

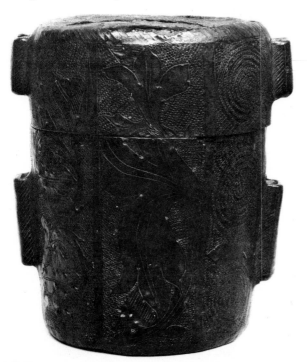

168. PORTABLE CANDLESTICK
Northwestern Europe
Circa 1300
Silver, H. 6⁹⁄₁₆ inches (16.7 cm)
Museum of Fine Arts, Boston, Otis Norcross Fund, 68.54
One rarely realizes just how portable the households of the late Middle Ages were: chairs folded in a number of ingenious ways, tables consisted of planks set on trestles, wall hangings (both of tapestries and other textiles) could be rolled and rehung in other settings (size was not always the primary concern: if too large for a particular wall space, they were simply carried around the corner or folded under at the floor). The remaining belongings were gen-

erally carried in a series of chests, caskets, and coffers of varying sizes.

Since travelers needed light, pricket candlesticks, that could be folded and easily packed, came into common usage. Many of these were strictly utilitarian in nature, being made of wrought iron, sometimes of rather crude workmanship. This tiny silver example, however, is among the smaller and more finely worked items of travel that have come down to us from the late Middle Ages. With its hinged legs folded up against the standard, it forms an extremely slender object, very light in weight, which could have been slipped into a leather traveling case or even into one's belt.

The actual provenance of this portable candlestick is unknown, but a clue to its origin comes from the fact that it was dredged up from the river Scheldt (French: Escaut), which flows from northern France through present-day Belgium and into the North Sea in the Netherlands.

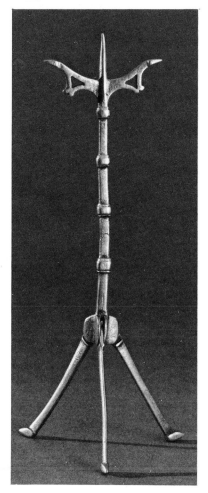

169a,b. COFFRET, WITH KEY
Possibly France or Spain
XV or XVI century
Iron, wood, and linen, H. (of coffret) 6⅜ inches (16.2 cm), L. 13½ inches (34.3 cm), W. 8⅝ inches (22 cm), L. (of key) 4¼ inches (10.9 cm)
The Metropolitan Museum of Art, The Cloisters Collection, 55.76.4a,b
Coffrets and caskets, which were of great importance for the storage of household goods, were also valued by medieval travelers, who frequently carried with them a major portion of their possessions. For this purpose, containers of a wide variety of shapes and sizes existed, all intended to secure the safety of the objects enclosed. Iron caskets provided a great measure of security but, because of their weight, were not easily portable. Therefore, caskets and coffrets of wood, covered with leather or other material and bound with iron, were more common.

The present coffret is an example of one of the most common and universal types of caskets produced during the fifteenth century and is known as *coffret à mailles* or *coffret à la manière d'Espagne*. Such coffrets were made of a wooden core, covered with rough linen, as here, or dyed leather. On the outside were two layers of iron openwork, one superimposed on the other allowing the decorative cover of the core to show through. Iron bars reinforced the cover, and a deceptively elaborate, though rudimentary, lock spanned the width of one end of the coffret. Two rings permitted it to be attached by thongs or chains to a saddle or, possibly, to be secured inside a larger chest too heavy to be easily stolen. Since it has been suggested that these coffrets were used for the transport of precious possessions, it is interesting to speculate that the suspension of the coffret within a larger chest might have been intended to protect these valuables from otherwise unavoidable damage caused by buffeting and jouncing.

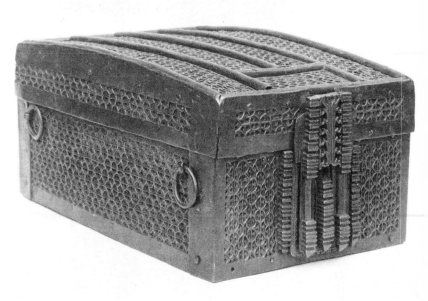

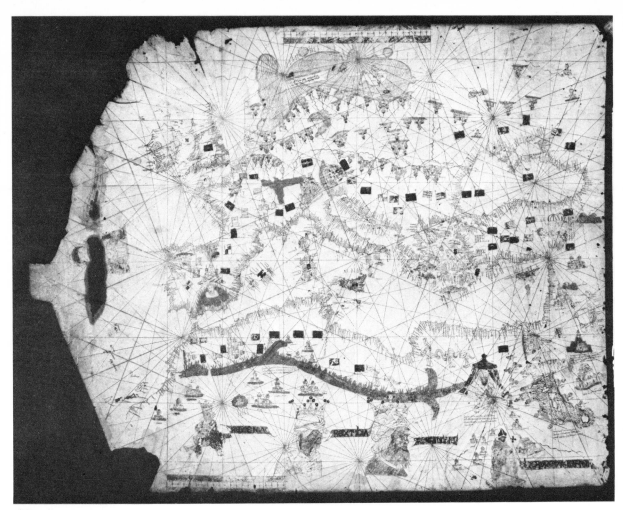

170. PORTOLAN CHART
Petrus Rubeus of Messina
Spain (Catalonia)
Circa 1453–1492
Map on vellum (folio), H. 28½
inches (72.4 cm), W. 37 inches (94
cm)
Smithsonian Institution, The National Museum of History and Technology
Portolan charts, graphic depictions of ports and other features important to navigators, were common during the period 1300 to 1500. Designed for use by Mediterranean sailors, they provide detailed information about the Mediterranean coast, and sometimes about the Atlantic coast of Europe and the Black Sea coast as well. Inland details, by contrast, are generally lacking. The most notable feature of portolan charts are the straight lines radiating from various centers in the directions of the 32 compass points called rhumb lines. These lines, together with a magnetic compass, enabled pilots to lay a course from one harbor to another. The Catalan communities on Mallorca and at Barcelona, and the Italian towns of Genoa and Venice, were the great centers of portolan map production.

171. TERRESTRIAL GLOBE
Western Europe
Circa 1510
Engraved copper, Dia. 5 inches
(12.7 cm)
The New York Public Library, Rare Book Division, Astor, Lenox, and Tilden Foundations
Although described in antiquity, terrestrial globes were unknown in medieval Europe. The age of exploration encouraged the production of globes as well as flat maps and, as European explorers discovered for themselves the coastlines of Africa, India, Asia, and the Americas, cartographers hastened to chart the new information.

The Lenox Globe is the oldest extant post-Columbian globe of the earth. Although unsigned and undated, internal evidence strongly suggests it must have been made around 1510. The globe shows the islands discovered by Columbus, as

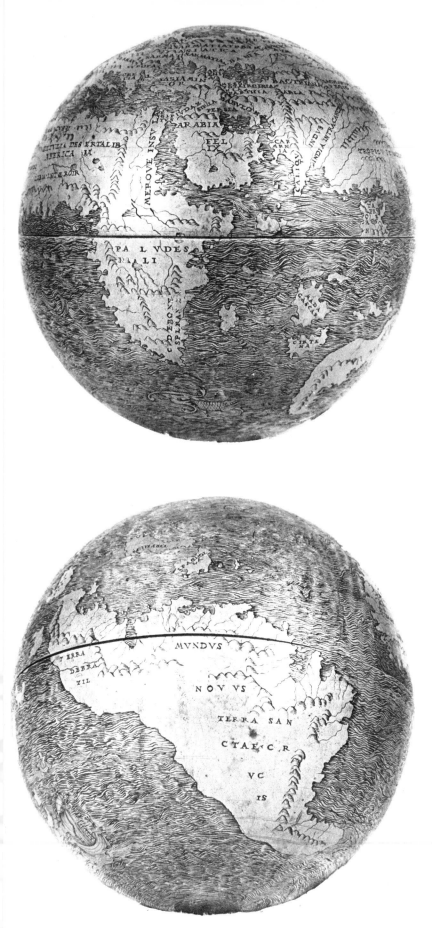

well as such lands as Newfoundland and South America found by Cabot and Vespucci who followed close in his wake. Although Magellan had not yet sailed around Cape Horn, it shows South America, probably by analogy with Africa, to be peninsular. Despite the inclusion of Japan, called Zipangri by Columbus, the globe clearly shows the new-found lands as a distinct continent, and not simply an extension of Asia. The names on the continent now known as South America—*Mundus Novus* and *Terrae Sanctae Crucis*—appeared on an important map of 1508, which suggests that this globe was made after that date. On the other hand, the globe was probably made before 1511, as it does not reflect the explorations of the North American mainland which appeared on other important maps of that date.

172. MAPPA MUNDI
Giovanni Leardo
Italy, Venice
1452–1453
Map on vellum, H. 28½ inches (72.4 cm), W. 23½ inches (59.4 cm)
American Geographical Society, New York
(See color plate no. 7)

This map depicts the parts of the inhabited world known and of interest to late medieval Europeans. Following a convention popular throughout the Middle Ages, the world appears flat, surrounded by the Ocean Stream; Jerusalem is in the center, Asia and the terrestrial paradise are at the top, Europe is at lower left, and Africa is at lower right. While some people may well have concluded from maps like this that the earth was truly flat, medieval scholars were clearly familiar with the ancient hypothesis of a spherical earth. The geographical information presented on this *mappa mundi*, as on all the many world maps of the period, came from a wide variety of literary sources—the Bible, ancient secular histories, medieval legendary figures like Prester John—as well as from navigators, cartographers, and travelers such as Marco Polo. In addition, the origin of some of the concepts was an ancient source that had come to Europe from Byzantium in 1409, and that would soon revolutionize cartography, namely, the *Geographia* of Ptolemy.

For reading terrestrial distances or charting routes, medieval cartographers produced detailed maps of limited areas. *Mappae mundi*, on the other hand, served to suggest to people in the medieval period the overall configuration of their world.

BOOKS AND LEARNING

A new and distinguishing feature of late medieval literature was the use of the vernacular. Dante, Petrarch, Boccaccio, and Chaucer all chose to write in their spoken language rather than in Latin, and the content and style of the literature they produced reflects little classical inspiration. Far from expressing a sudden revival of the ancient past, their writings continued long-standing medieval traditions. Another singular feature of this period is that most of the authors of the fourteenth century though trained as clerics in the universities were dominated in their writings by a secular spirit directed to a secular audience.

Increasingly, the universities themselves began to produce lay graduates rather than churchmen. Though the Church still dominated the faculties and still chose its clergy from the ranks of the schools of theology, many students, graduated from the colleges of liberal arts, took up careers in government rather than in the Church. The advanced study of law included branches of civil as well as canon law; medicine was wholly secular, and medical schools such at that at Salerno had lay faculty. It is significant that the universities founded in the fifteenth century were all established under civil rather than ecclesiastical authority. In addition to theology, the curriculum consisted of Aristotelian and other philosophy, the logic of Boethius, mathematics, music, and astronomy. *De Sphaera* by Johannes de Sacro Bosco provided the first satisfactory text for the study of the heavens, as did the translations of Ptolemy for geographical studies.

The library of an educated layman of the upper classes contained a selection of these standard texts in addition to books of a more practical nature. Household manuals such as those dealing with agriculture, the care of livestock, hunting and fishing, the preparation of food, and rudimentary health remedies were essential to the efficient management of his property.

In literature, the late Middle Ages showed a marked preference for the chivalric romance, the poetry and the allegory of past centuries. This was also the period for an unprecedented interest in heraldry and genealogy. Attention has often been drawn to the nostalgia that appears to have pervaded taste in this period; this has been attributed to the lackluster of a dying age. Equal attention has been focused on the vitality of the fifteenth century, a trait that has been explained by the fact that it saw the beginning of a new era. But a true measure of the times is the written word: the new works produced, the libraries assembled, and the curricula of the universities. By these standards late medieval learning demonstrates an amazing versatility.

Presentation of the manuscript of the *Teseide* by Giovanni Boccaccio, detail of an illuminated page by the Master of René of Anjou, France, ca. 1468 (Österreichische Nationalbibliothek, Vienna, cod. Vindob. 2617).

175. LE ROMAN DE LA ROSE, WITH ADDITIONS OF THE TESTAMENT AND CODICIL OF JEAN DE MEUN

Guillaume de Lorris and Jean de Meun

France, Paris

Second half of the XIV century

Manuscript on vellum (codex), 180 folios, H. 10¾ inches (27.3 cm), W. 7¼ inches (18.5 cm)

The Pierpont Morgan Library, Ms. M. 48

One of the more interesting aspects of late medieval culture was the persistence of the idea of courtly love, not as an actuality but as a concept. A manifestation of this was the tremendous popularity enjoyed by *Le roman de la rose.* This allegorical poem, begun by Guillaume de Lorris about 1240 and completed some 40 years later by Jean de Meun, was still being read two centuries later. Guillaume de Lorris, in the beginning of the poem, equates love with beauty and morality. For him, in true courtly style, the lover sought to attain through his own virtue the favor of his lady, whose morality was above reproach. This version of the poem, perhaps executed for Charles V of France in the second half of the fourteenth century, begins with a miniature showing the lover dreaming of his love, the rose, his awaking, and his approach to her castle, which is guarded by the virtues. This idyllic, chivalrous approach to the theme is interrupted when the poem was continued by Jean de Meun. The courtly conception of the poem was transformed into one of sensuous cynicism. This duality of theme may well explain the appeal of this work for readers in the late medieval period since Jean de Meun's writings condoned sexual immorality in the guise of chivalric courtesy. Of more importance, perhaps, was the idea that courtesy was limited to the upper class and had no place or meaning in lower-class society. The idea of courtly love, and its embodiment in the *Roman de la rose,* therefore, not only provided justification for upper-class moral deceit but also clearly distinguished class from class. The philosophy of Jean de Meun as expressed in the *Roman de la rose* was attacked by Christine de Pisan in her *Epître au dieu d'amour,* where she attempted to vindicate the character of woman, to elevate the role of her sex, and to apply moral conduct to women of all classes. Christine's approach was certainly more idealistic, but it did little to change the decadence of a dying social order.

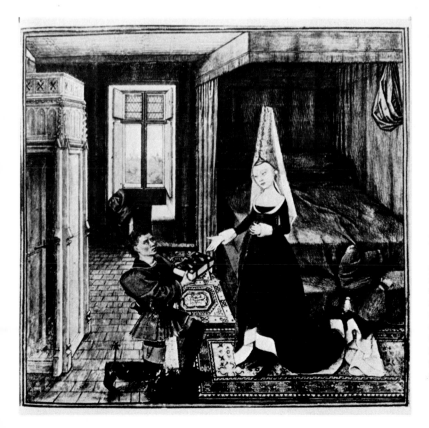

176. LANCELOT DU LAC

France, possibly Amiens
Circa 1300
Manuscript on vellum (codex), 141 folios, H. 13⅝ inches (34.6 cm), W. 10 inches (25.5 cm)
The Pierpont Morgan Library, Ms. M. 805

The first of four volumes, this manuscript in Picard dialect begins the Arthurian cycle with the legend of Lancelot. It was written at the very beginning of the fourteenth century at a time when the chivalric romance was at the height of its popularity. This type of literature expressed both the ideals of courtly love with all its proscribed formality and the nostalgic interest in the past generated by a society whose existence was already threatened by a changing class structure. Manuscripts such as this were made for, and could only be truly understood by, the ruling class. The original owner is unknown; by the end of the century it had come into the possession of Jehan I de Brosse, lord of Ste. Sévère and Boussac, *maréchal* of France. The miniatures of this profusely illustrated volume with their richly gilded backgrounds, their stylized settings, and their elegantly posed figures perfectly express the attitudes and taste of the social class for which they were made. This is court art carried to the ultimate stage of refinement, a tradition that would soon be supplanted by new and vigorous trends toward naturalism.

This first volume of the Lancelot story begins with a large miniature comprising multiple scenes recounting the knight's childhood. The first scene shows Lancelot's mother and father, Queen Helen and King Ban of Benoyc, journeying to Camelot, followed by a scene of the birth of Lancelot and the death and burial of King Ban. Queen Helen, mourning over the death of her husband, neglects to guard her infant son, who is in turn seized by the Lady of the Lake and carried off. After he is grown, the Lady takes Lancelot to King Arthur's court where he is knighted and falls in love with Queen Guenevere. One of the most poignant scenes in the manuscript is the first kiss of Lancelot and Guenevere, which, in true courtly fashion, is presided over by Sir Galahad. It was in the fourteenth century that the Round Table legends, which had previously emphasized deeds of valor, concentrated new emphasis on themes of courtly love. Like art, the literature of the period expressed the manners and condition of mind of the society for which it was created.

177. LE LIVRE DES TROIS VERTUS

Christine de Pisan
France
Circa 1460
Manuscript on vellum (codex), 96 folios, H. 13¾ inches (35 cm), W. 10⅟₁₆ inches (25.5 cm)
Beinecke Library, Yale University, Ms. 427

In the Middle Ages, women were considered chattels: those of the upper class were destined to marry advantageously, those of the lower classes to work. It is not unusual to find women listed as members of guilds for there were corporations that were predominantly female, such as the embroiderers, others like the textile industry that employed both sexes, and still others that were predominantly male, in which the widow of a master was permitted to take over the operation of his shop. Women illuminators of manuscripts are recorded in guild records of fourteenth-century Paris; they were often daughters practicing their father's trade. The education of women, however, was of a rudimentary nature—few of them were taught to read and write. Christine de Pisan was a notable exception, not only in her own time but in any period. She was born in Venice in 1363, the daughter of an astrologer-alchemist, who took her to Paris at the age of four when he was appointed astrologer to Charles V. She grew up at the French court and thereby had the advantage of an education. At the age of fifteen, she was married to the king's secretary, Étienne du Castel, and bore him three children. At the death of her husband, only ten years later, Christine was faced with having to support herself and her family, which she did by writing. She first wrote verse in the vernacular, and later, after a study of the Latin poets, longer epics and allegories. She was a prolific writer, declaring that she had produced fifteen prose works in six years. She gained immediate popularity and the patronage of Charles VI and of the dukes of Berry and Burgundy. Christine's most unusual preoccupation, however, was her defense of women in her writings. In her *Epître au dieu d'amour,* she defends them against their satirical presentation by Jean de Meun in his *Le roman de la rose* written some 75 years earlier. This involved her in a literary controversy which she countered by writing two more books on women, *La cité des dames,* containing many interesting contemporary sketches, and *Le livre des trois vertus,* which is a detailed observation of domestic life

in France in the fifteenth century. Christine de Pisan selected her own illuminators, often women, and had several copies made of a single work, which she sent to her various patrons and friends. This example of *Le livre des trois vertus* was made some thirty years after her death. Each of its four miniatures show personifications of the three virtues, whose characteristics should inspire women of all classes. In the first miniature, Christine, herself, is portrayed inscribing their words.

178. LE MORTIFIEMENT DE VAINE PLAISANCE

René I, duke of Anjou
France (Anjou)
Third quarter of the XV century
Ink and paint on vellum, 70 folios, 7 x 5 inches (17.8 x 12.8 cm)
The Pierpont Morgan Library, Ms. M. 705

It has often been said that the tenor of life at the close of the Middle Ages was affected by obsessions with death and the transitory qualities of worldly pleasures. Whether this was the result of exhausting wars, social upheavals, or the ravages of plagues is a debatable point. These generalizations are frequently based upon what is left to us in the arts and literature, and often overlooked is the undeniable fact that these mementos are largely representative of a single class, rather than the whole of late medieval society. *Le*

mortifiement de vaine plaisance was a book not only written for but also by a member of the aristocracy. René of Anjou, the author, who dedicated it to Jean Bernard, archbishop of Tours, was a man of unusual talents. He was not only a patron of the arts, as were many of his contemporaries, but also, in addition to producing literary works, he is said to have made stained glass, painted miniatures, and played music.

Le mortifiement de vaine plaisance is an allegory that takes the form of a dialogue between the soul inflamed by divine love (*l'âme devoté*) and the heart (*coeur*) led astray by worldly pleasures. The heart is visited by the virtues: fear of God, and perfect contrition, who denounce worldly vanities and pleasures and show that the soul can only achieve peace and true happiness by obedience to God. The virtues, divine grace, faith, hope, and love, demonstrate this by crucifying the heart. The similarity of this text with the philosophy of Boethius indicates the magnitude of the philosopher's influence on late medieval thought. René of Anjou's manuscript is typical of the attitudes of many of his social class. The nobility had outlived its usefulness in an increasingly urban society. Its political prestige was gradually being usurped by the power of the monarchs, and its financial security was being threatened by the empires of mercantilism.

162

179. DER RENNER
Hugo von Trimberg
Austria (Tirol)
Last quarter of the XV century
Manuscript on paper (codex), 263 folios, H. 10⅝ inches (29.3 cm), W. 8¹⁄₁₆ inches (20.7 cm)
The Pierpont Morgan Library, Ms. M. 763

Moralizing tales and fables formed a good part of medieval secular literature. The morally elevating character of these tales provided a "homespun" extension of religious teachings and were more than condoned by the clergy. Hugo von Trimberg was himself a cleric who taught for 40 years at Thurstadt in the diocese of Bamberg. During that period, toward the end of the thirteenth century, as he tells his readers, he wrote a little book in rhymed German and Latin verse. The present example is a late fifteenth-century copy in Tirolian dialect.

"Der Renner" is a traveler who in the course of his journeys sees many things and relates his experiences. Apparently Hugo von Trimberg drew from many sources for the content of his book: one can recognize stories from the Bible, passages from the philosophers, Aesop's fables, and physiologies and liturgy woven together as allegory. The illustrations that accompany the text help to point up the moralizing tone and, at the same time, give a fascinatingly detailed picture of late medieval life. In one section of the book, Hugo von Trimberg con-

demns gaming; the artist has illustrated the passage by showing two men seated at a table playing backgammon. Even church teachings are given a contemporary interpretation. Six of the works of mercy appear as scenes from everyday life: a nun gives alms to a soldier, a man places a cloak on a lame beggar, a nurse feeds a sick man who sits up in bed, a priest holds a crucifix toward a man in a pillory, another man is served food at a table, and, finally, a grave is being dug for a coffin. Trimberg comments upon the social abuses and the vanities of his day in his text and they are brought up-to-date by his capable illuminator; the weaknesses of the Church and the indiscretions of the clergy are noted side by side with secular greed and human conceit.

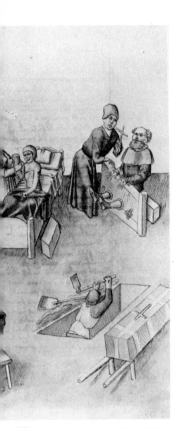

180. THE CANTERBURY TALES
Geoffrey Chaucer
England
Circa 1440
Manuscript on vellum (fragment of a codex), 2 folios, H. 12½ inches (31.5 cm), W. 8½ inches (21.5 cm)
Columbia University Library,
George A. Plimpton Collection,
Ms. 235

Unquestionably, the greatest literary achievements of the fourteenth century were the secular writings in the vernacular languages of poets like Chaucer, Dante, and Boccaccio. Though rooted in medieval tradition, the works of these writers contributed a freshness of approach that revitalized secular literature. It is significant that all three of these authors were laymen in an age when learning and literature were, for the most part, products of the church and churchmen.

Geoffrey Chaucer, who began *The Canterbury Tales* in 1386, was the son of a vintner of London and spent the major part of his career as an appointee of the royal courts of England. He served several royal masters as valet and diplomat and, finally, as a royal pensioner pursuing his literary career.

This fragment, comprising only two leaves of the text, dating some 50 years after *The Canterbury Tales* was completed, contains isolated parts of several portions of the complete text. Although the title of the page is "The Frankeleyn" (an early English term for freeholder), folio 1 recto begins with six lines from the epilogue to the "Merchant's Tale"; following directly are two lines from the end of the "Squire's Prologue," and four from the beginning of the "Franklin's Prologue." Words employed in the passages also differ from the several manuscripts used in the Oxford edition of Walter Skeat (1894–1897), and this text probably represents not the most commonly accepted Chaucer manuscripts, but a different recension.

181. HISTOIRE DE JASON
Raoul le Fèvre
Flanders
Circa 1470
Manuscript on paper (codex), 104 folios, H. 14¾ inches (37.5 cm), W. 10½ inches (26.7 cm)
The Pierpont Morgan Library, Ms.
M. 119
(See color plate no. 8)

Classical legends and history were popular in the literature of the fifteenth century as were chivalric romances, and the heroes of ancient Greece vied for favor with the knights of the Round Table. The heroic deeds recounted in the legends of ancient Troy held a romantic appeal for the upper-class nobility still charmed by the out-

moded chivalric ideal. In 1464 Philip the Good, duke of Burgundy, commissioned Raoul le Fèvre to compile the Trojan legends for his son. The Jason story was especially favored since it not only fulfilled the notion of romantic heroism, but also in the golden fleece there were religious overtones as it was regarded as a symbol of the purity of the Virgin Mary. The miniatures of this version of the story are painted in grisaille. In the "Sacrifice of the Bull" illustration, only the red flames are given color. It is thought by some that this technique is derived from imitation of sculpture, and by others it is viewed as an indication of the melancholic spirit, the general malaise that pervaded upper-class society at the close of the medieval period. The miniatures are in the style of Jean le Tavernier of Oudenaarde, one of the many Flemish painters employed by the Burgundian court.

182. DE VIRTUTIBUS ET VITIIS
Aristotle
France, Paris
Circa 1500
Manuscript on vellum (codex), 32 folios, H. 8¼ inches (21 cm), W. 5½ inches (14 cm)
The New York Public Library, Ms. 59
The works of Aristotle, because the scholastic philosophers had succeeded in reconciling them with Christian theology, had a profound effect on philosophical thought during the course of the Middle Ages which diminished only with the beginnings of humanism in Italy in the fourteenth century. Petrarch, who launched a diatribe against Aristotelian logic, contributed to the decline of Aristotle's influence. Part of the basis for this attack may have been his dissatisfaction with translations of Aristotle that tended to confuse text and gloss. Petrarch, himself, never learned Greek and

consequently never read Aristotle in the original. By the end of the fifteenth century, however, Aristotelianism was to override the Platonism of the humanists. This was largely due to the revising of his works from original Greek texts. In 1495, Aldus Manutius, the Venetian printer, began his monumental *editio princips* of Aristotle's works which was completed four years later. Aldus, himself, read Greek, and he employed eminent scholars to help in the work.

This manuscript on virtues and vices is one of Aristotle's minor works, of a practical rather than a theoretical nature. The text, written both in the original Greek and in Latin translation, is by George Hermonymos, a scholar who came from Greece to the University of Paris in 1476. His major contribution to scholarship was in the copying and translation of Greek texts such as this one. On the flyleaf of the manuscript appears the arms of Englebert of Cleves, count of Nivernais, who must have been one of the former owners of the book.

183. GIRDLE BOOK: DE CONSOLATIONE PHILOSOPHIAE
Boethius
England
XV century
Manuscript on vellum (codex), with leather wrapper, 171 folios, H. 3⁵⁄₁₆ inches (10 cm), W. 3⅛ inches (8 cm)
Beinecke Library, Yale University, Ms. 84
The medieval girdle book was the equivalent of today's pocketbook in that it could be easily carried about. Often small in size, these books were encased in a folded leather pouch that was worn suspended from a knot looped over the belt. For added convenience, the manuscript is sewn into the pouch upside down so that it could be read without detaching it. The few girdle books that have survived from the Middle Ages are almost all religious texts. The Boethius is therefore extremely rare, since it is a secular manuscript, perhaps the property of a wandering student or scholar. Though few exist today, girdle books must have been common in the Middle Ages since they are frequently shown in the art of the period, both as they were worn and as they were stored on the bookshelf of a scholar's library. Boethius' text, *De Consolatione Phi-*

losophiae, was second only to the works of Aristotle in popularity in the late Middle Ages. Perhaps it was the subject matter, which recounts how the study of philosophy can triumph over human adversity, that appealed to the literary minds of a changing society. The work is known to have had an influence on Dante, Chaucer, Petrarch, and on Boccaccio, who made a copy of the text that is still preserved. The Latin text was translated and commented on by writers in many different languages.

This girdle book is thought to have been written in England, since at the back of the text, and in a contemporary hand, are notes in English. These consist of household remedies including "Medicyn for the Colyk." Thus to the philosophy of Boethius for the consolation of the spirit there are appended medical recipes for the relief of the body.

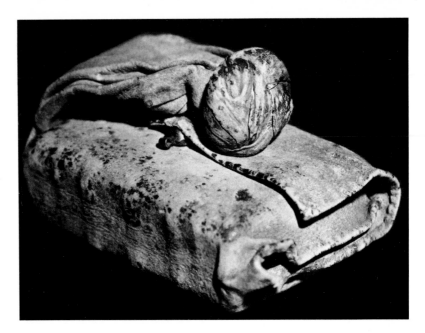

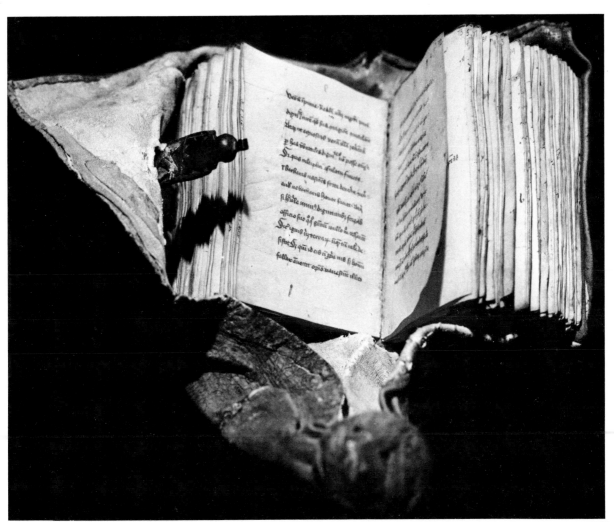

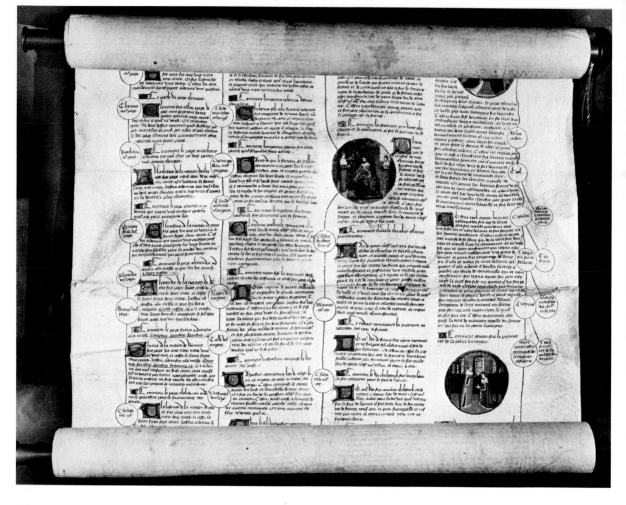

184. CHRONIQUES DU MONDE
France
Circa 1461
Manuscript on vellum (roll), L. 40 feet (12.2 m), W. 24 inches (.61 m)
The New York Public Library,
Ms. 124

The writing of history in the Middle Ages usually consisted of recounting the exploits of a major figure, most often a king or emperor. In most cases, these events were embroidered upon with no attempt at either evaluation or interpretation. Chronological sequence was often ignored and events were treated in the briefest of terms. The *Chroniques du monde* is typical of historical writing in the medieval period in that it begins with the Creation, sketches the lives of the patriarchs of the Old Testament, includes passages from the Gospels, the lives of Christ and the apostles, mentions briefly a few of the saints, and then follows with a history of the French monarchy beginning with Clovis, king of the Franks. This latter part of the chronicle is the most interesting since it records, however briefly, the major events of French history. It is written from the point of view of the personali-

ties involved and chronicles their lives up to the year 1461, presumably the time when the document was written.

The most interesting aspect of this manuscript is that it is in the form of a roll rather than a book. The text runs in columns along the edges of the sheet while the central section is reserved for a genealogical chart of the French royal family. Portraits of the monarchs and other illustrious figures such as popes or bishops are painted in roundels; lesser members of the family are inscribed by name only. A miniature of Clovis is followed by medallions containing the names of his son Clodomer and of Clodomer's son Chilperic, and so on down the royal line. Charles VI is shown seated upon his throne and the names of his brothers, John, duke of Berry, Philip of Burgundy, and Louis of Anjou, are written in circles that stem from the previous portrait of their father, Charles V. The genealogy, like the text, is only concerned with the monarchs and not with the lineage of their royal relatives. In all probability the roll was made for Louis XI of Valois, who occupied the throne of France at

the time when the chronicle comes to an end. Since it is neither signed nor dedicated, however, its ownership cannot be determined.

185. WELTKRONIK
Hartman Schedel, with woodcuts by Michael Wolgemut and Hans Pleydenwurff
Published by Anton Koberger
Germany, Nuremberg
10 July 1493
Incunabulum on paper, H. 18¾ inches (47.6 cm), W. 13¼ inches (33.7 cm)
The Metropolitan Museum of Art,
Rogers Fund, 21.36.145

Hartman Schedel's *Weltkronik,* commonly known as *The Nuremberg Chronicle,* was issued in Latin in July 1493 by the well-known printer Anton Koberger, who was active from 1464 to 1513. The *Weltkronik* was published under the title of *Liber cronicarum ab inicia mundi,* and advertised by Koberger as "a new book of chronicles with its pictures of famous men and cities which has been printed at the expense of some generous citizens of Nuremberg." A colophon indicates that the woodcuts were executed by the painters Michael Wolgemut

(1434–1519) and Wilhelm Pleyden-wurff (active 1490–1495). The contract from the printer for the illustrations was made in December 1491, but references in it to blocks already completed indicate that the work had been undertaken some time earlier. Only six months after its initial publication in Latin, in December of 1493, the book was published in German in an expanded form, even more profusely illustrated. Other editions in German and Latin appeared in 1496 and 1497.

As the Latin title implies, the book tells the history of the world, divided into six ages, from the creation to the year 1492 A.D. The 1800 woodcuts include genealogical trees, maps, and portraits; the depictions of various cities, such as the one of Cologne illustrated here, are of particular interest. These vary in correctness and reflect only the beginnings of faithful topographical illustrations.

186. AESOPUS VITA ET FABULAE
Published by Anton Sorg
Germany, Augsburg
Circa 1479
Incunabulum on paper, H. 12³⁄₁₆ inches (31 cm), W. 8⁹⁄₁₆ inches (21.6 cm)
The Metropolitan Museum of Art, Harris Brisbane Dick Fund, 37.39.6
Aesop, the shadowy, almost mythical figure of antiquity wrote nothing down himself, but versions of the fables associated with his name appear in both Greek and Latin from the first to the tenth century, and one version appears in old French in the twelfth. The fables were compiled and translated into German by Heinrich Steinhowel who had studied in Padua and who became one of the most important proponents of Italian and classical literature to German-speaking people.

The first edition of Steinhowel's translation was that published by Johann Zainer of Ulm about 1476–1477. The book contains a central core of Aesop stories, but has, in addition, a large amount of additional fable material from late classical, medieval, and Italian Renaissance sources. The woodcuts include a frontispiece of Aesop, shown as a hunchback surrounded by characters from his fables, as well as illustrations for the different fables. The woodcuts in this book are the same ones used for Zainer's original edition. These woodcuts were so well received by the late medieval public that before the end of the fifteenth century they had been reproduced in some 30 editions, including Caxton's English translation of 1484.

IMPLEMENTS OF LEARNING

While education before 1300 was the privilege only of the children of the nobility and those seeking to enter the priesthood, the rise of the merchant class in the fourteenth century necessitated new and more widespread opportunities for schooling. It was called for for the sons of these merchants, if they were to enter their father's firms, to write a legible hand and to keep accounts. Most towns of the period had grammar schools, sometimes connected with the church or sponsored by the guilds, and these were open to the middle as well as the upper classes of society. Illiteracy prevailed in the rural areas, but in the cities, education was available for those who had need of it.

Writing implements for children consisted of a tablet of wax and a scriber or a wood block and charcoal. The more sophisticated materials of the scribe were a waxed ivory tablet and a stylus or parchment, ink, and a quill; paper came into use only in the fifteenth century. Official sanction of a document was the affixing of the author's wax seal and the "mark" of the scribe or notary. Personal libraries, even at the university level, because of their cost, were infrequent. Books were available for sale only at the booksellers who kept exemplars of texts which were lent out on order to commercial scribes for copying. Each university library consisted of a section of reference books chained to the shelves and another section for lending. Most students arriving at the university brought a few books with them, the gifts or loans from their sponsors.

Preuniversity education consisted mainly of the study of Latin. Numerous schoolbooks and lexicons record Latin passages to be copied and learned; Latin was translated into the vernacular in grammars and vocabularies. In the course of his university education, the student would sometimes learn Greek and Hebrew, particularly if he intended to study theology.

No single aid to learning, however, can quite compare with the invention of the printing press. With this step, education entered a new dimension, although the effects were realized only gradually. Despite possible earlier claims to the invention of printing, it is generally conceded that it was Johann Gutenberg of Mainz who first produced large books by the process. Gutenberg's press employed movable type consisting of wood dies handcarved with Gothic letters. The contributing factor that made printing possible was the availability of paper. The first books printed by Gutenberg and his circle were religious: the famous Bible was completed in 1456 and a psalter in the following year. Secular books, such as the *Nuremberg Chronicle* (see entry no. 185), were appearing in profusion by the end of the century. The printing press, though it has often been called a product of humanism, was a medieval invention. It has recently been suggested that one of Gutenberg's intentions was to reproduce by mechanical means the miniatures, flourishings, and script of the illuminated manuscripts of the Middle Ages. In this, Gutenberg was far ahead of his time, for color reproduction in printing was many centuries in the future.

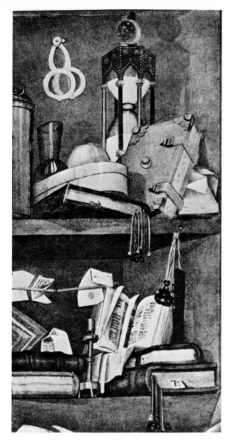

Bookshelves, detail of the *Tucher Altar*, oil painting, Germany, XV century (Frauenkirche, Nuremberg).

The printer, with the press open, woodcut by Jost Amman in *Panoplia omnium artium* by Hartmann Schopper, Frankfort on the Main, 1568 (The Metropolitan Museum of Art, Rogers Fund).

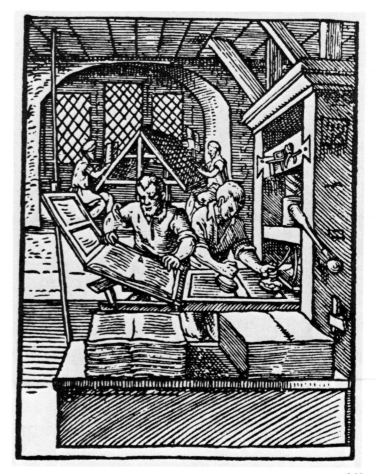

187. LEXICON, GRECO-LATINUM
Italy
Circa 1475
Manuscript on paper (codex), 323
folios, H. 11½ inches (29.1 cm), W.
7⅞ inches (20 cm)
*Beinecke Library, Yale University,
Ms. 277*
Until the fourteenth century, Latin
was the written language of West-
ern Europe. Knowledge of lan-
guages other than the spoken ver-
nacular was limited for the most
part to the clergy who, if they had
pursued higher learning in theol-
ogy, had studied Greek and Hebrew.
With the fall of Byzantium in
1453 and the ensuing exodus of
Greek scholars to the West, how-
ever, there followed a new interest
in the study of the heritage of an-
tiquity. This was sparked by the
importation of classical texts in the
original Greek, some of them pre-
viously unknown in the West.
Ptolemy's *Geography* was translated
for the first time; Aristotle was re-
translated from Greek. Greek was
taught in the academies of Italy, and
by the fifteenth century it was read
by many of the secular intelligent-
sia. This manuscript is an example
of the dictionaries these early hu-
manists were forced to make to aid
their studies. The Greek words, on
the left side of the page, were evi-
dently written by a professional
scribe, but the Latin equivalents on
the right, were probably added by
the owners or users. The manu-
script had at least two owners before
its completion since there are two
different hands represented in the
Latin part of the text. In a few
cases, these equivalents are omitted
entirely, but whether from oversight
on the part of the owner or igno-
rance is impossible to determine.

**188. VOCABULARIUS, IN LATIN AND
GERMAN**
Germany, probably Halberstadt
1463
Manuscript on paper (codex), 249
folios, H. 12⅝ inches (32 cm), W.
8⅝ inches (22 cm)
*Union Theological Seminary Li-
brary, Ms. 24*
This *vocabularius* or dictionary
which bears on its front pastedown
sheet (a part of the original first
quire of the manuscript) the sig-
nature of Selbaldus von Plaben, of
Nuremberg, gives an important in-
dication about secular life at the
end of the Middle Ages. Scribes
and notaries, who wrote and wit-
nessed legal documents, were forced
to understand precise Latin. It may
be deduced from the double arms—
his own and the arms of the no-
taries' guild—appearing on the
pastedown sheet in the form of a
holograph, that Sebaldus von Plaben
was both a notary and a scribe. He
is thought to have been the original
owner of the book, as the colophon
on the last page bears the date, June
1463, while the holograph that bears
his signature is approximately 40
years later. The terms defined in
the dictionary, relating to theology,
philosophy, and law, suggest that it
might well have served as the hand-
book of a notary. Words defined are
ranged in alphabetical order neatly
down the left-hand side of the page.
Although the definitions are usu-
ally in Latin, some in German sug-
gest that the author occasionally
chose the venacular in order to be
more explicit. On folio 125 verso,
mother is defined in Latin as "a
woman bearing an offspring within
herself," *matutinale* is defined in
German as a "mass book." The dic-
tionary was evidently planned to
have large colored initials at the
beginning of each section. The
scribe has carefully left space in the
text for them, and one or two are
sketched in at the beginning of the
book, but the project was never com-
pleted. Of special interest as a social
document, this dictionary shows that
while Latin remained the legal lan-
guage of the fifteenth century, the
vernacular had supplanted it as the
language of common usage.

189. SCHOOLBOOK

Italy

Early XV century

Manuscript on vellum (codex), 35 folios, H. 7½ inches (19 cm), W. 5⅛ inches (13 cm)

The Library of Congress, Ms. 56

In the fourteenth century, when the vernacular was used increasingly as the language of literature, Latin continued to be both the written and spoken language of such institutions as the Church, the universities, and the law courts. The universities and the schools taught writing by copying. This schoolbook exemplifies the painstaking efforts and mistakes that resulted from this method. On folio 10 verso, a student has evidently copied a Latin poem in script; his omissions have been corrected above the line by a different and more accomplished hand. On folio 11, the verb *abdico* has been declined twice in Gothic uncials with the third person singular left out in both cases; a prayer to the Virgin follows in a different hand. This book was evidently a copy or exercise book used by several different people in the process of learning to write in Latin. That they were attempting to follow correct procedure can be seen not only in the writing, but also in the scoring of the pages, a method followed by scribes of the Middle Ages to insure evenness of the lines of script on the vellum page.

190. CASE FOR A BOOK

Italy
XV century
Leather, H. 6⅜ inches (16.2 cm),
W. 6½ inches (16.5 cm), Depth 1½
inches (3.8 cm)
*The Metropolitan Museum of Art,
Gift of Mrs. Nancy G. Friedman,
52.131a,b*

During the Norman rule of the
eleventh century, southern Italy,
particularly Salerno and its neigh-
boring cities, developed, under
Arabic influence, into a major cen-
ter of medical studies. By the
twelfth century, much of the extant
medical knowledge had been com-
piled in alphabetical compendia,
which served as a basis of knowl-
edge for the ensuing centuries of
the Middle Ages. While the com-
pendia, herbals, and the like re-
flected a considerable scientific
knowledge, medical practices were
still influenced by superstitions,
horoscopic prognostications, and
traditional remedies. Consequently,
late medieval texts in common
usage were mixtures of scientific
and fallacious information. The
widely circulated *Gart der Gesund-
heit* (see entry no. 77) was typical,
containing herbal cures of demon-
strated medicinal value, some of
which are still in use today, as well
as more fantastic compounds such
as ground unicorn horn, considered
a universal cure. Nonetheless, these
books were valued highly, and fitted
leather cases to protect them were
not unusual. While this example is
too small to have held a complete
herbal or compendium, the inscrip-
tion: MEDIXINA VIRTU VIVE ("live by
virtue of medicine") does indicate
it was used to hold a medical text
of some sort. Practitioners often at-
tached such cases to their belts as
they traveled about calling on their
patients.

191. LEAF FROM A WRITING TABLET

France
XIV century
Ivory, H. 4⅝ inches (11.7 cm), W.
3¹/₁₆ inches (7.8 cm)
*The Metropolitan Museum of Art,
Gift of Amy Payne Blumenthal,
38.108*

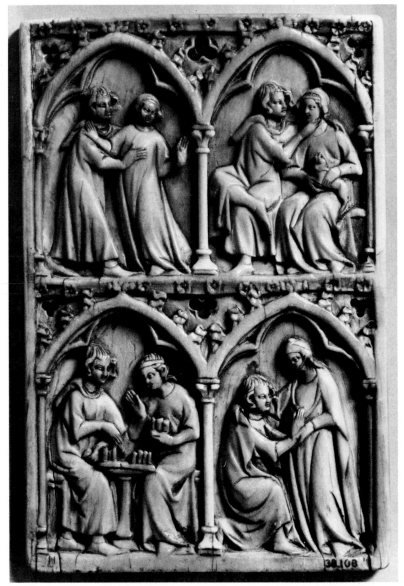

It is probable that this leaf from a
writing tablet, as with many extant
medieval writing tablets, was in-
tended for letter writing. The deco-
ration of the exterior of many of
these ivory tablets, carved with
scenes of courtship and chivalric ro-
mances, suggests that they were used
by noble men and women for love
poems or secret letters. Though this
particular tablet is in fragmentary
state, complete tablets are known.
A complete writing box, now in the
collection of the Walters Art Gal-
lery, Baltimore, was designed to

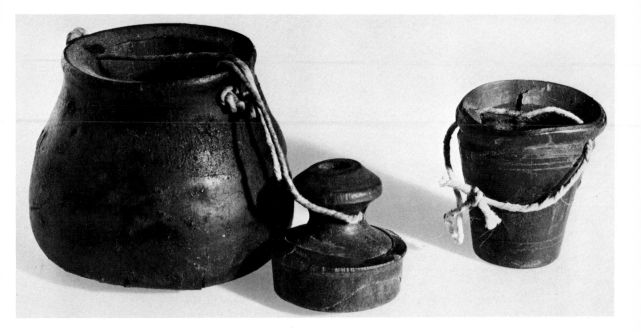

hold not only the leaves, but also the stylus and a sunken receptacle for wax.

Writing tablets of wood, metal, or ivory, which had been in use from the days of ancient Egypt, were not medieval inventions. They were, however, important writing implements in a period when paper and parchment were both scarce and expensive. The value of the writing tablets lay in their reusable character. A brief message or account could be inscribed with a stylus on a thin layer of wax spread on the back of the tablet. After the recipient had read it, it could be erased so that an answer could be written in the wax and sent back to the owner. Though this medium did not lend itself to permanent records, it is probable that scribes used writing tablets for dictation of information which was to be transcribed later on parchment or paper; students, too, may have used writing tablets for practice exercises, and housewives, for inventories or accounts.

These writing tablets were often equipped, as were many medieval objects, with leather cases to protect them both in storage and when carried on the person or during travel.

192a. INK HORN
England
Early XVI century
Horn, H. 2¼ inches (5.7 cm) Dia. (at foot) 2 inches (5.2 cm)
The Royal Ontario Museum, Toronto, 926.29.4

192b. INK HORN
England
Early XVI century
Horn, H. 1⅜ inches (3 cm) Dia. (at foot) ¾ inch (1.7 cm)
The Royal Ontario Museum, Toronto, 926.29.5

192c. CASE FOR AN INK CONTAINER
Italy (?)
XV or XVI century
Leather, H. 3½ inches (8.9 cm)
The Metropolitan Museum of Art, Gift of Alastair B. Martin, 49.61.1 a,b

Ink containers of different shapes and sizes frequently appear in manuscript illuminations and in paintings depicting scribes or scholars in their studies. Although it is difficult to determine their material from the pictorial evidence, ink containers are known to have been made not only of horn, but also of silver, tin, and leather, and, in later periods, of glass and stoneware. Horn was used early in the Middle Ages; a twelfth-century manuscript shows two containers made of ox horns set in holes in the scribe's desk. By the fifteenth and sixteenth centuries, however, ink pots were designed as free-standing containers.

Twelfth-century recipes for ink indicate that pigments, made of lampblack, gallnut, and similar materials, were stored in powder form and mixed with liquid in small amounts according to the scribes'

immediate requirements. This practice, which continued throughout the Middle Ages, allowed ink containers to be carried without fear of spilling. Portable writing cases, which could be attached to a belt, were equipped with a well for the ink pigment container and sheaths for quill pens. Unlike several leather ink pots which have been excavated in London, the leather case exhibited here is fitted with strap loops and was probably designed to carry either a pigment container or a more elaborately worked inkwell.

V

SCIENCE AND TECHNOLOGY IN THE FIFTEENTH CENTURY

In science and technology there was no renaissance. The ancient learning in these fields, unlike that of humane arts and letters, had only partially been lost, so that relatively little had to be rediscovered and reborn. The Greco-Roman traditions had all been well nurtured through Islamic culture from the eighth century onward, and there was not merely continuity but continuous steady growth in mathematics, astronomy, alchemy, chemistry, mechanics, medicine, and the construction of instruments and machines. It is this augmented tradition that was received by the West during the so-called twelfth-century renaissance that saw also the transmission of the university in form, function, and even architecture, and indeed the whole lively tradition of secular as well as holy learning.

Actually the transmission to the West of the scientific and technical material came in two waves. At first there was a partial and corrupt set of texts that came through Sicily in the tenth and eleventh centuries, and then a much better and fuller collection that emanated from the great melting pot of cultures in the Spain of Alfonso the Wise in the late twelfth and thirteenth centuries. From about 1300 onward the tradition was not merely alive but again in the process of growth among the scholars of the medieval West, particularly at Merton College, Oxford, which became a unique sort of Institute for Advanced Study, and the University of Paris.

The ancient, lively tradition that flourished from the fourteenth century through the last decades of the sixteenth has often been misrepresented by a romantic picture of alchemical and astrological pseudosciences and by some sort of blind Aristotelianism and Ptolemaic universe that had to be overthrown by revolution before modern science could begin. This is very far from true. In the most complex and complete of ancient sciences, the Ptolemaic system gave accurately and quantitatively all possible phenomena observable by the naked eye at least as well as the Copernican system could have done. As a result, there was a "delayed acceptance" of the latter system until Galileo's telescope and Kepler's reduction of Tycho Brahe's observations produced a new sort of evidence. Astrology was a highly technical craft which had little in common with the degraded modern practice of predicting the future from the date of a person's birth. Alchemy was a reasonable and working theory and practice of chemistry that failed only in the eighteenth century when one was forced to rest content with concepts that excluded the possibility of predicting the physical properties of compounds from those of their constituent elements.

Even though alchemists were not charlatans trying to make gold, and astrologers were not phony fortune-tellers, it is evident that then as now the technicalities of abstruse science led to misapprehension. The mathematics of Ptolemaic planetary theory was as generally uncomprehended in its day as theoretical physics is now. Thus, though the romantic legends may have had some basis in popular opinion of the late Middle Ages, the science

behind these legends was good hard stuff that formed the basis of our later developments. The big changes in the fifteenth century, and indeed those ultimately responsible for the scientific revolution, came not from the already flourishing sciences, but from great change in a whole range of technologies having special scientific repercussions, chiefly the technologies of instrument-making, printing, metalwork, and metallurgy. Yet again there tend to intervene certain romantic notions that fifteenth-century technology is a matter of printing and the genius of Leonardo da Vinci. This is a gross understatement and it inevitably distorts the role of Leonardo who reflects the ambient technology as much as he helps create it. What happened in the ambient technology is that the fifteenth century seems to have seen just the right social and economic conditions to lead to the emergence of a large class of urban artisans concentrated in such city-states as Nuremberg, Augsburg, and Florence. It is this that filled the vacuum caused by the Black Death that destroyed the continuity and scholarly hegemony of Oxford and Paris and led to fallow decades at the beginning of the fifteenth century. Only in Italy was there a continuity in the university learning and that predominantly in the strong medical school tradition which survived the plague years.

Contributory causes for this phenomenon of artisan emergence were doubtless the transition from feudal suzerainty to nation states, a long and general economic depression, and the fall of Constantinople in 1453, which turned trade and attention toward the West. Perhaps the strongest factor is that of the growth of urbanism and mercantilism in general. There were also a few noteworthy cases of typical renaissance recovery of ancient texts, that of Ptolemy's *Geographia* in 1409 and of the *Architecture* of Vitruvius in 1414. In these cases, however, it was not so much the classical text that was of value and led to advances. The books were treated as handbooks for modern practice and provided with figures and illustrations consonant with this rather than their classical heritage; the *Geographia,* which had lost its maps, became the carrier for a new atlas of the best maps which could be made, and the Vitruvius was filled with new machines and designs. Coupled with the rising crafts of the goldsmiths and of the fine clockmakers, it became an interacting new tradition of globes and instruments to illustrate and supply the burgeoning voyages of exploration and discovery, and these in turn led to interest of the apothecaries in the new exotic plants and drugs brought back from these trips.

A word is perhaps in order about the role of navigating instruments. In fact, though there existed from this period magnetic compasses and good angle measuring devices such as the Jacob staff and the quadrant, the accuracy was rather low and a good sailor relied more on his seaman's knowledge of coasts, winds, and soundings than on scientific navigation. Nevertheless, latitude and longitude were measured and reasonably well-known, and, in general, chart making was good and sufficient for its purpose. The size and shape of the globe were also well known—there was never any real problem with flat earth ideas—and the only major difficulty was the habitual overestimation of the extent of the land mass of Asia that made Columbus mistake the West Indies for the East Indies.

The mainstream of development in fifteenth-century technology came, however, in precisely those areas where there existed a frequent and stimulating interaction with the tradition of basic science, the chief direction of influence being the effect of the techniques upon the sciences rather than any application of the science to improve things of economic, social, or military importance. It is indeed not until the early nineteenth-century applications of organic chemistry and electricity that the sciences were the progenitors of technical change. Undoubtedly of all developments by far

the most important were the rise of the scientific instrument industry and the invention of printing.

In scientific instruments the key position is held by Regiomontanus (Johannes Mueller of Koenigsberg in South Germany, 1436–1476) who settled in Nuremberg because of its strategic location and concentration of artisans and founded there the first workshops for fine mechanics, and printing shops specifically for the spread of scientific books. His mentor, Georg Peurbach (1423–1461), had grounded him well in Ptolemaic astronomy and he had also been supported by the well-known Cardinal Bessarion who had come West for the Council of Florence bringing with him good manuscripts and a love of the instrument tradition. In addition to fundamental writing of an epitome of the Ptolemaic astronomy and a collection of ephemerides, Regiomontanus led the way toward the use of printing for astronomical tables and almanacs, and he was called on by Sixtus IV as a chief technical consultant in the vital and aggravating matter of calendar reform that then afflicted the church.

From the workshops set up by Regiomontanus and from his circle there developed a rapidly growing group of urban makers of astrolabes and a wide variety of sundials and other instruments, which depended for the most part on ingenious mathematical constructions of engraved lines permitting the elegant theories to be embodied in fine craftwork. For the most part the instruments so made were ingenious objects of beauty rather than utilitarian devices, showpieces of calculation and embodied theory rather than tools for measurement. Gradually, however, the utilitarian side also grew, and the craft spread rapidly from master to apprentice, so that within a few generations all the major towns of Europe had workshops, and at the chief centers there were dozens of ateliers competing against each other and dedicating their costly efforts to the rich patrons and their lesser wares to the stalls at the book fairs.

Most significant for all later development is the intimate rapport which grew up between these craftsmen of scientific instruments and the printing presses which were multiplying equally explosively at the same time. There was of course an early link in the fine metal work that went into the building of the press and its equipment, but there grew an even stronger tie in the technique of engraving which was central to the division and inscribing of all the instruments and also to the plates which provided the illustrations that made the printed book become so popular. This became particularly strong when the book left its incunabulum status as an artificial manuscript and became a new force quite abruptly around 1500. The force was so explosive perhaps because the mechanism of manuscript publication had begun to break down at the beginning of the fifteenth century. Still today many well-known texts of the fourteenth century are available in several manuscript copies, but most later manuscripts are unique copies. Beyond the techniques themselves, the book rapidly emerged as a medium for technical writing about such things as land surveying, navigation, and other useful arts. Thus, the artisans became not merely the producers but also the authors for their neighboring printing shops. The instrument makers evolved into a full-fledged practitioner movement of people who not only produced new instruments as fast as they could be designed, but also wrote tracts on their practical use, taught classes in such practice, and served as occasion arose as surveyors, navigators, mapmakers, etc. The influence of these practitioners resulted directly in the rise of the scientific revolution which brought about a new philosophy based on the observations made possible by these new instruments. The scientific practitioner movement became the backbone of all later advance and the origin of the traditions of experimental science and eventually also the Industrial Revolution.

In one of the most intense feedback reactions in all of history, the printed book itself radically changed and caused an enormous growth of the scientific movement that had helped it to come into being. The dissemination of scholarship far beyond the bounds of the old clerical and university system gave a certain vitality of democratization, and the particular literatures of science and technology found a most ready market in the new urban artisans, merchants, and burghers. The practitioner movement was able to mobilize around itself a ready body of customers and amateurs of all the sciences and practical technical trades, and through all this came a vital quickening in the pulse of scientific activity that flowered in the academies of the seventeenth century. The old technical sciences that had enjoyed a relatively continuous history—medicine, for example—were soon outdistanced by the new burgeoning of astronomy and mathematical sciences, navigation and surveying, and the beginnings of new interest in mechanics and in chemistry. The literature of instruments and experiments became a primary influence and a bringer of change.

Thus the fifteenth century is for us a sort of watershed in science and technology. The continuity of the old medieval tradition had been broken but the knowledge had not been lost. The century saw the rise of an urban development of artisans who became scientific practitioners and together with the reformation force of the printed book it is this which gave rise to the chief characteristics of the scientific and technical world in which we now live.

<div align="right">

Derek de Solla Price

Yale University

</div>

The study of the sky has always interested man, influencing his daily life and religion. It was also his first scientific pursuit. The regular recurrence of astronomical events led to the development of the calendar. A good example is the appearance of Sirius just before sunrise which foretold the annual flooding of the Nile.

The horizon and a vertical marker or plumb line were probably the earliest reference lines used by astronomers. These were replaced by an instrument that allowed sightings to be made at any time. It consisted of a large ring mounted parallel to the earth's equator and marked in degrees. Additional rings were later added to represent the ecliptic circle, the tropics of Cancer and Capricorn, etc. From this design came the armillary sphere, one of the earliest astronomical instruments. By Renaissance times, the armillary took a generally smaller form and, except for Tycho Brahe's instrument, was no longer used as an observing tool. It served as a teaching device, however, into the nineteenth century. Armillary spheres were still being made on the Ptolemaic (earth-centered) system long after Copernicus (1473–1543) formulated his theory of the sun-centered universe with a moving earth. This is a good example of how long it takes for a new idea to be accepted.

The sundial was the most popular instrument for determining time until the eighteenth century. It enables the hours to be counted by measuring either the changing length or direction of a shadow. There are three main types of sundials. Altitude sundials, which measure the height of the sun above the horizon, must be set for the latitude and the date. Some types of altitude sundials are ring dials, universal ring dials, pillar dials, and horary quadrants.

Another way of measuring time is by the hour angle. The hour angle of the sun is measured in a plane parallel to the equator. The sun travels 15 degrees each hour in this plane. The gnomon always points to the North Celestial Pole. The sundial must be set for the correct latitude but no correction is necessary for the time of the year. Examples of this method are the common garden and wall dials, the Butterfield-type dial, and the equatorial dial.

The last type is the azimuth sundial which measures the direction of the sun in relation to the points of the compass. It must be set for a specific latitude and adjusted to the time of the year. The Bloud-type dial made in Dieppe, France, in the late sixteenth century was a popular example of this method.

One of the most important and versatile instruments used by early astronomers, navigators, and surveyors was the planispheric astrolabe. Derived from the armillary, it consisted of two images of the celestial sphere projected onto a plane parallel to the equator. The first projection was the tympan, drawn for a specific latitude and showing the principal celestial circles: i.e., the horizon, zenith, altitude lines, meridian, and tropics of Cancer and Capricorn. The North Pole was at the center. The second projection was the rete, an openwork star map, which rotated over the tympan. The rete also showed the ecliptic circle (the yearly path of the sun) divided into the signs of the zodiac. Named pointers on the rete indicated some of the brightest stars.

The tympans and rete fit into a cavity in the body of the instrument. A pivoted rule was used to read off the hours engraved on the rim of the astrolabe. The back carried a sighting bar (alidade) and a circle of degrees with which the altitude of the sun or stars could be determined. The face

of the astrolabe was an analogue computer which could solve problems dealing with time, star positions, length of the day or night, etc., by mere rotation of the rete.

The mathematical principles involved in the construction of the astrolabe were known as early as 150 B.C. by the Greek astronomer, Hipparchus. The earliest known description of the instrument is by Theon of Alexandria in 375 A.D. Several tenth-century examples are to be found in museums and private collections.

Celestial bodies observed by scholars and astrologers of antiquity, detail of an illuminated page, central Germany, 1375-1400 (Österreichische Nationalbibliothek, Vienna, cod. Vindob. S.N. 2652).

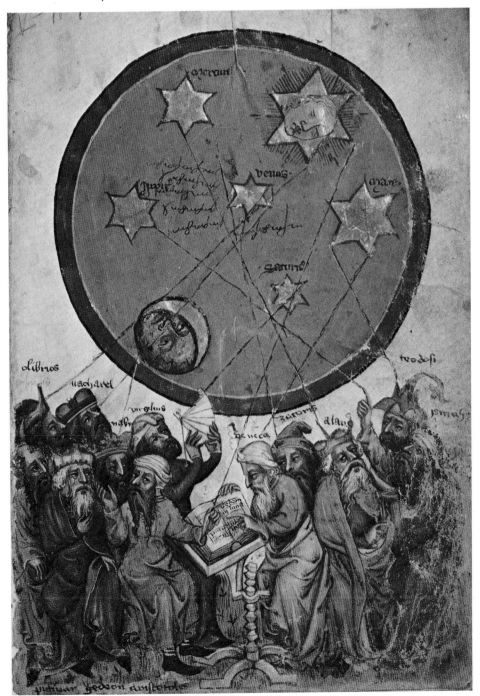

193. ARMILLARY SPHERE
Caspar Vopel
Germany, Cologne
1543
Engraved brass, Dia. 5 inches (12.7 cm)
Smithsonian Institution, The National Museum of History and Technology, S&T 327302
Designed to illustrate the motion of the heavenly bodies, armillary spheres have been used both as teaching devices and as decorative objects since the late Middle Ages. They usually included the horizon,

equator, and meridian bands, graduated in degrees. The ecliptic band provided an opportunity for the artisan to display his skill in engraving the figures of the zodiac. Most of Vopel's armillaries include the earth, a sphere at the center of the system, fastened to a rod representing the world axis. The four bands parallel to the equator represent the tropics of Cancer and Capricorn and the polar circles. Vopel's signature is on the Tropic of Cancer. The other circles represent the colures and the motions of selected planets.

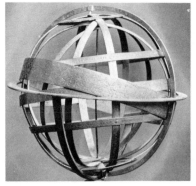

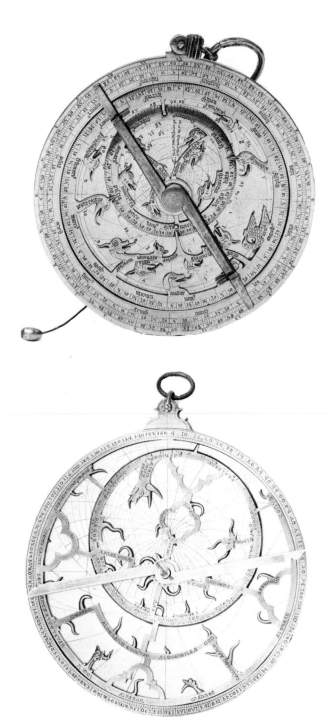

194. ASTROLABE
England
Circa 1325
Engraved brass, Dia. 5⅛ inches (12.8 cm)
Smithsonian Institution, The National Museum of History and Technology, S&T 318198
One of the few extant examples of medieval English astrolabes, this instrument is closely related to the type described by Chaucer in his *Treatise on the Astrolabe.*

The front of the instrument is typical of standard astrolabes. The movable rete is a stereographic projection of the skies. Its unusual zoomorphic star pointers indicate the positions of three dozen fixed stars. The latinized Arabic names of these stars are engraved nearby.

The back of the instrument is a less common type. It serves as a horary quadrant (sundial) with shadow square, multiple degree scales, and scales for latitude and longitude. Horizon lines are marked as usable for the latitudes of Jerusalem, Carthage, Rome, Paris, Oxford, and Berwick.

The back of the rete has been engraved by a later owner. It has markings for a dial scale and a signature, presumably of a seventeenth-century owner, which reads "Thomas W: Fecit."

195. ASTROLABE
Spain
Circa 1350
Brass and silver, Dia. 8¼ inches (21 cm)
Adler Planetarium, Chicago, M. 26
This astrolabe was made in the fourteenth century, and on the basis of the rete pattern was called Spanish. But because its rete closely resembles another astrolabe in the Science Museum in London which has six English saints listed on the calendar, it was later thought to be of English origin. This astrolabe, however, has only one English saint, Thomas à Becket, whose fame was international. For stylistic reasons the Spanish attribution seems preferable. Also, most of the stars are given

Arabic names demonstrating the Moorish influence on Spanish makers of that period.

The bolt at the bottom of the astrolabe has been carefully and skillfully set into the mater. Perhaps some astronomer fastened it to his desk to serve as a computor.

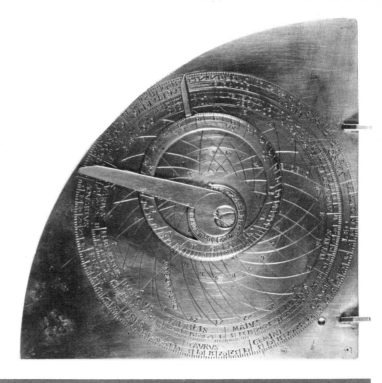

196. QUADRANT
Italy
XVI century
Engraved brass, Radius 4½ inches (11.4 cm)
Smithsonian Institution, The National Museum of History and Technology, S&T 326976
The quadrant continued to be a well-known form of sundial from the Middle Ages up to modern times. There were, however, distinctive differences between the typical medieval instrument with its central movable index and the style that flourished in various forms during the seventeenth century. This Italian instrument with double index represents an interesting transitional form.

Scientists of the period used the quadrant not only for measuring time, but for finding the declination of the sun, measuring latitude, and for computing other angular measurements.

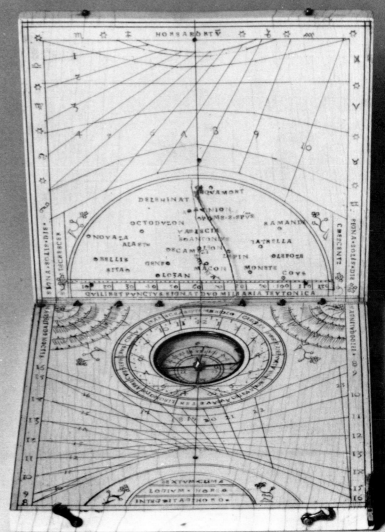

197. DIPTYCH SUNDIAL
Germany
1518
Ivory, L. 6 inches (15.3 cm), W. 6 inches (15.3 cm)
Smithsonian Institution, The National Museum of History and Technology, S&T 320148
This is an unusual, large, and early example of the type of dial that was common later in the sixteenth as well as in the seventeenth and eighteenth centuries.

Like other instruments of the period, this one was designed to tell time by the "new" equal hours as well as by the various traditional systems of unequal hours. The outside of the lid carries a conversion scale for this purpose. The inside of the instrument contains horizontal and vertical dials used after the instrument had been properly oriented by means of the compass. The lunar scale at the bottom helped the user with astrological as well as astronomical computations.

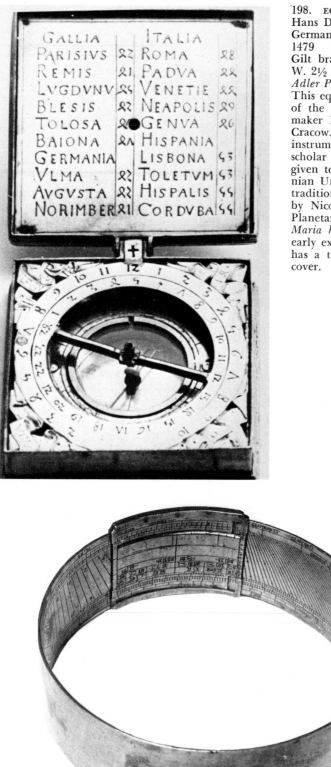

GALLIA | | ITALIA |
PARISIVS | 22 | ROMA | 28
REMIS | 21 | PADVA | 22
LVGDVNV | 25 | VENETIE | 22
BLESIS | 22 | NEAPOLIS | 29
TOLOSA | 20 | GENVA | 26
BAIONA | 2n | HISPANIA |
GERMANIA | | LISBONA | 53
VLMA | 22 | TOLETVM | 53
AVGVSTA | 22 | HISPALIS | 55
NORIMBER | 21 | CORDVBA | 55

198. EQUATORIAL SUNDIAL
Hans Dorn
Germany
1479
Gilt brass, H. 2½ inches (6.3 cm),
W. 2½ inches (6.3 cm)
Adler Planetarium, Chicago, M. 288
This equatorial sundial is the work
of the fifteenth-century instrument
maker Hans Dorn, of Vienna and
Cracow. He is best known for the
instruments he made for the Polish
scholar Martin Bylica which were
given to the library of the Jagello-
nian University in Cracow and, by
tradition, are said to have been used
by Nicolas Copernicus. The Adler
Planetarium's sundial is inscribed
Maria hilf uns an 1479. This very
early example of an equatorial dial
has a table of latitudes inside the
cover.

199. RING SUNDIAL
Regiomontanus (?)
Germany
Circa 1470
Brass, Dia. 5⅝ inches (14.3 cm)
Adler Planetarium, Chicago, M. 307
This Gothic ring dial is a good ex-
ample of an altitude dial. The sus-
pension bracket can be moved along
a calendar scale to adjust the dial
to any particular date. The time is
read on the scale engraved on the
inner surface of the instrument
as a shaft of sunlight passes through
the notch. The helical rising of sev-
eral important stars are also shown
on the inner scale. This instrument
has many similarities to the *Quad-
rans Vetus* as shown in the *Libros
del Saber.* Some experts believe this
dial to be the work of the Nurem-
berg astronomer Regiomontanus,
who lived from 1436 to 1476.

200. DIAL AND NOCTURNAL
Caspar Vopel
Germany, Cologne
1541
Brass H. 7¼ inches (18.4 cm), Dia.
6¼ inches (15.8 cm)
*Smithsonian Institution, The Na-
tional Museum of History and
Technology, S&T 319950*
This typical example of Caspar
Vopel's craftsmanship consists of
two instruments. One side serves as
a universal sundial designed to tell
time over a range of latitudes. This
also carries Vopel's signature. The
other side, more elaborately en-
graved with the signs of the zodiac,
is a nocturnal, with solar and lunar
dials. The lunar dial helps maintain
a record of the phases of the moon.
The nocturnal is intended to assist
in time measurement at night, when
a sight is set on a fixed star.
 The triangular table of "aspects"

in the center of the nocturnal was a frequent companion of sixteenth-century astronomical instruments, most commonly used in casting horoscopes.

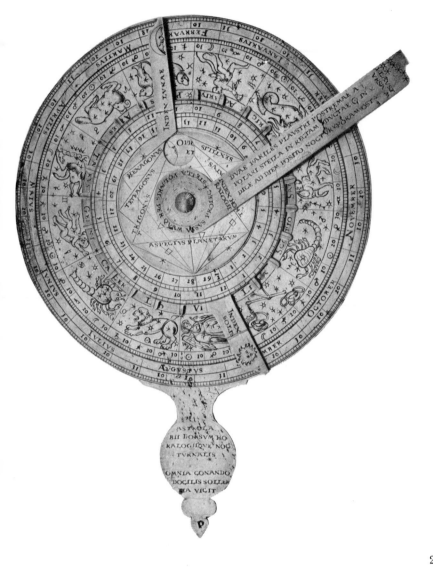

201. TREATISE ON ASTROLOGY
Michael Scotus
Germany (the Rhineland)
Second half of the XV century
Manuscript on paper (codex), 45 folios, H. 11¾ inches (30 cm), W. 8¼ inches (27 cm)
The Pierpont Morgan Library, Ms. M. 384
Studies of the heavens from a purely scientific point of view were rare in the Middle Ages. Even the most inquisitive scholars such as the English astronomer John Holywood (d. 1244), known as Sacro Bosco, resorted to the inclusion of a zodiacal chart. At the other extreme from this quasi-astronomy was the astrological treatise such as that written by Michael Scotus in the first half of the thirteenth century. Though he cites Sacro Bosco, Ptolemy, and Alfonso the Wise, among others, as

his sources, Scotus' chief interest lay in the influences of the heavenly bodies on the health and fortunes of man. This interest did not diminish with the scientific enlightenment of the fifteenth century, as witnessed by this copy of Scotus made in the Rhineland in the second half of the century. In it, the author discusses astronomic distances, the signs of the zodiac and their characteristics, the constellations, the planets and their effect upon human nature, the planetary houses, the seven climates, and the planetary influences on geographical divisions of the earth. Since the writer concentrates in this last part on cities along the Rhine, and since peculiarities in the text of this manuscript are similar to those of two other copies known to have originated in Strasburg, it is thought that the treatise was made in the Rhineland.

Each of the heavenly bodies is illustrated with an appropriate representation. The planets are personified and display their attributes. On folio 28, Saturn is shown holding his sword surrounded by his signs: the boar, Libra the balance, a noose, and dice. On the opposite page, Jupiter is depicted brandishing his arrows accompanied by his

184

signs: the ram, the raven, Scorpio the scorpion, and the dog Cerus.

202. SPHAERA MUNDI
Johannes de Sacro Bosco
Austria
Circa 1425
Manuscript on vellum (codex), 48 folios, H. 12 inches (30.5 cm), W. 9¼ inches (23.5 cm)
The Pierpont Morgan Library, Ms. M. 722

Among the earliest of the astronomical treatises of the medieval period was the *Sphaera Mundi* or *Tractatus de Sphaera* written by the thirteenth-century English astronomer Sacro Bosco. Trained as a mathematician at Oxford and later at the University of Paris where he taught, Sacro Bosco combined his mathematical studies with observations of the heavenly bodies. It was he who pointed out the increasing error in the Julian calendar and who suggested a remedy similar to that adopted under Gregory XIII nearly 350 years later. In the *Sphaera Mundi*, his most popular work, Sacro Bosco relied heavily on the existing Arabic commentaries on Ptolemy contributing little new material from his own observation. By 1500, however, the printed version

of the treatise had gone through 20 editions, thus becoming one of the most widely read works on astronomy of the fifteenth century.

The present manuscript, written in Austrian dialect, is based on the German translation of Sacro Bosco made by Konrad von Megenberg in the latter part of the fourteenth century. In it are combined traditional astrological concepts and observances of a more scientific nature. The zodiac on folio 18 joins the traditional zodiacal signs to a chart of the movements of the sun, moon, and planets around the earth. The earth is the center of the universe and the sun moves about it in variable paths, while the moon and the planets have their own orbits. Sacro Bosco's observations of the eclipses of the sun and moon included on folios 16 verso and 17 are in the direction of greater accuracy.

Appended to the *Sphaera Mundi* and written in the same hand is another text, the *Libellus Isagogicus* by the tenth-century Arabian astronomer Abd-al-Aziz known as Alchabitius, which was translated into German in the fourteenth century by Arnold von Freiburg. Astronomical studies in the East had, through superior technology, advanced far

Coment les promesses dentre le preu iason, et ayedee
furent Ratifflees / Coment medee luy baicta, tout ce que
mestier luy estoit, pour conquerre le noble mouton au
Kautre dor, et coment il le conquesta ·

AU point donaques que les estoilles leur
clarete Rendoient, et que la lune primst a
enluminer la nuit / Quant iason se Retray
en sa chambre / medee ne dormy pas / Elle lespia, et
Boyant, quil estoit Rettraix seul come chartre luy auoit
Elle ouury luys de la montee, par laquelle len descen//
doit de la chambre de iason en la sienne / Si appella
iason, quy celle part estoit moult pensif, / Et quant
iason bey luys ouuert, et medee quy lappelloit / Il
sen ala bers elle moult ioyeusement, et la salua, et
en soy approchant delle, baisler, et acoler la Boulu·
mais medee luy dist quil se cessast, et en prendant
par la main, le mena iusques en sa chambre, ou ils

PLATE 8 Cat. No. 181 185

PLATE 9
Cat. No. 217

186

more rapidly than they had in Western Europe. The dissemination of these texts in translation, together with equally important Eastern works in other disciplines, were to form the basis for the scientific expansion of Western Europe at the end of the Middle Ages.

203. CELESTIAL PLANISPHERES
Albrecht Dürer, Johann Stabius, and Conrad Heinfogel
Germany, Nuremberg
1515
Woodcut printed on paper, H. 24 inches (61 cm), W. 17⅞ inches (45.4 cm)
The Metropolitan Museum of Art, Harris Brisbane Dick Fund, 51.-537.1

Celestial maps and globes, known since antiquity, are actually tools for finding configurations in the heavens: these fanciful constellation figures are practical divisions of the celestial sphere and useful mnemonic aids, and when the star positions are well established, their coordinates can be read off the charts. These maps depict the northern and southern skies as presented in the great *Syntaxis* written by Ptolemy around 150 A.D., and as known in the scientific Islamic cultures of the Middle Ages, and in Europe from the twelfth century on. The 48 constellations on the maps are those described by Ptolemy, and the numbers next to each star refer to numbers in the Ptolemaic star catalogue.

These woodcut planispheres, famous as the first printed star maps, are due to the collaboration of three men: Johann Stabius, a noted humanist and mathematician, drew the coordinates; Conrad Heinfogel, also a mathematician, positioned the stars; Albrecht Dürer drew the constellation figures and had the woodblocks cut.

From a scientific point of view, these maps are a product of the Middle Ages. The stellar longitudes are derived from the thirteenth-century Alfonsine Tables, rather than from contemporary observations, and thus are about 1 degree too small. From an artistic point of view, these maps are Renaissance rather than medieval achievements. Islamic astronomers, though clearly basing their star maps on classical prototypes, nevertheless orientalized the figures and distorted the classical mythological attributes. Medieval European astronomers, in turn, knew the ancient constellation figures only through Islamic translations. As Renaissance ideas advanced, European artists and astronomers strove to rid the constellations of Islamic influences. The beautiful star maps drawn by Dürer mark the culmination of that effort.

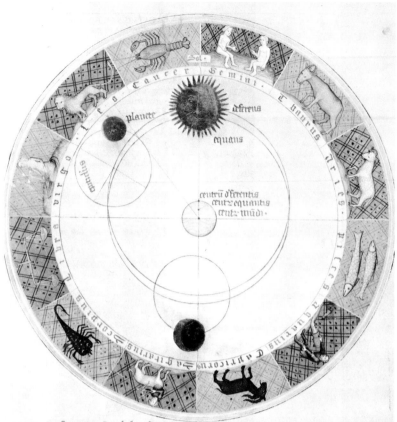

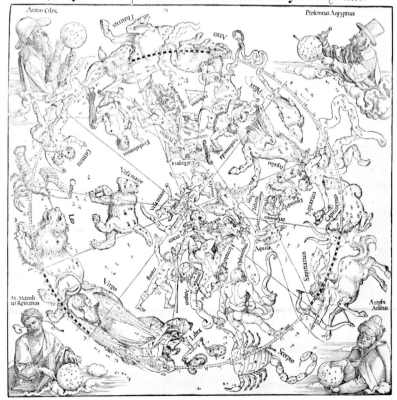

Imagines coeli Septentrionales cum duodecim imaginibus zodiaci.

Ebner Codex ence around addition to t and the 26 Ptolemy. Fou of the Ptole were known papal library teenth centu as the proto *Codex.* The may be the s brated Germ

TIME

The European concept of time as we know it today was developed in the period between 1300 and 1600. The technological advance which made this development possible was the invention of the mechanical clock escapement. Although the date and place of the invention remain a subject of controversy, increasingly large numbers of documents referring to the *horologium* or clock exist after about 1280. Throughout the late thirteenth and early fourteenth centuries there are numerous records of clocks on public buildings and on church towers. But we cannot be certain whether these documents refer to weight-driven clocks with mechanical escapements or to older devices for telling time, such as the water clock or sundial, which were also called *horologia*. Early references to monastic alarm clocks for calling the monks to worship are equally unspecific.

Clearly, however, the weight-driven clock with mechanical escapement must have been in the course of development, for the first such European clock of which we have a complete description is the extraordinarily complex astronomical clock built by Giovanni de Dòndi at Padua between 1348 and 1362. Although the clock no longer exists, it is fully described in a number of surviving late medieval manuscripts. The clock had separate faces for showing the positions of all of the known planets, as well as a dial for showing the hours.

The more usual Gothic clock was, however, the open-framed, iron turret clock which struck the hours on a bell. Several of these large clocks of the fourteenth century survive, most notably those from the cathedrals of Salisbury (1386) and Wells (1392) and the tower clock at Rouen (1389). Smaller domestic clocks were also made during the period, but these remained rare and expensive items. For example, surviving records describe an alarm clock with an astrolabe dial, commissioned by Peter II, king of Aragon, in 1379. About 1460 another advance in clockmaking came with the invention of the spring-driven clock with fusee which made possible the construction of the small, portable clock and, ultimately, of the watch.

Concurrent with the growing use of clocks in the fourteenth century was the gradual abandonment of the system of dividing the day and the night into twelve hours each. Each hour, therefore, varied in length according to the time of the year. These unequal or temporal hours were later replaced by the modern 24 equal hours that were better suited to the mechanical clock and more useful to an increasingly commercial and scientifically oriented society.

Sand glasses also are mentioned for the first time with certainty in the fourteenth century, when recipes appear for the refining of sand for their more accurate running. These measured short periods of time ranging from a few minutes up to one, two, or three hours.

The year, a large span of time, was recorded by the calendar. The Gregorian calendar reforms of the later sixteenth century were yet to come, but the invention of printing in mid-fifteenth-century Germany made possible, for the first time, the widespread, yearly publication of calendars and almanacs both in broadside and book form.

204. GEO
Claudius
Italy, Flo:
Circa 146
Manuscrij
folios, H.
inches (28
The New
In an age
standable
raphy wa
During th
mapmakii

Clock supported by wisdom, on the left, and a man, perhaps a representation of the author, on the right, ink and wash drawing in the *Horologium sapientiae* by Heinrich Suso (French version by Jean Dardenay), Lille, France, 1448 (Bibliothèque Royale de Belgique, Brussels, Ms. 10.981).

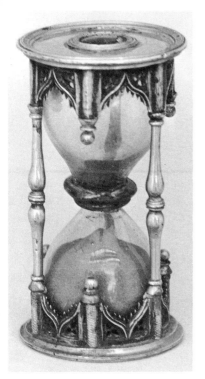

protective outer frame or case could be made of metal, wood, or ivory, and, as in this example, it was often highly decorative.

About 1500, advances in glass technology in Nuremberg permitted the establishment of a sand glass industry, and the resultant products were noted for their fine, reddish sand, obtained from the nearby village of Weissenbrun. The yellowish tint of the glass, together with the presence of the red sand inside, make it probable that this sand glass is an early Nuremberg product.

206. CHAMBER CLOCK
Germany (?)
Late XV or early XVI century
Iron and wood, H. 16½ inches (41.9 cm), L. 10 inches (25.4 cm), W. 16 inches (40.6 cm)
The Time Museum, Rockford, Illinois
Throughout the late Middle Ages the typical chamber clock was in fact a miniature version of the weight-driven, mechanical clocks or turret clocks which were placed in the tower of the church or the town hall where they could easily be seen and heard to strike the hour.

Like the turret clock, this clock consists of an open rectangular construction of four wrought iron posts supporting a mechanism driven by a falling weight and regulated by a verge and foliot escapement. A train of gears connects the mechanism to the single hand that indicates the hour. In addition, a set of knobs or touch pins on the iron chapter ring can be used to tell the time manually in the dark. This clock also has a second train driven by falling weights for striking the hours on the bell mounted above the frame. Such a clock was not easily movable. It was hung on a shelf or a bracket on the wall, allowing the weights to run down freely.

Household clocks first appeared in Europe in the fourteenth century, but were costly items used only by the few who could afford them.

205. SAND GLASS
Probably southern Germany, Nuremberg(?)
First quarter of the XVI century
Gilt bronze (partly enameled), glass and sand, H. 3⁵⁄₁₆ inches (8.4 cm), Dia. 1¹³⁄₁₆ inches (4.6 cm)
The Metropolitan Museum of Art, Gift of Samuel P. Avery, 12.23.1
As most sand glasses, this example measures a comparatively short period of time, approximately one half-hour. Less expensive and more durable than the clock, they also had the advantage of requiring little or no maintenance. Their traditional connections are with scholarship and religious devotions, but inventories of the late Middle Ages show the hour glass to have been in use in upper-class households. Fourteenth-century records show they were used to time the ringing of bells in towns where there were still no public clocks, and they had equally important functions at sea.

The basic technology of the hour glass remained little changed throughout the late Middle Ages. It consisted of two connected blown-glass vials. One of them was filled with a finely powdered substance, whether sand, eggshells, tin, or sometimes lead dust, and the narrow end was covered with a small metal or wooden leaf pierced with a tiny hole to allow the sand to run from vial to vial. The two vials were cemented together at the narrow ends with wax or pitch and the joint covered with a collar of leather, cloth, or parchment, wound with thread (here missing). The

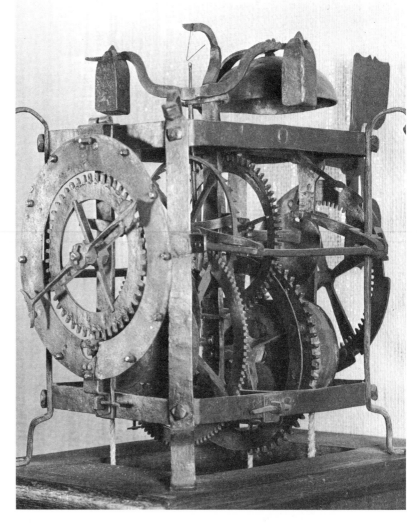

Mamert Fichet
France, Moûtiers (Savoy)
1440
Manuscript on vellum (codex), 4 folios, H. 4 inches (10.2 cm), W. 1½ inches (3.8 cm)
The Pierpont Morgan Library, Ms. M. 897

The primary purpose of the calendar in the Middle Ages was for ascertaining the dates when the holy days of the Christian year were celebrated. Christmas was a fixed feast and presented no problem, but Easter, a movable feast, had to be calculated from year to year. This calculation also involved the subsidiary observances leading up to Easter, such as Shrove Tuesday, Ash Wednesday, and Maundy Thursday. The calendar, therefore, while of special use to the clergy in fixing the dates for the liturgical year, affected the vast majority of people very little. Up to the end of the Middle Ages, the concept of time in general was very different from what it is today. Church bells tolled the canonical hours, which gave some consistency and order to the life of the village, and occasional sundials on public buildings provided some means of telling time. For most people, however, accurate timekeeping was of little importance. Even the invention of the clock made little difference before the sixteenth century, since most early clocks were for public rather than private use.

It is not surprising, therefore, that this girdle calendar was made and owned by a priest, Mamert Fichet of Tarentaise, a region of Savoy, who was also a notary. It is possible that Father Fichet's portable calendar helped him in dating the documents that he notarized, but its main use was undoubtedly religious since it is of the computus type. In the computus calendar, the fixed holy days of the liturgical year are supplemented by tables calculating the movable ones, which depended on the feast of Easter. That Father Fichet made his calendar a girdle book to be carried on his person indicates how important these dates were to him. Once carried by a strap attached to his belt, the calendar provided a ready reference not only for the holy days of the current year but, also by use of the tables, for other years as well.

The banking profession also used calendars in the Middle Ages. One has only to examine banking account books of the fifteenth century to realize how accurately dated are the entries of transactions.

Scientific learning in the late Middle Ages was a curious combination of observation and imagination. Much of this scholarship was based on texts from antiquity, both those that had been known for centuries as well as new translations of ancient writers only recently reintroduced to the Western world. These texts along with such remarkable works as Ptolemy's *Geographia* (see entry no. 204) were handbooks of folk remedies long known and compiled through the trial and error of practical application. One has only to examine such treatises as that concerned with the "care of horses" (see entry no. 215) to realize the equal weight given to actual medicine and traditional folk cures. Even medical compendia that attempted a more scientific rationale included the inevitable tract on bloodletting and an assessment of the personality according to the four humors.

There was far more dependence on the past, on tradition, and on accepted practice in medieval scientific writing, than on new research or invention. The greatest number of manuscripts that have come down to us from this period are republications of works first written centuries before. Few if any of the scientific books represent current thought. Although truly significant advances were made in technological instruments and inventions during the fifteenth century, writings about them lagged behind, except for technical treatises such as those made by the practitioners themselves, like Francesco Martini (see entry no. 210) and Leonardo da Vinci. Theory and the assessment of invention lay, with few notable exceptions, in the future.

Surgical instruments, detail of an illuminated page in the *Paneth Codex,* Italy, 1300-1326 (Yale Medical Library, Yale University).

208. DIVIDERS
Germany
Circa 1500
Brass, L. 6⅝₁₆ inches (16 cm)
Adler Planetarium, Chicago, M.71A
Dividers were universally used by and of importance to navigators, mathematicians, astronomers, surveyors, cartographers, architects, and others. Examples survive from Greek and Roman times. This pair of dividers shows the typical Gothic quatrefoil as a decorative motif.

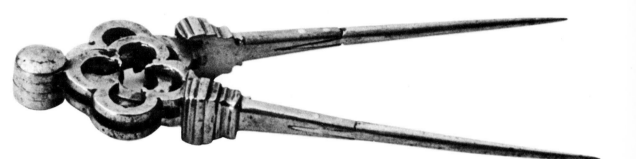

209. LEVEL
Germany
XVI century
Brass, L. 6⁹₁₆ inches (16.7 cm)
Smithsonian Institution, The National Museum of History and Technology, S&T 321679
This basic form of level represents the traditional means of determining whether a given surface or line is parallel to the horizon. The line to be tested meets this criterion— "level"—when the plumb bob intersects the crossbar at its center. In the instrument shown here, that center is designated by a bull's-eye, a dot surrounded by concentric circles.

At the end of the Middle Ages several characteristic forms of level were recognized. Among these was the artillery foot-level, designed to be placed on a piece of ordnance; the carpenter's or bricklayer's level, composed of two perpendicular rules and a plummet; and the mason's level, similar to the type exhibited here.

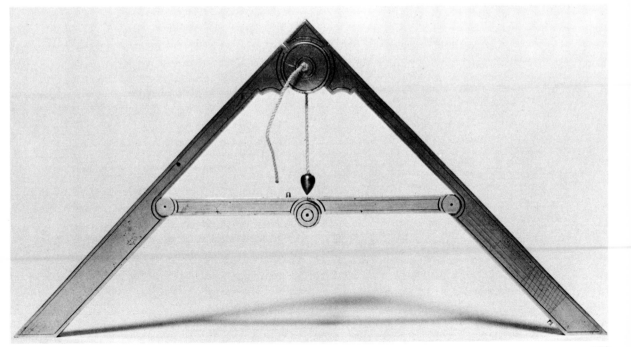

210. TREATISE ON CIVIL AND MILITARY ARCHITECTURE

Francesco di Giorgio Martini
Italy, Siena
Circa 1500
Manuscript on paper (codex), 57 folios, H. 16⅜ inches (41.2 cm), W. 9⅜ inches (23.6 cm)
Beinecke Library, Yale University, Ms. 491

The fifteenth century produced manuals of all types, from simple pattern books to full-scale treatises involving theory and invention. Among the more common of these treatises were those on architecture. The professional architect, more often than not, compiled his experience and experiments in a book. These architectural manuals may well have had their origin in such early sketchbooks as that produced by Villard d'Honnecourt in the thirteenth century; by the end of the Middle Ages they had advanced to truly scientific proportions. The treatise of Francesco di Giorgio Martini concerns itself with this scientific and theoretical approach to building. Born in Siena, Francesco di Giorgio spent the greater part of his career in the employ of Federigo da Montefeltro, duke of Urbino. He not only designed buildings for the duke, among them a part of the ducal palace, but he was also the military and civil architect for his patron. In addition to these accomplishments, Francesco di Giorgio was also an able painter, miniaturist, and sculptor.

The treatise, written in Siena about 1480, is known in three copies, this one having been made about 1500. In it, Francesco di Giorgio not only sets forth his theories on architecture, military installations, and war machines, but also his inventions concerned with hydraulics. An entire section of the book is devoted to various types of equipment for pumping water, profusely illustrated by marginal drawings. He employs the principles of the cam, the lever, the piston, linkage, and rotation in a bewilderingly complex series of machines for utilizing water power.

211. COMPENDIUM OF MEDICAL TEXTS

Italy, Bologna
Circa 1300–1326
Manuscript on vellum (codex), 689 folios, H. 13¼ inches (33.7 cm), W. 9¼ inches (23.5 cm)
Yale University Medical Historical Library

Medical knowledge in the fourteenth century was based primarily upon works of antiquity, including those of Hippocrates and Galen, writings of Arabic scholars, such as Albucasis, and Italian treatises by Bruno and Rolando, among others. From the ninth century, the chief medical school in Western Europe had been at Salerno, where Constantinus Africanus had translated the Greek writers into Latin in the eleventh century, and where Arabic texts were studied somewhat later.

The University of Salerno was a purely secular institution and lost its primacy only with the rise of other Italian universities at Bologna and Padua in the thirteenth century. The so-called *Paneth Codex,* a compendium of medical texts, was probably compiled at Bologna in the first quarter of the fourteenth century for use in the newly established medical school at the University of Prague. The codex is composed of 42 texts ranging in date from antiquity to the thirteenth century, including the *Ars medicinae* of Hippocrates with Galen's commentary. Incorporated are also texts on bloodletting, drugs, medicinal plants, general health, the urine, the pulse, and alchemy, all common practices in medieval medicine. Less commonly thought of interest to the medieval physician

are the sections devoted to dietetics, prognosis, pathology and therapy employed in children's diseases, diseases of the eye, and surgery. The last treatise is of special interest since, in addition to numerous illustrations of surgical instruments, it also includes a demonstration of the treatment of a fracture of the spine through traction. The patient is shown immobilized and roped to a rack. This illustration is unique to the *Paneth Codex*. At the end of the treatise are several texts involving veterinary medicine, comprising studies on animal anatomy and on the breeding and sicknesses of falcons.

212a. LANCET
England, London
XVI century
Iron, wood, and bone, L. 4¾ inches (12.1 cm)
The Royal Ontario Museum, Toronto, 927.28.190

212b. PROBE
England, London
XVI century
Iron, wood, and bone, L. 3⅞ inches (9.7 cm)
The Royal Ontario Museum, Toronto, 927.28.188

Judging from illuminated medical treatises that still exist from the late medieval period, surgical instruments had gained a considerable degree of sophistication. In the surgical treatise by Albucasis in the *Paneth Codex* (see entry no. 211) numerous instruments of various types are illustrated, several of which are depicted in the illuminated initials. Knowledge of opiates and soporific drugs, which had been intro-

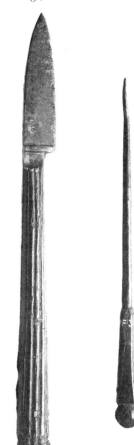

duced to Western Europe from the East by the eleventh century, and the dissection of human cadavers, practiced in medical schools throughout the late Middle Ages, greatly improved both the technique and efficacy of surgery. These two instruments, a lancet for making incisions and a probe for examination, were two of the commonest types of medical tools. In both cases, the tang of the instrument extends through the handle for counterweight or balance, and both handles are faceted to ensure a firm grip. Surgery, as these two instruments indicate, was limited to external operations or, at most, to the superficial treatment of wounds and occasional amputation of limbs, since there was no means of anesthetization. It was only with the introduction of anesthesia that the advances made during the late medieval period in the design of instruments could be applied in practice.

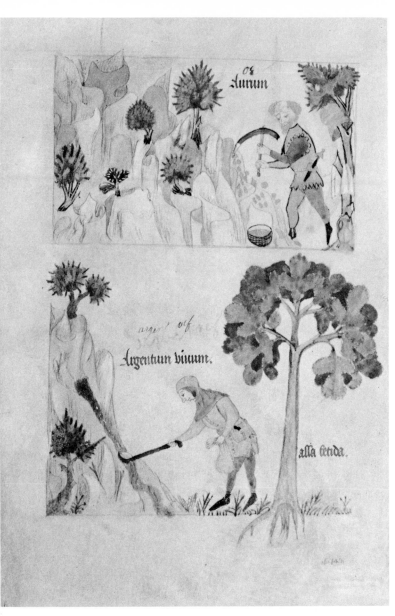

exertion blow the glass bubble on the end of the pipe. The potholes where the glass was heated in the furnace and the annealing oven with finished pieces can be seen at the top.

214. CALENDAR BOOK
Published by Johann Schönsperger
Germany, Augsburg
Circa 1484
Incunabulum on paper, H. 7⅝ inches (19.3 cm), W. 5½ inches (14 cm)
The Metropolitan Museum of Art, Harris Brisbane Dick Fund, 26.56.1
This is the only surviving copy of one of the earliest German almanacs in book form. The almanac, one of the most frequently used books in the late Middle Ages, contained a great deal of useful miscellaneous information. This example contains advice on health from twelve well-known authorities, one section for each month of the year. Also included are the occupations of the months, the planets, the temperaments, the humors, and a section on bloodletting. There are ilustrations of two anatomical figures, one with signs of the zodiac for each part of the human body and another indicating veins for bloodletting. Such diagrams were of significance for medieval medicine, for it was believed that man and his bodily states were closely linked to the movements of the heavens and that various ailments caused by these movements could only be cured under the correct astrological conjunctions; it was considered dangerous, for instance, to treat with a knife or apply medication to the afflicted part of the body if the moon was in the sign governing that particular organ.

213. COMPENDIUM SALERNITANUM
Johannes Platearius
Italy, Venice
Mid-XIV century
Manuscript on vellum (codex), 94 folios, H. 11⅜ inches (29 cm), W. 7⅞ inches (20 cm)
The Pierpont Morgan Library, Ms. M. 873
During the early Middle Ages, the medical school at Salerno served not only as a center for training physicians, but also as a repository for medical knowledge, where the works of the writers of antiquity and the scholarship of the Arab world were brought together. Johannes Platearius studied there in the twelfth century and compiled from various sources a listing of the medicinal properties of plants known as the *Compendium salernitanum*. The text was copied many times and was widely disseminated throughout Western Europe. This copy, made in northern Italy in the middle of the fourteenth century, lacks Platearius' text. Illustrations of various plants are arranged alphabetically by name and, because of the particular species chosen, the work has been identified with a Platearius manuscript. In addition to the plants, this copy also includes some animal drawings, such as that of the cantharis beetles on folio 90, as well as an occasional representation of human industry like the scenes of mining that accompany illustrations of various rocks and the depiction of glassblowing. Lacking the text, one has no clue as to the reason for including this last scene which appears in only one other copy of Platearius now in the British Museum. The interest of the scene lies in its description of the method of glassblowing in the fourteenth century. The two glaziers with cheeks puffed from

Bonifacio di Calabria
Italy, Venice
First quarter of the XV century
Manuscript on vellum (codex), 108
folios, H. 14¼ inches (36.2 cm), W.
10⅜ inches (26.4 cm)
*The Pierpont Morgan Library, Ms.
M. 735*
The fastest and most efficient means

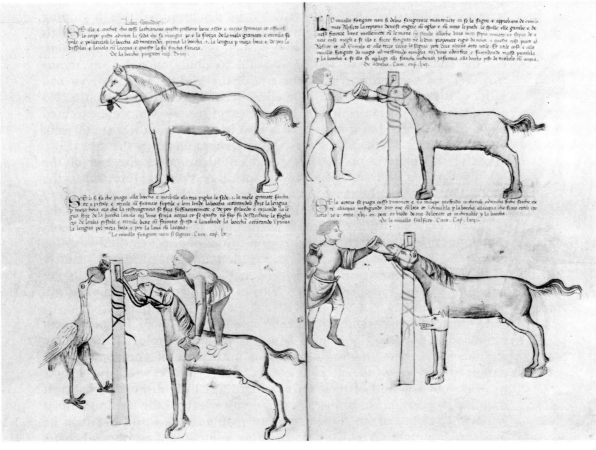

of overland transportation in the
Middle Ages was on horseback. It is
understandable, therefore, that vet-
erinary medicine of the period con-
centrated on the rearing and care
of the horse. Bonifacio di Calabria's
treatise on the subject was first writ-
ten in southern Italy in the last
quarter of the thirteenth century,
but its popularity led to many copies
and expanded versions.

The present manuscript, an early
fourteenth-century copy, was owned
in the first part of the sixteenth cen-
tury by Giovanni Maria della Salla,
master of the stables of Alfonso
d'Este, duke of Ferrara. Its exten-
sively illustrated text describes the
physical appearance and character-

istics of the horse, gives advice on
rearing and breeding, and describes
symptoms and cures for various mal-
adies as well as precautions against
accidents that could happen to the
animal. Four chapters are devoted
to the treatment of diseases. In the
chapter on diseases of the skin, the
author describes remedies for ulcers
and scratches, and a bloodletting
chart designates the points for mak-
ing incisions. On folios 81 verso and
82 recto, illustrating the chapter on
internal diseases, methods of giving
medicine to the horse are shown,
including the use of a funnel as a
means of pouring the potion down
the horse's throat; a fanciful note is
seen in the large crane who appears

to be helping the process. The
manuscript also includes, as in the
case of treatises on human medicine,
certain aspects of the art of a less
scientific nature. There is, for exam-
ple, a zodiacal diagram of the horse
showing which signs affect which
parts of the animal's body. The lo-
cation of these signs correspond to
those on zodiacal charts of the hu-
man being as illustrated in many
medieval examples. The two fish of
Pisces affecting the feet, which in
the zodiacal man are placed one on
each of these extremities are, in the
case of the horse, distributed on two
of the four feet of the animal, while
the other two feet rest in water to
suggest the environment of the sign.

216. ON PREPARING THE PHILOSO-
PHER'S STONE
George Ripley
England
XVI century
Manuscript on vellum (roll), H.
55⅛ inches (140 cm), W. 21¼ inches
(53 cm)
*Princeton University Library, Gift
of Robert H. Taylor, Ms. 93*

Among those scholars interested in
the alchemical principles of matter
from the philosophical point of
view was George Ripley. Like many
of his contemporaries who dabbled
in alchemy, he was a theologian, a
canon of Bridlington in England
until his death in 1490.

In his poem on the preparation
of the philosopher's stone, Ripley
combines religious symbolism and
chemical formulas in a description
accompanied by elaborate diagrams
detailing the process. The "Great
Work" (the finding or preparation
of the stone) involved twelve opera-
tions by which matter could be
changed, among them: distillation,
calcination, and fixation. These op-
erations performed in proper se-
quence and employing the proper
combination of materials would sup-
posedly produce the philosopher's
stone. In order to understand the
Great Work, as it was called by late
medieval alchemists, one must re-
member that alchemy is composed
of qualities borrowed from other
disciplines. Numerology, music, art,
and astrology all contributed factors
such as the cosmic significance of
numbers, harmonic motion, color
properties and changes, and the ef-
fects of the zodiacal signs. In the
preparation of the stone, four prin-
cipal colors were said to make their
successive appearance. These colors:
black, white, citrine, and red were
associated with the four elements
and the four humors of the body.
If these colors appeared in the
wrong order the operation had to
be started over again.

The portion of the roll shown
here illustrates the appearance of
the red color or tincture which is
associated with the caloric humor.
Because of its red color it is also
known as the *elixir vitae*, the life
supporting substance equated with
blood. The appearance of the red
tincture, the ultimate stage in color
change, is represented here as the
fountain of life. For the philoso-
pher-alchemist, the stone itself was
the agent for curing all human ills
and conferring longevity. The prac-
tice of alchemy existed long after
the close of the Middle Ages. From
its beginnings as a study of the four
elements: earth, air, fire, and water
and their qualities, it had developed
by the seventeenth century into the
basis for modern chemistry.

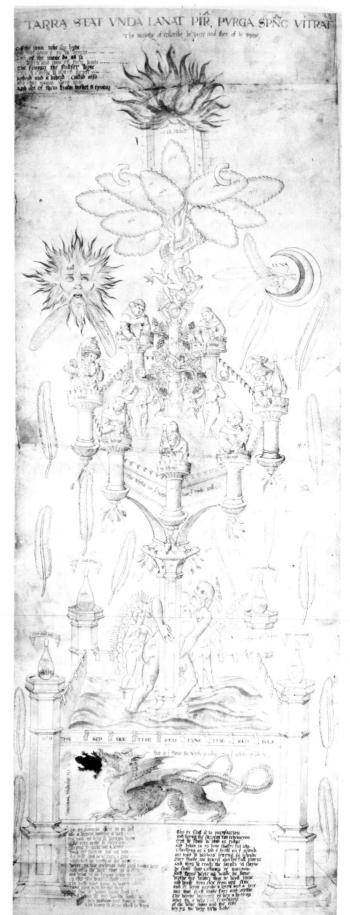

217. THE VOYNICH "CIPHER" MANU-SCRIPT

Western Europe
Circa 1500
Manuscript on vellum (codex), 102 folios, H. 9¹⁄₁₆ inches (23 cm), W. 6³⁄₈ inches (16 cm)
Beinecke Library, Yale University, Ms. 408
(See color plate no. 9)

An astrological treatise, an alchemical book, an herbal—the Voynich "Cipher" manuscript may be all of these in combination but no one can, at this juncture, be certain. It has been called "the most mysterious manuscript in the world," which is probably not an exaggeration. Though the book is profusely illustrated with drawings that are, at first observation, perfectly comprehensible, and though it is written in a hand that, at first glance, appears perfectly legible, no one is now able to interpret the meanings of the illuminations or to read the text.

The manuscript is divided into four parts: an herbal of fantastic plants which have defied classification, a pharmacopeia of equal obscurity, astrological charts peopled with female nudes, and a biological section illustrated with more female nudes, who disport themselves in pools, play with sections of pipe, and strange plants.

The manuscript was discovered by Wilfred Voynich in 1912 at the Villa of Mondragone near Frascati, a summer villa frequented by the papal court. Voynich identified the manuscript as one that had been associated with the English alchemist and scientist Roger Bacon, who died in 1294, and that had been owned by Rudolph II, emperor of Bohemia. Rudolph II may have acquired the book from John Dee, an English attaché to his court (1585–1588), well known for his interest in the occult. The emperor apparently gave the manuscript to Joannes Marcus, rector of the university of Prague, who in 1666 presented it to Athanasius Kircher, one of the foremost Jesuit scholars in Rome.

It seems reasonable to suppose, therefore, that the manuscript must have been in existence by about 1500, but perhaps not much before. Scholars, even those agreeing with, or at least not doubting the "Bacon" provenance, have noticed that there are no erasures or additions to the text, and have surmised that it may well be a copy of a lost original—a fifteenth-century copy of a thirteenth-century text. The circa 1500 dating has been made on the basis of style. The text is now thought to be an artificial or universal language rather than a cipher or code; no one has suggested that it is meaningless.

VI

HUNTING, GAMING, AND SPORTS

Hunting was the only source of meat supply in the early days of mankind, and even in the Middle Ages it still was essential to fill out the meager diet supplied by an agriculture that was barely sufficient at the best of times, and more often than not was plagued by scarcity of food and even outright famine.

The pursuit of game, however, provided excitement for the sometimes tedious and dull life on the feudal manor, and therefore the lord was anxious to reserve this sport for himself. In countries that had not been under Roman rule earlier, but had brought forth the barbarian invaders who had smashed the Roman Empire, the idea lingered on that this was an unjustified usurpation. During the great peasant rebellions in Germany, significantly, the freedom to hunt and to fish were among the twelve basic rights demanded.

In contrast to this, in countries conquered by the barbarian invaders, who made use of whatever remained of the strict organization and supervision by the Romans, such as in France and Spain, the pleasures of the hunt were unquestionably reserved for the lords who held the land. In England after the Norman Conquest, the wild creatures of the forest became "the king's deer," and were jealously guarded from what now was considered poaching —a system particularly difficult to enforce in a country the military strength of which was based upon its archers, and where possession of good yew bows and clothyard arrows as well as the constant practice of archery were strongly encouraged and at times even compulsory for the yeomen of the countryside.

The game animals were divided into two basic groups of creatures—furred and feathered—and methods of hunting devised accordingly. The most exciting and status-indicating style of the hunt was on horseback, were it in the chase of the stag or hart, the hunt of the wild boar of the forest, or in the pursuit of ducks and egrets with falcons.

Both these types of hunting on horseback—chase and falconry—had been introduced into Europe by nomadic horsemen of the steppes, notably the Iranian Alans, who had themselves been allied to those—for us more familiar —Germanic tribes of the Ostrogoths, Visigoths, Burgundians, and Vandals. As a result of pressure from the invading Huns, these originally sedentary tribes adopted the horseman culture of their allies, the Alans, and invaded the booty-promising provinces of the Roman Empire, spreading a new ruling class and a new ethic in their wake, a warrior culture based upon the use of mailed heavy cavalry—Alanic—combined with the mutual loyalty system of leader and follower—Germanic—that finally was to bring forth the knightly class, the feudal system, and the code of chivalry.

With increasing sophistication this chivalrous conduct extended into all ways of life, and especially into the ways of the lordly pastime, the hunt. It is significant that in the romances of chivalry about Tristan and Isolde unfailingly a special point is made of Tristan's knowlege of the niceties in all aspects of the hunt down to the proper way of dissecting the carcass. In the first half of the thirteenth century (1244–48), Emperor Frederick II, *stupor mundi,* himself wrote a treatise about falconry—*De arte venandi cum avibus*—the first scientific zoological work based upon personal observation. In 1387, Gaston III Phébus, count of Foix-Béarn (who possessed more than 1500 hounds at one time), wrote his famous *Livre de chasse,* which served as model for handbooks of hunting for centuries to come, and the hunting

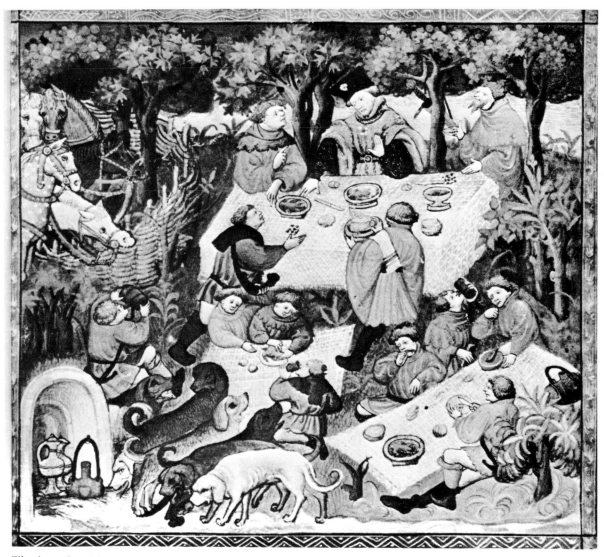

The hunt breakfast, detail of an illuminated page in the *Livre de chasse* by Gaston Phébus, France, 1387 (Bibliothèque Nationale, Paris, Ms. fr. 2691).

Hare hunting with nets and small bells, detail of an illuminated page in the *Livre de chasse* by Gaston Phébus, France, 1387 (Bibliothèque Nationale, Paris, Ms. fr. 2691).

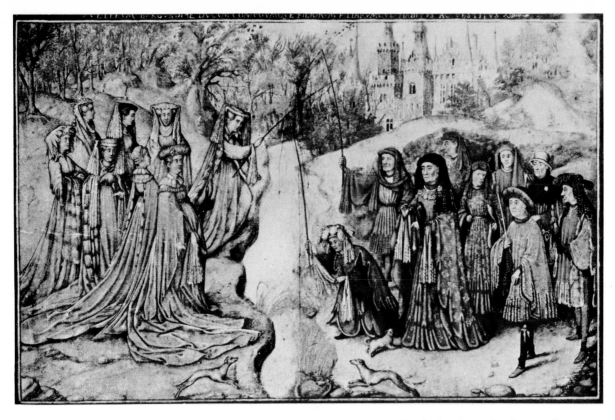

Fishing party, possibly at the court of William VI of Holland, drawing, Flanders, early XV century (Cabinet des Dessins, Musée du Louvre, Paris).

enthusiast Emperor Maximilian had compiled several works about hunting, hawking, and fishing, including topographically oriented handbooks with inventories of given areas, such as the *Tiroler Jagdbuch* (1500) and the *Tiroler Fischereibuch* (1504). In some countries, such as Germany, the way of hunting "according to the art" included the use of a special language with intricately detailed terms, doubtlessly based upon the belief that the animals of the forest could understand human language—the reasoning was probably, "My dog and my horse understand every word I say to them; so why shouldn't the stag or the boar?"—and therefore might guess the hunters' intentions when "normal" words are used.

Besides the practical use of the hunt for supplying food and sport, there was a religious and spiritual significance in the hunt, as understood by medieval man. The stag, who in the words of the psalmist cries for fresh water, was likened to the human soul thirsting for God, and in the *Physiologus,* the popular zoological encyclopedia with allegorical interpretations, and in the bestiaries the supposed enmity of the stag to snakes made him a symbol of Christ.

The hunter became then a symbol of evil, pursuing stag and hare (another symbol for the human soul, because the hare with his short forelegs can be easily caught when running downhill, in the same way as the human soul falls prey to the devil when rushing towards the nether regions of sin), and thus appears in medieval iconography as a reversal of the normal course of the world, the strange concept of the hunter caught by the hares, indicating the victory of the human soul over the devil, who fell into his own snares. Another evil aspect of the hunt was the widespread superstition of the "Wild Hunt," a survival of pagan lore, where the old Germanic storm god Woden on his gray steed, the storm cloud, once led the souls of the

dead warriors riding through the sky. In the Christian Middle Ages, he was replaced by heretic rulers hateful to the Church, such as Theodoric the Ostrogoth, or by local lords of unfavorable folk memory, who were cursed for hunting on a Sunday or, in an entirely different twist, by

> *Kyng Arthour knycht he raid on nycht*
> *With gyltin spur and candil lycht.*

On the other hand, in the ambiguity of medieval symbolism, the huntsman too could be a personification of the human soul striving after a high spiritual goal, as shown in the stag hunt or, more sublimely, in the hunt of the unicorn.

Among the other sports of the upper classes during the Middle Ages the most spectacular—and for us the most typically medieval one—was the tournament, the knightly game of skill in arms and prowess par excellence. Originally straightforward battle-training of the armored fighting men on horseback—*chevalier, caballeros,* and *Ritter*—these events soon became major entertainment for everybody as spectator sports. The practice games that led up to the clash of arms and breaking of lances in the lists were entertaining courses in their own right, and they still survive, such as the tilting

A garden party with card players and chess players, tapestry, Brussels, 1500-1535 (The Metropolitan Museum of Art, Gift of Van Santvoord Merle-Smith, 1942).

at the quintain that is the main attraction of local festivals in quaint hill-towns in Tuscany, and the running at the ring that is the official state sport (by law!) of Maryland.

Tournaments and their gatherings of crowds not only provided entertainment, but a livelihood for armorers, saddlemakers, shield painters, embroiderers of banners, surcoats, and horse trappings, and for minstrels and mountebanks, peddlers, pastry-cooks, and cut-purses as well. Through the introduction of helmets that covered the face, the knight—from the later part of the twelfth century on—had to identify himself by a cognizance painted on his shield, fastened on the top of his helmet or emblazoned on the coat worn over his mail hauberk. This heraldry was to play a major role in the developing culture of chivalry. The participating knights tried to outshine each other in the splendor of their harness and equipment and in the ingenuity of their badges and devices romantically, but transparently, hiding their identity, and equally transparently hinting at that of their lady, for whose favors they challenged their opponents.

A stag hunt, detail of an illuminated page in *Le livre du Roy Modus et de la Reine Racio,* France, XV century (The Pierpont Morgan Library, Ms. M. 820).

The common people, and especially the well-to-do burghers of flourishing cities, not to be outdone by the high style of the nobility, devised their own spectacular entertainments, but based on their own way of fighting, i.e., defending their walled cities with crossbows from the battlements. Every citizen had to keep his own weapons for the defense of the town (if he failed to do so, he might lose his voting rights and face an extra tax as well), and every self-respecting city had an archers' guild, membership in which carried great prestige and status. Their annual shooting contests, the *Schützenfeste* still so beloved in German-speaking towns great and small, were events quite as colorful as the nobles' tournaments, and certainly much more boisterous, since they were usually combined with a county fair and the consumption of strong drink which was considered to be essential to sharpen the eyesight of the marksmen. The shooting was done with crossbows at a man-sized bird in the shape of a heraldic eagle with spread wings on a high pole; the individual feathers and limbs of the bird were numbered

and careful score was kept of the shots. The best shot was declared the "king" for the year (with tax exemption), and the worst was awarded a suckling pig as a consolation prize. In Flanders, where archers preferred the longbow over the crossbow, the target was a wooden popinjay on a pole or sometimes a rooster tied to a wingtip of a windmill in upright position.

Of the other, less strenuous games with competing opponents the most important were board games, particularly chess, and card games. Chess originated in India and spread to the West through the Islamic Near Eastern countries as intermediaries; the original concept of two armies with king, vezier, chariots, horsemen, war elephants, and footsoldiers is much more evident in the Eastern game pieces than in the European version with queen and bishops, though the nearly unlimited power of the queen is a nice indication of the position of ladies in the society of chivalry and courtly love.

Cards, too, were introduced from the East, again they seem to have come from India, and they too are meant to represent opposing armies, with a king, a knight, and a squire, plus faceless footsoldiers (the numerals). Some card systems replaced the knight with a queen, but in some countries it was felt to be indecent to have a lady in the "Devil's Prayerbook." The symbols on the cards themselves were meant to be representations of the four classes of society: peasant, burghers, knights, and clergy as mirrored by the suits of the tarot, staves, coins, swords, and cups (chalices), or the more familiar clubs, diamonds, spades (from Italian *spada*—"sword"), and hearts. The diamonds were actually stylized heads of crossbow bolts, representative of the burghers with their archers' guilds. Forest-loving Germany, on the other hand, developed a separate system of card symbols closely related to the hunt and forestry by using hawks' bells, acorns, linden leaves, and hearts as suit signs, and boar, stag, falcon, unicorn, and other animals to indicate the aces, and some numerals.

Any gambling was, of course, an abomination in the eyes of the authorities, particularly the church, who could point with a shudder to the soldiers at the Crucifixion throwing dice over the garments of Christ at the very foot of the cross. In altarpieces showing the Resurrection, the soldiers guarding the tomb of our Lord might be painted as playing cards to indicate their hardened souls. The tarot cards with their curious Major Arcana were loaded with mystical meaning and used for fortune telling. But even the simpler ordinary cards could reveal a deeper and even deliberately political-satirical meaning with "antiestablishment" tendencies, such as in the very popular German card game *Landsknecht* ("mercenary soldier"), in which the strongest card "that kills all" was the *Untermann*, the lowly valet of clubs represented as the peasant knave called *Karnöffel* (a lout with oversized reproductive organs), and in which the "pig" (acorn two) would beat any king.

Helmut Nickel

The Metropolitan Museum of Art

224a. PAIR OF DICE
Western Europe
XV or XVI century
Bone, with ebony pips, approximately ⅝ inch (1.6 cm) square
Columbia University Libraries, David Eugene Smith Collection, 27.183

224b. PAIR OF DICE
Western Europe
XV or XVI century
Boxwood, approximately ⅝ inch (1.6 cm) square
Columbia University Libraries, David Eugene Smith Collection, 27.184

Dice and knucklebones, from which they are derived, have been known throughout recorded time. Both Sophocles and Herodotus mention their use and examples have been excavated from ancient times. Dicing, for gambling purposes, was, in spite of both civic and ecclesiastical prohibitions, widespread throughout the Middle Ages, and both societies (*scholae deciorum*) and guilds for dicing were known to exist. German mercenaries known as the *Landsknechte,* who increased in number after the decline of feudalism, were notorious for their dicing activities. Although the numbering systems differed, the general shape of dice has not changed since antiquity. The bone dice with ebony pips that are plugged in two sides to seal off the hollow section of the bone closely follow the Roman type and demonstrate their derivation from knucklebones. Dice of wood without inlaid pips were less expensive and readily available to all.

225. FIVE TAROT CARDS
Attributed to Marziano da Tortona
Italy, Milan
1428–1447
Tempera and gold leaf on heavy paper, H. 7⅜ inches (18.9 cm), W. 3½ inches (9 cm)
Beinecke Library, Yale University, Cary Collection
(See color plate no. 10)

The game of tarot or *tarocchi* was an Italian invention. The typical tarot pack consisted of three types of cards: court cards, suits, and trumps. There was, evidently, more than one game that could be played with the *tarocchi,* since the game of triumphs involved only the trumps. In the normal game of tarot, the court cards were higher than the numbered suits, and the trumps highest of all.

These five cards, from a set that must originally have included 105 cards of which only 67 remain, are a Florentine variation of the *tarocchi* known as *minchiate,* which includes 41 instead of the usual 21 trumps. This particular set is further augmented by two court cards in each of the four suits, a lady and an attendant, in addition to the king, queen, cavalier, and valet. Each of the four suits of swords, cups, coins, and staves has ten numbered cards. The set was made for Filippo Maria Visconti and his wife Maria of Savoy at some time between their marriage in 1428 and the duke's death in 1447. The duke's motto, *A bon droyt,* and insigne, a winged serpent, appear on several of the cards, and his name is on the coins. Maria of Savoy's arms are on the Amore trump. The painter of the cards is unknown, but Marziano da Tortona, who lived at the court of the duke, and who is known to have made playing cards for him, has been suggested. Bonifacio Bembo, who painted a similar set for the duke's daughter, but in quite a different style, is not likely to have made this set. Perhaps these cards were a wedding gift from the duke to his bride, and the early date of 1428, before the game had been perfected, might well explain the two additional court cards. These lavishly gilded and exquisitely painted cards would also have served more fittingly as the memento of a royal marriage than as a set for everyday use. Two of the five cards shown are court cards: the valet of cups has the crown of Milan with olive branches embroidered on his cloak; the queen of swords wears a robe patterned with pomegranates, symbol of fertility, and the cape of her attendant bears the inscription HALMENTE, perhaps referring to the sword suit. The two suit cards, the three of swords, and the five

of cups, are painted in blue with silver leaf on a punched gold ground. Death is one of the trump cards of the set. The trump cards have been explained as symbolizing the characters in the carnival procession that took place in Italy on the day preceding the beginning of Lent.

226. PLAYING CARDS: FOUR VALETS
France (Provence)
1440–1460
Woodcut printed and hand-colored on paper, H. 4 inches (10.2 cm), W. 3⅛ inches (7.8 cm)
Beinecke Library, Yale University, Cary Collection

The suit symbols of modern playing cards, spades, hearts, diamonds, and clubs, were introduced into France in the mid-fifteenth century by Etienne Vignole, captain of the army of Charles VII. These four valets or jacks are all that remain from a set that is among the earliest examples of printed cards known. Each card bears a suit sign stenciled on the paper after the card was printed from the wood block, and at the

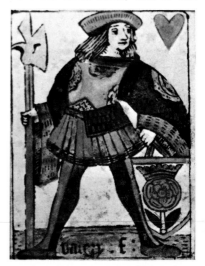

time it was hand-colored. In addition to the suit symbol, each valet has a name originating from the legendary heroes of the *Chanson de geste*. The knave of spades is Hogier, of hearts Valery, of diamonds Rolant, and of clubs Lancelot. The game played with these cards is known as piquet. Only 36 cards were used in this game. The tarot trumps were dispensed with, as well as the cavalier of the court cards, together with the two, three, four, and five of each suit. The four suits represented the four classes of medieval society.

227. PLAYING CARD
Master E.S.
Germany (Region of Lake Constance)
Circa 1450
Engraving on paper, H. 4⅛ inches (10.4 cm), W. 2⅞ inches (7.4 cm)
The Metropolitan Museum of Art, Harris Brisbane Dick Fund, 22.83.-16
Block-printed cards, while having the advantage of mass production, were crudely conceived and lacked the elegance of hand-painted sets. The introduction of engraved cards

around 1450 in Germany helped to solve the problem since the first engravers, presumably goldsmiths, were accustomed to creating impeccably finished designs, more sophisticated and skillfully executed than were the products of their contemporaries, the woodcarvers, who were usually trained as carpenters. Because of their greater refinement, engraved playing cards were eagerly sought as prized items. These cards, because of the wearing down of the copper plate from which they were printed during successive impres-

sions, could only be made in limited editions, available only to a few. Nine sets of tarot cards are known to have been printed in Germany around the middle of the fifteenth century, and two of them are by the Master E.S. This master, known only by the initials with which he signed some of his prints, apparently worked in the region of Lake Constance. The wild woman with the unicorn shown here is one of the two cards surviving from a small set that he engraved around 1450. The other card shows a wild man battling a bear with spikes and a club. The suit sign was evidently that of wild men and women, and these two remaining cards are probably court cards. German tarot cards did not follow the symbols of the Italian *tarocchi* since one finds flowers, beasts, shields, and acrobats used in place of the more conventional staves, swords, cups, and coins. The predecessor of Master E.S., the Master of the Playing Cards, engraved a suit of wild men, and E.S. himself has been associated with a similar suit known from a leaflet of a model book.

228a. TOY FIGURINE: FALCONER
France
XIII century
Lead (fragmentary), H. 1⅜ inches (3.5 cm)
The Metropolitan Museum of Art, Bashford Dean Memorial Collection, 29.158.736c

228b. TOY FIGURINE: FALCONER
France
XIII century
Lead (fragmentary), H. 1⅜ inches (3.5 cm)
The Metropolitan Museum of Art, Rogers Fund, 12.222.2

These figurines were dredged from the Seine in Paris and are said to have fallen through cracks in the floor of a booth standing on one of the bridges crossing the river. They represent falconers in the dress of the thirteenth century. One of them has unfortunately lost his falcon from his fist. The casting in lead of these figurines was most skillfully done in a tripartite mold with a special wedge-shaped piece inserted

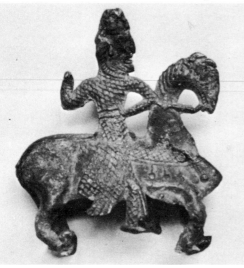

to splay the horses' feet apart. Cast onto the horses' hooves are tiny loops, through which axles for wheels could be inserted so that they could be rolled along or pulled by a string. These axle loops are the proof that these little figurines were actually toys, quite possibly the oldest surviving "tin soldiers."

229. PEG TOP
Western Europe
XVI century
Wood and iron, H. 2¾ inches (7 cm), Dia. 1⅝ inches (4 cm)
The Royal Ontario Museum, Toronto, 927.28.45

Children's toys, of which this top, found in London, is an example, were as varied in the medieval period as now. Dolls, hobbyhorses, marbles (known as basses or bonces), knucklebones, hoops, kites, as well as noisemaking toys, such as horns, drums, rattles, and whistles, are among the playthings known from representations in art and written accounts, as well as from some extant examples. Tops themselves are known from antiquity; the earliest were spun tops, started by a string, and possibly developed from the primitive spindle whorl used in spinning. The whip top is thought to have originated in China or Japan. It is possible that this medieval top was of the latter variety, set in motion by flailing it with a short whip, as seen in a marginal illustration in the book of hours of Jeanne d' Évreux illuminated before 1328 by Jean Pucelle. Spun tops are also known to have existed in the earlier Middle Ages. This particular top has, through its center, an iron pin on which it pivots when in motion.

HUNTING

Perhaps the primary form of outdoor amusement among the nobility and upper classes was hunting, which could be classified in two main types: venery, which involved the direct pursuit of animals, and falconry, which involved the use of birds of prey. The vast manorial preserves of the nobility abounded with game and fowl which were hunted not only for food, but also for entertainment. The activity was pursued with fervor and pleasure by both noblemen and their ladies, the latter riding astride as well as sidesaddle.

Large animals such as bears, wild boars, wolves, and various kinds of deer were chased by large, trained dogs bred for the hunt. Among these dogs were the rache or scenting hound, the greyhound, and the mastiff. The dogs brought the quarry to bay ready to be killed by the hunters' knives and spears. Dogs and ferrets were also used to flush out smaller animals, such as foxes, martins, hares, and fowl, such as partridges and even cranes. For the pursuit of these smaller creatures, however, falconry was a commonly adopted method of hunting. Falconry or hawking was of particular value in killing birds, for though these could be shot down with bow and arrow, the swift and highly trained falcons and hawks could bring down birds which had flown beyond shooting range.

Hunting and falconry were regarded in some regions not merely as amusement but as an art. Traps, snares, and nets were generally considered less sporting. It is interesting in this connection, however, that a Portuguese edict of 1425 permitted the inhabitants of the region of Évora to use these devices in hunting; this has been interpreted as recognition that for the lower classes hunting was not a mere pastime but an activity of economic importance. Though illegal hunting on manorial preserves was severely punished, and legal hunting rights could only be obtained in exchange for payment of some kind, the bourgeoisie and peasantry did hunt. For them the hunt fulfilled a practical purpose; for their social superiors it was a skilled pleasure.

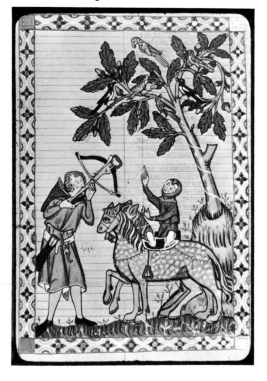

Bird hunting with a crossbow, detail of an illuminated page in the *Manessa Codex* by Kol von Nussen, Switzerland, XIV century (Universitätsbibliothek, Heidelberg, cod. pal. germ. 848).

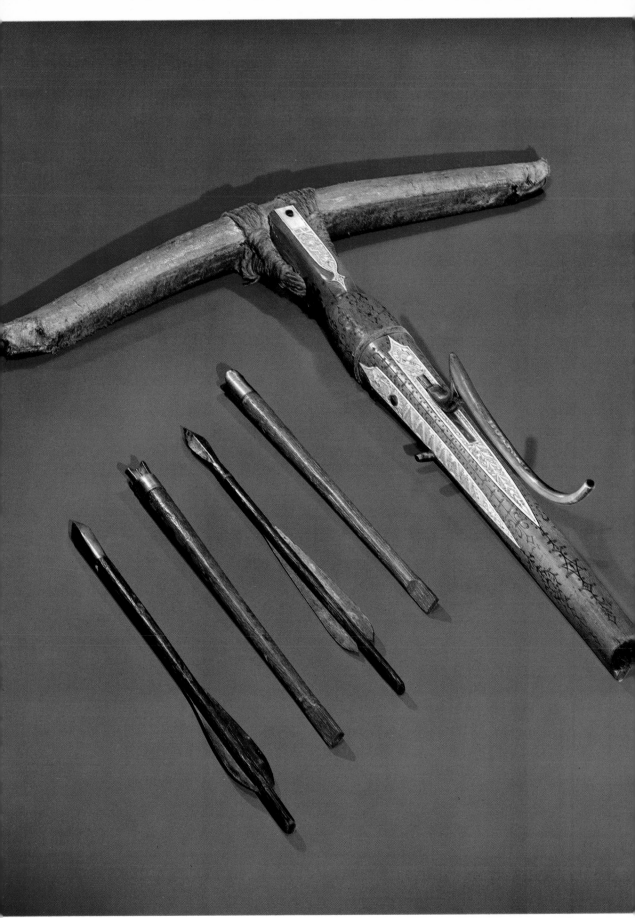

 PLATE 11 Cat. Nos. 236, 237 a-d

233. HUNTING SWORD
Austria (Tirol)
Circa 1500
Steel and brass, with wood inlays,
L. 49½ inches (125.7 cm)
*The Metropolitan Museum of Art,
Bashford Dean Memorial Collection, 29.158.704*

When hunting in the deep forests
that once covered the greater part
of what is now Germany, Austria,
and Czechoslovakia, a stout hand
weapon was necessary, to cut one's
way through the tangled under-
brush or, as a last resort, if one ran
unexpectedly into a bear or wolf.

More elegant hunting swords like
this one were worn by the lord of
the hunt and his noble guests. Being
single-edged, they are strictly speak-
ing long knives, but because of their
size and cross-shaped guard the term
"sword" became established. They
were used for the coup de grace, or
piercing the throat of the wounded
animal, which was the right of the
lord of the hunt at the end of the
chase or of the lucky marksman,
whose bolt had felled the prey. Be-
sides their use as hunting weapons,
they were worn as civilian weapons
by fashionable young men.

234. HEAD OF A BOAR SPEAR
Austria
Late XV century
Blued steel, with engraved latten in-
lays, L. 18¼ inches (44 cm)
*The Metropolitan Museum of Art,
Gift of William H. Riggs, 14.25.321*

The most remarkable feature of this
spearhead is the pair of projecting
flanges at the socket, which formed
a bar that prevented the blade from
entering too deeply, and kept an
onrushing boar a full shaft's length
away from the huntsman. The finely
engraved figures of a boar and a
hound on the crossbars indicate this
type of hunt; the acorn, a decora-
tive motif connected with woodcraft
and very popular in German-speak-
ing countries, also appears. Toward
the end of the fifteenth century and
during the sixteenth it became fash-
ionable to have the crossbars not in
one piece with the spearhead, but
attached by a heavy rivet as a mov-
able steel toggle or carved of a
piece of staghorn, and tied on by a
strong leather strap.

In order to give a firm grip on
the shaft, which might become slip-
pery with rain or dew, the shafts of
boar spears were carefully selected
from naturally knobby woods such
as hawthorn, sometimes improved
upon artificially by nicking the bark
of the living sapling to produce cal-
louses and thick scar tissue. At other
times, they were made of tough,
straight woods, such as ash, but
wrapped crisscross with leather
straps nailed on with heavy brass
studs.

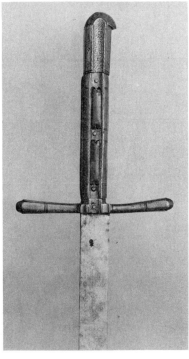

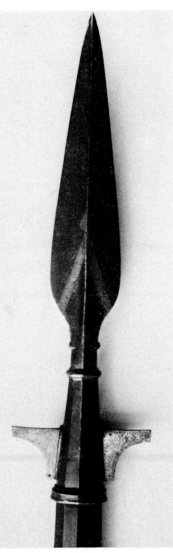

235. BOAR SWORD
Germany
Early XVI century
Steel and wood (on blade, maker's
mark: shield with flowering tree
flanked by initials NS), L. 54 inches
(137.1 cm)
*The Metropolitan Museum of Art,
Rogers Fund, 04.3.26*

Strangely shaped boar swords, with
their lanceolate double-edged heads
on long shaft-rods, such as this one,
were used in the hunt of the wild
boar on horseback. Often they had
a movable toggle set into the rod
just above the blade. This served
to keep the stabbed animal at a safe
distance. The huntsman himself

often wore leg armor—a quite un-
usual feature—as protection against
the murderous tusks of the boar.
The hounds that held the boar at
bay were sometimes protected by
buckled-on thick quilts, or in some
cases even by carefully fashioned
plate armor of steel (there is one
such suit of armor, made for a
hound of Emperor Charles V, in
the Real Armeria, Madrid).

It is thought that the boar sword
was invented by the hunting en-
thusiast, Emperor Maximilian. In
any case, it did not become popular
outside of Austria and Germany,
and went out of use before the
middle of the sixteenth century.

236. HUNTING CROSSBOW
Germany (Württemberg)
1460
Wood and horn, with staghorn inlays and steel tiller, L. 28¼ inches (71.8 cm)
The Metropolitan Museum of Art, Rogers Fund, 04.3.36
(See color plate no. 11)
The carved staghorn inlays on the stock of this crossbow include the arms of Ulrich V, count of Württemberg—*or,* three stag's antlers *sable;* crest: a hunting horn with a plume of peacock feathers in its mouthpiece—as the hereditary master of the hunt of the Holy Roman Empire, and of his wife, Margaret of Savoy—*gules,* a *cross argent.* The date 1460 carved at the ends of the lengthy religious inscriptions in Latin is that of their marriage. A peculiar feature is the inlay with the inscription in Hebrew letters, which may be translated into German as: HAB.GOT.LIEB.HOCH.HERZE ("Love God dearly, high heart"). The Hebrew letters were presumably chosen because Hebrew was thought to have been the language in which God spoke to Adam.

The crossbow was the perfect hunting weapon with its silent discharge, great accuracy, and power of penetration. While a longbow had a "pull" of 40–60 pounds, a crossbow easily had several hundreds. The strong bows were built up from layers of horn, whalebone, and flexible woods, covered with birchbark against the wet. In the late fifteenth century, steel bows were introduced, but were not practical in the northern countries, because they were likely to break in very cold weather.

237a–d. FOUR CROSSBOW BOLTS
Germany
XV century
Steel, wood, and leather, L. (of largest) 15½ inches (39.4 cm)
The Metropolitan Museum of Art, Gift of William H. Riggs, 14.25.1591j, 14.25.1591l, 14.25.1604a, 14.25.1604b
(See color plate no. 11)
Crossbow bolts for war and the hunt were sometimes called "quarrels," derived from French *carreau*—"square," because of the cross section of the heads. Fletchings of thin slivers of wood or stiff leather were set at a slight angle to the shaft to make the missile spin for greater air stability and accuracy.

The blunt-headed bolts were for target shooting at the annual *Schützenfest* (marksmen's festival), where a man-sized wooden bird with spread wings mounted on a high pole was shot at and gradually shot to bits. Every single element of the bird was numbered and carefully counted as score points. The marksman with the highest score became *Schützenkönig* (king of the marksmen); he was feasted and paraded through the streets wearing a precious silver collar, and was tax-exempt for the year.

This shooting originally was serious practice for the local militia which every able-bodied citizen was expected to join in the defense of his town, but in due time became a mere folk festival.

238. DOG COLLAR
Germany or Austria
XVI century
Steel, Dia. 8 inches (20.3 cm)
The Metropolitan Museum of Art, Gift of Stephen V. Grancsay, 42.50.535
Wolf packs were common in Europe up to the seventeenth century; in some places they exist even today. They were not only a constant menace to the livestock, but were considered unwanted competition by the huntsmen too. Therefore, the wolves were hunted with great vigor, resulting in their extinction in the greater part of Western and Central Europe.

For the hunt of wolves, specially bred large wolfhounds were used, and they were equipped with spiked collars like this one to protect their throats against the jaws of the wolves.

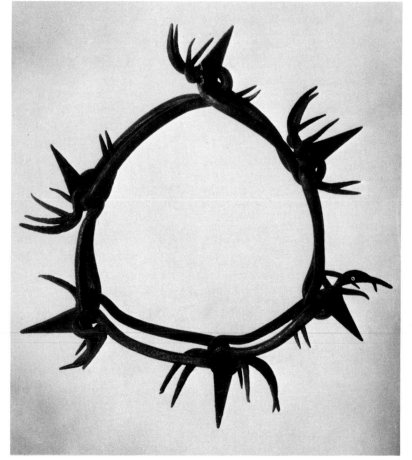

239. HUNTING HORN
France (possibly Burgundy)
XV century
Engraved silver and bronze, L. 12⅜ inches (31.4 cm), Dia. (of bell) 3½ inches (8.8 cm)
Yale University, Collection of Musical Instruments
Signaling with a loudly sounding and far-carrying instrument, such as a horn, was imperative for cooperation within a hunting party. Special signals were employed to indicate whether the game animal was sighted, was at bay, or was finally caught or killed (there were even special signals to indicate what species of animal was found), not to mention emergency signals when a hunter got lost in the trackless forest or had an accident that left him helpless. At the beginning and at

the official end of the hunt—the "Great Halai" (from French, *Ha, là lit*—"Hey, there he lies")—all the horns of the assembled hunters were to be ceremoniously blown in unison "with their heads bared," as the *Livre de chasse* of Gaston Phébus (1387) makes a special point of mentioning.

The hunting horn was hung at the right hip, where it would not bang against the hilt of the hunting sword or knife, by means of a long and wide bandoleer cast over the left shoulder. The lower ranks of huntsmen had their horns made simply of hollowed ox horns, but the material of the horns of their masters might have been anything precious from ivory (the famous *oliphants* of the early Middle Ages) to silver and enameled bronze.

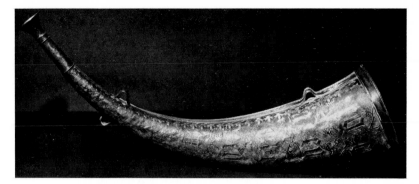

240. CARVING KNIFE
Austria (Tirol)
Circa 1500
Steel, brass, and wood, with bone inlays, L. 18⅝ inches (47.3 cm)
The Metropolitan Museum of Art, Rogers Fund, 1972.95.1
Carving the meat into conveniently sized pieces was a necessity at a medieval banquet because the individual diner did not usually have tableware at his place setting. At best there was a spoon, but there rarely was a fork; fingers or a deftly shaped piece of bread were used to scoop up the morsels.

The carving knives were elaborate, because they were part of the display at the beginning of the banquet that was arranged on side tables and buffets along the walls of the dining hall, together with dishes, goblets, pitchers, etc., ready for use.

This carving knife was probably one of a set made for the court of Emperor Maximilian (1493–1519). Its hilt is decorated on one side with a brass plaque in openwork showing the double-headed eagle of the empire (the opposite plaque is unfortunately missing) and its blade bears a maker's mark in the shape of an ibex. From this and from the general shape of the grip, which is closely related to those of Tirolean hunting knives, it can be assumed that it might have been made at Innsbruck to be used on the emperor's hunting excursions, which included sumptuous picnics.

241. LE LIVRE DU ROY MODUS ET DE LA ROYNE RACIO
Henri de Ferrières
France (Picardy)
1450–1500
Manuscript on vellum (codex), 160 folios, H. 11½ inches (29.2 cm), W. 8½ inches (21.5 cm)
The Pierpont Morgan Library, Ms. M. 820

All manner of game was hunted or trapped during the Middle Ages, and for each type there was an approved or prescribed method of capture. The *Livre du roy Modus* describes these procedures in detail. In the best medieval literary tradition, the book is written as an allegory with expected allusions to the supernatural.

Its chief characters are King Practice and Queen Theory who take their reader, in the person of the courtier, through the intricacies of the hunt. The courtier is instructed in the stalking of deer (actually done by grooms), the etiquette of the picnic, stag hunting, the chase of the hare, the boar, the fox, otters, the netting of rabbits, squirrels, and game birds, and the use of traps and falconry. The final chapters of the book, departures from the rules of the chase but necessary in an allegory, concern the indictment of Satan by Practice and Theory before God, and their final victory over the world and the flesh. First written in the early fourteenth century, the *Livre de roy Modus* was the first comprehensive treatment of the hunt and was copied many times. This example is elaborately illustrated. The miniature illustrated here depicts in considerable detail the implements of the chase and their use in a stag hunt.

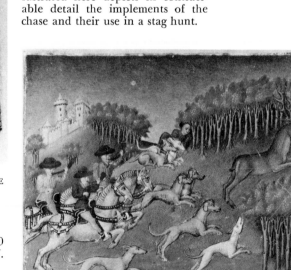

The musical topics in the visual arts of the Middle Ages were for a long time limited to illustrations of the Scriptures, especially of Psalms 43, 71, 92, 108, 147, 150, and of apocalyptical themes. The apocalyptical subjects were:

1. The seven angels with trumpets (Rev. 8: 2, 6).
2. The seven holy men playing instruments in front of the Lamb *(numeri habentes cytharas).*
3. The two figures flanking each of the animals with the Lamb *(tenens cytharam* in Spanish Beatus manuscripts, represented with long-necked fiddles).
4. The seven holy men, *stantes super mare vitreum habentes cytharas* (Rev. 15: 2).
5. The Twenty-Four Elders surrounding Christ in Glory (Rev.5: 8). For the organologist, this theme is by far the most rewarding of the apocalyptical visions.

In illustrating these texts, the artist was usually not free. The interpretation of the Scriptures and of other ecclesiastical texts was provided to him by the Church. He depended on the guidance and often on strict instructions from the ecclesiastical authorities. Yet, within these limits, the artist achieved some freedom by the very nature of his medium, painting or sculpture. Where the Scriptures, the theologian, or the poet used words, the painter

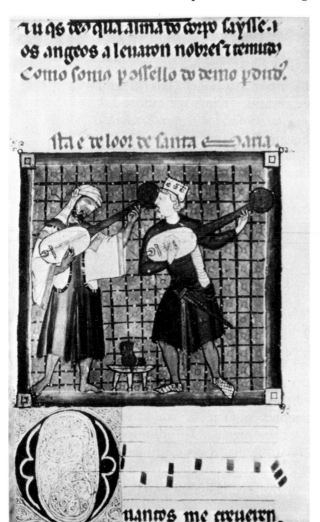

Two musicians, illuminated page in the *Cantigas de Santa Maria* of Alfonso X the Wise, Spain, XIII century (The Escorial, Spain, Ms. j b 2).

The Virgin and Child Surrounded by Angels, Some Playing Musical Instruments, oil on panel by Geertgen tot Sint Jans, the North Netherlands, 1465-1495 (Museum Boymans—van Beuningen, Rotterdam).

and the sculptor were permitted and, of course, expected to add details to create a lifelike, sensuously convincing appearance. For this task, they often turned to mundane objects, for instance, musical instruments. The Twenty-Four Elders depicted in miniatures of Beatus manuscripts, such as those in the eleventh-century manuscript of St. Severus in the Bibliothèque Nationale, Paris, all hold the same kind of instrument—usually vielles of their time. But, as soon as sculptors were commissioned to create the multitude of elders in the portals of the abbey church of Moissac and other Romanesque churches, the natural artistic tendency toward variety gained the upper hand, and though all the elders retain the vielles as their attributes, these instruments were sculpted in many variants (different contours, different number of strings, different shape of sound holes, etc.).

Later, when the elders are shown in the Portico de la Gloria of Santiago de Compostela, they play different instruments including harp, psaltery, organistrum, vielles, and others: a full irruption of secular musical tradition into the realm of sacred art. The sculptor simply took what was familiar to him from his everyday environment, and also familiar to the faithful who felt invited to the church by this concert of the elders.

At this point, one may ask how strict the distinction was between sacred and secular musical practice and whether the instruments depicted in sculpture outside were actually played in church and participated in the liturgy. This is a difficult chapter in the history of church music, revealing the slow, gradual, and hesitating admission of instruments into the service. The Sistine Chapel is still restricted to vocal music, and the organ, today, the proverbial queen of instruments, was banned from church for centuries because in Imperial Rome, the hydraulic organ had provided the customary musical accompaniment to animal and gladiator fights in the circus and, probably, the musical background to the martyrdom of Christians.

The liturgical and moral value of music and its instruments have been discussed and reexamined by the Church with ever-changing results from

portrayed with such precision as to please the eye of every historian of instrumental music, the grouping of the musicians and their combination into ensembles is often far from being true to real practice. And it is here where the iconology of music has to exert much criticism.

A comparison between two extraordinary fifteenth-century paintings, both devoted to the Virgin Mary, may illustrate our problem: the first, by Geertgeen tot Sint Jans, shows the crowned Virgin with the Infant, enshrined by dense clouds of angels, performing angels—in fact, the largest accumulation of instruments depicted at the time. While the painting echoes Gothic tradition in many ways and reveals some familiarity of the painter with the Pseudo-Areopagitan and the Thomistic doctrines (the consonance of instruments symbolizing God as the prime mover of the universe), the single instruments are shaped after early earthly models and the same is true of the manners of performance, notwithstanding the small size of the whole painting.

The second painting, the *Assumption and Coronation of the Virgin* by the Flemish Master of the St. Lucy Legend, combines in a unique and complex composition views of the outer and inner heaven. The Virgin, rising to heaven, is accompanied by many angels; eight carrying her, four singing, eight playing instruments. Portrayed with minute care, they could never form a convincing earthly ensemble, i.e., corresponding to Flemish practice at the painter's time. The eight instruments, including three shawms and a trumpet, would overpower the four singers. The inner heaven, visible through a hole in the clouds, shows God the Father and Christ holding the crown and the Dove hovering above. Here, the proportion between the two groups of performers, eleven singers and six players of soft instruments, is realistic, i.e., corresponding to profane usage.

The last type of pictures that we have to mention in our search for traces of secular musical practice within sacred art are the drolleries—that puzzling branch of medieval imagination where the sacred and the unholy are in close proximity. It offers an untamed ocean of life, full of wild and fantastic creatures, pipes and drums, satyrs and nymphs, jugglers and beggars, foaming with sin and sex, and all this on the margins and between the lines of sacred texts. The pages of Books of Hours admit a crowd of whimsical and funny creatures, laymen and clerics and dream-borne compound animals, such as lion-reptiles and snake-goats, dragons with monk heads and friars with the hind legs of beasts of prey, mingling with the innocent beasts of the woods and fields, hare and deer, birds and monkeys. There are also peasants, shepherds, knights, jugglers, and acrobats. This multitude of creatures inevitably includes many musicians with their instruments, and it is here that we find, besides fantastic instruments and playful caricatures, many exact portrayals of secular instruments and players of the time.

The themes of sacred art listed above, while not the only ones, are probably the most rewarding for the historian interested in the secular music of the Middle Ages. Extricated with delicacy and a critical eye from their celestial environment, they will help to complete our notion of profane musical life and thereby reduce one of the large gaps in musical history of the Middle Ages.

Emanuel Winternitz

The Metropolitan Museum of Art

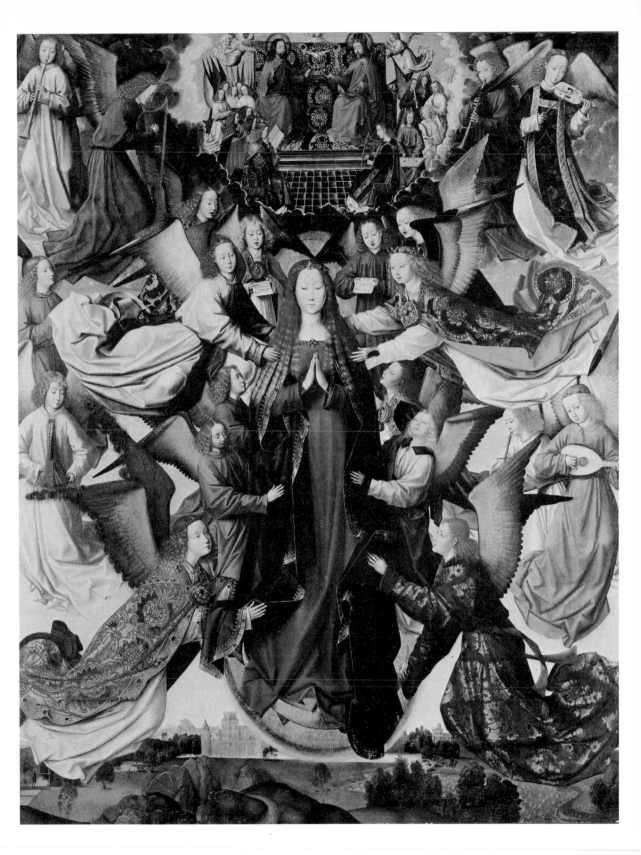

Assumption and Coronation of the Virgin, oil on panel by the Master of the St. Lucy Legend, Bruges, Flanders, ca. 1485 (Samuel H. Kress Collection, National Gallery of Art, Washington, D.C.).

MUSICAL INSTRUMENTS

Because of their fragile substance and utilitarian function, few medieval or early Renaissance instruments survive intact. Among those extant are some preserved more for their visual charm than musical importance. The elaborately carved rebec exhibited here (see entry no. 242), an ancestor of the violin, exemplifies those bowed chordophones mentioned so often in contemporary inventories and held by angels in religious paintings. Accompanying voices and improvising instrumental pieces, rebecs served sacred and secular purposes throughout Europe—though whether this remarkably ornamented one saw much use is doubtful. Such instruments enjoyed an elevated status in the medieval instrumentarium.

Secular, indeed, phallic, in iconographic symbolism, flutes became increasingly popular during the later Middle Ages. Transverse flutes appeared commonly with military and dance ensembles especially in Switzerland and Germany. By the 1520s they comprised a family of varied sizes and pitches, bass to soprano. These were usually turned in boxwood, with a wide cylindrical bore and open fingerholes. More readily constructed, durable, and cheaper than most stringed instruments, flutes and recorders were widely distributed among all classes of musical amateurs as well as professional performers.

Ratchets (cog rattles), familiar today as New Year's Eve noisemakers and children's toys, fall within everyone's ability to perform. Our large crecelle resembles those shown in manuscript illustrations in the hands of men and monsters. Such noisemakers played a part in ceremonies and entertainments, and accompanied watchmen on their rounds. Being a simple non-pitched mechanism, the crecelle could have been fashioned by a talented provincial craftsman. Artlessly naive decoration and a cleverly joined body form an instrument that delighted eye and hand as it assaulted the ear.

These three musical instruments display the range from a highly sophisticated, elite type that might have graced a courtly ensemble, through the elegant simplicity of design characterizing a much-used tool, to the rustic solidity of an object that a child could appreciate. Conventional medieval estimation would have placed the stringed instrument closest to God, the noisemaker farthest, while perhaps the flute was the most mundane.

The Lute Player and the Harpist, engraving by Israhel van Meckenem, Germany, 1495-1503 (Rosenwald Collection, National Gallery of Art, Washington, D.C.).

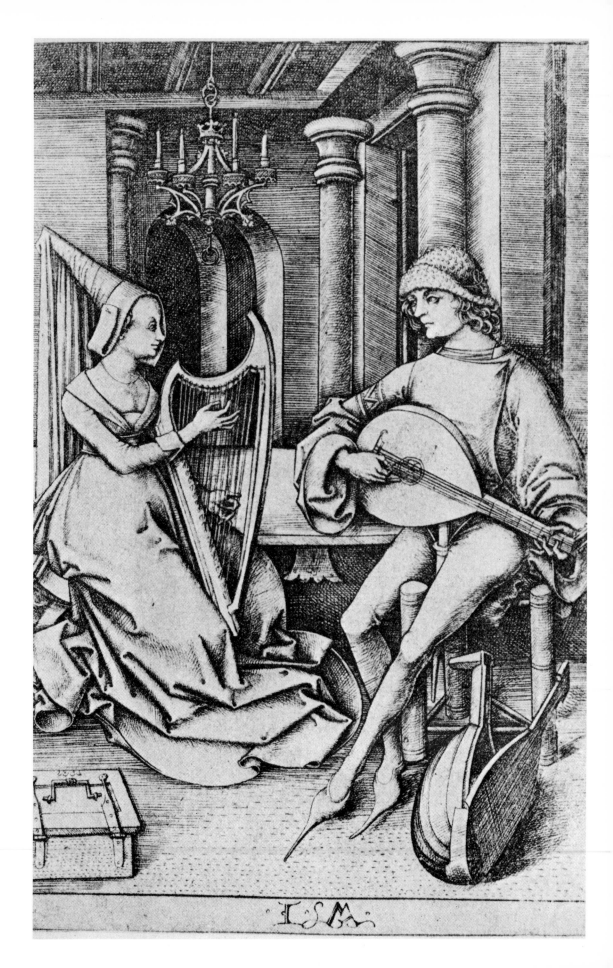

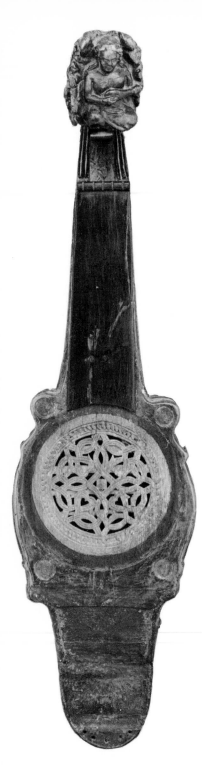

242. REBEC (?)

Northern Italy (?)
Late XIV century (?)
Boxwood, spruce, and rosewood, H. 14¾₁₆ inches (36 cm), L. 3²⁵⁄₃₂ inches (9.5 cm), W. 1½ inches (3.8 cm)
The Metropolitan Museum of Art, The Irwin Untermyer Collection, 64.101.1409
(See color plate no. 13)

The "Untermyer fiddle" has been altered from its original condition so that we are uncertain whether it was meant to be bowed or plucked. However, the small one-piece body's shape, unfretted neck, and lateral pegs (missing) suggest the definition of a rebec. Perhaps its bridge once stood in the shallow groove across a narrow, crude slanting portion of the belly near the tail. Five hitchpin holes occur at the lowest point of the belly; five more appear at the tail. The flat nut has five corresponding notches and the sickle pegbox holds alternately placed tapered holes for five pegs. The nut and rosewood fingerboard are probably of later origin, and the slightly concave, ribbed rose that occupies much of the wider part of the belly could as well have been fashioned in the eighteenth century as the fourteenth. The thin plate into which the rose is set seems to be lacking four circular inlays. Finally, the massive boss at the head has been grafted and there are other evidences of repair. Whatever its original form, the instrument, only about ½ inch deep inside, is unlikely to have produced a very robust tone.

The decorative carvings on the back, excellently done in deep relief, are full of symbolism. A serious-faced falconer and his taller mistress, accompanied by their faithful dog, stand beneath a tree in which Cupid draws his bow. A stag leaps or lies below the couple, while high above the tree, behind the pegbox, a figure in heaven stands with one hand upraised, the other holding an unfurled scroll. Higher still crouches a grotesque monster of the sort that inhabits the margins of contemporary manuscripts. The front of the pegbox boss shows a woman plucking a mandora, perhaps after all the true classification of this unique instrument.

243. CRECELLE

France, Escaladieu Monastery near Bagnères (Hautes-Pyrénées)
XV or XVI century
Oak, H. (of enclosure) 9⅜ inches (23.8 cm), L. 3⅞ inches (9.9 cm), W. 2½ inches (6.4 cm), L. (of handle) 6½ inches (16.5 cm)
The Metropolitan Museum of Art, Gift of Mr. and Mrs. Leopold Blumka, 54.160

Cog rattles or ratchets of this sort still are twirled on ceremonial occasions. Our early example no doubt was played in church in place of the bells that were silenced during Holy Week. The "cage" that encloses the broad wooden tongue even looks like a little church, one end surmounted by a cross and the other by a triple-arched window. Other windows and openings are formed by the ingeniously tenoned and pegged pieces of oak that comprise the enclosure, making the structure open to the stiff tongue's loud clacking against a thick ratchet wheel. Worn areas on the wheel's ridges betoken its use; yet the enclosure's decorative carving remains incomplete. This durable but slightly worm-eaten idiophone was never intended to be visually stunning. Perhaps the carver, who might have been still a boy, tired of cutting hard wood with his none-too-sharp tools. A few test cuts remain within the enclosure. This modest yet charming instrument enjoys much the same limited social status today as it did when new. Its clever, rugged construction commands respect, and its manufacture was largely an act of devotion.

244. BASS FLUTE
Inscribed: IA NENI (Jacopo Neni?)
Probably Italy
Early XVI century
Boxwood, L. 35¹³⁄₁₆ inches (91 cm)
Collection of Dorothy and Robert Rosenbaum

Though transverse flutes of this period are familiar from contemporary illustrations (for example Praetorius' *De organographia* of 1619, which shows many typical Renaissance instruments), this is perhaps the only one surviving in playing condition. Its pitch, with all six finger holes covered, is about the modern G; calibrated marks on the head joint tenon suggest that the flute can be "pulled out" to sound at least a half-step lower. If these marks are in fact a tuning guide, they represent a very early use of this practice. Evidence of repair is shown in the later brass ferrule covering a split in the body joint at the socket; otherwise the flute appears to be entirely original. The care taken in its manufacture shows up in the subtle taper of bore and wall, and the skillful undercutting of finger holes. The small size of the oval embouchure is surprising. This opening is so placed, with its major axis across the head joint, as to allow the flute to be held at an oblique angle to the player's lips, a position common at that time. The flute, lowest member of the consort illustrated by Praetorius, has a diatonic range of two octaves.

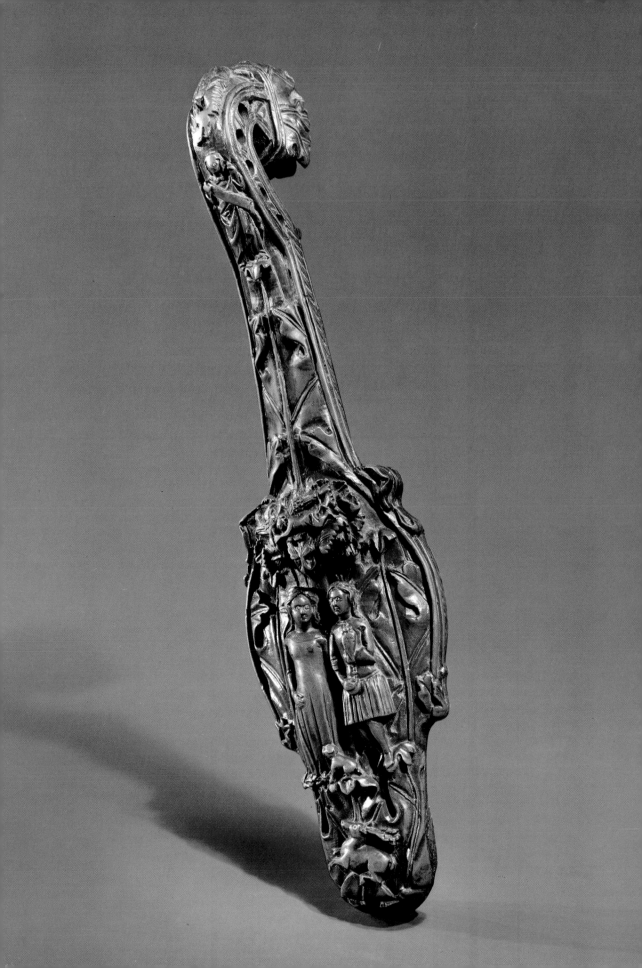

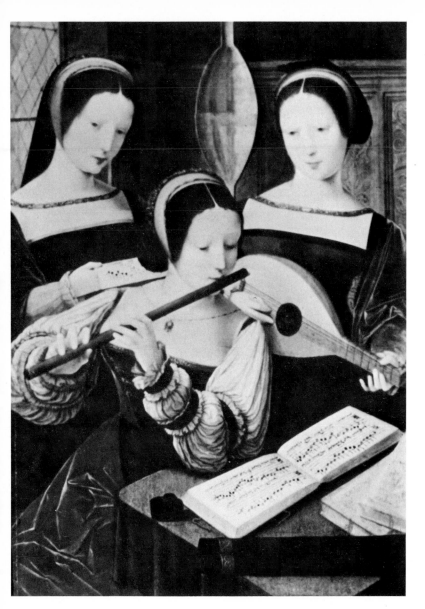

A concert with lute, transverse flute, and voice, oil on panel by the Master of the Half-Lengths, Flanders, XVI century (Harrach Collection, Vienna).

245. CHANSONNIER
France (Burgundy)
Circa 1480
Manuscript on vellum (codex), 81 folios, H. 7½ inches (19 cm), W. 5¼ inches (13.4 cm)
Beinecke Library, Yale University, Ms. 91
(See color plate no. 12)

The "Mellon *chansonnier*," named after its donor to Yale University, comprises a collection of 57 compositions in three and four parts, nearly all secular and mainly Burgundian in origin. The mixture of languages (French, Italian, English, Latin, and Spanish) and varied musical styles point to a fertile confluence of composers present at the courts of Philip the Good, Charles the Bold (an amateur composer and pupil of Robert Morton, an English composer represented in the manuscript), and Mary of Burgundy. Brilliantly illuminated initials and floral ornaments in red, blue, and gold

testify further to the Burgundian love of radiant color.

Among those composers named in the manuscript, at least ten were at some time around 1450–80 connected with the music-loving courtly establishments. One of these, Antoine Busnois, was responsible for nearly a quarter of the manuscript's contents. In many ways a typical Burgundian composer, though among the finest, Busnois was as well a priest and a poet. His contemporaries saw no contradiction in a musician of the ducal chapel being also a successful composer of *chansons* that deal mainly with courtly love. Busnois, who taught both Charles and Mary of Burgundy, enjoyed friendship with other composers of the first rank also represented in the *chansonnier*, men who borrowed freely from one another's works and whose *chansons* were widely popular in aristocratic circles.

While *chansons* are of course primarily vocal, instrumental parts occur among the different lines. The *chansons* are not disposed in score form, but place each part complete in a separate area of the facing pages. Disposition and notation are normal for the period; what is unusual is that the manuscript was planned as a cohesive unit and written by one scribe. Other *chansonniers* show evidence of having been compiled by several copyists over a longer time, and are often incomplete. Among other features of the Mellon *chansonnier* are its English and Spanish pieces, uncommon in such sources, and particularly those that are unique to this central source (the majority of the Mellon pieces also appear in other manuscripts). Although some of the pieces remain anonymous, musicologists have identified the composers of some of the *chansons* unattributed in this manuscript.

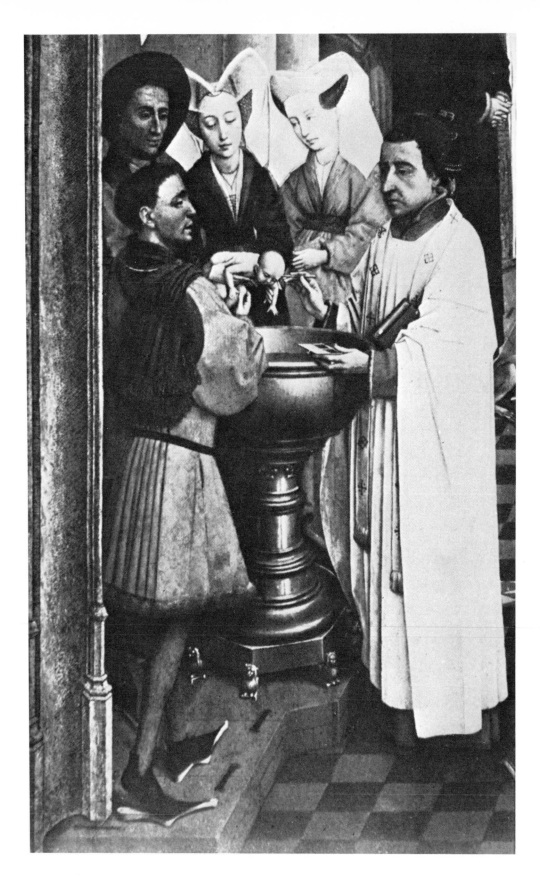

A baptism, detail of the *Altarpiece of the Seven Sacraments,* oil on panel by Rogier van der Weyden, the South Netherlands, 1452-1455 (Koninklijk Museum voor Schone Kunsten, Antwerp).

VIII

CEREMONIES, SECULAR AND NONSECULAR

Between 1300 and 1550, ritual and ceremony dominated both private and public life. Just as before and since that period, ceremonies expressed the community's sense of common purpose, sanctioned the exercise of religious authority and political power, defined the individual's social status, marked the great transitions in his passage from birth to death, celebrated the seasons on which preindustrial society depended, and even regularly provided its principal amusements and diversions. Differently stated, during the Middle Ages and early Renaissance, attitudes toward ceremonial reflected a general tendency of thought. Throughout these centuries, countless works were devoted to ecclesiastical rites, but the secular world too had its rituals; one might note the striking fact that Constantine VII (Porphyrogenitus), a tenth-century Byzantine emperor, wrote *De ceremoniis aulae Byzantinae,* a long treatise which deals not only with the ceremonial at the court of Constantinople, but also with many aspects of Byzantine history and government. Indeed, it is not merely historians of Church or state, of religion or secular society, who must study ceremonial: it is impossible to understand the artistic monuments and even the crafts of the period from 1300 to 1550 without appreciating the degree to which the major and minor ceremonies of life commonly furnished the subject matter of a particular work as well as the occasion for executing it.

Though the Roman Catholic mass and the various Protestant services were probably, for Western Europeans in general, the most important ceremonies, not all ceremonial was essentially religious in character: much was clearly secular, much was indistinguishably religious and secular at the same time. Like a Christian church built on the foundations of a pagan temple, religious ceremonies often conceal secular or pre-Christian origins; for example, Christians appropriated the characteristic position of the hands in prayer from the entirely secular act of homage. In another example, the act of knighting began as a purely secular rite admitting a young man to the fraternity of mounted soldiers, but, as the ceremony was celebrated in literature, it quickly acquired ethical content, and though it never lost all of its secular elements (for instance, it started with a ritual bath), by 1300 it had moved into the church building. Moreover, in a contemporary volume devoted to the details of ecclesiastical rituals, such as the consecration of bishops and the ordination of priests, one finds a scenario for the ceremony of a knighting.

Not all ceremonies tended, as they evolved, to acquire or deepen religious and ecclesiastical overtones. Some of the great festivals of Christian Europe —like the celebration of spring and of the rebirth of vegetation on May Day, and like Carnival just before Lent—had a pagan past, and had successfully resisted the Church's efforts either to abolish or to Christianize them. With feasting and dancing, May Day was a festival for all classes, for tiny villages as well as great cities. In the towns and cities, moreover, the feast days of the Church—Assumption, Corpus Christi, and others—were celebrated with growing lavishness in the fourteenth and fifteenth centuries. On feast days, mystery plays dramatized the history of man's salvation, and great processions bearing religious images moved through the streets. Increasingly, these processions turned into elaborate parades, with music, floats, and dramatic or allegorical tableaux presented by different guilds,

town districts, military units, and religious orders. Feasts, games, performances, and tournaments might accompany the celebration, until eventually the secular display eclipsed the religious observance.

In the life of a lay Christian, however, undoubtedly the most notable ceremonies were those that marked and solemnized the great transitions in his life: birth, marriage, and death. Inevitably, the Church sought to imprint these great events of life; the sacramental system itself was closely linked to them and provided rites of passage to accompany them. The sacrament of baptism admitted a newborn infant into the Church, and into the community of Christians. (Incidentally, 40 days after the birth the mother was "churched," that is, given a blessing by the priest that removed the ritual impurity of childbirth and restored her to full activity in the family and community.) In the fourteenth and fifteenth centuries, the eighth year became the standard age at which children received the sacra-

Funeral procession of Charles VI of France, detail of an illuminated page in the *Chroniques de Charles VI*, France, XV century (Bibliothèque Nationale, Paris, Ms. fr. 2691).

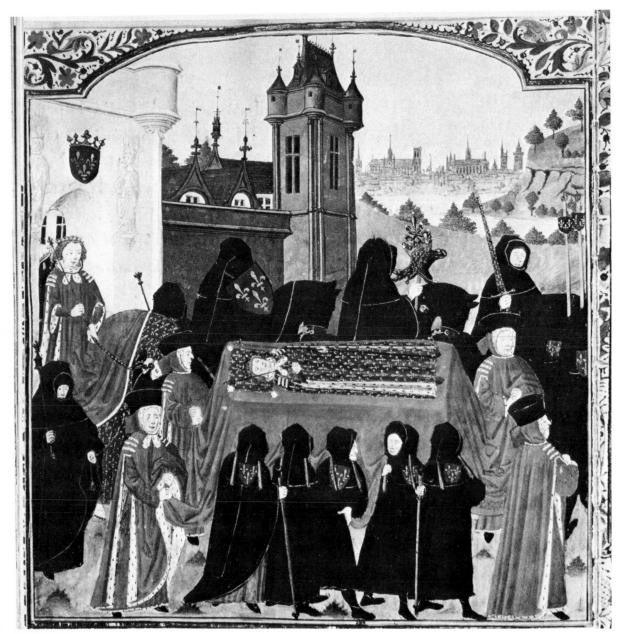

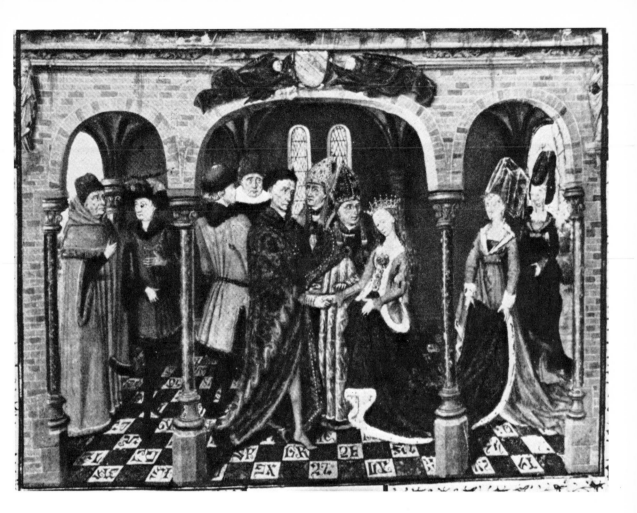

Marriage of Count Girart de Roussillon to the daughter of the count of Sens, detail of an illuminated page in the *Roman de Girart de Roussillon,* Mons, the South Netherlands, 1448 (Österreichische Nationalbibliothek, Vienna, Ms. 2549).

ment of confirmation, which strengthened the effects of baptism. Despite certain secular elements, marriage was always numbered among the sacraments. A dying person commonly received not only the sacrament of extreme unction (a final anointment with chrism which had been blessed by the bishop) but also the sacraments of penance, through confession, and of the Eucharist.

To the modern sensibility, late medieval and Renaissance attitudes toward marriage and death constitute perhaps the least intelligible facets of that era. In particular, attitudes toward marriage were, at one and the same time, more idealistic, more matter-of-fact, and more negative than ours. At least in the earlier part of this period, few voices defended marriage as a choice preferable to celibacy. Women were considered more lustful and incapable of restraint than men. Indeed, late medieval and Renaissance literature made high and low comedy from the miseries and dangers of marriage. An opposing attitude, however, appeared in the tradition of chivalry and courtly love, a tradition primarily supported by the poetry and the popular romances of this age. Undoubtedly the cult of the Virgin Mary and the many tales of her miracles also helped to popularize an idealized picture of women.

Yet the underlying reality of marriage belonged ultimately to questions of

property: marriage was much too serious a matter to be left to the emotions. Most marriages were arranged by parents and, equally for aristocrats, bourgeois, and well-to-do peasants, the essence of the transaction was a simple contract, primarily concerned with property; this aspect of marriage is illustrated in the exhibition by a French marriage contract of 1463 (see entry no. 249). As early as the twelfth century, the Church tried to regulate marriage, but with only partial success. To lessen the risks attendant on the material aspects of that contract and on the youth of the parties (brides were frequently thirteen or fourteen years old), the Church appropriated the ancient Roman law idea of matrimonial consent—"Consent, not sexual intercourse, makes the marriage"—and insisted that both parties freely give their consent. Under the social circumstances, it is perhaps surprising that so many marriages in this period seem truly affectionate and cooperative. Yet, extramarital liaisons were common, widely accepted by aristocratic society (though never by the Church), and perhaps encouraged by the literature of courtly love.

The ceremony of marriage took place in two steps: a betrothal in which one made a marriage promise for the future (*sponsalia de futuro*), and the actual wedding itself (*sponsalia de praesenti*). In fact, the betrothal was legally binding on the parties. It is noteworthy that the nuptial couple, by consenting to their marriage, actually administered the sacrament of marriage to themselves, while the priest played the juridical and theological role of a mere witness. Not surprisingly, therefore, couples frequently dispensed with the prescribed form of a wedding at the door of the church, and entered clandestine marriages. Throughout the fourteenth and fifteenth centuries, the Church fought against these and demanded the publishing of banns as well as the presence of the priest. Only at the Council of Trent in 1563 was the priest's presence finally declared necessary for the validity of the marriage.

Of course, the devout Christian had always been obligated to contemplate death as a release from the miseries of this world and as the possible portal to eternal bliss. Moreover, the state of a Christian's soul at the moment of dying decided his fate forever. Though early Christians had conceived the Christian's death as a victory, the late Middle Ages generally regarded death with dread. Indeed, since the thirteenth century, there had been an increasing popular preoccupation with man's mortality (note the death's head on the rosary bead terminal in the exhibition, see entry no. 254) which, by the fifteenth century, could be described as having become a feverish preoccupation with death. (Ingmar Bergman's film *The Seventh Seal* conveys a vivid sense of this widespread attitude.) Undoubtedly, the Black Death, which first appeared around 1350 and swiftly wiped out a quarter of Europe's population, gave the greatest impetus to this preoccupation. New artistic styles quickly reflected the catastrophic experience, and the dislocations caused by the disaster eventually transformed all aspects of European society. Not surprisingly, this period witnessed the composition of many treatises on "The Art of Dying" (*Ars moriendi*), one of which may be seen in this exhibition (see entry no. 257). In theme, these treatises on "How To Die" resemble the contemporary morality play *Everyman,* which preached the inevitability and sudden unexpectedness of death, the fleeting nature of all worldly powers, pleasures, and values, and the need for confession and contrition. Only knowledge and good deeds, supported by the seven sacraments of the Church, could help the Christian to win Heaven. A comparable theme, the "Dance of Death," found frequent and varied expression in fifteenth-century art, and reached a spectacular culmination in the series of wood engravings by Hans Holbein the Younger, which show Death as a skeleton in the act of carrying off persons of all classes and conditions.

The coronation of a king and his queen, detail of an illuminated page in the *Liber Regalis*, England, late XIV century (Westminster Abbey, London).

Ceremonies also played a central role in the great affairs of state—to mention only a few examples, in the making of war or peace, in the election of a Venetian doge, in the protocols of diplomacy (which originated in this period), and in the opening of an English parliament. Better than any political theory or written constitution, political ceremonies could eloquently

MARRIAGE

Despite the romantic traditions of courtly and chivalric love, marriage during the Middle Ages was in every social class closely bound to financial and dynastic interests, so that marriages prearranged by parents, guardians, and, in the case of serfs, by overlords, were most common. Women, who had been barred from the inheritance of land, as it was originally associated with military service owed the overlord, did acquire in the Middle Ages the right to inherit property. Marriage for the highborn was thus often regarded as a substantial financial transaction, as in fact it was for the serf class, whose children were the property of the overlord. Often, for this reason, during the earlier medieval period, the overlord chose mates for his serfs at an early age. The custom, though exceptional in the late Middle Ages, was still found in fifteen-century Germany. Though such a marriage, considered a feudal obligation, was punishable if contracted without seigneurial consent, women did acquire the right to purchase free choice in marriage (just as men were able to purchase their freedom from feudal military service).

In the strictest orthodox sense, marriage was not originally a sacrament, though it was claimed as one from the time of Peter Lombard onward. It did not become a question of faith until the Council of Trent held it so in the mid-sixteenth century. This was reflected in the secular marriage for which no parties were required to be present (neither priest nor witnesses) except the marrying couple, who verbally pledged themselves and later cohabited. Such a marriage was considered valid and was subject to the same canon law, once contracted, as a marriage performed within the Church.

Despite the reluctance of the Church to dissolve a marriage, certain procedures tantamount to divorce (the word *divortium* does appear in medieval documents though the Church did not recognize divorce) could be instituted to declare a marrage null and void. Foremost among the arguments that a "true marriage" had not taken place, was the discovery, sometimes fabricated (though the strictness of the legal process generally prevented this even in an age with few systematic records), of consanguinity of the couple within the prohibited fourth degree. The discovery of servile ancestry in a wife, or testimony that the marriage had been performed before the parties were of age, and therefore without their legal consent, were other grounds for the dissolution of a marriage.

Generally, marriageable age was considered to be not before 14 years of age for boys and 12 for girls, though as a rule men were not married at such an early age because of the financial obligations entailed in the maintenance of a family. Betrothals, almost as binding as marriage, could, however, be contracted at an early age; these involved the exchange of vows, as well as the exchange of token rings and kisses, in the presence of a priest. A broken betrothal subjected the groom to a forfeiture of a betrothal settlement made on his bride; likewise, after the consummation of the marriage, a gift was often made to the bride in compensation for the loss of her maidenhood.

Customs pertaining to weddings were not dictated by the church but rather by popular tradition. The wedding ring was at first worn on the middle finger of the right hand, later more frequently on the ring finger of the left hand, which was believed to be directly connected to the heart by a nerve or vein. The bride often wore white and let her hair flow unbound, though a description of a sixteenth-century English peasant wedding indi-

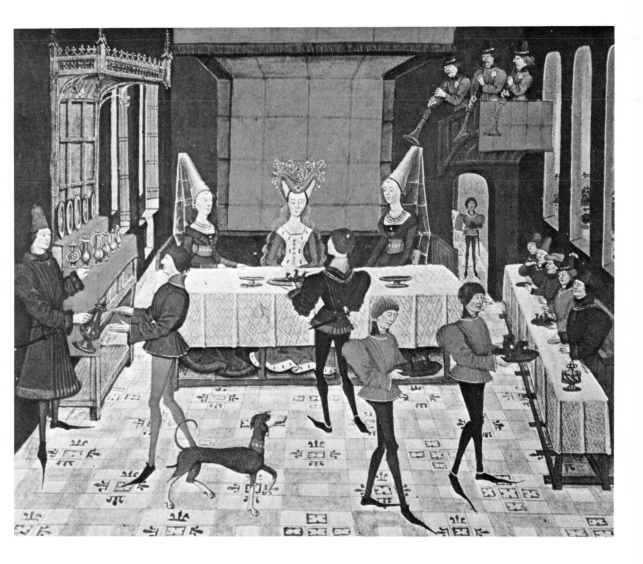

Bride, flanked by maids of honor, at the high table with lords dining at the side table, wedding banquet of Clarisse de Gascogne and Renaud de Montauban, detail of an illuminated page in the *Histoire de Renau de Montauban,* France, 1468-1470 (Bibliothèque de l'Arsenal, Paris, Ms. 5073).

cates that this was not consistently observed, since the bride is described as "attired in a gown of sheep's russet, and a kirtle of fine worsted, attired with abillement of gold, and her hair hanging down behind her, which was curiously combed and plaited." A silver-gilt bride cup was carried before her, and behind her came musicians, then maidens, some with bride cakes, others with gilded garlands of wheat. Grain was often thrown on the bride; a thirteenth-century Parisian account describes a scene of women throwing corn and crying, "Plenté, plenté," invoking abundance. A perversion of this custom can be inferred from the 1289 Bologna statute, reenacted four times in the following 70 years, against those who threw "snow, grain, paper-cuttings, sawdust, street sweepings, and other impurities" at wedding processions. The festivities following the wedding were often of a lusty nature. A complaint by Erasmus against the licentiousness of wedding festivities records the wedding feast open to all of the general populace, at which excessive dancing, eating, and drinking took place.

247. SUMMA DE SPONSALIBUS ET MATRIMONIIS. ARBOR CONSANGUINITATIS ET AFFINITATIS

Johannes Andreae
Italy, Bologna
First half of the XIV century
Manuscript on vellum (codex), 2 folios, H. (each) 17 inches (43.1 cm), W. (each) 11 inches (28 cm)
The Pierpont Morgan Library, Ms. M. 715

These two manuscript leaves contain the concluding portion of the Latin text of Johannes Andreae's treatise on marriage, *Summa de sponsalibus et matrimoniis,* of which printed versions from the fifteenth century also exist. The two large illuminations are charts illustrating the bonds of consanguinity (blood relationship) and of affinity (relationship through marriage). According to canon law, persons who were related by certain blood ties were enjoined from marrying each other; if a marriage had taken place between such persons, their relationship could be considered incestuous and constituted grounds for nullification. For example, a man was prohibited from marrying his deceased brother's wife by the close degree of affinity between them. The problems of this particular relationship were dramatically illustrated in England by Henry VIII's suit for separation from his first wife, Catherine of Aragon, on the grounds that she had been the widow of his brother Arthur.

The miniature of the tree of consanguinity on folio 1 verso shows, diagonally across the image of a paterfamilias, a broad band of white on which are placed red circles giving family relationships, numbered to show the degrees of consanguinity. The miniature of the tree of affinity, folio 2 verso, depicts a blue-robed figure, possibly the author of the treatise, handing a book to a priest on either side of him. Full-length figures of a bride and groom are placed on the far right and left of the miniature. In the lower panel, the degrees of affinity are shown in white circles.

248. MARRIAGE PENDANT
France (Burgundy or Ile-de-France)
First half of the XV century
Gold, enamel, and jewels, Dia. 1½ inches (3.8 cm)
Museum of Fine Arts, Boston, Purchase Fund, 48.262

In the center of this pendant, which was probably intended as a betrothal gift and is adorned with diamonds and garnets, are the figures, enameled *en ronde bosse,* of a man and a maiden, reminiscent of the many fifteenth-century depictions of courtiers and lovers meeting in gardens. However, the formal, almost solemn, pose of the couple does not reflect the dalliances typical of scenes of courtly love. The entwined wreath, forming the frame of the pendant, may have been intended to emphasize the joining of their hands in secular wedlock. The most famous representation of such a private ceremony is the painting by Jan van Eyck, in the National Gallery, London, of Giovanni Arnolfini, a wealthy Italian financier established in Bruges, and Jeanne Cenani.

Inventories list numerous small round clasps of enameled gold, hav-

ing such diverse subject matter as unicorns, stags, dogs, pelicans, huntsmen, and maidens. A pendant similar in composition and in the distribution of the gems to the present, believed to have been made for the Burgundian court, is now in the Kunsthistorisches Museum, Vienna. The couple's pose in that example, however, is slightly more relaxed and affectionate, and their costumes are more typical of the very elegant styles worn by the Burgundian nobility. Those of the Boston pendant are closer to the sober style of dress of the well-to-do middle class.

249. MARRIAGE CONTRACT BETWEEN JEHAN D'ARGENTEAU, SEIGNEUR D'ASCENOY, AND MARIE DE SPONTIN

Belgium
18 December 1463
Manuscript on parchment (folio), H. 20¼ inches (51.4 cm), W. 18 inches (45.7 cm)
Library of Congress, Mercy-Argenteau Collection

On 18 December 1463 "at approximately the hour of vespers," on the road between Ailbailhe and Albans, Jacques de Celles, priest and notary, drew up this marriage contract between Jehan d'Argenteau and Marie de Spontin. The bride-to-be was not present but was represented by her father, Gielle, seigneur of Pousseur. Before witnesses it was agreed that Jehan would "bring to the marriage" his seigniory of Ascenoy and a house in the city of Liège. Marie's dowry consisted of part of the yield from two estates. If either Jehan or Marie died before they had children, the survivor was entitled to keep the marriage portion of the deceased but "for life only." In the event that Marie had children and survived her husband, she was to hold half of his property as her widow's dower, while the other half went to their children. Marie's dowry did not include a sum of money and seems quite modest when compared to the dowries of the higher nobility. In 1423, Philip the Good, duke of Burgundy, had contracted to pay 50,000 *écus d'or* in cash installments as part of the dowry of his sister Anne. Charles VI of France, having granted 300,000 francs in 1404 for the marriage of his daughter Isabelle to her cousin, the poet Charles d'Orléans, later added an extra 200,000. In many instances, the payment of such large sums was long delayed as in the case of Catherine of Burgundy, daughter of Philip the Bold, whose husband received only one-fifth of her dowry of 100,000 francs over a period of 9 years. The contract of Jehan d'Argenteau had three witnesses whose seals were originally attached to the bottom of the document. One of the witnesses, a certain Louise "eldest daughter of Yve," having no seal of her own, was obliged to use that of her uncle, the seigneur of Fauchon.

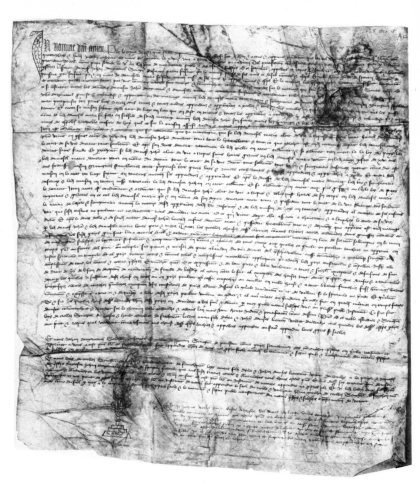

250. MARRIAGE CASKET

Western Switzerland or France (Burgundy)
Circa 1360
Incised, punched, embossed and polychromed leather, H. 5¼ inches (13.5 cm), L. 16⅜ inches (41 cm), W. 5⅛ inches (13 cm)
Philadelphia Museum of Art, Gift of Thomas J., Clarence W., and H. Yale Dolan, 30.1.87

This casket, which is similar in its decorative iconography to the small caskets known today as *Minnekästchen,* is more accurately identified as a marriage casket. The armorial bearings which appear on the lid of the box (on the left those of the Savoy family, on the right those of Montferrand of the Swiss canton of Vaud) indicate a family or political connection between these two houses. It is quite possible that the casket was made for the marriage of two members of these families.

At either end of the front of the casket stand the figures of a pair of courtly lovers; on the left is a lady holding a lute, and facing her, on the right, is her lord. Busts of noblemen and their ladies, encircled by vines as well as medallions with fabulous creatures and birds, surround these figures.

The decoration provides numerous details of medieval secular costume, which support a dating of circa 1360 for the casket. The cowl with a poke, known as a *gugel,* the long, buttoned robe, the kerchiefs on the female heads, the hat with the pointed brim, and the nobleman's belt purse or pouch (this being one of the earliest representations of this particular form, with a single flap which rests directly on the belt) are all recognizable items of clothing of the period, particularly in the regions north of the Alps.

The casket is an exceptionally splendid example of its type. The fine workmanship of the leather covering of the wooden case, the traces of once bright polychromy, and the copper-gilt mountings suggest that this casket was once a valued gift between noble lovers.

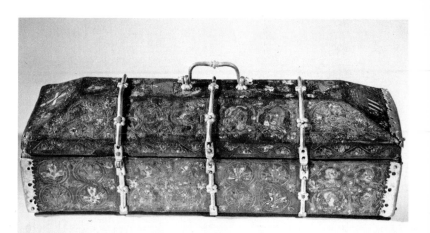

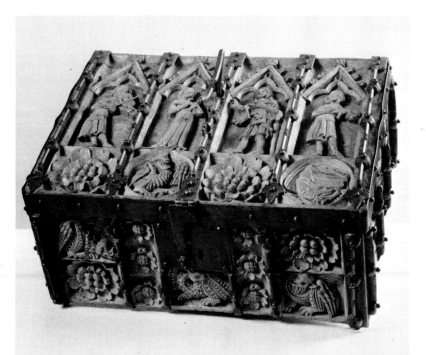

251. BRIDAL BOX
Western Europe
Circa 1400
Carved and painted oak, H. 5½ inches (14 cm), L. 12½ inches (31 cm), W. 9½ inches (24 cm)
Museum of Fine Arts, Boston, Gift of Mr. and Mrs. Alastair B. Martin, 50.33.29
Although caskets with figures of lovers were often courtship and betrothal gifts as well as wedding gifts, the presence of the symbols of love and fidelity (the dog and the arrow) and the addition of the flanking figures of musicians, suggestive of ceremonial celebration, make it likely that this casket was indeed a bridal box. Though it is clearly too small for the storage of household or personal linens, which might have belonged to a new bride, it is large enough to have held an assortment of small private possessions. The lack of any coats of arms and the relative inexpensiveness of the material of the casket, despite its attractive carving, indicate that bridal boxes of this type were made for a general market rather than for a specific individual.

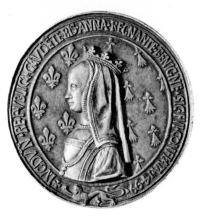

252. MEDAL OF LOUIS XII AND ANNE OF BRITTANY
Nicholas Le Clerc and Jean de Saint-Priest
France, Lyons
1499
Bronze, Dia. 4½ inches (11.4 cm)
The Metropolitan Museum of Art, Gift of George and Florence Blumenthal, 35.77

Portrait medals, derived from antique coins and medallions bearing busts of emperors, enjoyed considerable popularity by the end of the fifteenth century and were made in great numbers. Through the inspiration of a number of Italian artists, notably Pisanello, medals of gold, silver, and principally bronze became the ideal medium for combining the artistry of sculptors with that of goldsmiths. John, duke of Berry, who died in the second decade of the fifteenth century, left a large collection of medals and commemorative coins, both antique examples and medieval imitations. In addition to being prized as collectors' items, portrait medals were often given as presentation pieces.

The present example, with the bust of Louis XII of France on the obverse, and his wife, Anne of Brittany, on the reverse, was struck to commemorate the entry of the recently married royal couple into Lyons on 10 July 1499. Their marriage, achieved through a series of complicated events, by which Anne became both the mother-in-law and wife of Louis XII, was not uncharacteristic of the political matches among the noble and royal ranks. Duchess, in her own right, of the powerful and strategic lands of Brittany, Anne was married by proxy to Maximilian of Austria, who subsequently failed to uphold his pledge to protect her lands. As a result, the marriage was annulled and Charles VIII of France, considerably older, secured her as his wife. As he had no son, the crown was to pass to Louis of Orléans, later Louis XII. Charles took advantage of this line of succession by commanding the marriage of his daughter, Joan of France, to the heir apparent. Upon the death of Charles, Louis, who had always fancied his comely mother-in-law, annulled his marriage and almost immediately wedded Anne. The twice queen of France, who was visiting Lyons for the second time, is portrayed on the medal, encircled by an inscription which in translation reads, "Amid the joy of the commonwealth of Lyons, for the second time under the kindly reign of Anne, thus I was made. 1499." Louis XII is depicted wearing the chain of the Order of St. Michael, while Anne is coiffed in the typical headdress of Brittany. Under each bust appears a lion, the symbol of Lyons.

The model, said to be after a design of Jean Perréal, was made by two sculptors of Lyons, Nicholas Le Clerc and Jean de Saint-Priest. The original medal, in gold, cast and finished by Jean (or Colin) Lepère, was presented to the royal pair on their entrance. Other casts were undoubtedly made in less precious metals at the time and aftercasts, in bronze, were made in 1502 and 1514. The medal was cast then, not only as a presentation piece to commemorate a specific occasion, but also as a more general token of honor to the royal couple.

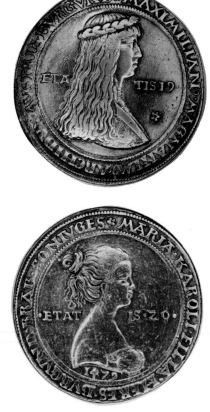

253. TALER OF MAXIMILIAN I OF AUSTRIA
Flanders, Antwerp, 1517
Silver, 30.10 grams
American Numismatic Society, 60.111

To commemorate his first marriage to Mary of Burgundy, and after the death of his second wife, Maximilian of Austria commissioned the original dies of this type in 1511. Dies sent to Amsterdam in 1517 were marked with a rosette on the obverse in front of Maximilian's bust. The prototype is an Italian cast medal contemporary with the marriage.

The transitory nature of life was a dominant theme throughout the Middle Ages. While the principle concern of the early medieval period had been the salvation of the soul, the focus shifted, during the later period, to the evanescence of earthly life. This attitude reflected not only the awareness of the immediacy of death, perhaps heightened by the plagues of the mid-fourteenth century, but also the increasing materialism and individualism of secular man.

Memento mori and *vanitas* themes appeared on a wide variety of objects from pendants to tomb sculptures. Effigies that idealized and perpetuated the memory of the deceased were frequently abandoned in favor of those that portrayed the deceased as a decomposing corpse. The "dance of death" which originated in thirteenth-century French literature characterized death as the universal leveler and ridiculed the helplessness of even the most powerful men in the face of death. Very popular in the late Middle Ages, this theme appeared not only in art, but also was the subject of a pantomime, one performance of which was given at the Burgundian ducal palace in Bruges in 1449. To better prepare man for the inevitable, a book of advice and instruction known as the *Ars moriendi* was written. With the advent of the printing press, this volume became one of the most widely circulated texts of the late Middle Ages.

Funerals, however, tended to mask the loss of the physical being. Accounts exist of noble funerals in which the deceased were represented as living men; a 1375 account of the Polignacs lists a payment of six shillings "to Blaise for representing the dead knight at the funeral." The deceased were also frequently represented by wooden or wax effigies and, in the case of royalty, by leather figures dressed in full state regalia. Occasionally the corpse itself was dressed in its robes of office and displayed on a bier during the funeral procession. The custom of making funeral masks was also a development of fifteenth-century France.

The drama of funeral ceremony was most evident in court circles. Black, the color of mourning, was adopted by the entire court, not only for the elaborately magnificent funeral processions, but for a long period of mourning after the death of a prince or monarch. At the French court, the new king wore red during the mourning period, just as at the funeral of a French monarch, the members of Parliament wore red expressing the concept that the "king never dies." During the period of mourning (which in the case of the queen of France meant a year's seclusion in the room in which she first learned of her husband's death) black covered everything surrounding the bereaved, including clothing and the furnishing of rooms. The funeral in 1393 in Paris of the exiled king of Armenia, however, was a startling exception to this use of color for the funeral was entirely white. The pall covering the coffin was often of plain black cloth but occasionally was also of costly velvets and cloth of gold. During the funeral service itself, the coffin, surrounded by black-clothed mourners, was placed in the center of the church nave, and, in case of grand funerals, was placed within a wood or metal framework (known as a hearse) intended to carry a number of tapers and other decorations.

In preparation for burial, corpses, often embalmed, were wrapped in shrouds knotted at the head and feet before being placed in the coffin, which was usually made of wood or lead; sometimes the body was laid directly in the grave. Great importance was attached to the place of burial and cases are known of great men, dying far from home, whose flesh was separated from the skeleton by boiling, so that his bones could be returned to his homeland for burial.

These customs were consistently observed except in disasters like the Great Plague when the mortality rate rose so rapidly that the bodies of the victims were disposed of in mass graves; contemporary accounts bemoan the fact that even a rich man could be dragged to burial "without lights, without a friend to follow him," and that magistrates and notaries refused to see the dying to draw up their wills.

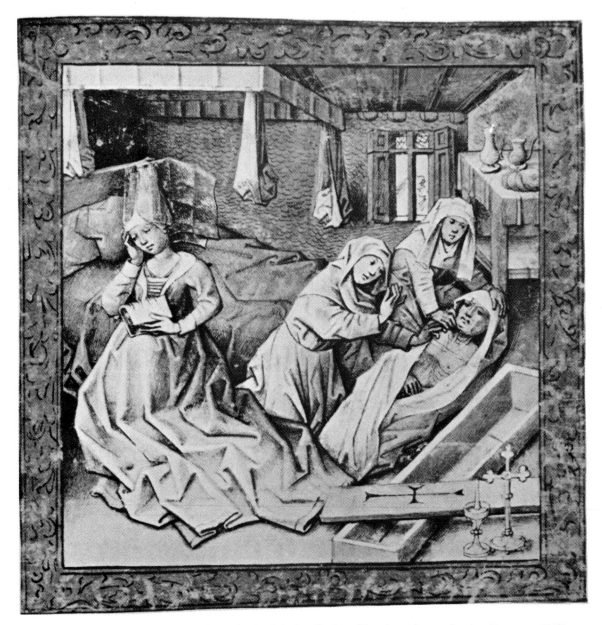

Preparation of the body for burial, detail of an illuminated page in the *Hours of Philip the Good,* Flanders, mid-XV century (Koninklijke Bibliotheek, The Hague, Ms. 76 F 2).

In the late Middle Ages, death was not only a subject of fear but also one of great curiosity and fascination. The venerated cemetery of the Holy Innocents in Paris had become such a popular burying ground in the fifteenth century that graves were opened and the bones stacked in the charnel houses flanking the cloisters in order to make room for more corpses. The cemetery soon became a popular place to visit and shops catering to the tourist trade began to thrive. Cemeteries were even used as the locations for feasts, perhaps an attempt to deny the fear and reality of death which so preoccupied the late medieval mind.

254. PENDANT (TERMINAL OF A RO-
SARY OR CHAPLET)
Northern France or Flanders
Early XVI century
Ivory and uncut emerald, H. 5¼
inches (13.3 cm)
*The Metropolitan Museum of Art,
Gift of J. Pierpont Morgan,
17.190.305*

The ever-present fear and horror of
death instilled by the plagues which
ravished Europe during the four-
teenth century left an indelible im-
pression on the later Middle Ages.
The themes of death and *vanitas*
pervade secular as well as religious
thought and iconography. Both of
these themes by the late fifteenth
and early sixteenth centuries were
widely circulated through the new
medium of printing.

A frequent illustration of the
vanitas theme was that of two young
lovers appearing side by side con-
fronted with a skeleton to remind
them that death was the end of the
vain pleasures of the world. This
pendant, although probably in-
tended as a terminal for a rosary or
chaplet, is a typical expression of
this *vanitas* theme. The two young
lovers, elegantly dressed, are placed
back to back with the rotting figure
of death. While the association with
Adam and Eve and original sin is
intended, the image of the lovers
is essentially a secular one which
can be traced to fourteenth-century
ivories that illustrated the ideals of
courtly love. An inscription on a
similar ivory in the Museum of Fine
Arts, Boston, *Mors quam amara est
memoria* ("Death how bitter it is
to be reminded of you") further ex-
emplifies the sentiment.

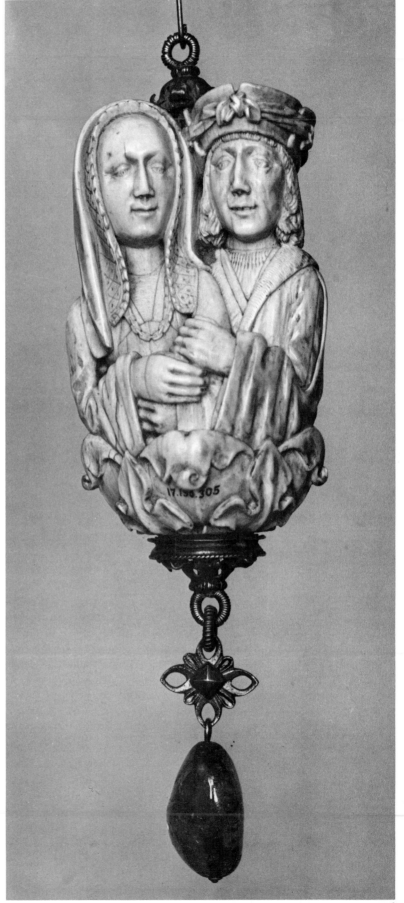

255. NOTARIAL INSTRUMENT CONTAINING THE PROVISIONS OF THE TESTAMENT AND CODICIL OF WAULTIER DE HAUTEPENNE

Belgium
After 7 February 1488
Manuscript on parchment (folio), H. 14 1/16 inches (35.6 cm), W. 13 inches (33 cm)
Library of Congress, Mercy-Argenteau Collection

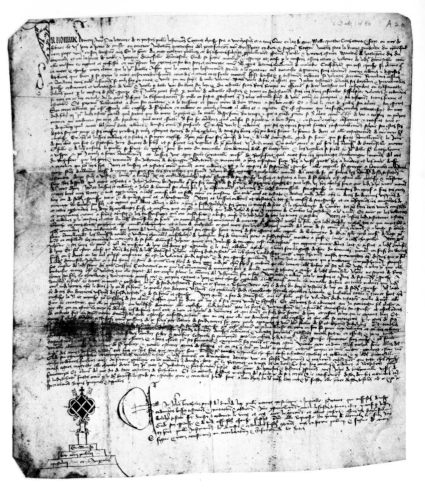

This document was drawn up after the death of Waultier de Hautepenne (February 1488) for his widow, Gude, at the request of their third son, Henry de Barmalz. In his testament, written in Rochefort on 6 February 1487, Waultier had elected the church of Hubert in Ardenne as his place of burial, but in his codicil of 3 February 1488, the location was changed to the church of Hou. As was the custom, he ordered that all his debts be paid. Usually the executors were required to sell the personal property of the deceased to cover his debts, funeral expenses, and the monetary donations made in his testament. The entire library of Charles VI of France, comprised of over 800 volumes, was sold to the Duke of Bedford in England in order to settle the king's debts. A widow could be held legally responsible for her husband's debts, but could avoid this obligation by renouncing her rights to his personal property as did Margaret of Flanders, wife of Philip the Bold of Burgundy, and Jacqueline of Hainaut (after the death of her first husband, the dauphin John, son of Charles VI). Waultier's testament carefully provided for the division of his lands among his surviving three sons and three daughters. He wished his daughter Eve to enter a nunnery "in order to pray for him and for his friends living and dead," but if she decided not to stay there specific alternate arrangements were to be made. Waultier founded anniversary memorial masses for himself, his wife, and their deceased daughter Marie, and made donations to two churches. Of particular interest here is the design drawn at the bottom of the document by the "apostolic and imperial" notary, Jehan Berthelos, a priest of the diocese of Liège. Each notary had a distinctive design which he used instead of a seal. This one is signed on the base in abbreviated Latin form. As this document was not the original testament, it had no seals of witnesses attached to it.

256. LETTRES D'AMORTISSEMENT
OF LOUIS DUKE OF ORLÉANS
France, Vernon-sur-Seine
July 1405
Manuscript (folio), H. 12 inches
(30.6 cm), W. 17¼ inches (43.7 cm)
Massachusetts Historical Society

Louis, duke of Orléans (1372–1407),
son of Charles V of France, gives in
this letter an annual income of 100
livres parisis in the form of a *rente
amortie* to the Celestine monks of
Sens. Because his father had re-
stricted in 1372 the right of amorti-
zation to the king alone, Louis
quotes here in full a letter written
in 1400 by his brother Charles VI
allowing him to make donations of
this type to a total of 2000 *livres
parisis*. Generally in return for an
income of 100 *livres parisis*, the
monks were required to build a
chapel in their church in the donor's
name, and to say in his memory
both a daily mass and an annual fu-
neral mass. Louis had a particular
fondness for the Celestine order and
in his testament of 19 October 1403
provided for the foundation of
chapels in 11 Celestine churches,
giving each an annual income of
100 *livres parisis*. He also allotted
30,000 *francs d'or* for the construc-
tion of a Celestine monastery to
house 12 monks and a prior, either
in Orléans (the capital of his duchy)
or in Blois. Louis designated the
church of the Celestines in Paris as
his burial place, and ordered his
body to be clothed in the habit of
the Celestine monks. He wished to
be buried on a wooden stretcher
with face and hands uncovered (if
his body "could keep without smell-
ing too much"), or, if this proved
unfeasible, his likeness (made prob-
ably out of wax, as was the custom)
was to be used as a substitute. Nei-
ther body nor image was to be cov-
ered with the traditional pall. Louis
also ordered his tomb statue to rep-
resent him as a Celestine, with a
rough-hewn rock under his head
instead of a pillow and another un-
der his feet instead of the customary
"lion or other animal." There is,
however, no evidence that such a
sculpture was ever made. This docu-
ment demonstrates not only the
duke's legacy to the Celestine order,
but his concern with the details of
his own funeral as well. That both
matters were considered in the same
document was not atypical of a
privileged man's attitude toward
death during the Middle Ages.

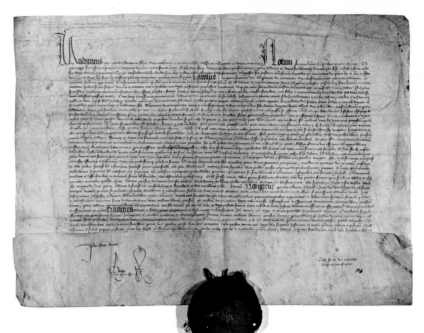

257. ARS MORIENDI
Published by Nicolaus Gotz
Germany, Cologne
Circa 1496
Incunabulum on paper, H. 11 inch-
es (27.9 cm), W. 8¼ inches (21 cm)
*The Metropolitan Museum of Art,
Harris Brisbane Dick Fund, 23.17.5*
This short but very popular book by
an unidentified author on the art of
dying was intended to be a guide in
giving comfort and counsel to the
dying as well as to the living. The
text states that it was intended not
only for "religious and devout men
but also for carnal and secular men."
Since there is only one brief refer-
ence to a priest, it appears that this
little book may have been planned
for those to whom the ministrations
of the clergy were not available. It
has been suggested that the idea for
the book may have originated be-

cause of the number of clergy, as well as laity, who perished in the plague years. The earliest editions were "block books," in which not only the illustration was printed from a woodblock but the text as well. This particular edition was printed with movable type, but contains some of the original woodblock illustrations. The text discusses five subjects: faith, despair, impatience, vainglory, and avarice, each of which is accompanied by a pair of illustrations including the temptations of the devil and the comfort and inspiration of an angel. The eleventh woodcut shows the final deathbed scene of the patient. In it, the dying man has knocked over his medicine table and is kicking the doctor out of impatience. The devil, hopeful that the man's display of temper has cost him the salvation of his soul, has on his scroll "How well have I deceived him," while his wife encourages him with "See how much pain can be endured."

258a. JUG
France, Paris
Circa 1500
Lead-glazed earthenware, H. 4⅜ inches (11.7 cm)
Lent anonymously

258b. JUG
France, Paris (?)
Late XIV century
Unglazed earthenware, H. 4⅝ inches (11.7 cm)
Lent anonymously

Both these jugs, which served as ordinary household vessels, were adapted for use as funerary charcoal burners. Both were excavated under the nave floor of the abbey of St.-Denis, near Paris, and the green-glazed jug was recovered with pieces of original charcoal still in it. The unglazed jug, decorated with a red drip design, was the most ordinary of household vessels, but was converted to a burner by punching air holes in its walls to allow better circulation. The burning of charcoal was a standard practice during funerals of the Middle Ages as the smoke was thought to purify the air and protect against contagion. Being of little intrinsic value, these objects were discarded after use, often simply thrown into the grave. In this case, both, having

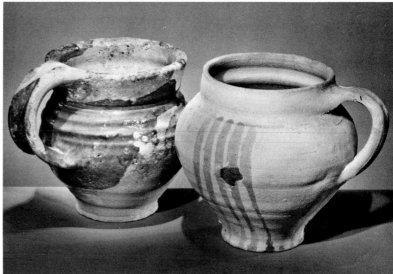

been unearthed from their original graves, were later used as fill for construction or repairs. The fact that they were buried, and fortunately not broken in the process, accounts for their remarkably fresh state of preservation. The green-glazed jug, although it bears a resemblance to English pottery produced in Surrey, was manufactured in Paris, where many other similar examples have been excavated.

259. JEHAN BRACQUE'S ACCOUNT OF THE FUNERAL EXPENSES OF JEHAN D'ORLÉANS

France

October 1393

Manuscript on parchment (folio), H. 6⅛ inches (15.5 cm), W. 7⅛ inches (18 cm)

Folger Shakespeare Library, Ms. X.d. 40

Jehan d'Orléans, third son of Louis duke of Orléans and Valentina Visconti, was born circa September 1393 and died in October of the same year near Paris at the Château of Vincennes, a castle belonging to the king, where, from 1389 to 1396, Valentina and her children were often in residence with the queen, Isabeau of Bavaria. This document relates that the remains of the infant Jehan were covered with a cloth of gold and carried in a hearse draped with black from the "forest" of Vincennes to the church of the Celestine monks in Paris. In the funeral procession were 50 valets dressed in black, each carrying a torch. They had been hired through Jehan Girart, a wax worker, who appears to have assumed here the role of undertaker. One hundred sixty-six pounds of wax, purchased at 3 *sous parisis* a pound, were delivered to Valentina's "fruitier" (a household officer in charge of fruit and candles), and in two days he fashioned 13 large torches, each weighing 4 pounds, three torches weighing 3 pounds, 34 torches weighing 2 pounds, and 25 *cierges* weighing 1½ pounds, all to be used in the church service. This is a rather modest amount when compared to the 1200 pounds of wax that remained after the duke's funeral in 1407 in the same church. The church of the Celestines, adjacent to the royal residence, l'Hôtel St.-Pol, had been founded by Charles V, grandfather of the deceased Jehan, and was consecrated by the archbishop of Sens in 1370. By 1393, it was already the resting place of the hearts of two members of the royal family: Charles V and his wife, Jeanne of Bourbon. During the Middle Ages the separate burial of the entrails, heart, and body of an important personage was a common occurrence.

GENERAL CUSTOM AND CEREMONY

Ceremony pervaded all aspects of late medieval life. For the poorer classes, feast days and commercial fairs provided the occasion for pageantry and festivity. For the middle-class professional and tradesman, membership in fraternal organizations was closely tied to ceremonial activities. A craftsman presenting his "master" piece for acceptance into a guild was encumbered by heavy fees due to the craft court and often by the expense of a banquet for the guild members if the candidate's application was successful. The rules of etiquette for the guild ceremonies and banquets were formulated in their statutes. An amusing example exists in the early regulations of a guild at St.-Omer imposing penalties on those who disrupted the wine drinking assemblies, at which the presence of all guild members was required.

Long after the demise of the feudal system, ceremonial activities associated with it were still observed. Peasants and even freeholders continued to practice ceremonial fealty to their local lords and the titular dependents of higher rank frequently appeared at the manor or court for a variety of traditional ceremonial occasions. The investiture of men into the knighthood and the ceremony of *adoubement,* once the right of the feudal lord, was, after the fourteenth century, the prerogative of the king alone. Such public ceremony constituted a symbolic drama that gave continuity to a changing social and governing order.

The pageantry and ceremony of knighthood found further expression in tournaments and jousting, serious forms of entertainment. Tournaments, a French invention (in England they were controlled by license and at times banned), were in the earlier medieval period true battles between groups of rival knights carried out under established rules until one or the other side proved victorious. Jousting, the ceremonial combat between pairs of knights, became increasingly popular at a later date and was accompanied by great panoply; the victor was rewarded with honor while the loser was often required to forfeit his horse and armor or was held for ransom.

The most exaggerated ceremonial etiquette governed the courts of great noblemen and rulers, especially that of the house of Burgundy. The pomp and fanfare of public courtly processions, designed to impress the populace, had its counterpart within the castles themselves. Splendid households testi-

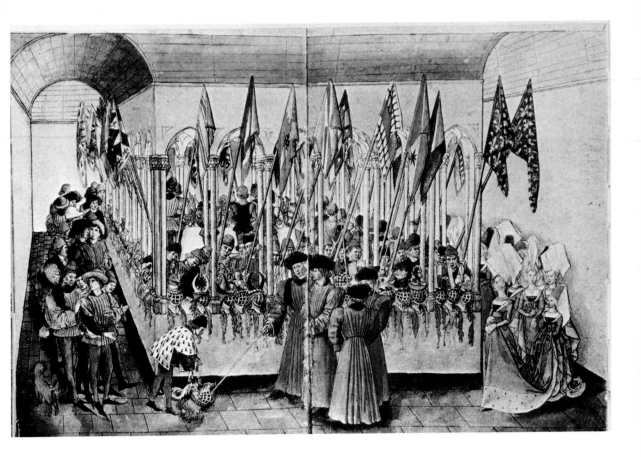

The showing of the helms before the tournament, illuminated page in *Traittié de la forme et devis comme on fait les tournois* by René of Anjou, France, 1460-1465 (Bibliothèque Nationale, Paris, Ms. fr. 2695).

fied to the power of the ruler before his court and noble guests. Charles the Bold, duke of Burgundy, held several weekly solemn audiences, seated on a *hautdos* covered with cloth of gold, attended by two kneeling officials. His banquets were splendid ceremonial affairs in which a rigorous etiquette applied even to the hierarchy of servitors. Pantomimes or pageants, called *entremets,* were frequently performed for amusement at these elaborate banquets. Even the most inconsequential details of protocol, such as the right to first beckon another courtier, were strictly followed. Though the Burgundian ducal household represented an extreme, all aristocratic households had to fulfill the obligations of courtly hospitality and its attendant ceremony.

The ceremony with which medieval life was imbued, not only denoted class distinction, but also gave the semblance of structure and order to lives which were in reality subject to the most abrupt and violent disruptions.

260. GOBLET

Attributed to the workshop of Angelo Barovier
Italy, Venice
Circa 1475
Free-blown glass, with gilt and enamel decoration, H. 8½ inches (21.5 cm)
The Metropolitan Museum of Art, Gift of J. Pierpont Morgan, 17.190.730

In the production of glass tableware, no other center equaled Venice. The supremacy of Venetian glass was acknowledged throughout Europe in the late Middle Ages. From existing documents the names of many of her craftsmen are known, and of them none was more renowned than Angelo Barovier. Born about 1424 into an old Venetian glassmaking family, Barovier is credited with the perfecting of formulas for colored glass. This remarkable wine goblet is an example of the fine glassware produced in the Barovier workshop. It is made of a deep sapphire blue glass with a ribbed, knopped stem and a fluted foot spangled with gold. The cup is decorated with colored opaque enamels depicting the legend of Virgil the Sorcerer. Because of his complex mathematical works, which were well known in the Middle Ages, the Roman poet and philosopher Virgil was considered a sorcerer by many. A number of legends concerning his powers were current in the popular

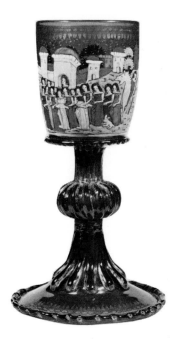

literature of central Italy, among them, the story of his hopeless love for Febilla, the daughter of the Roman emperor. According to the legend, Virgil arranged a trist with Febilla by night in which he was to be drawn up to her tower in a basket. But the faithless Febilla tricked him so that he was left dangling from the tower until the next morning, exposed to the ridicule of the townspeople. In revenge, Virgil caused all the fires in Rome to go out. In order to rekindle the fires, the Roman emperor had to submit his daughter to public humiliation. The naked Febilla was prostrated before the sorcerer who then placed a live coal on her body and from that the women of Rome were permitted to relight their fires.

In contrast to the more utilitarian glassware produced in Germany in the fifteenth century, this Venetian goblet rivals the splendid metalwork of the period. It is hardly surprising that Venetian glassware was exported throughout Europe, or that the glass industry, located on the neighboring island of Murano, was jealously guarded by the Venetian doges. Venetian glassworkers were prohibited from working abroad, and their guild regulations, the earliest known, exercised precise restrictions on the craft. In this way, Venice controlled her leading industry and kept her monopoly of the market.

261. EWER

Italy, Venice
Late XV century
Glass, with enamel decoration, H. 9½ inches (24.1 cm)
The Cleveland Museum of Art, J. H. Wade Fund, 44.257

Among the remarkable achievements of Venetian glassmakers was their perfection of the art of coloring glass. This was accomplished by the addition of metallic oxides to the molten glass. Oxide of cobalt was undoubtedly the coloring agent employed in the making of this deep blue ewer. The adhesion of the enamel decoration required a second firing of the glass after tempering, an exacting process, wherein too much heat could burn or rupture the vessel. The enamel decoration of this ewer draws attention to its use as a pouring vessel. On one side, a medallion encloses a jester about to drink from a bottle and, on the other, a lady holds a goblet. The remainder of the surface is lavishly decorated with points, flowers, and stylized leaves in colored enamels. Fine glassware such as this ewer and the so-called portrait goblets were probably commissioned by wealthy patrons as gifts and were used only on special occasions.

262. BOWL WITH PROFILE PORTRAIT
Italy, Venice
Late XV century
Glass, with enamel decoration, Dia.
6¾ inches (17.1 cm)
The Metropolitan Museum of Art,
Gift of J. Pierpont Morgan,
17.190.550
Portraiture enjoyed widespread popularity throughout the end of the Middle Ages, both in Italy and in the North, and was employed not only in panel painting and book illumination, but in the decorative arts as well. This bowl, with the depiction of a young man at the center, may have been intended as a betrothal gift, indicated by the symbolic inclusions of the flower the man holds in his hand and the brightly shining sun above his head. The colored enamel lattice design on the sides of the bowl is a forerunner of a glass-thread technique known as *latticino* introduced in the sixteenth century.

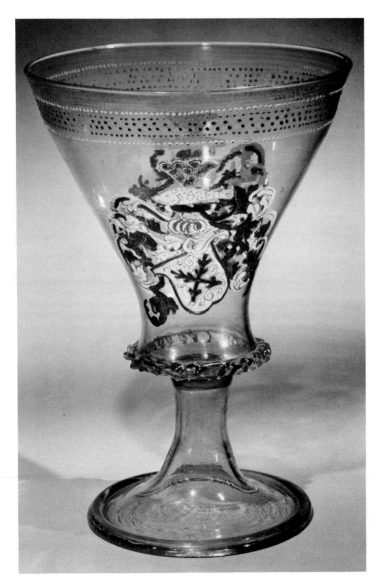

263. GOBLET
Italy, Venice
XVI century
Glass, with gold-enamel decoration,
H. 9 inches (22.8 cm)
Collection of Mrs. Leopold Blumka
The extent of the exportation of Venetian glass in the fifteenth and sixteenth centuries is witnessed by this goblet and others related to it. Though clearly of Venetian manufacture, the goblet is decorated with the arms of the Barons von Liechtenberg of Austria. (Shield: *or*, two *ragged staves sable in saltire*. Crest: a *chapeau de maintenance* surmounted by a fish *naissant* topped by a plume of peacock feathers.) The glass was undoubtedly specially ordered. A set of six goblets closely resembling the flared shape and enamel point decoration of this example was ordered from Venice in 1500 by the senators of the Bohemian town of Bardějov. The arms of the town are painted on each goblet. Like the Bohemian set, it is probable that this goblet was not intended for common usage but was reserved for special or ceremonial purposes.

264. PAIR OF EWERS

Germany, Nuremberg (?)
Circa 1500
Silver gilt, with painted enamel, H. 25 inches (63.5 cm)
The Metropolitan Museum of Art, The Cloisters Collection, 53.20.1; 53.20.2
(See color plate no. 15)

The Order of Teutonic Knights of the Hospital of St. Mary in Jerusalem was one of the three military and religious orders established during the Crusades. From its original headquarters at Acre in the Holy Land, it transferred its seat of government briefly to Venice, and then to Marienburg on the Vistula (1309–1457). In the late Middle Ages, with the advent of Protestantism, the Order moved its headquarters to

265. COVERED BEAKER

France (cut crystal) and Germany (mountings)
XV century
Rock crystal and silver gilt, with rubies, sapphires, emeralds, and pearls, H. 10 inches (25.4 cm)
The Metropolitan Museum of Art, Bequest of Benjamin Altman, 14.40.662a,b

Rock crystal was valued most highly throughout history for its hardness and brilliant clarity. In the Middle Ages it was viewed by the Church as a symbol of unblemished purity, and thus a most appropriate material for containers of holy relics and for other ecclesiastical vessels. For kings, princes, and other high-placed persons, drinking vessels made of cut and highly-polished rock crystal, and decorated with precious metals and jewels, had great appeal. Various locations in Central and Western Europe have been suggested as fourteenth- and fifteenth-century centers for the cutting of crystals, including Paris, Burgundy, Prague, Nuremberg, Venice, and Freiburg im Breisgau. Rock-crystal vessels cut with a pattern of concave roundels, such as those seen on the beaker exhibited, and a beaker that belonged to Philip the Good of Burgundy now in the Kunsthistorisches Museum, Vienna, are usually considered to be of French workmanship. The cut rock-crystal cup of the beaker shown is believed to be French; however, its bejewelled mounting is thought to have been executed not in France or Burgundy, but in the Upper Rhine region of Germany, possibly in Freiburg im Breisgau. A comparable beaker of rock crystal, with a silver-gilt setting studded with jewels, is seen in the painting dated 1514, by Quentin Massys, *The Money Changer and His Wife,* now in the Louvre, Paris. The fact that Massys' style was frequently archaicizing in response to the vogue of the day,

Koenigsberg (1457–1525) in East Prussia. The Order in Prussia ceased to be semimonastic and branched off from the Roman Catholic Order, which maintained headquarters in Mergentheim and much later in Vienna. The Order's membership was limited to Germans of noble birth, a factor which contributed to its great wealth and power.

The present ewers stand as an eloquent testimony to the extraordinary treasures for which the Teutonic Knights were renowned. In the 1585 inventory of the Teutonic Order treasury these ewers are described as "two silver presentation ewers with coat of arms of Stockheim" (the arms, now missing, were on the shields held by the wild men surmounting the covers of the ves-

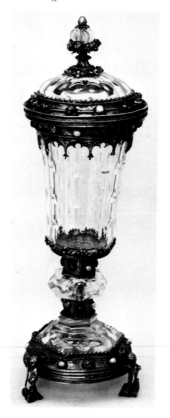

makes the dating for the model of this beaker around the middle of fifteenth century quite credible. Such a splendid beaker undoubtedly was intended to grace the table or sideboard of some magnificent court of the mid-fifteenth century. Its appearance in an otherwise bourgeois setting in Massys' painting could represent a status symbol and a reminder of the great changes in social structure which had taken place in the course of a half century, when the wealthy class adopted the customs formerly associated only with the nobility. On the other hand, this beaker could represent a "pledge" left by its owner for money borrowed from the money changer.

sels). Hartmann von Stockheim, probably a native of Franconia, was the German Master of the Order between 1499 and 1510 or 1513. The ewers were originally his private property and were left to the treasury of the Teutonic Knights upon his death. By the late Middle Ages, the wealth of guilds and confraternities was often held in such objects wrought of precious metals which, in time of need, were sometimes sold and melted down.

A vessel similar to these ewers is seen on a cupboard in the background of a painting of about 1500, *The Beheading of St. John the Baptist,* by the Master of Saint Severin, now in the Museum of Fine Arts, Boston, indicating that such vessels were used in households as well.

266. DOUBLE CUP

Germany, Nuremberg
Second half of the XVI century
Silver gilt, H. 20⅝ inches (52.3 cm), Dia. 6 inches (15.2 cm)
The Metropolitan Museum of Art, Gift of J. Pierpont Morgan, 17.190.607a,b

Double cups of great size and splendor were popular during the late fifteenth century and remained in

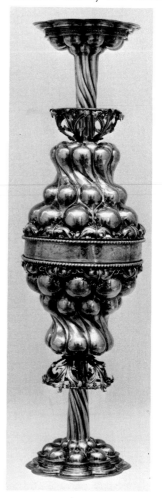

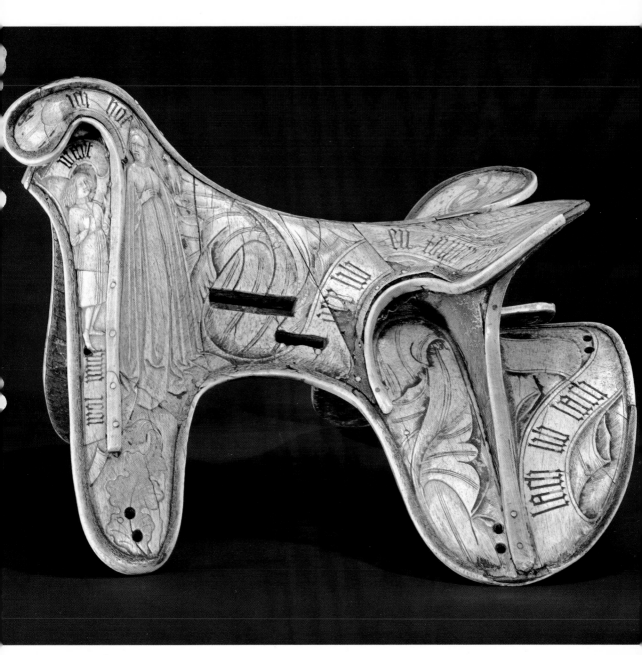

PLATE 14
Cat. No. 276

271

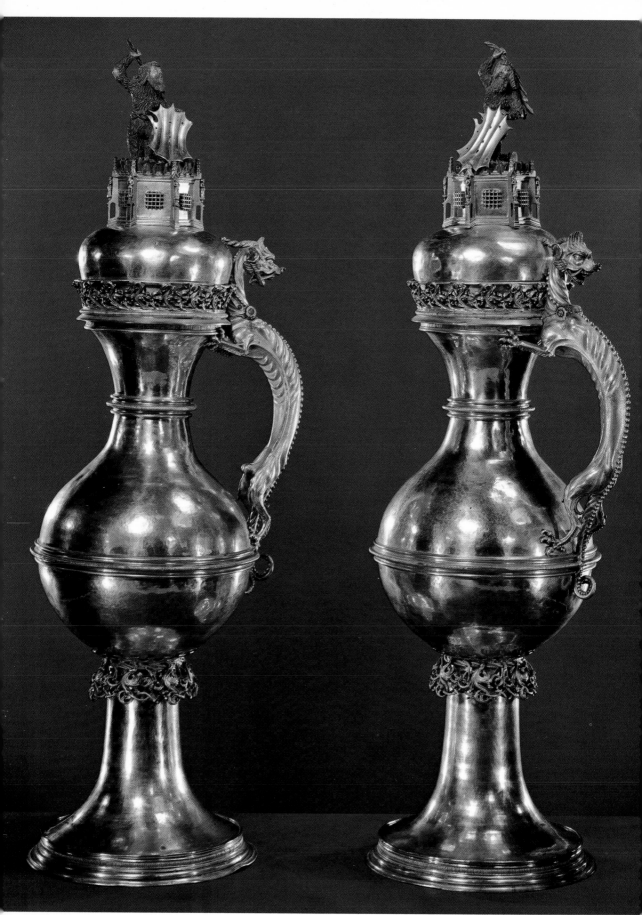

PLATE 15 Cat. No. 264

270. SPOON

Flanders

Second quarter of the XV century
Silver, silver gilt, painted enamel,
and niello, L. 6⅞ inches (17.5 cm)
*Museum of Fine Arts, Boston,
Helen and Alice Colburn Fund,
51.2472*

This spoon has been linked techni-
cally and stylistically to the group
of enamels which includes the so-
called Monkey Cup (see entry no.
269). The decoration of the interior
of the bowl of the spoon, like that
of the Monkey Cup, consists of
episodic representations of secular
character probably developed in
marginal drolleries of Gothic manu-
scripts. The subject is a fox in eccle-
siastical garb preaching to a congre-
gation of geese while another fox
steals one of the flock. (The inscrip-
tions within the scene on the bowl
are not clearly legible except for the
word "pax.") This satirical episode
can be linked to the *Roman de
Renart,* and especially to the later
versions of the poem, through the
thirteenth-century Flemish poem,
Van den Vos Reynarde. The theme
is, though, one of the most common
involving the fox in medieval art.
It appears, for example, in the mar-
ginalia of the mid-fourteenth-cen-
tury decretals of Gregory IX made
for St. Bartholomew's Priory, Smith-
field, in which the story of the ped-
dler and the apes is also found. It
has been suggested that the latter
tale may have been related, in En-
gland at least, through oral tradition
to the epic of Renard the Fox. It is
tempting to see the relationship of
the Boston spoon and the Monkey
Cup as evidence of this tradition.
Literary evidence is, however, lack-
ing; the ape is generally ignored in
the Renard epic in its numerous ver-
sions, and in none of them is the
peddler story recounted. Only in
the *Shifts of Reynardine,* printed in
1684, an English literary pastiche,
does the ape story appear, and then
it is itself probably inspired by ear-
lier pictorial sources. The connec-
tion between the theme of the Bos-
ton spoon and The Cloister's cup
probably lies in common inspira-
tion in the coarse secular humor
current at the time of their execu-
tion, particularly at the court of
Burgundy, for which both the cup
and the spoon may have been made.
In view of their extremely high
quality and the slight evidence of
wear, it is probable that both the
spoon and cup were intended for
use on ceremonial occasions or for
display.

271. SPOON

Flanders (?)

XV century
Silver gilt and enamel, L. 6¾ inches
(17.1 cm)
*The Metropolitan Museum of Art,
Rogers Fund, 48.153*

The elaborateness of design and
high quality of workmanship, as well
as the preciousness of the materials,
of this spoon indicate with cer-
tainty that it belonged to a person
of rank. Unfortunately, neither the
motifs nor the color scheme have
successfully been associated with a
particular family. This spoon, sur-
mounted by a pomegranate finial, is
executed in translucent green and
purple enamel, separated by a band
of white enamel, into which are im-
pressed silver-gilt motifs: floral trac-
ery, stars, radiant crescents, and
pairs of ornamental symbols (pos-
sibly undeciphered initials).

The technique of impressing
enamel with metallic ornament links
the spoon to a group of objects,
principally an almost identical
spoon in the Victoria and Albert
Museum and a pair of beakers in the
Vienna Kunsthistorisches Museum,
which have pomegranate finials and
gold stars impressed in the enamel.
The Vienna beakers have been asso-
ciated with the painted enamel tech-
nique thought to have been devel-
oped in the Netherlands in the
second quarter of the fifteenth cen-
tury, though it has also been sug-
gested that they may have been
produced in Germany, possibly the
Rhineland, for the Venetian market,
or in Venice itself. The problem of
the origins of several innovative
fifteenth-century enamel tech-
niques, including that employed on
this spoon, remains controversial.

272. JUG
Attributed to Paul Preuning
Germany, Nuremberg
1540–1550
Lead-glazed earthenware, H. 14
inches (35.5 cm)
*The Metropolitan Museum of Art,
Gift of Thornton Wilson in memory
of Florence Ellsworth Wilson,
50.211.202*

The term *Hafner,* applied to a variety of lead-glazed wares, refers to the particular potters who, in the German-speaking areas of Europe, produced tiles of a hollow, backless brick shape out of which heat-retaining, efficient ovens were made to warm households. Generally surfaced with a dark green lead glaze, these tiles were more and more embellished with elaborate relief decorations toward the end of the fifteenth century. Although great numbers of these tiles were produced in the South Tirol, Swabia, and parts of Switzerland, Nuremberg was the principal center of manufacture. The lead-glazing technique, not dissimilar from the technique used in the French Palissy wares, was practiced in particular by the Preuning family of Nuremberg from 1525 until the early seventeenth century. Employing various colors and applied decorations, vessels of considerable elaborateness were produced, especially by the foremost master of the family, Paul. The present jug, with its architectural details and deep sculptured reliefs, is typical of his work. The subject matter of the decoration of his wares was often profane; the Nuremberg archives reveals a judg-

ment in which he was pronounced guilty of sacrilege, presumably for depicting a Crucifixion scene elaborated with drummers, pipers, and dancing peasants. In the present example, the coupling of fighting figures with religious symbols may be an allusion to the Reformation uprisings. The size and decoration of this vessel, which probably was used for serving beer or wine on festive occasions, was designed to impress with both its richness of decoration and the large amount it could hold. Such vessels were also bought as gifts or presentation pieces.

273. DRINKING VESSEL
Austria (South Tirol)
Circa 1540
Tin-glazed earthenware, H. 16½
inches (41.9 cm)
*The Metropolitan Museum of Art,
Gift of Thornton Wilson in memory of Florence Ellsworth Wilson,
50.211.187a,b*

The few extant drinking vessels in the form of an owl (the head acts

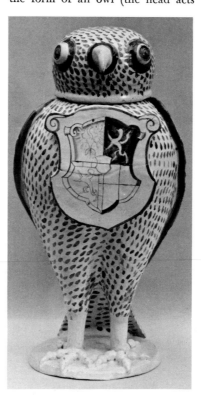

as a cover and may be removed) seem to have been made in southern Germany, Switzerland, and the Tirol. The earliest examples, among which this one may be numbered, date from about 1540. The body of this vessel was thrown on a wheel and then embellished with applied decoration which included the coat of arms of the Hohenzollern family. The association of these arms with Joachim Friedrich, archbishop of Magdeburg (1566–1598) and mar-

grave of Brandenburg (1598–1608), must be discounted, as it is incompatible with the style and technique of the vessel, and the lack of tinctures make so precise an identification impossible. It is more likely that the piece was made for a Franconian branch of the family (the arms bear quarterings of Brandenburg, Pomerania, Nuremberg, and Hohenzollern), and the tinctures were intended to be added in cold enamel by an artist in the area where the commissioner lived. The South Tirol has generally been accepted as the place of manufacture, perhaps in the town of Bozen (Bolzano). An inventory of the town of Neudeck-bei-Arnstadt, also in this region, mentions a "large owl made of fired clay," while a cockerel of the same technique has been excavated at Arnstadt. Although it has been suggested that such vessels were given as awards for athletic or sporting contests, it is more likely that they were intended as presentation pieces or drinking vessels for festive occasions. As drinking habits of many German-speaking areas tended to be extravagant, the large size of the vessel can hardly be used as an argument against this usage.

274. JUG (*Bartmannkrug*)
Germany, Cologne or Frechen
Circa 1540
Salt-glazed stoneware, H. 3³⁄₁₆
inches (8.1 cm)
*The Metropolitan Museum of Art,
Gift of Thornton Wilson in memory of Florence Ellsworth Wilson,
54.147.53*

The German name of this small jug refers to the face of the bearded man on its neck. It exemplifies two techniques of the potters' art which are purely German in origin: stoneware and salt-glazing. Stoneware is made of a fine pipe clay which is fired at a high temperature until the clay vitrifies and forms an extremely durable biscuit akin to the later developed porcelains. The mottled brown salt glaze was achieved by tossing salt, at the zenith of firing, on the surface of the vessel which was coated with a wash of vitrifiable brown clay. The iron compounds were thereby chemically removed from the ware by solution in the glaze. When stoneware was discovered is uncertain, but evidence indicates it was at the end of the fourteenth century, perhaps at Siegburg, which, along with Höhr, Grenzhausen, Frechen, Raeren, and Cologne, was one of the principal centers of production, as it was located near the rich clay beds of the Westerwald slopes along the lower Rhine. Although

the first decorated stonewares might well have been produced in Dreihausen (Hesse), the *Bartmannkrug*, as a type, seems to have been developed in Frechen and then introduced to Cologne by emigrant potters who established factories principally on the Maximenstrasse. The decorative elements, the bearded face, tendrils, oak leaves, and acorns, were both impressed and applied. Still Gothic in nature, these designs, similar to those which appear in the pattern books of Peter Quentel, are primarily of a whimsical nature, but they may hold an illusion to the Tree of Jesse as well. As the size and shape serve no specific need, these vessels were probably used as gifts or presentation pieces.

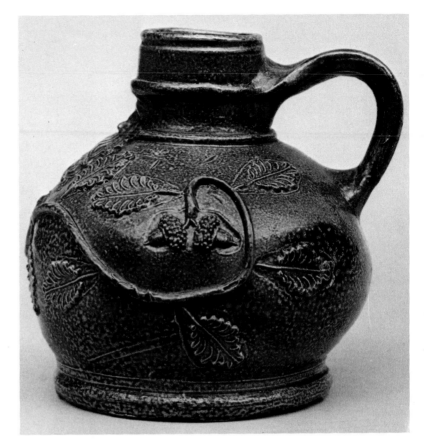

275a-g. PENDANTS FOR A HORSE'S HARNESS

Spain (Catalonia)
XIV century
Bronze, gilt, and enamel, H. (of largest) 4⅜ inches (11.1 cm)
The Metropolitan Museum of Art, Rogers Fund, 04.3.307; 04.3.308; 04.3.355; 04.3.405; 04.3.408; 04.3.429; 04.3.453

Pendants like the seven exhibited here were attached as spangles on the breast straps and crupper harness of horses. They display either the arms of the owner, such as the large quatrefoil plaque with the arms of the duke of Avalos, or devices connected with courtly love and ladies' service, such as the one with the letter S pierced by a nail (*clavo*) forming a rebus *Esclavo*—"your slave." The lion's head (symbol of courage) bears also the motto LEAL SO—"I am loyal." The dogs are symbols of loyalty themselves, and one pendant with this motif also displays the inscription LEAL—"loyal." The swan shown on the last badge was another symbol of purity, beauty, and love. The pair of lovers with a goblet and a little dog are probably Tristan and Isolde with their lapdog Peticriu, who carried their messages.

276. SADDLE

Austria (Tirol)
Circa 1400
Wood, overlaid with carved staghorn and lined with birch bark, H. 17½ inches (44.4 cm), L. 18¾ inches (47.6 cm), W. 18 inches (45.7 cm)
The Metropolitan Museum of Art, Rogers Fund, 04.3.249
(See color plate no. 14)

This saddle with its high-swept pommel and bilobate cantle is of Hungarian form, though, as is proved by its fifteenth-century German inscriptions, it was probably made in southern Germany or the Tirol. These Hungarian-style saddles with their elegant lines were very popular in this area of Europe as parade and fine sporting pieces. It is to be remembered that Hungary and Bohemia were at that time ruled by the Luxembourgs and Anjous, princely houses of French extraction, which kept up strong connections with Western Europe. The late Gothic decoration of figures and foliage is thoroughly Germanic, as are the inscriptions of amorous and even salacious texts.

277. L'ARBRE DES BATAILLES, ESPEJO DE VERDADERA NOBLEZA (IN FRENCH), AND OTHER TEXTS

Honoré Bonet, Díego de Valera, and other authors
Flanders
1481
Manuscript on vellum (codex), 210 folios, H. 13⅜ inches (34 cm), W. 9½ inches (21 cm)
Beinecke Library, Yale University, Ms. 230

The formalities required by the chivalric code tended to encourage ceremonial. As the nobility became less and less powerful during the course of the Middle Ages, the code of etiquette for upper-class society became increasingly rigid and formalized. To maintain their exclusivity, it became necessary for the members of this class to make laws regarding rights and privileges that had previously been unquestioned. For example, before the fourteenth century, the right to display arms had been the exclusive privilege of the nobility. Knighthood was conferred in the name of the king, and the knight was given his distinctive marking or device designating his rank and person. With the growing power and wealth of the merchants in the fourteenth century, however, these privileges tended to be usurped by the middle class. It was finally necessary for King Henry V in 1417 to decree against the bearing of coats of arms by those without hereditary titles.

This richly illuminated volume, a compilation of treatises on chivalric protocol, was dedicated to Louis XI and Charles the Bold, duke of Burgundy—one of the few remaining powerful dukedoms in France. It is significant that most, if not all, of these treatises were composed during the course of the fourteenth century. Chief among them are Honoré Bonet's *L'arbre des batailles*, a genealogy of noble exploits, and Diego de Valera's *Right of Arms*. Several shorter pieces include: a treatise on rank, the ceremonial for the election of an emperor, protocol for tournaments and dueling, the oaths and duties of heralds and the installation of a king of arms, the office of arms at noble funerals, and Burgundian ordinances regarding rank in the army. Each of these ceremonials is illustrated with a representation of the event showing proper demeanor for the participants.

278. ARMORIAL

England
Early XVI century
Manuscript on paper (codex), 64 folios, H. 11¾ inches (30 cm), W. 7⅞ inches (20 cm)
The Pierpont Morgan Library, Ms.

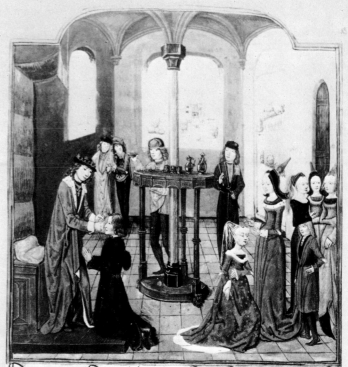

M. 940

In 1483, Richard III established the College of Arms in England and incorporated the heralds as a means of standardizing armorial bearings. For nearly a century before this date, the question of who was entitled to display armorial bearings had been a problem to the British crown. In 1417, Henry V had been forced to control this by royal decree, but even this had not stopped the practice of unauthorized usurpation of coats of arms.

The armorial device originated early in the Middle Ages as a means of distinguishing the various knights on a field of battle. Each knight, when he was granted the rank, received an insigne or device that was unique and that was his alone to display. This usually assumed the form of a combination of colored markings, or a symbol, or both. This device was then painted upon his shield, borne as a pennant on his lance, and embroidered upon his coat; the term "coat of arms" originated from the latter custom.

Following the establishment of the College of Arms, there were a number of compilations of arms made, among them, *The Baron Book* by Robert Cook in 1573. Since the manuscript exhibited here apparently predates *The Baron Book*, it may well have been one of the sources drawn upon by Cook. The manuscript describes and illustrates English arms from the time of the Conquest up to the period of the Tudors. In each case, the shields are painted in color and then described with notes on their owners in the text. While awarded first to individuals, by the late medieval period arms also designated institutions, such as cities or guilds. They were, by that time, no longer the exclusive property of the nobles since kings, throughout the fifteenth century, awarded armorial bearings to commoners in recognition of special services.

279. BEAKER
Austria, Hall (Tirol)
Circa 1550
Free-blown glass, with gilt and enamel decoration, H. 15 inches (38 cm)
Collection of Mrs. Leopold Blumka

It was customary in the noble houses of the German lands in the sixteenth century to record the names of distinguished guests on a special beaker from which they drank. These glasses, often very large and richly ornamented, were kept for purely ceremonial purposes and passed from generation to generation in the family. They are commonly known as "welcoming glasses." This example bears the arms of the Trapp family, painted twice in gilt and colored enamels, on the sides of the glass. Borders of colored enamel dots and gilding embellish the rim and foot of the beaker, and the glass itself is of a slightly yellowish cast rather than the greenish tint of earlier examples because it has been decolorized with oxide of manganese. These improvements, invented by the Venetians, quickly spread to the North and were adopted by the glass houses at Hall, where the Trapp beaker was probably made. The dating of the glass can be established by the arms which show a family shield with helm and jewel. After 1555, the Trapp arms were elaborated to include three helms. The signatures and personal devices which are engraved on the glass date from 1559 to 1629 and include those of Archduke Ferdinand of Tirol, his successor, Maximilian, members of the Order of Teutonic Knights, and other notable figures from the Tirol, Styria, and Carinthia.

NOTES TO THE CATALOGUE

●1 J. J. Rorimer, *The Cloisters: The Building and the Collection of Medieval Art in Fort Tryon Park*, New York, 1963, p. 186.

●5 S. Rubinstein-Bloch, *Catalogue of the Collection of George and Florence Blumenthal*, Paris, 1926–30, III, pl. XXXI.

●6 Information provided through the courtesy of the library of Bryn Mawr College, Bryn Mawr, Pennsylvania (including a newspaper article, undated and unidentified, possibly published in July, 1936, by Edward Owen, recounting the sale of the roll by the dealers Maggs on June 29, 1936); S. de Ricci, *Census of Medieval and Renaissance Manuscripts in the United States and Canada*, New York, 1937, II, p. 1684, no. 38; C. U. Faye and W. H. Bond, *Supplement to the Census of Medieval and Renaissance Manuscripts in the United States and Canada*, New York, 1962, p. 434, no. 8.

●8 H. Kohlhaussen, *Minnekästchen im Mittelalter*, Berlin, 1928, p. 76, no. 31, pl. 25; V. K. Ostoia, *The Middle Ages: Treasures from The Cloisters and The Metropolitan Museum of Art*, exhibition catalogue, Los Angeles County Museum of Art, Los Angeles, 1969, p. 114, no. 15.

●9 H. Kohlhaussen, *Minnekästchen im Mittelalter*, Berlin, 1928, p. 104, no. 147.

●10 R. Koechlin, *Les ivoires gothiques français*, Paris, 1924, I, pp. 472–507; II, p. 453, no. 1284; T. P. Hoopes, "An Ivory Casket in The Metropolitan Museum of Art," *The Art Bulletin*, VIII, March, 1926, pp. 127–139; R. S. Loomis and L. H. Loomis, *Arthurian Legends in Medieval Art*, London, 1938, pp. 66, 70, 72, 76, figs. 122, 137; M. R. Scherer, *About the Round Table*, New York, 1945, pp. 42, 55, 68.

●11 *Sammlung Dr. Albert Figdor, Wien*, sale catalogue, Berlin, 1930, V, Part I, no. 336.

●13 J. M. Hoffeld, "The Art of the Medieval Blacksmith," *The Metropolitan Museum of Art Bulletin*, December, 1969, p. 169, ill.

●14 C. Gómez-Moreno, *Medieval Art from Private Collections: A Special Exhibition at The Cloisters*, exhibition catalogue, The Cloisters, New York, 1968, no. 119.

●15 *Sammlung Dr. Albert Figdor, Wien*, sale catalogue, Berlin, 1930, IV, Part I, pl. DCII, no. 176; H. Wentzel, "Blasebalg," in *Reallexikon zur deutschen Kunstgeschichte*, ed. O. Schmitt, Stuttgart, 1948, II, cols. 833–834; Columbia, South Carolina, Columbia Museum of Art, *Landscape in Art*, exhibition catalogue, 1967, no. 9.

●16a,b *Joseph Brummer Collection*, sale catalogue, Parke-Bernet Galleries, New York, June 8, 1949, Part III, p. 17, no. 93; remarks by Roger Loomis regarding the inscription in a letter of June 22, 1949, on file in the Medieval Department, The Metropolitan Museum of Art; remarks by Lawton P. G. Peckham regarding the inscription in letters of July 22 and August 15, 1949, on file in the Medieval Department, The Metropolitan Museum of Art.

●17 Boston, Museum of Fine Arts, *Arts of the Middle Ages*, exhibition catalogue, 1940, p. 108, pl. LXVIII; Y. Hackenbroch, *The Irwin Untermyer Collection*, New York, 1962, V, pp. XLV–XLVI, 29, pl. 120, fig. 131; C. Gómez-Moreno, *Medieval Art from Private Collections: A Special Exhibition at The Cloisters*, exhibition catalogue, The Cloisters, New York, 1968, no. 108.

●20 *Joseph Brummer Collection*, sale catalogue, Parke-Bernet Galleries, New York, May 12, 1949, Part II, p. 86, no. 358; G. Swarzenski, "Profane Work of the High Middle Ages," *Bulletin of the Museum of Fine Arts, Boston*, XLVII, 1949, pp. 76–81, fig. 6; *Bulletin of the Museum of Fine Arts, Boston*, LV, 1957, p. 84, fig. 38; C. Gómez-Moreno, *Medieval Art from Private Collections: A Special Exhibition at The Cloisters*, exhibition catalogue, The Cloisters, New York, 1968, no. 112.

●21 Information provided through the courtesy of the Royal Ontario Museum, Toronto.

●22 Y. Hackenbroch, "A Group of XVth-Century Bronze Mortars," *The Connoisseur*, January, 1954, p. 171; Y. Hackenbroch, *The Irwin Untermyer Collection*, New York, 1962, V, pp. XLVIII, 31, pls. 136, 137, figs. 147, 148; C. Gómez-Moreno, *Medieval Art from Private Collections: A Special Exhibition at The Cloisters*, exhibition catalogue, The Cloisters, New York, 1968, no. 118, ill.

●23 J. D. Vehling, "Platina's Indebtedness to Martino," *Hotel Bulletin and Nation's Chefs*, October, 1932, pp. 193 ff.

26 R. M. Home, "Three Medieval Pitchers," *Bulletin of the Royal Ontario Museum of Archaeology*, May, 1931, pp. 15–16; Detroit, Detroit Institute of Arts, *English Pottery and Porcelain: 1300–1850*, exhibition catalogue, 1954, pp. 14–15, no. 2.

●27 R. M. Home, "Three Medieval Pitchers," *Bulletin of the Royal Ontario Museum of Archaeology*, May, 1931, pp. 15–16.

●28a,b V. K. Ostoia, *The Middle Ages: Treasures from The Cloisters and The Metropolitan Museum of Art*, exhibition catalogue, Los Angeles County Museum of Art, Los Angeles, 1969, p. 140, no. 68.

●30 T. Husband, "Valencian Lusterware of the Fifteenth Century: Notes and Documents," *The Metropolitan Museum of Art Bulletin*, Summer, 1970, pp. 11–19, 30, no. 16.

●34 R. Schmidt, *Die Gläser der Sammlung Mühsam*, Berlin, 1926, II, no. 26; H. Comstock, "The Mühsam Collection of Glass, Part II," *International Studio*, 86, January, 1927, p. 46; H. E. Winlock, "The History of Glass: An Exhibition," *The Metropolitan Museum of Art Bulletin*, October, 1936, pp. 192–197.

●35 *Sammlung Dr. Max Strauss, Wien, Porzellan und deutsches Glas*, Vienna, 1922, no. 7; F. Rademacher, "Gotische Gläser in den Rheinlanden," *Wallraf-Richartz Jahrbuch*, 1926–27, p. 99; H. Comstock, "The Mühsam Collection of Glass, Part II," *International Studio*, 86, January, 1927, p. 46; F. Rademacher, *Die deutschen Gläser des Mittelalters*, Berlin, 1963, pp. 114, 123, pl. 46.

●36 E. Molinier, *Collection du Baron A. Oppenheim*, Paris, 1904, p. 61, pl. LXXVI, no. 142; E. A. Jones, *Illustrated Catalogue of the Collection of Old Plate of J. Pierpont Morgan, Esquire*, London, 1908, pl. LXIII.

●38 *The John Henry Taylor Collection*, sale catalogue, London, 1912, no. 34a; R. Schmidt, *Das Glas*, Berlin, 1922, p. 83; *The Eumorfopoulos Collections*, sale catalogue, Sotheby & Co., London, June 5, 1940, no. 223.

●40 V. Gay, *Glossaire archéologique du moyen âge et de la renaissance*, Paris, 1887, I, pp. 349–350.

●41 V. K. Ostoia, *The Middle Ages: Treasures from The Cloisters and The Metropolitan Museum of Art*, exhibition catalogue, Los Angeles County Museum of Art, Los Angeles, 1969, p. 140, no. 68, fig. 68A.

●42 R. M. Home, "Three Medieval Pitchers," *Bulletin of the Royal Ontario Museum of Archaeology*, May, 1931, pp. 15–16.

●43 T. Husband, "Valencian Lusterware of the Fifteenth Century: Notes and Documents," *The Metropolitan Museum of Art Bulletin*, Summer, 1970, pp. 11–19, 25, no. 6; A. W. Frothingham, *Fine European Earthenware*, exhibition catalogue, The Museum of Fine Arts, St. Petersburg, Florida, 1973, pp. 5–6, no. 2, fig. 7.

●45 Corning, New York, Corning Museum of Glass, *Three Great Centuries of Venetian Glass*, exhibition catalogue, 1958, no. 39.

●46 F. de Mély, "Vases de Cana," *Fondation Eugène Piot. Monuments et Mémoires*, X, 1903, pp. 145–170, pl. XIV, fig. 1; J. Breck and M. Rogers, *The Pierpont Morgan Wing: A Handbook*, New York, 1925, p. 128, fig. 73; H. Kohlhaussen, "Gotisches Kunstgewerbe," in *Geschichte des Kunstgewerbes aller Zeiten und Völker*, ed. H. T. Bossert, Berlin, 1932, V, pp. 399–400, ill.; G. Schiedlausky, *Essen und Trinken: Tafelsitten bis zum Ausgang des Mittelalters*, Bibliothek des Germanischen National-Museums Nürnberg zur deutschen Kunst- und Kulturgeschichte, ed. Ludwig Grote, 4, Munich, 1956, fig. 15; Provisory remarks

by Erich Steingräber in Spring, 1960, calling the flagon middle or lower Rhenish, mid-XV century, on file in the Medieval Department, The Metropolitan Museum of Art; H. Kohlhaussen, *Nürnberger Goldschmiedekunst des Mittelalters und der Dürerzeit: 1240 bis 1540*, Berlin, 1968, p. 146.

● 49 T. Husband, "Valencian Lusterware of the Fifteenth Century: Notes and Documents," *The Metropolitan Museum of Art Bulletin*, Summer, 1970, pp. 11–19, fig. 3.

● 50 London, Burlington Fine Arts Club, *Exhibition of a Collection of Silversmiths' Work*, exhibition catalogue, 1901, p. 65, no. 4; E. A. Jones, "Some Old Foreign Silver in the Collection of Mr. William Randolph Hearst," *The Connoisseur*, LXXXVI, 1930, pp. 220–225; *Bulletin of the Museum of Fine Arts, Boston*, LV, 1957, p. 87, fig. 43.

● 51 H. H. Cotterell, *Pewter down the Ages*, London, 1932, p. 49, fig. 16.

● 52 T. Husband, "Valencian Lusterware of the Fifteenth Century: Notes and Documents," *The Metropolitan Museum of Art Bulletin*, Summer, 1970, pp. 11–19, fig. 12.

● 53 G. Brett, "Trenchers," *Royal Ontario Museum. Annual. Art and Archaeology Division*, Toronto, 1962, pp. 23–28.

●54 Information provided through the courtesy of The Royal Ontario Museum, Toronto.

●55 Information provided through the courtesy of The Royal Ontario Museum, Toronto.

● 56 Sir Charles J. Jackson, *English Goldsmiths and Their Marks*, 2nd ed., London, 1921, p. 79; G. E. P. How, *English and Scottish Silver Spoons*, London, 1952, I, pp. 84–85.

●57a,b G. E. P. How, *English and Scottish Silver Spoons*, London, 1952, I, pp. 114–115, ill., pp. 152–153, ill.

● 58 M. Weinberger, *The George Gray Barnard Collection*, New York, 1941, no. 250.

● 61 R. Schmidt, "Die Venezianischen Emailgläser des XV. und XVI. Jahrhunderts," *Jahrbuch der königlich preussischen Kunstsammlungen*, 32, 1911, p. 249; *The Eumorfopoulos Collections*, sale catalogue, Sotheby & Co., London, June 5, 1940, no. 216; Corning, New York, Corning Museum of Glass, *Three Great Centuries of Venetian Glass*, exhibition catalogue, New York, 1958, no. 35.

● 63 T. Husband, "Valencian Lusterware of the Fifteenth Century: Notes and Documents," *The Metropolitan Museum of Art Bulletin*, Summer, 1970, pp. 11–19, 23, no. 5; A. W. Frothingham, *Fine European Earthenware*, exhibition catalogue, The Museum of Fine Arts, St. Petersburg, Florida, 1973, pp. 5–6, 19, no. 9.

● 64 W. von Bode, *Die Anfänge der Majolikakunst in Toskana*, Berlin, 1911, pl. V; E. Hannover, *Pottery & Porcelain*, London, 1925, I, p. 97; B. Rackham, *Italian Maiolica*, London, 1952, p. 14; R. J. Charleston, ed., *World Ceramics*, New York, 1968, pl. 147, fig. 410.

● 65 B. Thomas, "The Hunting Knives of Emperor Maximilian I," *The Metropolitan Museum of Art Bulletin*, February, 1955, pp. 201–208.

● 67 C. Pagé, *La coutellerie depuis l'origine jusqu'à nos jours*, Châtellerault, 1896, I, pl. IV.

● 68 W. Stammler, "Aristoteles," in *Reallexikon zur deutschen Kunstgeschichte*, ed. O. Schmitt, Stuttgart, 1937, I, cols. 1027–1040, fig. 2; [O. Raggio], *La Collection Lehman de New York*, exhibition catalogue, Musée de l'Orangerie, Paris, 1957, no. 185, pl. LXXXIII; C. Gómez-Moreno, *Medieval Art from Private Collections: A Special Exhibition at The Cloisters*, exhibition catalogue, The Cloisters, New York, 1968, no. 110, ill.; G. Szabo, "Medieval Bronzes in Prodigious Variety," *Apollo*, LXXXIX, 1969, pp. 359–360, ill.; J. L. Schrader, *The Waning Middle Ages*, exhibition catalogue, Museum of Art, University of Kansas, Lawrence, Kansas, 1969, pp. 78–79, no. 96, pl. VI.

● 69 Y. Hackenbroch, *The Irwin Untermyer Collection*, New York, 1962, V, pp. XLIV, 27, pl. 101, fig. 104.

● 70 Boston, Museum of Fine Arts, *Arts of the Middle Ages*, exhibition catalogue, 1940, p. 83, no. 294; J. J. Rorimer, "A Treasury at The Cloisters," *The Metropolitan Museum of Art Bulletin*, May, 1948, p. 253, ill.; V. K. Ostoia, *The Middle Ages: Treasures from The Cloisters and The Metropolitan Museum of Art*, exhibition catalogue, Los Angeles County Museum of Art, Los Angeles, 1969, pp. 124–125, no. 56, ill.

● 72 A. von Walcher-Moltheim, "Deutsches und französisches Edelzinn in zwei Wiener Sammlungen," *Kunst und Kunsthandwerk*, VII, 1904, pp. 65–86, ill. p. 77; F. Luthmer, *Deutsche Möbel der Vergangenheit*, Monographien des Kunstgewerbes, ed. J. L. Sponsel, VII, Leipzig, 1913, pp. 62, 69, ill.; K. Berling, *Altes Zinn*, Berlin, 1919, pp. 69–70, fig. 49; New York, Brooklyn Museum, *An Exhibition of European Art: 1450–1500*, exhibition catalogue, 1936, no. 203, pl. 203; *Bulletin of the Detroit Institute of Arts*, XXXI, 1951–52, p. 80, ill.; *Medieval Treasures: Art from the Middle Ages*, Young People's Guide Series, 2, Detroit Institute of Arts, Detroit, 1973, p. 21, ill.

● 73 A. von Walcher-Moltheim, "Geschlagene Messingbecken," *Altes Kunsthandwerk*, I, 1927, pl. 1, fig. 2; *Sammlung Dr. Albert Figdor, Wien*, sale catalogue, Berlin, 1930, V, Part I, no. 496, pl. CLXXX; Y. Hackenbroch, *The Irwin Untermyer Collection*, New York, 1962, V, pp. XLIII–XLIV, 26, pl. 99, fig. 102; C. Gómez-Moreno, *Medieval Art from Private Collections: A Special Exhibition at The Cloisters*, exhibition catalogue, The Cloisters, New York, 1968, no. 122, ill.; R. Delort, *Life in the Middle Ages*, New York, 1973, p. 113, ill.

● 74 T. Husband, "Valencian Lusterware of the Fifteenth Century: Notes and Documents," *The Metropolitan Museum of Art Bulletin*, Summer, 1970, pp. 11–19, 28, no. 12; A. W. Frothingham, *Fine European Earthenware*, exhibition catalogue, The Museum of Fine Arts, St. Petersburg, Florida, 1973, pp. 5–6, 20, no. 15.

● 75 S. de Ricci, *A Catalogue of Early Italian Maiolica in the Collection of M. L. Schiff*, New York, 1927, no. 7; V. K. Ostoia, *The Middle Ages: Treasures from The Cloisters and The Metropolitan Museum of Art*, exhibition catalogue, Los Angeles County Museum of Art, Los Angeles, 1969, p. 184, no. 85.

● 76 K. Kup, "A Medieval Codex of Italy," *Natural History*, December, 1963, pp. 30–41.

● 80 C. Gómez-Moreno, *Medieval Art from Private Collections: A Special Exhibition at The Cloisters*, exhibition catalogue, The Cloisters, New York, 1968, no. 171, ill.

● 82 W. Milliken, "A Girdle of the Sixteenth Century," *The Bulletin of the Cleveland Museum of Art*, March, 1930, pp. 35 ff.; Cleveland, Cleveland Museum of Art, *Gothic Art: 1360–1440*, exhibition catalogue, 1963, pp. 180–181, no. 91; I. Fingerlin, *Gürtel des hohen und späten Mittelalters*, Munich, 1971, pp. 334–338, no. 66; M. M. Gauthier, *Emaux du moyen âge occidental*, Fribourg, 1972, pp. 296–297, no. 240.

● 86 Cleveland, Cleveland Museum of Art, *Gothic Art: 1360–1440*, exhibition catalogue, 1963, no. 101, p. 215.

● 88a,b F. Morris, "A Gift of Embroidery," *The Metropolitan Museum of Art Bulletin*, XXII, 1927, p. 186.

● 90a,b J. L. Schrader, *The Waning Middle Ages*, exhibition catalogue, Museum of Art, University of Kansas, Lawrence, Kansas, 1969, no. 117, p. 90.

● 91 B. Dean, *Catalogue of European Daggers*, New York, 1929, no. 93, pl. XVI.

● 92 B. Dean, *Catalogue of European Daggers*, New York, 1929, no. 93, pl. XXXVI.

●93a,b V. Gay, *Glossaire archéologique du moyen âge et de la renaissance*, Paris, 1887, I, p. 182.

●94 Information provided by Carmen Gómez-Moreno, curator of the Medieval Department, The Metropolitan Museum of Art.

● 95 T. Müller and E. Steingräber, "Die französische Goldemailplastik um 1400," *Münchner Jahrbuch der bildenden Kunst*, V, 1954, pp. 29–79, no. 26, fig. 66; Detroit, Detroit Institute of Arts, *Flanders in the Fifteenth Century: Art and Civilization*, exhibition catalogue, 1960, pp. 289–291, no. 128; P. Verdier, *The International Style*, exhibition catalogue, Walters Art Gallery, Baltimore, 1962,

pp. 125–126, no. 127; W. D. Wixom, *Treasures from Medieval France,* exhibition catalogue, Cleveland Museum of Art, Cleveland, 1967, p. 252, no. VI 19.

● 96 V. K. Ostoia, *The Middle Ages: Treasures from The Cloisters and The Metropolitan Museum of Art,* exhibition catalogue, Los Angeles County Museum of Art, Los Angeles, 1969, p. 249, no. 118.

● 101 *Bulletin of the Museum of Fine Arts, Boston,* LV, 1957, p. 91, no. 50.

● 102 Cleveland, Cleveland Museum of Art, *Gothic Art: 1360–1440,* exhibition catalogue, 1963, pp. 205–206, no. 42.

● 104 R. Koechlin, *Les ivoires gothiques français,* Paris, 1924, I, pp. 423–431; II, p. 378, no. 1032; V. K. Ostoia, *The Middle Ages: Treasures from The Cloisters and The Metropolitan Museum of Art,* exhibition catalogue, Los Angeles County Museum of Art, Los Angeles, 1969, p. 162, no. 74.

● 105 V. K. Ostoia, "The Lusignan Mirror," *The Metropolitan Museum of Art Bulletin,* XVIII, Summer, 1959, pp. 18–27; V. K. Ostoia, *The Middle Ages: Treasures from The Cloisters and The Metropolitan Museum of Art,* exhibition catalogue, Los Angeles County Museum of Art, Los Angeles, 1969, p. 146, no. 67.

● 109 G. Savage, *English Pottery and Porcelain,* New York, 1961, no. 10.

● 112 S. de Ricci, *Census of Medieval and Renaissance Manuscripts in the United States and Canada,* New York, 1935, I, p. 193, no. A 19.

● 113 D. E. Smith, "An Interesting Fourteenth Century Table," *The American Mathematical Monthly,* XXIX, 2, February, 1922, pp. 62–63; S. de Ricci, *Census of Medieval and Renaissance Manuscripts in the United States and Canada,* New York, 1937, II, p. 1261, no. 15.

● 114 New York, New York Public Library, *The Pierpont Morgan Library Exhibition of Illuminated Manuscripts Held at the New York Public Library,* exhibition catalogue, 1934, no. 107; "Medieval Life," *Life,* May 6, 1947, pp. 77–80.

● 115 K. Bühler, "Astrological Prognostications in Morgan 775," *Isis,* XXXIII, 1942, pp. 609–620.

● 121 New Haven, Yale University Library, *The Art of the Playing Card,* exhibition catalogue, 1973, no. 8.
122a,b Syracuse, Everson Museum of Art, *Medieval Art in Upper New York State,* exhibition catalogue, 1974, no. 6.

● 126 T. Husband, "Valencian Lusterware of the Fifteenth Century: Notes and Documents," *The Metropolitan Museum of Art Bulletin,* Summer, 1970, pp. 11–19, fig. 6.

● 130 H. Arthur [Viscount Dillon], "On a Manuscript Collection of Ordinances of Chivalry of the Fifteenth Century Belonging to Lord Hastings," *Archaeological Journal,* LVII, 1900, pp. 20–70; New York, New York Public Library, *The Pierpont Morgan Library Exhibition of Illuminated Manuscripts Held at the New York Public Library,* exhibition catalogue, 1934, pp. 47–48, no. 100; C. F. Bühler, "Astrological Prognostications in MS 775 of the Pierpont Morgan Library," *Modern Language Notes,* V, 1941, pp. 345–355; M. Rickert, *Painting in Britain: The Middle Ages,* 2nd ed., Baltimore, 1963, p. 185, pl. 187; New York, The Pierpont Morgan Library, *Medieval and Renaissance Manuscripts,* exhibition catalogue, 1974, no. 35.

● 132a,b,c B. Kisch, *Scales and Weights,* New Haven, 1965, pp. 156, 159, 161.

● 133 Houston, Texas, University of St. Thomas, *Made of Iron,* exhibition catalogue, 1966, no. 216.

● 135 S. de Ricci, *Census of Medieval and Renaissance Manuscripts in the United States and Canada,* New York, 1935, I, p. 192 (where the erroneous date April 13, 1335, is given to the document).

● 136 F. C. Lane, "Le vecchie monete di conto veneziane ed il ritorno all'oro," *Atti del' Instituto Veneto di Scienze. Lettere ed Arti,* CXVII, 1958–59, pp. 49–78; A. Stussi et al., "Zibaldone da Canal," *Fonti per la storia di Venezia,* V, 1967, p. 1.

● 137 R. G. Brown and K. S. Johnston, *Paciolo on Accounting,* New York, 1963, pp. 3–17.

● 138a,b *Florentine Merchants in the Age of the Medici. Letters and Documents from the Selfridge Collection of Medici Manuscripts,* ed. G. R. B. Richards, Cambridge, Massachusetts, 1932, pp. 6–9, 227.

● 140 B. Kisch, *Gewichte- und Waagenmacher im alten Köln (16.–19. Jahrhundert),* Cologne, 1960, p. 102, no. 2.

● 141 J. J. North, *English Hammered Coinage,* London, 1960, II, p. 56, no. 1431.

● 142 J. J. North, *English Hammered Coinage,* London, 1960, II, p. 56, no. 1424.

● 143 *Corpus Nummorum Italicorum,* 12, *Toscana (Firenze),* Rome, 1930, p. 89; H. E. Ives, MS catalogue at ANS, s. a. 1418.

● 144 L. M. Hewlett, *Anglo-Gallic Coins,* London, 1920, no. 2, pp. 34, 35, 48 (third issue); R. D. Beresford-Jones, *A Manual of Anglo-Gallic Gold Coins,* London, 1964, no. 25, pl. 13.

● 145 J. Lafaurie, *Les monnaies des rois de France,* Paris, 1951, I, p. 51, no. 297.

● 146 L. M. Hewlett, *Anglo-Gallic Coins,* London, 1920, no. 1, pp. 137, 142, pls. 10, 11 (type 2).

● 147 L. Deschamps de Pas, "Essai sur l'histoire monétaire des comtes de Flandre de la maison de Bourgogne et description de leurs monnaies d'or et d'argent. I. Philippe le Hardi," *Revue numismatique,* n. s. 6, 1861, pp. 106–139, pls. 6–8, no. 15, pp. 117–122, 137, 138, pl. 8; cf. H. E. Ives, *Foreign Imitations of the English Noble,* American Numismatic Society, Numismatic Notes and Monographs, 93, New York, 1941, no. 12, p. 26, pl. 2; A. Delmonte, *Le Bénélux d'or/De Gouden Benelux,* Amsterdam, 1964, p. 78, no. 474.

● 148 J. Lafaurie, *Les monnaies des rois de France,* Paris, 1951, I, p. 98, no. 459a (second issue).

● 149 I. Halley Stewart, *The Scottish Coinage,* London, 1967, no. 121, pp. 65, 66, pl. 9 (type 2); J. E. L. Murray, "The Early Unicorn and the Heavy Groats of James III and James IV," *British Numismatic Journal,* 40, 1971, pp. 62, 96, pls. 5, 2 (type X-first issue).

● 150 J. Lafaurie, *Les monnaies des rois de France,* Paris, 1951, I, p. 124, no. 573, pl. 27.

● 151 H. J. Kellner, *Die Münzen der freien Reichsstadt Nürnberg,* Bayerische Münzkataloge, ed. H. Geiger, Munich, 1959, I, p. 18, no. 5.

● 152 J. J. North, *English Hammered Coinage,* London, 1960, II, p. 78, no. 1692; P. Grierson, "The Origin of the English Sovereign and the Symbolism of the Closed Crown," *British Numismatic Journal,* 33, 1964, pp. 118–134 (type D).

● 153 L. Réthy, *Corpus Nummorum Hungariae,* trans. G. Probszt, Graz, 1958, p. 119, no. 268, pl. 40.

● 154 J. and A. Erbstein, *Erörterungen auf dem Gebiete der sächsischen Münz- und Medaillen-Geschichte. Bei Verzeichnung der Hofrath Engelhardt'schen Sammlung,* Dresden, 1888, I, cf. no. 92, p. 17; *Sammlung Otto Merseburger umfassend Münzen und Medaillen von Sachsen,* Leipzig, 1894, p. 18, no. 397.

● 155 A. Noss, *Die Münzen und Medaillen von Köln,* Cologne, 1926, IV, pp. 47, 48, no. 76a, pl. 2.

● 156 A. Colosanti, *Catalogue Canessa's Collection,* exhibition catalogue, Panama-Pacific International Exposition, San Francisco, 1915, p. 156, no. 160; *Joseph Brummer Collection,* sale catalogue, Parke-Bernet Galleries, New York, May 14, 1949, Part II, p. 184, no. 715; *Bulletin of the Museum of Fine Arts, Boston,* LV, 1957, p. 86, fig. 42; M. M. Gauthier, *Emaux du moyen âge occidental,* Fribourg, 1972, p. 393, no. 182.

● 157 D. Miner, *Illuminated Books of the Middle Ages and Renaissance,* exhibition catalogue, Walters Art Gallery, Baltimore, 1949, p. 16, pl. LXV, no. 164; C. U. Faye and W. H. Bond, *Supplement to the Census of Medieval and Renaissance Manuscripts in the United States and Canada,* New York, 1962, p. 127, no. 1.

● 158 H. Kuhn, *Die Alt-Ingolstädter Goldschmiede,* Sammelblatt des historischen Vereins, Ingolstadt, LIV, 1936, pp. II, 21–24, 107–108, no. 1, p. III, no. 19; H. Wentzel, "Becher," in *Reallexikon zur deutschen Kunstgeschichte,* ed. O. Schmitt, Stuttgart-Waldsee, 1948, II, pp. 136–148, fig. 6; letter from Max Grünzinger of the Stadtarchiv, Ingolstadt, May 21, 1951, regarding the inability to identify in entirety the arms inside the cover, suggesting they may be a seventeenth-century addition, on file in the Medieval Department, The Metropolitan Museum of Art; J. J. Rorimer, "The Treasury at The Cloisters and Two Ingolstadt Beakers," *The Metropolitan Museum of Art Bulletin,* June, 1951, pp. 253–259, ill.; J. J. Rorimer, *The Cloisters: The Building and the Collection of Medieval Art in Fort Tryon Park,* New York, 1963, pp. 146–148, ill.

● 159 E. A. Jones, *Illustrated Catalogue of the Collection of Old Plate of J. Pierpont Morgan, Esquire,* London, 1908, pl. LXI; G. C. Williamson, *Catalogue of the Collection of Jewels and Precious Works of Art. The Property of J. Pierpont Morgan,* London, 1910, pl. LIX, no. 79; J. Breck and M. R. Rogers, *The Pierpont Morgan Wing: A Handbook,* New York, 1925, p. 212, fig. 113; H. Kuhn, *Die Alt-Ingolstädter Goldschmiede,* Sammelblatt des historischen Vereins, Ingolstadt, LIV, 1936, p. 108, fig. 7.

● 160 W. F. Cook, *Catalogue of the Art Collection,* London, 1904, I, p. 179, no. 727; *The Pierpont Morgan Library. A Review of the Growth, Development and Activities of the Library during the Period between Its Establishment as an Educational Institution in February 1924 and the Close of the Year 1929,* New York, 1930, p. 62; New York, New York Public Library, *The Pierpont Morgan Library Exhibition of Illuminated Manuscripts Held at the New York Public Library,* exhibition catalogue, 1933–34, p. 40, no. 78; New York, The Pierpont Morgan Library, *The First Quarter Century,* 1949, p. 36, no. 41; F. Heer, *The Medieval World,* Cleveland, 1962, p. 84.

● 161 J. Breck, "A Sienese Book Cover," *The Metropolitan Museum of Art Bulletin,* VI, 1911, pp. 40–41; H. B. Wehle, *A Catalogue of Italian, Spanish and Byzantine Paintings,* New York, 1940, pp. 75–76; F. Zeri, unpublished information on file in the Department of European Paintings, The Metropolitan Museum of Art.

● 163a,b,c Baron de Cosson, *Le cabinet d'armes de M. de Talleyrand-Périgord,* Paris, 1901, pp. 106–107, no. M3, pl. 22; H. Nickel, "The Little Man behind the Gate," *The Metropolitan Museum of Art Bulletin,* April, 1966, pp. 237–244.

● 164 Information provided through the courtesy of the Postal Division of the Smithsonian Institution, Washington, D.C.

● 166 Detroit, Detroit Institute of Arts, *English Pottery and Porcelain: 1300–1850,* exhibition catalogue, 1954, p. 16, no. 7.

● 168 Information provided through the courtesy of the Museum of Fine Arts, Boston.

● 170 L. Bagrow, *History of Cartography,* London, 1964, pp. 61–66.

● 171 B. F. De Costa, "The Lenox Globe," *Magazine of American History,* 1879, pp. 529–540; reproduced in *Acta Cartographica,* IV, 1969, pp. 120, 134.

● 172 J. K. Wright, "The Leardo Map of the World, 1452 or 1453," *American Geographical Society. Library Series,* 4, 1928, pp. 1–17; M. Destombes, ed., *Mappemondes: A.D. 1200–1300,* Amsterdam, 1964, pp. 208–212.

● 173 M. Letts, *Sir John Mandeville: The Man and His Book,* London, 1949, p. 175 and frontispiece; E. J. Morrall. "Michel Velser and His German Translation of Mandeville's Travels," *Durham University Journal,* December, 1962, pp. 16–22.

● 174 L. F. Benedetto, "Marco Polo," *Il Milione,* 1928, pp. XXXV–XXXVI, 269; *The Pierpont Morgan Library. A Review of the Growth, Development and Activities of the Library during the Period between its Establishment as an Educational Institution in February 1924 and the Close of the Year 1929,* New York, 1930, p. 61; New York, New York Public Library, *The Pierpont Morgan Library Exhibition of Illuminated Manuscripts Held at the New York Public Library,* exhibition catalogue, 1934, p. 39, no. 75; L. C. Wroth, "The Pierpont Morgan Library and the Historian," in *Studies in Art and Literature for Belle da Costa Greene,* Princeton, 1954, p. 16.

● 175 H. Beraldi, *Bibliothèque d'un bibliophile,* Paris, 1885, pl. 1, no. 1.

● 176 R. S. and L. H. Loomis, *Arthurian Legends in Medieval Art,* London, 1938, pp. 98–101, figs. 250–253; M. R. Scherer, *About the Round Table,* New York, 1945, pp. 53–54, 56; D. Miner, *Illuminated Books of the Middle Ages and Renaissance,* exhibition catalogue, Walters Art Gallery, Baltimore, 1949, no. 64; New York, The Pierpont Morgan Library, *Medieval and Renaissance Manuscripts,* exhibition catalogue, 1974, no. 28.

● 178 F. Lyna, *Le mortifiement de vaine plaisance de René d'Anjou,* Brussels, 1926, pp. 77–80, pls. 19–23; New York, New York Public Library, *The Pierpont Morgan Library Exhibition of Illuminated Manuscripts Held at the New York Public Library,* exhibition catalogue, 1934, no. 110; L. Réau, *Histoire de la peinture au moyen âge,* Melun, I, 1946, p. 200; New York, The Pierpont Morgan Library, *Medieval and Renaissance Manuscripts,* exhibition catalogue, 1974, no. 37.

● 179 F. Winkler, "Über einige deutsche Buchmalereien aus den Anfängen des Realismus und ihr Verhältnis zu Tafelbildern," *Jahrbuch der Preussischen Kunstsammlungen,* XLIII, 1921, pp. 163–168; New York, Brooklyn Museum, *An Exhibition of European Art: 1450–1500,* exhibition catalogue, 1936, no. 100; B. Müller, "Die Titelbilder der illustrierten Rennerhandschriften," *Bericht des Historischen Vereins Bamberg,* 1966, pp. 276, 278, 297, 300; New York, The Pierpont Morgan Library, *Medieval and Renaissance Manuscripts,* exhibition catalogue, 1974, no. 50.

● 180 J. S. P. Tatlock, "The Plimpton Fragment of the Canterbury Tales," *Modern Language Notes,* XXIX, 1914, pp. 140–141; W. McCormick and J. E. Haseltine, *The Manuscripts of Chaucer's Canterbury Tales,* Oxford, 1933, p. 556; G. A. Plimpton, *The Education of Chaucer,* New York, 1935, p. x, pl. 11; J. M. Manley and E. Richert, *The Text of the Canterbury Tales,* Chicago, 1940, I, pp. 447–449.

● 181 Detroit, Detroit Institute of Arts, *Flanders in the Fifteenth Century: Art and Civilization,* exhibition catalogue, 1960, no. 206.

● 183 *The A. Edward Newton Collection of Books and Manuscripts,* New York, 1941, II, p. 28; E. T. Silk, "The Yale Girdle-Book of Boethius," *The Yale University Library Gazette,* XVII, 1942, pp. 1–5; Baltimore, Walters Art Gallery, *The History of Bookbinding: 525–1950 A.D.,* exhibition catalogue, 1957, p. 130.

● 185 C. F. Murray, *Catalogue of a Collection of Early German Books in the Library of C. F. Murray,* comp. H. W. Davis, London, 1913, II, p. 628, no. 394.

● 186 B. Quinnam, *Fables from Incunabula to Modern Picture Books,* Library of Congress, Washington, D. C., 1966, pp. 30–31.

● 188 Information supplied by R. H. Pachella, Librarian for Rare Books and Manuscripts, Union Theological Seminary, New York.

● 191 R. Koechlin, *Les ivoires gothiques français,* Paris, 1924, I, p. 437; II, pp. 428–429, no. 1219; W. Forsyth, "A Medieval Writing Tablet," *The Metropolitan Museum of Art Bulletin,* XXXIII, 1938, pp. 259–260.

● 195 M. Engelmann, *Sammlung Mensing, Altwissenschaftliche Instrumente,* Amsterdam, 1924.

● 198 M. Engelmann, *Sammlung Mensing, Altwissenschaftliche Instrumente,* Amsterdam, 1924; E. Zinner, *Deutsche und niederländische astronomische instrumente 11.–18. Jahrhunderts,* Munich, 1956; Z. Ameisenowa, *The Globe of Martin Bylica of Olkusz,* Warsaw, 1959.

● 199 Alfonso X, *Libros del Saber de Astronomia del Rey*

D. Alfonso X de Castilla, comp. M. Rico y Sinobas, 5 vols., Madrid, 1863–67; M. Engelmann, *Sammlung Mensing, Altwissenschaftliche Instrumente,* Amsterdam, 1924; E. Zinner, *Deutsche und niederländische astronomische Instrumente 11.–18. Jahrhunderts,* Munich, 1956.

● 201 R. Brown, Jr., "On a German Astronomico-Astrological Manuscript and on the Origin of the Signs of the Zodiac," *Archaeologia,* XLVII, 1882, pp. 1–24, pls. VIII–IX; A. Hauber, *Planetenkinderbilder,* Strassburg, 1916, pp. 189–199.

● 202 E. Zinner, *Verzeichnis der astronomischen Handschriften des deutschen Kulturgebietes,* Munich, 1925, p. 19, no. 74; H. Wegener, *Beschreibendes Verzeichnis der Miniaturen und des Initialschmuckes in den deutschen Handschriften bis 1500,* Leipzig, 1928, V, pp. 17 ff.; New York, The Pierpont Morgan Library, *The First Quarter Century,* exhibition catalogue, 1949, no. 53; S. C. Easton, *The Heritage of the Past,* New York, 1955, p. 387; New York, The Pierpont Morgan Library, *Medieval and Renaissance Manuscripts,* exhibition catalogue, 1974, no. 30.

● 203 J. Meder, *Dürer-Katalog,* Vienna, 1932, pp. 242–243; W. Talbot, ed., *Dürer in America: His Graphic Work,* New York, 1971, p. 203, no. 199; D. J. Warner, *European Star Charts: 1500–1800,* Amsterdam–New York, forthcoming.

● 204 J. Fischer, "An Important Ptolemy Manuscript with Maps in the New York Public Library," in C. G. Herbermann, *Historical Records and Studies,* 12, 1913, pp. 216–234.

● 205 J. Sternfeld, "Hour Glasses," *Supplement to the Bulletin of the National Association of Watch and Clock Collectors,* February, 1952, p. 9.

● 207 "Two Manuscripts in Utilitarian Bindings," *Eleventh Annual Report to the Fellows,* The Pierpont Morgan Library, New York, 1960, pp. 15–17.

● 208 M. Engelmann, *Sammlung Mensing, Altwissenschaftliche Instrumente,* Amsterdam, 1924.

● 211 K. Sudhoff, "Codex Fritz Paneth," *Archiv für Geschichte der Mathematik der Naturwissenschaften und der Technik,* 12, 1929, pp. 2–32.

● 214 F. B. Adams, Jr., "Platerius Herbal," *Sixth Annual Report to the Fellows,* The Pierpont Morgan Library, New York, 1955, pp. 13–15.

● 215 New York, New York Public Library, *The Pierpont Morgan Library Exhibition of Illuminated Manuscripts Held at the New York Public Library,* exhibition catalogue, 1934, p. 34, no. 89; M. Harrsen and G. K. Boyce, *Italian Manuscripts in The Pierpont Morgan Library,* New York, 1953, p. 41.

● 216 E. Ashmole, *Theatrum chemicum britannicum,* London, 1652, pp. 275–277; R. H. Robbins, *Secular Lyrics of the Fourteenth and Fifteenth Centuries,* Oxford, 1952, no. 88; "New and Notable: A Sixteenth Century Scroll of Alchemical Problems," *The Princeton University Library Chronicle,* XIX, Spring–Summer, 1958, pp. 201–202.

● 217 W. R. Newbold, *The Cipher of Roger Bacon,* ed. R. G. Kent, Philadelphia, 1928, pp. 1–51; J. M. Manley, "Roger Bacon and the Voynich Ms.," *Speculum,* VI, 1931, pp. 345–391; H. O'Neill, "Botanical Observations on the Voynich Ms.," *Speculum,* XIX, 1944, p. 126; J. H. Tiltman, *The Voynich Manuscript. The Most Mysterious Manuscript in the World* (paper delivered at a meeting of the Baltimore Bibliophiles, March 4, 1967), privately printed, 1968; C. A. Zimarsky, "Editor's Note: William F. Friedman and the Voynich Manuscript," *Philological Quarterly,* XLIX, 4, 1970, pp. 433–441.

● 218 A. Way, "Ancient Dress-Men with Some Remarks on Their Value as Illustrative of Medieval Costume," *Archaeological Journal,* 3, 1846, pp. 239–245, figs. 5, 6; J. Hewitt, *Ancient Armour and Weapons in Europe,* Oxford, 1860, II, pp. 314–315, pl. XLVIII; W. Boeheim, *Handbuch der Waffenkunde,* Leipzig, 1890, p. 215, fig. 23; C. J. Ffoulkes, *Armour and Weapons,* Oxford, 1909, p. 88, fig. 39; C. J. Ffoulkes, *The Armourer and His Craft,* London, 1912, pl. XVIII; Sir Guy F. Laking, *A Record of European Armour*

and Arms through Seven Centuries, London, 1920, III, p. 150, fig. 956; C. J. Ffoulkes and Sir J. Fortescue, *Medieval Arms and Warfare,* Harmsworth's Universal History of the World, London, 1928, p. 2931; H. Nickel, "Sir Gawayne and the Three White Knights," *The Metropolitan Museum of Art Bulletin,* December, 1969, pp. 174–182.

● 219 H. Nickel, "Sir Gawayne and the Three White Knights," *The Metropolitan Museum of Art Bulletin,* December, 1969, pp. 174–182.

● 220 E. E. Viollet-le-Duc, *Dictionnaire raisonné du mobilier français,* Paris, 1871, II, pp. 462–469; E. Falkener, *Games Ancient and Oriental and How to Play Them,* London, 1892; H. J. R. Murray, *A History of Chess,* Oxford, 1913.

● 221 T. von Heydebrand und der Lasa, *Zur Geschichte und Literatur des Schachspiels,* Leipzig, 1897, pp. 141–150; L. Randall, *Images in the Margins of Gothic Manuscripts,* Berkeley, California, 1966, p. 13 ff., no. 222.

● 224a,b E. Falkener, *Games Ancient and Oriental and How to Play Them,* London, 1892; L. Curtius, *Der Astragal des Sotades,* Heidelberg, 1923; A. Fraser, *A History of Toys,* London, 1966, p. 54.

● 225 C. P. Hargrave, *A History of Playing Cards,* New York, 1930, pp. 225–226; New Haven, Yale University Library, *The Art of the Playing Card,* exhibition catalogue, 1973, no. 7.

● 226 New Haven, Yale University Library, *The Art of the Playing Card,* exhibition catalogue, 1973, no. 1.

● 227 M. Lehrs, *Geschichte und kritischer Katalog des deutschen niederländischen und französischen Kupferstichs im XV. Jahrhundert,* Vienna, 1908–34, II, no. 229.

● 228a,b W. R. Valentiner, "Recent Accessions," *The Metropolitan Museum of Art Bulletin,* May, 1913, p. 108; M. S. Dimand, *A Handbook of Mohammedan Decorative Arts,* New York, 1930, p. 104; H. Nickel, "The Little Knights of the Living Room Table," *The Metropolitan Museum of Art Bulletin,* December, 1966, p. 172, fig. 5.

● 230a,b Baron de Cosson, *Le cabinet d'armes de M. de Talleyrand-Périgord,* Paris, 1901, pp. 107–108, no. M4; J. L. Schrader, *The Waning Middle Ages,* exhibition catalogue, Museum of Art, University of Kansas, Lawrence, Kansas, 1969, pp. 88–89, nos. 111–112.

● 232 B. Dean, *Catalogue of European Daggers,* New York, 1929, no. 323; B. Thomas, "The Hunting Knives of Emperor Maximilian I," *The Metropolitan Museum of Art Bulletin,* February, 1955, pp. 206–207, ill.

● 233 S. V. Grancsay, *The Bashford Dean Collection of Arms and Armor in the Metropolitan Museum of Art,* Portland, Maine, 1933, no. 139.

● 235 Baron de Cosson, *Le cabinet d'armes de M. de Talleyrand-Périgord,* Paris, 1901, p. 56, no. F7.

● 236 Baron de Cosson, "The Crossbow of Ulrich V, Count of Würtemburg, 1460," *Archaeologia,* 53, 1892, pp. 445–464, ill.; Baron de Cosson, *Le cabinet d'armes de M. de Talleyrand-Périgord,* Paris, 1901, no. 1.1; Sir Guy F. Laking, *A Record of European Armour and Arms through Seven Centuries,* London, 1920, III, pp. 135–136, fig. 936.

● 241 W. A. and F. Baillie-Grohman, ed., *The Master of the Game,* London, 1904, p. 220; G. Tilander, *Les Livres du roy Modus et de la royne Ratio,* Société des anciens textes français, Paris, 1932, I, pp. VII–LVII; L. C. Wroth, "The Pierpont Morgan Library and the Historian," in *Studies in Art and Literature for Belle da Costa Greene,* Princeton, 1954, p. 15.

● 242 *Sammlung Dr. Albert Figdor, Wien,* sale catalogue, Berlin, 1930, pl. 97, no. 125; K. Geiringer, *Musical Instruments,* New York, 1945, pl. 12, no. 1; E. Winternitz, *Musical Instruments of the Western World,* New York, 1967, pp. 48, 51; F. Crane, *Extant Medieval Musical Instruments,* Iowa City, 1972, p. 16.

● 243 V. Gay, *Glossaire archéologique du moyen âge et de la renaissance,* Paris, 1887, I, p. 492; T. Norlind, *Musikinstrumentens historia i ord och bild,* Stockholm, 1941, pl. 15, no. 8; E. Winternitz, *Musical Instruments of the Western World,* New York, 1967, pp. 52, 53; F. Crane,

Extant Medieval Musical Instruments, Iowa City, 1972, p. 6.

●244 E. Halfpenny, "Two Rare Transverse Flutes," *Galpin Society Journal,* XIII, 1960, pp. 38–43.

●245 M. F. Bukofzer, "The Mellon Chansonnier," *Yale University Library Gazette,* XV, 1940, pp. 25–28; M. F. Bukofzer, "An Unknown Chansonnier of the 15th Century," *The Musical Quarterly,* XXVIII, 1942, pp. 14–49; R. J. Menner, "Three Fragmentary English Ballads in the Mellon Chansonnier," *Modern Language Quarterly,* VI, 1945, pp. 381–387.

●246 G. E. P. How, *English and Scottish Silver Spoons,* London, 1953, II, pp. 76–77.

●247 *The Pierpont Morgan Library. A Review of the Growth, Development and Activities of the Library during the Period between its Establishment as an Educational Institution in February 1924 and the Close of the Year 1929,* New York, 1930, p. 62; S. de Ricci, *Census of Medieval and Renaissance Manuscripts in the United States and Canada,* New York, 1937, II, p. 1487, no. 715.

●249 S. de Ricci, *Census of Medieval and Renaissance Manuscripts in the United States and Canada,* New York, 1935, I, p. 193, A.12.

●250 Boston, Museum of Fine Arts, *Arts of the Middle Ages,* exhibition catalogue, 1940, p. 86, pl. LXVII, no. 306; G. Gall, "Leather Objects in the Philadelphia Museum of Art," *Bulletin, Philadelphia Museum of Art,* July–September, 1967, pp. 260–275; J. L. Schrader, *The Waning Middle Ages,* exhibition catalogue, Museum of Art, University of Kansas, Lawrence, Kansas, 1969, pp. 74–75, no. 92, pl. VII; J. L. Schrader, "Mysticism to Humanism in Kansas: Watching the Middle Ages Wane," *The Connoisseur,* CLXXV, September, 1970, p. 37, ill., p. 38, fig. 2.

●251 H. Kohlhaussen, *Minnekästchen im Mittelalter,* Berlin, 1928, p. 106, pl. 33, no. 158; *Bulletin of the Museum of Fine Arts, Boston,* LV, 1957, p. 103, fig. 67.

●252 M. A. R. de Maulde La Clavière, "Jean Perréal, dit Jean de Paris," *Gazette des Beaux-Arts,* II, 1895, pp. 265–278; J. Breck, "Renaissance Portrait Medals," *The Metropolitan Museum of Art Bulletin,* March, 1912, pp. 52, 54; G. Ring, "An Attempt to Reconstruct Perréal," *The Burlington Magazine,* September, 1950, pp. 255–260; L. Goldscheider, ed., *Unknown Renaissance Portraits: Medals of Famous Men and Women of the XV and XVI Centuries,* New York, 1952; M. L. D'Otrange Mastai, "The Connoisseur in America (French Medal for Raleigh Museum)," *The Connoisseur,* December, 1964, pp. 273–275; J. L. Schrader, *The Waning Middle Ages,* exhibition catalogue, Museum of Art, University of Kansas, Lawrence, Kansas, 1969, pp. 86–87, nos. 106, 107, pl. LXVIII.

253 E. Egg, *Die Münzen Kaiser Maximilians I,* Innsbruck [1972], pp. 40–44 (type 5).

●254 Providence, Rhode Island School of Design, *Europe in Torment,* exhibition catalogue, 1974, p. 109, nos. 41–1, 41–2.

●255 S. de Ricci, *Census of Medieval and Renaissance Manuscripts in the United States and Canada,* New York, 1935, I, p. 193, A.20 (where the document is incorrectly dated "Liège, 6 Feb. 1486").

●256 *Proceedings of the Massachusetts Historical Society,* 1863–64, pp. 153–154 (where an exact date of July 2 is incorrectly given to the document); testament of Louis, duke of Orléans, published by L. Beurrier, *Histoire du monastère et couvent des pères célestins de Paris,* Paris, 1634, p. 295 ff., and F. M. Graves, *Quelques pièces relatives à la vie de Louis d'Orléans,* Paris, 1913, no. 127.

●257 Sister Mary Catherine O'Conner, *The Art of Dying Well,* New York, 1942, pp. 3, 135; W. M. Ivins, Jr., "The Museum Editions of the Ars Moriendi," *The Metropolitan Museum of Art Bulletin,* XVIII, 1923, pp. 230–236.

●259 S. de Ricci, *Census of Medieval and Renaissance Manuscripts in the United States and Canada,* New York, 1935, I, p. 412, no. 1541.7 (where Jehan d'Orléans is mistakenly identified as Jean, duc de Berry).

●260 R. Schmidt, "Die venezianischen Emailgläser des XV. und XVI. Jahrhunderts," *Jahrbuch der königlich preussischen Kunstsammlungen,* 32, 1911, pp. 257–258; R. Schmidt, *Das Glas,* Berlin, 1912, p. 89; P. Perrot in *Three Great Centuries of Venetian Glass,* exhibition catalogue, Corning Museum of Glass, Corning, New York, 1958, pp. 13–15.

●261 R. Schmidt, "Die venezianischen Emailgläser des XV. und XVI. Jahrhunderts," *Jahrbuch der königlich preussischen Kunstsammlungen,* 32, 1911, pp. 265 ff.; Estate of the Late J. Pierpont Morgan, sale catalogue, Parke-Bernet Galleries, New York, 1944, no. 121; H. S. Foote, "A Venetian Ewer Decorated with Enamel," *Bulletin of the Cleveland Museum of Art,* September, 1944, pp. 140–141; Corning, New York, Corning Museum of Glass, *Three Great Centuries of Venetian Glass,* exhibition catalogue, 1958, no. 9.

●262 *Charles Mannheim Collection: objets d'art,* ed. E. Molinier, Paris, 1898, no. 90; R. Schmidt, "Die venezianischen Emailgläser des XV. und XVI. Jahrhunderts," *Jahrbuch der königlich preussischen Kunstsammlungen,* 32, 1911, p. 268.

●263 Corning, New York, Corning Museum of Glass, *Three Great Centuries of Venetian Glass,* exhibition catalogue, 1958, no. 19.

●264 B. Dudnik, *Kleinodien des deutschen Ritterordens,* Vienna, 1865, p. 13, passim; J. J. Rorimer, "Acquisitions for The Cloisters," *The Metropolitan Museum of Art Bulletin,* XI, 1953, pp. 270–276, ill.; W. Borchers, "Der Deckelbecher der Familie von Bar-Altbarenaue," *Westfalen,* XXXVI, 1958, p. 225; J. J. Rorimer, *The Cloisters: The Building and the Collection of Medieval Art in Fort Tryon Park,* New York, 1963, pp. 183–184, fig. 92; H. Kohlhaussen, *Nürnberger Goldschmiedekunst des Mittelalters und der Dürerzeit, 1240 bis 1540,* Berlin, 1968, p. 175, nos. 261–262, figs. 294–296, passim; V. K. Ostoia, *The Middle Ages: Treasures from The Cloisters and The Metropolitan Museum of Art,* exhibition catalogue, Los Angeles County Museum of Art, Los Angeles, 1969, pp. 226–227, no. 107, ill.

●265 E. Bonnaffé, "Les gemmes," in *La collection Spitzer: antiquité, moyen-âge, renaissance,* ed. F. Spitzer, Paris, 1892, V, p. 24, no. 42; A. Legner, "Ein Freiburger Kristallpokal in Graz," *Studien zur Kunst des Oberrheins: Festschrift für Werner Noack,* Konstanz-Freiburg, 1958, pp. 134–135, fig. 9; provisory remarks by Hans R. Hahnloser, October, 1959, on file in the Medieval Department, The Metropolitan Museum of Art; A. Legner, "Schweizer Bergkristall und die Kristallschleiferei von Freiburg im Breisgau," *Zeitschrift für schweizerisches Archäologie und Kunstgewerbe,* XIX, 1959, pp. 226–240.

●266 J. Starkie Gardner, *Old Silver-Work Chiefly English from the XVth to the XVIIIth Centuries,* London, 1903, p. 106, case B, no. 25; E. A. Jones, *Catalogue of the Gutmann Collection of Plate: Now the Property of J. Pierpont Morgan,* London, 1907, pl. LX; M. Rosenberg, *Der Goldschmiede Merkzeichen,* 3rd ed., Frankfurt am Main, 1925, III, p. 13, no. 3686, p. 114, no. 3979.

●267 A. von Walcher-Moltheim, "Deutsches und französisches Edelzinn aus zwei Wiener Sammlungen," *Kunst und Kunsthandwerk,* VII, 1904, pp. 65-86, ill.; K. Berling, *Altes Zinn,* Leipzig, 1919, pp. 61-62, fig. 42; *Sammlung Dr. Albert Figdor, Wien,* sale catalogue, Berlin, 1930, I, Part I, no. 305, pl. 62; H. H. Cotterell and R. M. Vetter, " 'Decorated' or 'Show' Pewter," *Apollo,* XVIII, 1933, p. 318, ill.; Y. Hackenbroch, *The Irwin Untermyer Collection,* New York, 1962, V, pp. L, 32, pl. 139, fig. 150; C. Gómez-Moreno, *Medieval Art from Private Collections: A Special Exhibition at The Cloisters,* exhibition catalogue, The Cloisters, New York, 1968, no. 123, ill.

●268 C. Gómez-Moreno, *Medieval Art from Private Collections: A Special Exhibition at The Cloisters,* exhibition catalogue, The Cloisters, New York, 1968, no. 136, ill.

●269 P. Verdier, "A Medallion of the 'Ara Coeli' and the Netherlandish Enamels of the Fifteenth Century," *Journal of the Walters Art Gallery,* XXIV, 1961, pp. 9-37; B.

Young, "The Monkeys and the Peddler," *The Metropolitan Museum of Art Bulletin*, XXVI, 1968, pp. 441–454; M. M. Gauthier, *Emaux de moyen âge occidental*, Fribourg, 1972, p. 417, no. 246; E. Steingräber, "Kunsthandwerk," in *Spätmittelalter und beginnende Neuzeit*, ed. J. Bialostocki, Propyläen-Kunstgeschichte, VII, Berlin, 1972, p. 319, no. 292.
● 270 H. Kohlhaussen, "Niederländisches Schmelzwerk," *Jahrbuch der Preussischen Kunstsammlungen*, LII, 1931, pp. 153–169; H. Kohlhaussen, "Gotisches Kunstgewerbe," in *Geschichte des Kunstgewerbes*, ed. H. T. Bossert, Berlin, 1932, V, pp. 388–390; *Bulletin of the Museum of Fine Arts, Boston*, LV, 1957, p. 86, fig. 41; Detroit, Detroit Institute of Arts, *Flanders in the Fifteenth Century: Art and Civilization*, exhibition catalogue, 1960, pp. 294–296, no. 131; P. Verdier, "A Medallion of the 'Ara Coeli' and the Netherlandish Enamels of the Fifteenth Century," *Journal of the Walters Art Gallery*, XXIV, 1961, pp. 9–37; B. Young, "The Monkeys and the Peddler," *The Metropolitan Museum of Art Bulletin*, XXVI, 1968, pp. 441–454.

● 272 S. Ducret, *German Porcelain and Faience*, New York, 1962, p. 396, fig. 157.
● 273 S. Ducret, *German Porcelain and Faience*, New York, 1962, p. 399, pl. 158.
● 275a–g Baron de Cosson, *Le cabinet d'armes de M. de Talleyrand-Périgord*, Paris, 1901, pp. 107–108, no. M4.
● 276 Sir Guy F. Laking, *A Record of European Armour and Arms through Seven Centuries*, London, 1920, III, p. 171, fig. 978; S. V. Grancsay, "An Early Sculptured Saddle," *The Metropolitan Museum of Art Bulletin*, April, 1937, pp. 92–94.
● 277 "Eight Medieval Manuscripts," *Yale University Library Gazette*, XXIX, 3, January, 1955, pp. 106–110; J. L. Schrader, *The Waning Middle Ages*, exhibition catalogue, Museum of Art, University of Kansas, Lawrence, Kansas, 1969, p. 23, no. 19.
● 279 O. Trapp, "Die Geschichte eines Trappischen Willkommglas," *Der Schlern*, 40, 1966, pp. 120–122.

SELECTED BIBLIOGRAPHY

SURVEY TEXTS

F. B. Artz, *The Mind of the Middle Ages: A.D. 200–1500. An Historical Survey*, 3rd ed., rev., New York, 1962.
The Cambridge Medieval History, ed. J. B. Bury et al., New York, 1932, VII; 1936, VIII.
E. R. Chamberlin, *Everyday Life in Renaissance Times*, New York, 1965.
R. Delort, *Life in the Middle Ages*, New York, 1973.
J. Evans, ed., *The Flowering of the Middle Ages*, New York, 1966.
V. Gay, *Glossaire archéologique du moyen âge et de la renaissance*, 2 vols., Paris, 1887–1928.
F. Heer, *The Medieval World*, Cleveland, 1962.
J. Huizinga, *The Waning of the Middle Ages*, New York, 1962.
R. S. Lopez, *The Birth of Europe*, New York, 1967.
C. Stephenson and B. Lyon, *Medieval History: Europe from the Second to the Sixteenth Century*, 4th ed., rev., New York, 1962.
R. van Marle, *Iconographie de l'art profane au moyen-âge et à la renaissance*, The Hague, 1931–32.
E. E. Viollet-le-Duc, *Dictionnaire raisonné du mobilier français*, Paris, 1871.

GENERAL

In addition to the information supplied by the lenders and that found in the notes, the following works have been used in the preparation of the catalogue.

A. Abram, *English Life and Manners in the Later Middle Ages*, London, 1913.
Abstracts of the Papers Presented at the Eighth Conference on Medieval Studies, 2, Western Michigan University, Kalamazoo, Michigan, 1973.
Abstracts of the Papers Presented at the Ninth Conference on Medieval Studies, 3, Western Michigan University, Kalamazoo, Michigan, 1974.
J. Ainaud de Lasarte, *Cerámica y vidrio*, Ars Hispaniae, 10, Madrid, 1952.
H. R. d'Allemagne, *Decorative Antique Ironwork*, New York, 1968.
C. d'Altenbourg, *Deux miniatures des annales de Toulouse*, 1909.
P. Anselme, *Histoire généalogique et chronologique de la Maison Royale de France*, Paris, 1726, III.

M. S. Antrabus and L. Preece, *Needlework through the Ages*, London, 1928.
P. M. de Artiñano y Galdicano, *Exposicións de hierros antiguos españales*, Madrid, 1919.
D. Ash, *How to Identify English Silver Drinking Vessels: 600–1830*, London, 1964.
G. Axel-Nilsson, "Ein Doppelbecher von 1585," *Röhsska Konstlöjdmuseet, Göteborg, Sweden*, Årstryck, 1955.
C. T. P. Bailey, *Knives and Forks*, London, 1927.
Baltimore, Walters Art Gallery, *The International Style: The Arts in Europe around 1400*, exhibition catalogue, 1962.
M. Beaulieu and J. Baylé, *Le costume en Bourgogne de Philippe le Hardi à la mort de Charles le Téméraire (1364–1477)*, Paris, 1956.
K. Becher, *Early Herbals from the Library of Dr. Karl Becher*, Karlsbad, n.d.
J. Bedford, *Pewter*, New York [1966].
M. Bell, *Old Pewter*, London [1905].
J. W. Bennett, *The Rediscovery of Sir John Mandeville*, New York, 1954.
R. Bernheimer, *Wild Men in the Middle Ages*, Cambridge, Massachusetts, 1952.
W. de Gray Birch, *Catalogue of Seals in the Department of Manuscripts in the British Museum*, 6 vols., London, 1885–1900.
M. Bishop, *The Middle Ages*, New York, 1970.
T. S. R. Boase, *Death in the Middle Ages*, New York, 1972.
S. Bond, "The History of Sewing Tools, Parts I–V," *Embroidery: The Journal of the Embroiderers' Guild of London*, 13–14, 1962–63.
A. Boorde, *A Compendyous Regyment or a Dyetary of Helth Made in Mountpyllier (1542)*, ed. F. J. Furnivall, Early English Text Society, extra series X, London, 1870.
Bulletin of The Museum of Fine Arts, Boston, LV, 1957.
F. L. L. Boucher, *20,000 Years of Fashion*, New York, 1967.
H. R. Boulton, *Palaeography, Genealogy, and Topography*, sale catalogue, London, 1930.
H. Braun, "The Hall" and "Private Houses," in *An Introduction to English Mediaeval Architecture*, 2nd ed., New York, 1968.
G. Brett, *Dinner Is Served: A Study of Manners*, Hamden, Connecticut, 1969.
S. J. C. Brinton, *Francesco di Giorgio Martini of Siena: Painter, Sculptor, Engineer, Civil and Military Architect (1439–1502)*, London, 1934.
C. Brooke, in *The Flowering of the Middle Ages*, ed. J. Evans, New York, 1966.

Brussels, Palais des beaux-arts, *La miniature flamande: Le mécénat de Philippe le Bon*, comp. L. M. J. Delaissé, exhibition catalogue, 1959.
C. F. Bühler, *The Fifteenth-Century Book*, Philadelphia, 1960.
J. Burckhardt, *The Civilization of the Renaissance in Italy*, New York, 1958, I.
Sir [John] B. Burke, *The General Armory of England, Scotland, Ireland and Wales* (Burke's Peerage), London, 1961.
L. Burrier, *Histoire du monastère et couvent des pères célestins de Paris, Paris*, 1634.
R. de Bury, *Philobiblon*, trans. E. C. Thomas, Oxford, 1960.
Cambridge Economic History of Europe, I–IV, Cambridge, England, 1941–1967.
Catalogue des peintures anciennes, Strasbourg, 1938.
E. R. Chamberlain, *Everyday Life in Renaissance Times*, London, 1965.
R. J. Charleston, ed., *World Ceramics*, New York, 1968.
J. Chartier, *Chroniques de France*, Paris, 1493.
J. Chompret, *Répertoire de la majolica italienne*, Paris, 1949, II.
A. H. Christie, *Embroidery and Tapestry Weaving*, London, 1938.
C. M. Cipolla, *Money, Prices and Civilization in the Mediterranean World*, Princeton, 1956.
C. Clair, *Kitchen and Table*, London, 1965.
"Twelve Additions to the Medieval Treasury," *The Bulletin of the Cleveland Museum of Art*, LIX, 1972.
D. C. Colthrop, *English Costume*, London, 1931, III.
Columbia, South Carolina, Columbia Museum of Art, *Landscape in Art*, exhibition catalogue, 1967.
M. Contini, *Fashion from Ancient Egypt to the Present Day*, New York, 1965.
R. Corson, *Fashions in Hair: The First 5,000 Years*, New York, 1965.
H. H. Cotterell, *Pewter down the Ages*, London, 1932.
G. G. Coulton, ed., *Life in the Middle Ages*, New York, 1935.
Idem, *Medieval Panorama: The English Scene from Conquest to Reformation*, New York, 1946.
A. O. Curle, "Domestic Candlesticks from the Fourteenth to the Eighteenth Century," *Proceedings of the Society of Antiquaries of Scotland*, XI, 1925–26.
O. M. Dalton, "On a Set of Table-Knives in the British Museum Made for John the Intrepid, Duke of Burgundy, Part 2," *Archaeologia*, LX, 1907.
M. Davenport, *The Book of Costume*, New York, 1948, I.
P. A. Delalain, *Etude sur le libraire parisien du XIIIe au XVe siècle*, Paris, 1891.
J. Destrez, *La pecia dans les manuscrits universitaires du XIIIe et XIVe siècles*, Paris, 1935.
Detroit, Detroit Institute of Arts, *Flanders in the Fifteenth Century: Art and Civilization*, exhibition catalogue, 1960.
F. Deuchler, *Die Burgunderbeute*, Bern, 1963.
J. C. Drummond and A. Wilbraham, *The Englishman's Food: A History of Five Centuries of English Diet*, London, 1937.
G. Duby, *Rural Economy and Country Life in the Medieval West*, Columbia, South Carolina, 1968.
E. Egg, *Die Glashütten zu Hall und Innsbruck im 16. Jahrhundert*, Innsbruck, 1962.
G. R. Elton, *Reformation Europe: 1517–1559*, History of Europe Series, ed. J. H. Plumb, New York, 1963.
C. Enlart, *Le costume*, Paris, 1916.
H. M. von Erffa and D. F. Rittmeyer, "Doppelbecher," in *Reallexikon zur deutschen Kunstgeschichte*, ed. O. Schmitt, Stuttgart-Waldsee, 1961, IV.
J. Evans, *English Jewellery from the Fifth Century A.D. to 1800*, London, 1921.
Idem, "Medieval Wheel-Shaped Brooches," *The Art Bulletin*, XV, September, 1933.
Idem, *Gothic Art in Europe*, exhibition catalogue, Burlington Fine Arts Club, London, 1936.

Idem, *A History of Jewellery: 1100–1870*, New York, 1953.
Idem, *Art in Mediaeval France: 987–1498*, 2nd ed., Oxford, 1969.
Idem, *Life in Medieval France*, 3rd ed., London, 1969.
J. von Falke, *Mittelalterliches Holzmobiliar*, Vienna, 1894.
O. von Falke, ed., *Deutsche Möbel des Mittalters und der Renaissance*, Stuttgart, 1924, I.
Sammlung Dr. Albert Figdor, Wien, sale catalogue, Berlin, 1930, V, Part I.
I. Fingerlin, *Gürtel des hohen und späten Mittelalters*, Munich, 1971.
R. J. Forbes, "Metallurgy," in *A History of Technology*, ed. Charles Singer et al., Oxford, 1957, II.
E. B. Frank, "Small Gothic Ironwork," *Speculum*, XXIV, 1949.
Idem, *Old French Ironwork*, Cambridge, Massachusetts, 1950.
P. Frankl, *Gothic Architecture*, Baltimore, 1962.
A. Fraser, *A History of Toys*, London, 1966.
M. Freeman, *Herbs for the Mediaeval Household*, New York, 1943.
A. W. Frothingham, *Catalogue of Hispano-Moresque Pottery in the Collection of the Hispanic Society of America*, New York, 1936.
Idem, "Apothecaries' Shops in Spain," *Notes Hispanic*, 1941.
Idem, *Lustreware of Spain*, New York, 1951.
G. Gall, *Leder im europäischen Kunsthandwerk*, Braunschweig, 1965.
Idem, "Leather Objects in the Philadelphia Museum of Art," *Bulletin, Philadelphia Museum of Art*, July-September, 1967.
N. Gask, *Old Silver Spoons of England*, London, 1926.
Idem, "Apostle Spoons," *The Connoisseur*, XCIII, 1934.
M. M. Gauthier, *Emaux du moyen âge occidental*, Fribourg, 1972.
Lorenz Gedon Collection, sale catalogue, Munich, 1884.
Glas, Kataloge des Kunstgewerbemuseums Köln, I, Cologne, 1963.
M. Gonzáles Martí, *Céramica del Levante Español, siglos medievales*, Barcelona, 1944, I.
W. L. Goodman, *The History of Woodworking Tools*, London, 1964.
L. Grodecki, *Ivoires français*, Paris, 1947.
P. Guilhiermoz, "Remarques diverses sur les poids et mesures du moyen âge," *Bibliothèque de l'école des chartes*, LXXX, 1919.
Y. Hackenbroch, *The Irwin Untermyer Collection*, New York, 1962, V.
P. Hamelius, ed., *Mandeville's Travels*, Early English Text Society, original series, CLIII, London, 1919.
E. Hannover, *Pottery & Porcelain*, London, 1925, I.
C. P. Hargrave, *A History of Playing Cards*, New York, 1930.
J. H. Harrington, *The Production and Distribution of Books in Western Europe to the Year 1500*, New York, 1956.
J. P. Harthan, *Bookbindings*, London, 1961.
T. Hausmann, *Majolika, spanische und italienische Keramik vom 14. bis zum 18. Jahrhundert*, Kataloge des Kunstgewerbemuseums Berlin, VI, Berlin, 1972.
D. Hay, *The Medieval Centuries*, New York, 1964.
J. F. Hayward, *English Cutlery: Sixteenth to Eighteenth Century*, London, 1956.
W. S. Heckscher, "Bernini's Elephant and Obelisk," *The Art Bulletin*, XXIX, 1947.
A. Henriques de Oliveira Marques, *Daily Life in Portugal in the Late Middle Ages*, Madison, Wisconsin, 1971.
K. Hettes, *Old Venetian Glass*, London, 1960.
G. Himmelheber, *Spiele*, Munich, 1972.
A. M. Hind, *An Introduction to a History of the Woodcut*, London, 1935.
J. M. Hoffeld, "The Art of the Medieval Blacksmith," *The Metropolitan Museum of Art Bulletin*, December, 1969.

C. Hohler, in *The Flowering of the Middle Ages*, ed. J. Evans, New York, 1966.

U. T. Holmes, *Daily Living in the Twelfth Century: Based on the Observations of Alexander Neckam in London and Paris*, Madison, Wisconsin, 1952.

W. B. Honey, *Glass: A Handbook for the Study of Glass Vessels*, London, 1946.

G. E. P. How, "Scottish Standing Mazers," *Proceedings of the Society of Antiquaries of Scotland*, LXVIII, 1933–34.

C. J. Jackson, "The Spoon and Its History: Its Form, Material and Development More Particularly in England, Part I," *Archaeologia*, LIII, 1892.

Idem, *An Illustrated History of English Plate*, London, 1911, I.

R. Jacques, "Brettspiel, Brettstein," in *Reallexikon zur deutschen Kunstgeschichte*, ed. O. Schmitt, Stuttgart-Waldsee, 1948, II.

H. W. Janson, *Apes and Ape Lore in the Middle Ages and the Renaissance*, London, 1952.

J. A. Jungmann, *The Mass of the Roman Rite*, 2 vols., New York, 1951–55.

H. H. T. Kimble, *Geography in the Middle Ages*, London, 1935.

D. King, in *The Flowering of the Middle Ages*, ed. J. Evans, New York, 1966.

B. Kisch, *Scales and Weights*, New Haven, 1965.

A. C. Klebs, "Incunabula: Lists of Herbs," in *The Papers of the Bibliographical Society of America*, 11–12, 1917–18.

B. Klesse, *Majolika*, Cologne, 1966.

R. Koechlin, *Les ivoires gothiques français*, Paris, 1924, I.

H. Kohlhaussen, "Rheinische Minnekästchen des Mittelalters," *Jahrbuch der Preussischen Kunstsammlungen*, XLVI, 1925.

Idem, *Minnekästchen im Mittelalter*, Berlin, 1928.

Idem, "Niederländisches Schmelzwerk," *Jahrbuch der Preussischen Kunstsammlungen*, LII, 1931.

Idem, "Der Doppelmaserbecher auf der Veste Coburg und seine Verwandten," *Jahrbuch der Coburger Landesstiftung*, 1959.

Idem, "Der Doppelkopf: Seine Bedeutung für das deutsche Brauchtum des 13. bis 17. Jahrhunderts," *Zeitschrift für Kunstwissenschaft*, XIV, 1–2, 1960.

Idem, *Europäisches Kunsthandwerk*, Frankfurt am Main, 1969, II.

Idem, "Die Minne in der deutschen Kunst des Mittelalters," *Zeitschrift des deutschen Vereins für Kunstwissenschaft*, IX, 3–4, 1942.

H. Kraus, *The Living Theatre of Medieval Art*, Bloomington, Indiana, 1967.

Kurzes Verzeichnis der Bilder, Amtliche Ausgabe, Alte Pinakothek, Munich, 1958.

M. W. Labarge, *A Baronial Household of the Thirteenth Century*, New York, 1965.

L. E. de Laborde, *Glossaire français du moyen âge*, Paris, 1872.

D. Landau, "Forthcoming Sales," *The Burlington Magazine*, LVII, 1930.

C. V. Langlois, *La vie en France au moyen âge*, Paris, 1925.

J. Laver, *Clothes*, London, 1952.

J. Leeuwenberg, "De Vlucht naar Egypte," *Bulletin van het Rijksmuseum*, IV, 1956.

H. Lehmann-Haupt, *Gutenberg and the Master of the Playing Cards*, New Haven, 1966.

Idem, "The Heritage of the Manuscript," *A History of the Printed Book*, ed. L. C. Wroth, The Dolphin, 3, New York, 1938.

A. Lisini, *Le Tavolette Dipinte di Biccherna e di Gabella*, Florence, 1904.

R. S. Lopez, *The Three Ages of the Italian Renaissance*, Charlottesville, Virginia, 1970.

Idem, *The Commercial Revolution of the Middle Ages*, Englewood Cliffs, New Jersey, 1971.

R. S. Lopez and I. W. Raymond, *Medieval Trade in the Mediterranean World*, New York, 1955.

Martin Luther: Selections from His Writings, ed. J. Dillenberger, New York, 1961.

G. Mariacher, *Vetri italiani del cinquecento*, Milan, 1959.

Idem, *Italian Blown Glass*, New York, 1961.

H. Martin, *La miniature française du XIIIe au XVe siècle*, Paris, 1923.

K. Martin, *Minnesänger*, Baden-Baden, 1964, II.

W. E. Mead, *The English Medieval Feast*, London, 1931.

M. Meiss, *French Painting in the Time of Jean de Berry*, New York, 1967.

H. C. Mercer, "Ancient Carpenters' Tools," *Old-Time New England*, 17, 1927, Part VI; 18, 1928, Part VII.

E. Meyer, *Mittelalterliche Bronzen*, Bilderhefte des Museums für Kunst und Gewerbe Hamburg, III, Hamburg, 1960.

F. Milkau and G. Leyh, *Handbuch der Bibliothekswissenschaft* Wiesbaden, 1952–55, esp. E. Kuhnert and E. Christ.

A. L. Millin, *Antiquités nationales*, Paris, 1790, I.

H. A. Miskimin, *The Economy of Early Renaissance Europe*, Englewood Cliffs, New Jersey, 1969.

C. Moakley, *The Tarot Cards*, New York, 1966.

C. F. Murray, *Catalogue of a Collection of Early German Books in the Library of C. F. Murray*, comp. H. W. Davis, 2 vols., London, 1913.

A. de Navarro, *Causeries on English Pewter*, New York [1911].

A. P. Newton, *Travel and Travellers of the Middle Ages*, London, 1930.

New York, Cooper Union Museum, *Leather in the Decorative Arts*, exhibition catalogue, 1950.

H. Nickel, "The Man Beside the Gate," *The Metropolitan Museum of Art Bulletin*, April, 1966.

H. Omont, *Georges Hermonyme de Sparte, maître grec à Paris*, Paris, 1885.

Our English Home: Its Early History and Progress, 2nd ed., Oxford, 1861.

O. Pächt, "Early Italian Nature Studies and the Early Calendar Landscape," *Journal of the Warburg and Courtauld Institutes*, XIII, 1950.

J. H. Parry, *The Age of Reconnaissance*, New York, 1963.

R. Patterson, "Spinning and Weaving," in *A History of Technology*, ed. Charles Singer et al., Oxford, 1957, II, *The Mediterranean Civilizations and the Middle Ages*.

K. Pechstein, in *Kunsthandwerk vom Mittelalter bis zur Gegenwart, Neuerwerbungen 1959–69*, Kataloge des Kunstgewerbemuseums Berlin, IV, Berlin, 1970.

A Picture Book of Leatherwork, Victoria and Albert Museum, London, 1930.

H. Pierenne, *Medieval Cities: Their Origins and the Revival of Trade*, Princeton, 1948.

C. de Pisan, *The Epistle of Otheo to Hector*, trans. S. Scrope, ed. G. F. Warner, London, 1904.

L. Planiscig and E. Kris, *Sammlungen für Plastik und Kunstgewerbe*, Vienna, 1935.

E. Power, *The Goodman of Paris* [Le ménagier de Paris], London, 1928.

Prague, National Museum, *Medieval Ceramics in Czechoslovakia*, exhibition catalogue, 1962–63.

F. G. H. Price, *Old Base Metal Spoons*, London, 1908.

R. Procter, *The Printing of Greek in the Fifteenth Century*, London, 1900.

Geography of Claudius Ptolemy, trans. and ed. E. L. Stevenson, New York, 1932.

G. H. Putnam, *Books and Their Makers during the Middle Ages*, New York, 1896.

M. and C. H. B. Quennell, *A History of Everyday Things in England: 1066–1179*, New York, n.d.

B. Rackham, *Italian Maiolica*, New York, 1952.

F. Rademacher, *Die deutschen Gläser des Mittelalters*, Berlin, 1963.

L. Randall, "A Medieval Slander," *The Art Bulletin*, XLII, 1960.

Idem, *Images in the Margins of Gothic Manuscripts*, Berkeley, California, 1966.

E. Rickert, comp., *Chaucer's World*, ed. C. C. Olson and M. M. Crow, New York, 1948.

F. W. Robins, *The Story of the Lamp (and the Candle)*, London, 1939.

F. W. Robinson, "Medieval Writing Tablets," *Bulletin of the Detroit Institute of Arts*, 22, 1943.

F. Rogers and A. Beard, *5000 Years of Gems and Jewelry*, New York, 1970.

Le roman de la rose, par Guillaume de Lorris et Jean de Meun, ed. E. Langlois, Société des anciens textes français, 3 vols., Paris, 1914–21.

M. Rosenberg, "Studien über Goldschmiedekunst in der Sammlung Figdor, Wien," *Kunst und Kunsthandwerk*, XIV, 1911.

M. V. Rosenberg, *Eleanor of Aquitaine: Queen of the Troubadours and of the Courts of Love*, Boston, 1937.

M. Rowling, *Life in Medieval Times*, New York, 1973.

P. Ruelle, *L'ornement des dames*, Brussels, 1967.

C. G. Rupert, *Apostle Spoons: Their Evolution from Earlier Types, and the Emblems Used by the Silversmiths for the Apostles*, London, 1929.

J. Russell, *Medieval Regions & Their Cities*, Bloomington, Indiana, 1972.

L. Salzman, *English Life in the Middle Ages*, London, 1926.

Idem, *Building in England down to 1540*, Oxford, 1952.

Idem, *Edward I*, New York, 1968.

G. Savage, *English Pottery and Porcelain*, New York, 1961.

G. Schiedlausky, *Essen und Trinken: Tafelsitten bis zum Ausgang des Mittelalters*, Munich, 1956.

P. E. Schramm, *A History of the English Coronation*, Oxford, 1937.

J. P. Sequin, *Le jeu de carte*, Paris, 1968.

A. Shestack, *Master E. S.*, exhibition catalogue, Philadelphia Museum of Art, Philadelphia, 1967.

C. Singer et al., eds., *A History of Technology*, Oxford, 1957, II.

C. Smith, *Jewellery*, London, 1908.

R. C. Smith, *The Art of Portugal: 1500–1800*, London, 1968.

E. Steingräber, "Die französische Goldemailplastik um 1400," *Münchner Jahrbuch der Bildenden Kunst*, 1954.

Idem, *Antique Jewelry*, New York, 1957.

Idem, "Kunsthandwerk," in *Spätmittelalter und beginnende Neuzeit*, ed. J. Bialostocki, Propyläen Kunstgeschichte, VII, Berlin, 1972.

Steinzeug, Kataloge des Kunstgewerbemuseums Köln, IV, Cologne, 1971.

G. R. Stephens, "A Medieval Game in Use Today," *Speculum*, XII, 1937.

W. Stoddard, *Monastery and Cathedral in France*, Middletown, Connecticut, 1966.

E. Strohmer, *Prunkgefässe aus Bergkristall*, Vienna, 1947.

K. Sudhoff, "Codex Fritz Paneth," *Archiv für Geschichte der Mathematik, der Naturwissenschaften und der Technik*, 12, 1929.

G. Taylor, *Silver*, Baltimore, 1965.

Theophilus, *On Diverse Arts: The Treatise of Theophilus*, Chicago, 1963.

J. W. Thompson, *The Medieval Library*, Chicago, 1939.

L. Thorndike, in *The Cambridge Medieval History*, ed. J. B. Bury et al., New York, 1936, VIII.

Two Fifteenth Century Cookery Books, ed. T. Austin, Early English Text Society, original series, XCI, London, 1888.

A. van de Put, "Hispano-Moresque Ware," *Supplementary Studies and Some Later Examples*, London, 1911.

K. Varty, "Reynard the Fox and the Smithfield Decretals," *Journal of the Warburg and Courtauld Institutes*, XXVI, 1963.

P. Verdier, "A Medallion of the 'Ara Coeli' and the Netherlandish Enamels of the Fifteenth Century," *Journal of the Walters Art Gallery*, XXIV, 1961.

W. Vogelsang, *Die Holzskulptur in den Niederlanden*, Utrecht, 1912, II.

N. V. Wade, *Basic Stitches of Embroidery for the Victoria and Albert Museum*, London, 1960.

A. Wagner, *Heralds and Heraldry in the Middle Ages*, 2nd ed., London, 1956.

F. Wall, "The Search for Beauty," *Special Libraries*, 28, 1937.

J. B. Ward-Perkins, *Medieval Catalogue*, London Museum Catalogues, 7, London, 1954.

B. Wason, *Cooks, Gluttons & Gourmets: A History of Cookery*, Garden City, New York, 1962.

J. W. Waterer, *Leather in Life, Art and Industry*, London, 1946.

W. Wattenbach, *Das Schriftwesen im Mittelalter*, rev. ed., Graz, 1958.

H. Wegener, "Die deutschen Volkshandschriften des späten Mittelalters," *Mittelalterliche Handschriften: Festgabe . . . Hermann Degering*, Leipzig, 1926.

H. Wentzel, "Apostellöffel," in *Reallexikon zur deutschen Kunstgeschichte*, ed. O. Schmitt, Stuttgart-Waldsee, 1937, I.

Idem, "Bergkristall," in *Reallexikon zur deutschen Kunstgeschichte*, ed. O. Schmitt, Stuttgart-Waldsee, 1948, II.

L. White, *Medieval Technology and Social Change*, Oxford, 1962.

H. Widmann, *Geschichte des Buchhandels vom Altertum bis zur Gegenwart*, Wiesbaden, 1952.

E. Winternitz, "Bagpipes for the Lord," *The Metropolitan Museum of Art Bulletin*, June, 1958.

Idem, "On Angel Concerts in the Fifteenth Century: A Critical Approach of Realism and Symbolism in Sacred Painting," *The Musical Quarterly*, XLIX, 4, 1963.

Idem, "Musicians and Musical Instruments in 'The Hours of Charles the Noble,'" *The Bulletin of the Cleveland Museum of Art*, March, 1965.

Idem, *Musical Instruments and Their Symbolism in Western Art*, New York, 1967.

Idem, "Images as Records for the History of Music," *The Times Literary Supplement*, June, 1974.

F. Wormald and C. E. Wright, *The English Library before 1700*, London, 1958.

F. Zambrini, ed., *Il libro di cucina del secolo XIV*, Bologna, 1863.